PAOLA GIANTURCO

CELEBRATING WOMEN

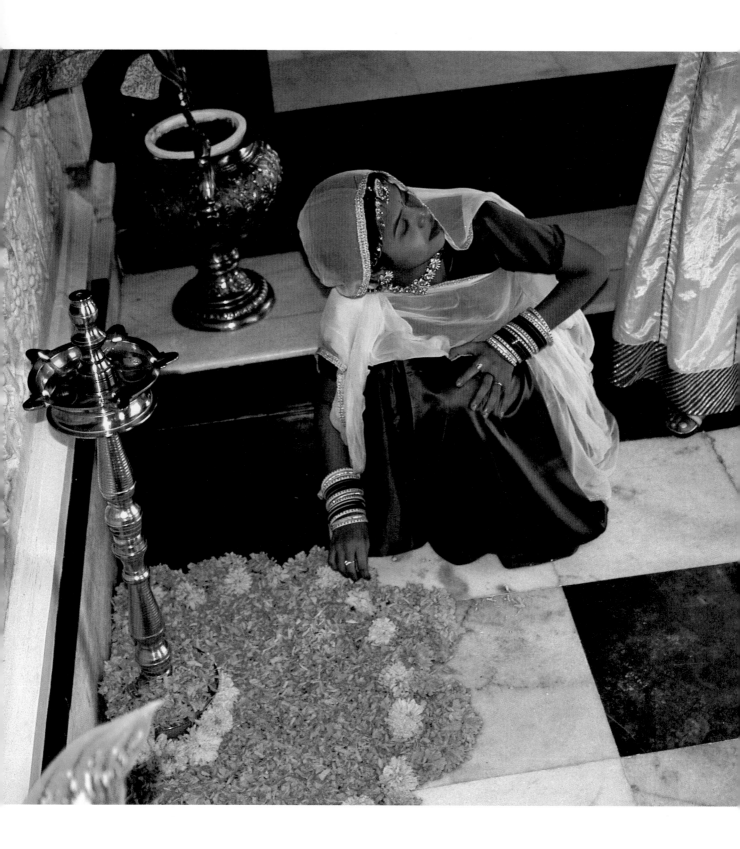

For Nara Shedd,
with best wishes,
Paola Gianturco

PAOLA GIANTURCO

CELEBRATING
WOMEN

pH powerHouse Books New York, NY

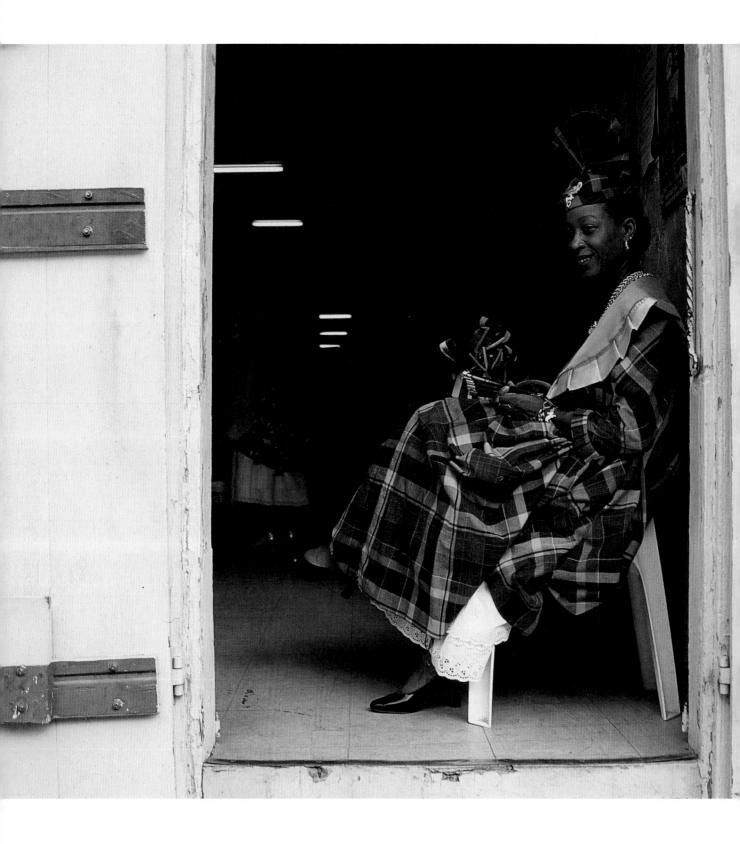

CONTENTS

PREFACE

Eight years ago, I began dreaming about this book. Interviewing artisans around the world for my first book, *In Her Hands: Craftswomen Changing the World*, I heard story upon story about festivals that celebrate women's many attributes, roles, and accomplishments.

I later discovered that there are hundreds, perhaps thousands, of festivals held in celebration of women, attended by men, women, and children on every continent. I was excited to learn that so many of these exist, since in many places women are considered less valuable than men, and in some places not valuable at all. United Nations poverty and literacy statistics continue to provide vivid testimony to that disturbing reality.

As culture helps shape gender roles, different societies deem diverse characteristics worth celebrating as they honor the feminine spirit, observe women's rites of passage, and comme-morate women's achievements. This book includes celebrations that honor women as mothers, athletes, killers, goddesses, providers, lovers, warriors, and flirts. Still others praise women as the sources of wisdom, health, and wealth.

These incredible festivals have never been documented in a single book before, and it was a difficult and delicious task to decide which festivals to include. The possibilities were almost univer-sally tempting. My selection criteria was artistic and subjective. I chose these festivals because they are visually sumptuous,

richly varied, and also geographically dispersed. The result is a sampling, not a survey, and I hope others will continue the work I have begun.

Between 1999 and 2003 I photographed and interviewed at seventeen festivals in fifteen countries on five continents, arriving about four days before each event to document the final preparations. Some of these events are controversial— I tried not to judge them, just to record what the participants and spectators experience.

To learn about the festivals, I interviewed musicians, singers, dancers, and choreographers, food, balloon, ticket and program vendors, mask makers and costume designers, security guards and limo drivers, journalists, priests, mayors, governors, festival organizers, spectators, and participants. Not to mention a princess and a king.

To gain insight into the relationship between the festivals and gender roles, I asked local people to finish this sentence: "An ideal woman is...." and I interviewed local women to give readers insights into their lives.

It was a blessing that my interpreters fully shared my excite-ment and curiosity about this project. Without their expertise, I would not have gained access to the people I interviewed— such as the only living descendant of a Thai woman who saved

Page 1: The Thao Suranari Festival in northeastern Thailand features dance competitions for chil-dren, teens, and adults who create their own costumes and choreograph their own performances.

Page 2: Women honor the warrior goddess, Durga, by "painting" designs with marigold petals and blossoms near the threshold of the hotel where they work in Udaipur, India.

her city from invading forces in 1826—nor would I have gained access to shoot from exotic perches—for example, from the roof of a Taoist temple bell tower on an island in the East China Sea.

Some of the festivals seemed exotic to me—healthy people in Spain riding in open coffins to thank Santa Marta for sparing their lives in near-death experiences. Some seemed magical— little girls launching wreaths of flowers on a river one starry night in Poland. They told me about their experiences over ice cream the next day: "There were lots of bugs," a ten-year-old began. I had never heard such soaring teen voices as I did in Sweden, when the choir at the high school, Sankta Lucias, brought light to the longest night of the year. I have never met so many seventeen-to-twenty-four-year-old women committed to agendas of positive social change as I did at the Miss America pageant, despite the fact that the event is so often wrongly dismissed as irrelevant.

It is an honor to be the one to collect such inspiring evidence that women and girls are making important contributions to their communities and our world. Many people want to share this experience and asked for the dates and locations of festivals so they can witness them for themselves. For those of you who may wish to do the same, there is a list of more than one hundred fifty festivals at the back of this book that celebrate women every month on every continent.

I am humbled to consider the possibility that my work might help shape our knowledge of one another and of ourselves.

Perhaps other women will discover perspectives that help them understand more about "why we are who we are—and what we can become." As we witness what women are rewarded for in different cultures perhaps we can see how arbitrary gender assignments really are. How richly dimensioned life could be if we exploded the limits of what our societies consider "appropriate." How much stronger, more resilient and honest that would make us, and all of our relationships.

It would make my heart sing if this book could help women everywhere understand one another more completely so we could find an understanding of our similarities—and differences—and a new cooperation that could tackle the problems beleaguering our world: poverty, hunger, illiteracy, disease, inequality, violence, and environmental degradation. As we enter a millennium in which the distance between countries and people shrinks daily, I hope that we will be inspired to capitalize on our steadily increasing opportunity for collaboration.

—PAOLA GIANTURCO

Page 4: On the island of Guadeloupe in the French West Indies, women cooks gather to have breakfast together before they parade, carrying trays full of the Creole delicacies that they will serve at a five-hour feast during the Fête des Cuisinières.

FESTIVAL MAP

1 UMHLANGA, LOBAMBA, SWAZILAND

2 RUDOLFINA REDOUTE, VIENNA, AUSTRIA

3 FESTIVIDAD DE LA VIRGEN DE CANDELARIA, PUNO, PERU

4 FESTIVIDAD DE LA VIRGEN DE URKUPIÑA, QUILLACOLLO, BOLIVIA

5 NOC ŚWIĘTOJAŃSKA, CIECHANOWEIC, POLAND

6 DURGA PUJA; KALI PUJA, CALCUTTA, INDIA

7 FÊTE DES CUISINIÈRES, GUADELOUPE, FRENCH WEST INDIES

8 EUKONKANNON, SONKAJÄRVI, FINLAND

9 SANKTA LUCIA DAY, ÖSTERSUND, SWEDEN

10 THAO SURANARI FESTIVAL, NAKHON RATCHASIMA, THAILAND

11 MAZU FESTIVAL, MEI ZHOU ISLAND, CHINA

12 FESTA DA NOSSA SENHORA DA BOA MORTE, CACHOEIRA, BRAZIL

13 ROMERIA DE SANTA MARTA DE RIBARTEME, RIBARTEME, SPAIN

14 MOUSSEM OF IMILCHIL, IMILCHIL, MOROCCO

15 KA POMBLANG NONGKREM, SHILLONG, INDIA

16 MISS AMERICA COMPETITION, ATLANTIC CITY, UNITED STATES

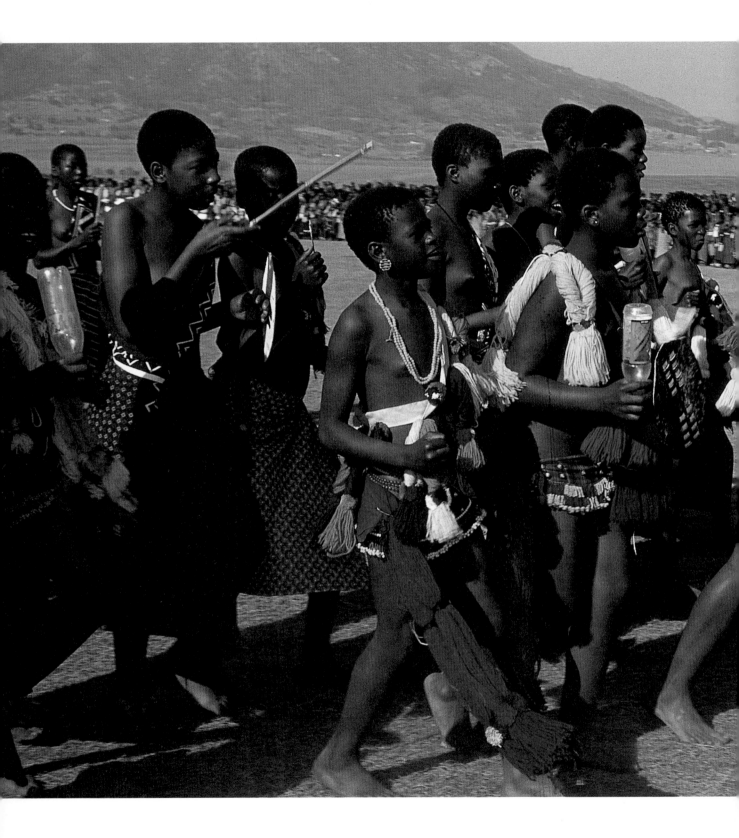

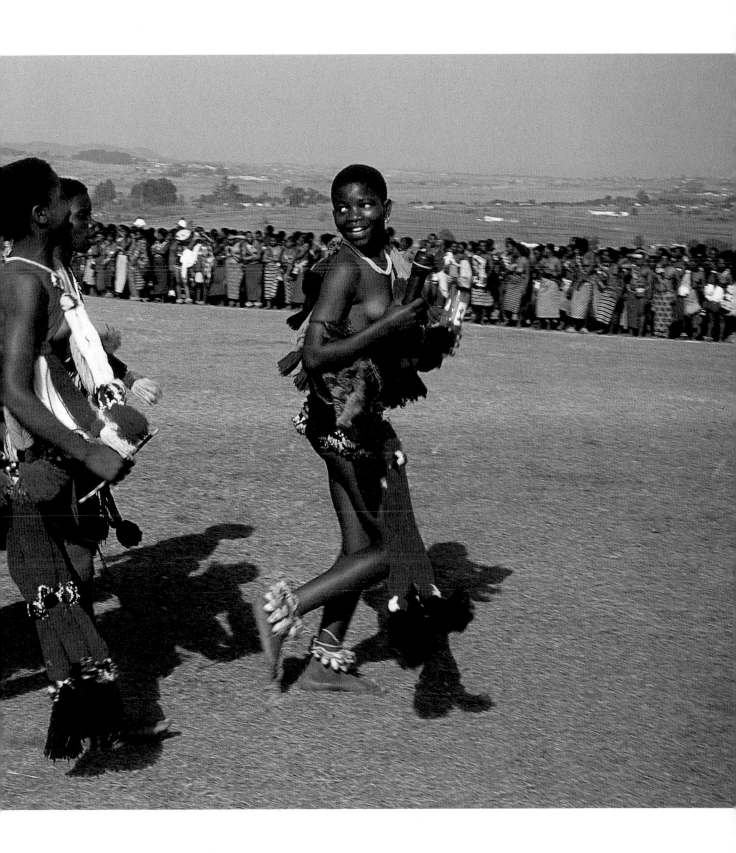

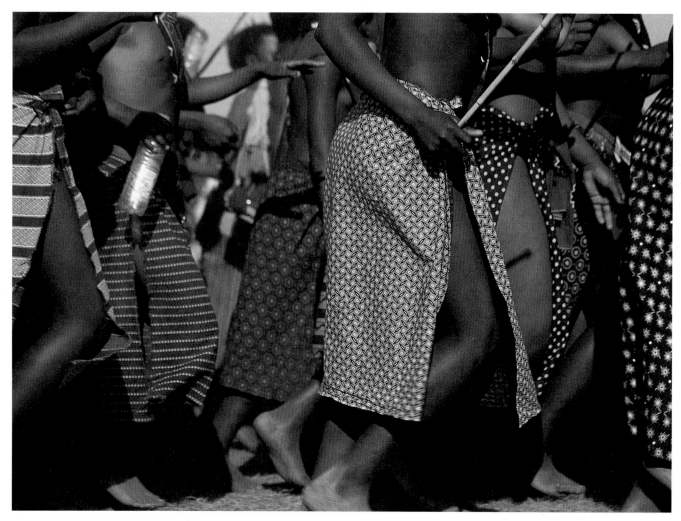

VIRTUALLY EVERY VIRGIN IN SWAZILAND ATTENDS UMHLANGA (THE REED DANCE) ANNUALLY. ON THE LAST WEDNESDAY IN AUGUST, TWENTY-FIVE THOUSAND MAIDENS ABANDON THEIR HIGH SCHOOLS, UNIVERSITIES, AND JOBS IN VILLAGES, TOWNS, AND CITIES AND FLOCK TO THE QUEEN MOTHER'S COMPOUND, LUDZIDZINI, THE SPIRITUAL CAPITAL OF THE COUNTRY, IN LOBAMBA.

Imagine camping out for three days with all your best friends, doing community service for the Queen Mother, then dancing for two days straight. As if that wasn't enough fun, you are honored on the final day by the king, queens, princesses, princes, and warriors, plus VIPs from other countries.

I join the maidens as they set off on their camping expedition. Many wear red, maroon, or orange cotton scarves, printed with the king's photograph and tied toga-style over the right shoulder, with batik long skirts. Swazi princesses lead the procession of girls forth, joyously singing "Ulhambago" ("We're Moving"). Some of the girls carry backpacks and suitcases on their heads jammed with the possessions that the king's daughter suggested they bring: "cycling shorts or tights, socks and sneakers, a shower bag, a blanket, and a pleasant attitude so we can all get along and have a fabulous time."

After being greeted by the king at Ngabezweni, one of the six royal residences, the young women proceed with their twenty-two–mile trek. At the end of their first day they stop to sleep overnight in a valley with huge tents whose red, blue, and yellow Swazi-flag colors suggest a medieval encampment.

Their destination is the intersection of the Sidvokodvo and Mkhondvo Rivers. They descend the banks where each young woman harvests an armload of reeds ten or fifteen feet tall. Months later, when the reeds are dry, they will be used to build a windbreak around the Queen Mother's compound—reeds are important for symbolic reasons, too; the Swazis believe that humans were created from reeds. The young women take advantage of the water to cool off, splash, and swim, jump, sit, laugh, and gossip.

The maiden governor, Lungile Ndlovu, who has been chosen by the king to lead the activities, collects the maidens after breakfast on the third day for the return trip. A seemingly endless parade of young women carrying feather-topped stalks marches through winding roads, over hills, through fields.

When they reconvene outside the Queen Mother's compound, the princesses announce: "Open the gates for us; we are here now!" Her Majesty and her co-monarch, her son the king, watch as the maidens, now dressed in full dancing regalia, stack the reeds inside the palace yard.

The court's protocol officer, Mavis Litchfield, is everywhere, issuing imperatives to help educate foreign journalists. I reach for my bottled water and she instructs, "Squat to drink when you are in the company of royalty; you must be lower than they are!"

Limousines flying Swaziland, UN, and U.K. flags on their radio antennae let VIP guests out onto the red carpet that leads to the reviewing stands. The Queen Mother steps from her Mercedes, which has nothing more than an elephant on its license plates. The mother of the country is called the She Elephant, because she is strong, wise, and majestic. Now in her early fifties, Queen Ntombi Tfwala was one of the wives of the legendary King Sobuza II, who married her because he dreamed about her. After he died, she ruled as regent until her only son was crowned at age eighteen.

Now thirty-three, King Mswati III arrives in a separate limousine. His name alludes to Mswati I, who unified the country. Like his progenitors, this king is known as the Lion because he was required to hunt and kill this majestic beast before his coronation, which was attended by dignitaries from all around the world. Everyone remembers the twenty-one–gun salute, the choir singing the "Hallelujah Chorus," the royal regiment and 500,000 people shouting the royal greeting, "Bayethe!" Today, the king's flag, which is red, yellow, and blue with a lion graphic, already flies above the grandstand.

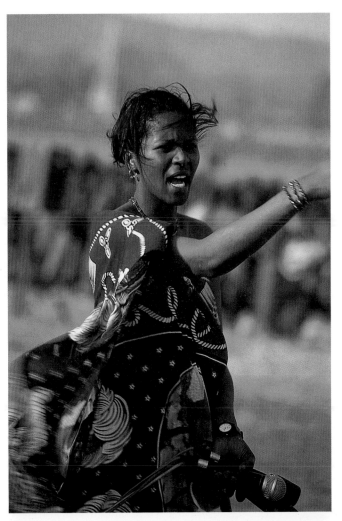

Above, top: Maiden govenor, Lungile Ndlovu

13

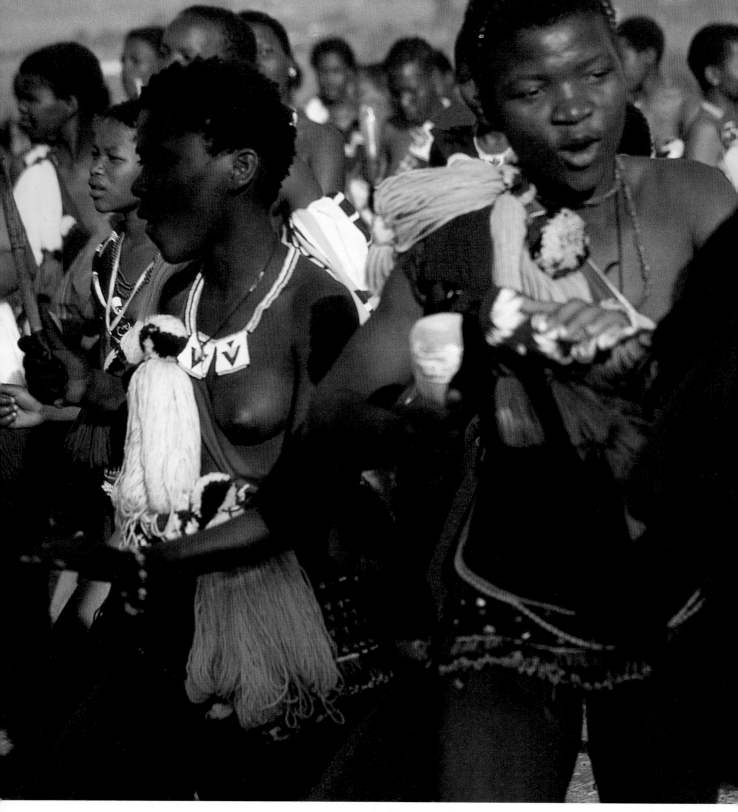

FOR THE NEXT TWO DAYS, TWENTY-FIVE THOUSAND VIRGINS DANCE. EACH WEARS A MINISKIRT THAT IS FIVE INCHES WIDE WITH BRIGHT YARN TASSELS AND ANKLE RATTLES, AND CARRIES A KNIFE AND A SMALL FUR SHIELD. PROUD OF THEIR BODIES AND THEIR VIRGINITY, ENJOYING THEIR GIRLFRIENDS, EXUBERANT ABOUT PARTICIPATING IN THE GREAT UMHLANGA FESTIVAL, THE YOUNG WOMEN SING, CLAP, STOMP, ULULATE, WHISTLE, AND CHANT.

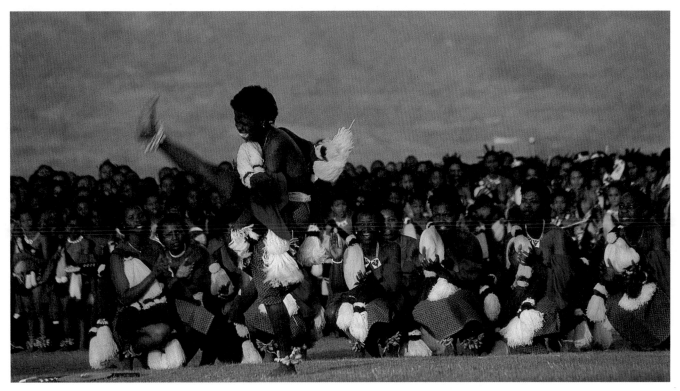

So far, few men have been present to witness this national festival of virginity; each group of maidens has been escorted by just four guards. However, many men appear on the sixth day as spectators: brothers, fathers, uncles, boyfriends. Many of the men would like to find wives here. So would the king.

The king is expected to unify the country by marrying women from all parts of Swaziland. If a young woman catches his fancy, his representatives invite her to the royal compound to talk with him for a few hours, after which he proposes. Young women are free to say no, but almost none do. The new fiancée lives in the king's harem while she learns royal protocol. After she proves her fertility by becoming pregnant with his child, the king marries her.

Although this is a polygynous society, many commoners can only afford to marry one woman. The Reed Dance is an opportunity to observe all the unmarried virgins in the country at once. Men as diverse as ditchdiggers and dignitaries marry women they first see here.

However, few young women are thinking about marriage. They are too busy having fun dancing with their girlfriends and receiving respect and admiration because they have remained virgins.

The king's wives and sisters dance onto the field to drop oranges at their feet and perform a fluttering, pitter-pat jig to honor them. The king runs twice around the huge oval of dancers, stopping to put his royal shield on the ground before them, paying homage to them simply for being.

The young princes do the same with their scepters, darting across the field to honor their older sisters. War clubs are the markers left by warriors in the royal regiments who wear fur loincloths and leap onto the field two-by-two to show their appreciation to the maidens. Policewomen remove their matronly navy uniforms and flat shoes, change into dancing clothes, and have a contest to see who can kick the highest.

The king's eldest daughter, Princess S'Khanyiso, who is almost fourteen, is the superstar of the event. She alone performs the final dance. The Queen Mother descends from the stands in her full-length, black-and-white calfskin cape, singing and dancing with great dignity, lifting her golden scepter to salute the country's beautiful young virgins.

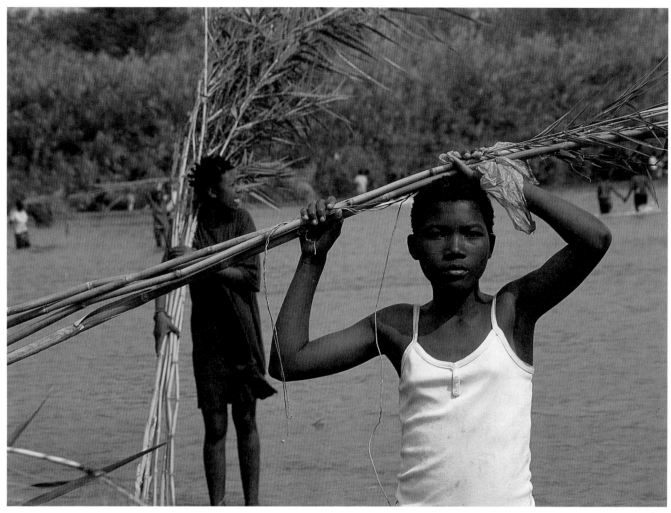

In Swaziland, sexual morality is demonstrated by chastity. Grand-mothers warn granddaughters: "Men have a snake. If you let this snake in you, it will sting like a wasp and produce a baby. Allow him only into your thighs until you are legally married." Self-discipline was key to traditional Swazi courtships, during which a boy and girl stayed together for several days and made love with no penetration.

One young woman told me, "My grandmother is eighty-six years old, a princess, a sister of King Sobuza II. When I was twelve, she taught me to keep my virginity so I could attend the Reed Dance. 'Be responsible, take care of yourself, come back in one piece.' I did the Reed Dance for seven years. When I lost my virginity, I stopped. If you go when you are pregnant, you will lose the baby. The seven years I did the dance, that happened to many girls. It is the punish-ment of the ancestors."

Today, a maiden's virginity is referred to as the "flower of the nation." When girls' families receive cattle as their bride price, a virgin's family will receive more cows.

Although the Reed Dance is an ancient tradition, today's monarchs feel it has particular relevance to contemporary life because it addresses two critical social issues: teen pregnancy and HIV/AIDS.

In 1997, the She Elephant founded an organization to encourage parents to make sure their children are fully grown before they have sexual relations. The Queen Mother hopes that when younger girls see how proud their older sisters are of their virginity at Umhlanga, teenage pregnancies will diminish—right now half of all Swazi births are to unwed mothers.

The king has taken up AIDS as his cause—he worries that a quarter of the Swaziland population is HIV positive. To combat the pandemic, Mswati has commissioned pop musicians to write music, cut a record, and stage a concert to raise money to fight AIDS in southern Africa. Because he hopes that sexual abstinence will inhibit the spread of this rampant disease, he too is invested in rewarding virginity at Umhlanga.

The monarchs' concerns about these sobering realities have inspired their announcement, at this year's Reed Dance, of the reinstatement of an ancient tradition that was abandoned in 1982. This is the practice of wearing *umcwasho*, a yarn tassel that maidens wear to identify themselves as virgins. For the next five years, the monarchs announce, men must not touch women wearing the tassel, even to shake hands. The day after the festival, some people greet the old tradition enthusiastically. Tizzie Maphalala, a psychological counselor who does volunteer work with abused women, believes *umcwasho* is a "public reminder of how precious our young girls are. It's a lay-off sign. Women here have not been socialized to say 'no.' If a woman wearing *umcwasho* is seduced, men have the responsibility, which is as it should be."

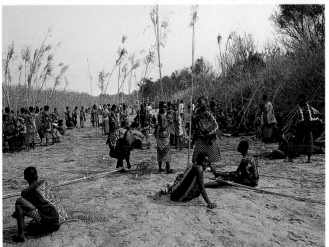

One young woman laughs about *umcwasho*, telling me that the young men who work with her rubbed her forearm that morning and told her, "It will be five years before we can touch you again, so we have to touch you now!" Mumsy Zwane, a vendor in the capital, Mbabane, tells the local paper that she is "over the moon" about the business opportunity, and plans to start making *umcwasho* tassels immediately.

Within months, however, *umcwasho* proves a difficult discipline, even for its sponsor. King Mswati, who selected a virgin at the Reed Dance, married her a few months later when she became pregnant. Obviously, he did not wait five years to touch her. He paid the designated penalty to his new wife's family—one cow, providing her village with a great feast.

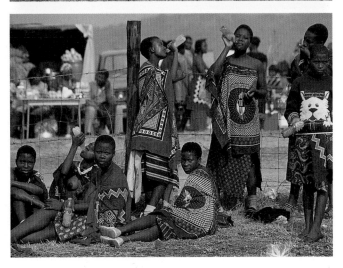

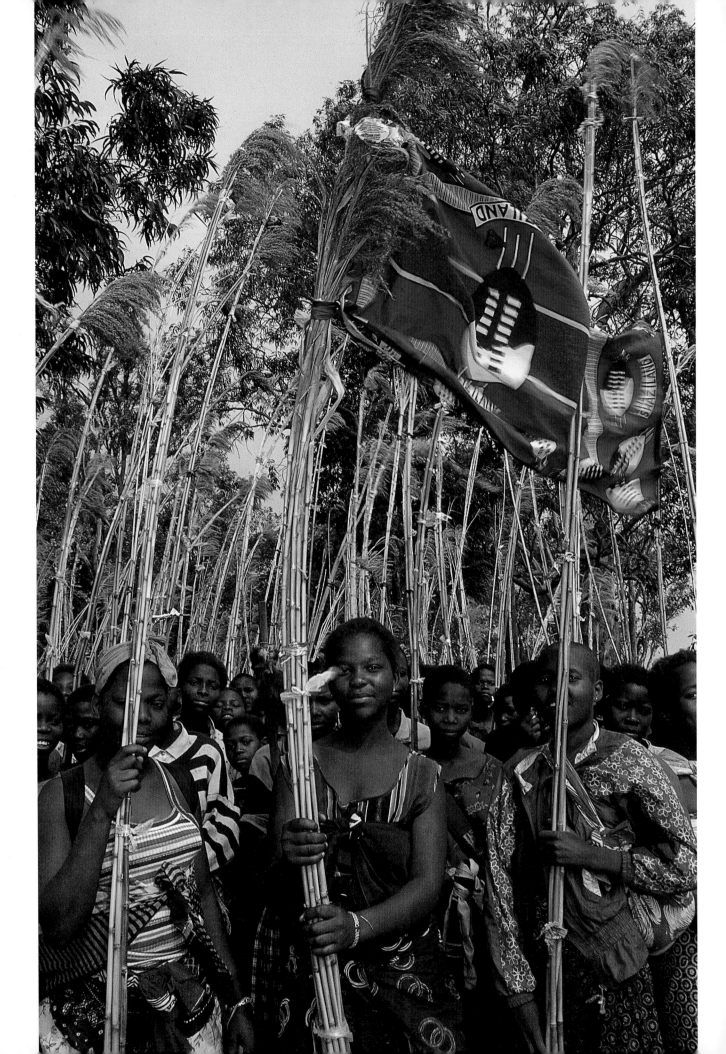

PRINCESS TSANDZILE escorts Tessa Gordon, my photographer friend from Capetown, and me into the Queen Mother's compound and becomes our hostess. Educated at Boston University, she now works at the National Archives, founded by her father King Sobuza II who reigned for sixty years. His official biography says he married sixty-five wives and fathered one hundred ten children, including Princess Tsandzile and her brother King Mswati III.

"We grew up like any other children but I was always in the royal places. When I attended high school I was to go straight home, while my friends would go out. Grown woman as I am at forty-one, I still mingle among my sisters and brothers.

"I was a fully active participant in the Reed Dance from the time I was five. The older women used to come and teach us the traditional songs. Once you get the songs, you know how to do the dance. I think it's inborn. One of my earliest memories of Umhlanga: my bigger sisters were dancing and I wanted to dance with them. I was screaming like a mad person wanting to get out there!

"From oral history, a lot of girls were stopped from doing the Reed Dance because the missionaries believed it was satanic: the women were bare, young men came to look. My father intervened so the Reed Dance never completely stopped. He made it a point that the girls going to the Reed Dance be readmitted to the missionary schools that had expelled them.

"Girls love going to the Reed Dance. You are out there all by yourselves singing, dancing, meeting old friends. You even get to know new people. For those of us who were never allowed to go in and out, the Reed Dance was the only time we could meet people, make friends, have fun.

"I cut reeds a few times. It is not an easy job. Wet. Thorns grow in the water and stick into you. The top of the reed dries out and can get into your eye. We had special men who used to come and cut the reeds for the princesses.

"Among my age mates, there was one senior princess chosen by His Majesty to lead all of us. Red feathers symbolize royalty. The senior princess put two lines of feathers in her hair. If you are a junior princess, you put in one line of maybe twelve or fifteen.

"My daughter [Hlengiwe Mdluli] is now eleven. She started participating in the Reed Dance at two. She wore the outfit but, unfortunately, she just fell asleep when we got there. Without fail, she has been there all the other years. My mother made my costumes and I am giving them to her. The costumes I wore as a big girl are still waiting for her. They are quite a family treasure."

Above: Hlengiwe Mdluli, Princess Tsandzile's daughter, wears the lourie feathers that identify her as royalty.

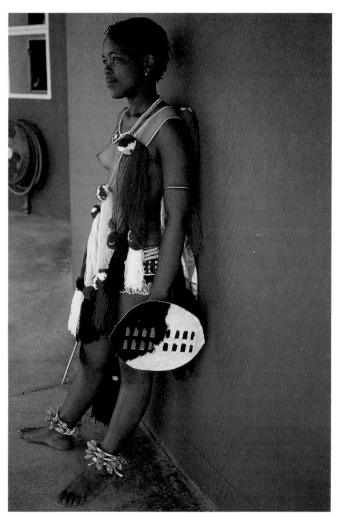

As an Anglican, it is hard for her to imagine wearing such a skimpy skirt with neither top nor underwear, but she is longing to dance in the festival at least once. Ultimately, she decides she will feel comfortable if she bans her boyfriend from attending. The two of us go shopping for her costume.

Old women doing beadwork on the second floor of the Manzini Market direct us toward the stalls selling the requisite skirt, tassels, necklace, ankle bracelets, shields, and knives. To my astonishment, Ndileka strips bare to try on the whole outfit. The women vendors jump up to help her dress and conduct an animated conversation in siSwati, which she reports later: "They were talking about my body. ' That's right,' they said, 'be proud of it.'"

We have lunch with Ndileka's four sisters, enjoying warthog with rice and peas. This afternoon their family compound, which is far from town, is the site of an outdoor wedding rehearsal. Ndileka's aunt, now fifty, has decided—after living with a man for twenty-seven years, birthing several children, and surviving a seven-year separation—to marry him. Now, some seventy-five family members sing a cappella, dance, and whistle. Twin girls lead the rehearsal, tooting silver whistles to keep time. The old women ululate and dance. And although most of her cousins are dressed in jeans and T-shirts, Ndileka preens and struts in her new Reed Dance finery.

The next day when Ndileka joins the throngs of maidens at Umhlanga, I lose track of her in the crowd of identically dressed young women. Afterwards, she is still high on Swazi womanhood when I locate her surrounded by Reed Dancers who are pulling their cell phones from underneath their shields, preparing to reconnect with the rest of the world.

NDILEKA MABUSA, MY TWENTY-THREE-YEAR-OLD INTERPRETER, WENT TO COLLEGE IN PRETORIA, SOUTH AFRICA. BECAUSE SHE HAS BEEN OUT OF THE COUNTRY, SHE HAS NEVER PARTICIPATED IN A REED DANCE.

"It was wonderful." Ndileka bubbles. "I can't wait for next year! You are not afraid of showing your bum because the other girls have also got their bums out, your breasts because everybody's got their breasts out. You don't have to worry about someone staring at you because everyone is dressed the same. Some girls are really big and I was proud of them for showing off their bodies like that; they were confident. I met many people I knew and they had their friends, so now I have even more friends. Plenty of boys were shouting at us, 'Hey sweetie, come here, can I see you after the dance?' but since we were many, we just ignored them or talked back, which was quite fun. Quite fun."

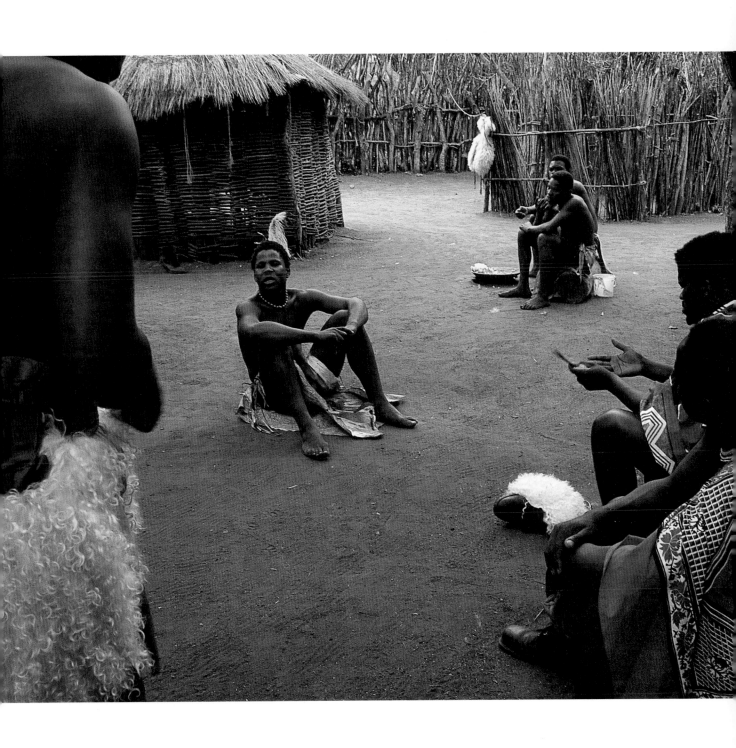

Above: Reed fences like the one that will be built for the Queen Mother surround the Swazi Cultural Village.

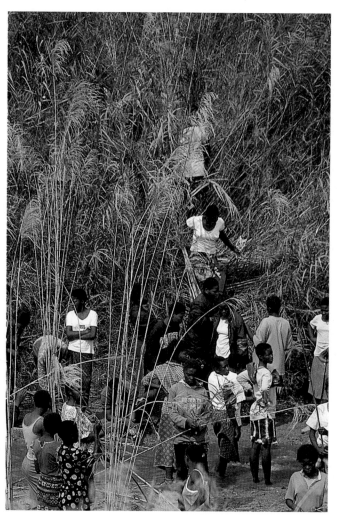

"We just did our official wedding celebration two weeks ago. I wore a black pleated leather skirt and a cape made from the tails of cows, a headdress [a little modern, with some feathers painted a royal blue] and two spears given to me by His Majesty. I went to my mother-in-law's with my sisters and gave her a blanket, a way of asking to be part of her family. Then my sisters and I joined the other people and danced with them.

"The following day, I gave gifts to my in-laws: blankets, brooms, matches, some sweets. I gave my husband a very nice chair, a sofa, a lounge suite, a bedroom suite, beautiful blankets.

"There will be another big day of celebration when the *lobola* (bride price) comes. One hundred cows are required for a princess. The morning after my in-laws deliver them, the women in the royal household will get up and dance.

"I retain my last name, Dlamini, but the children use my husband's name, Mdluli. When I marry into my husband's family, everything becomes mine. People say, 'I am going to the princess's place.' It is no longer Mdluli's place. My husband is a member of the regiment, so he knows the ins and outs of royalty; his family entered into this knowingly. He does not have other wives, although that is quite normal here. Even if he had a wife before me, the day I come, she would know I am taking over everything.

"Four of the king's wives have been chosen at Reed Dances. A lot of other girls ended up marrying men they met at the Reed Dance; it is quite normal."

"IF I MAY TELL YOU," PRINCESS TSANDZILE OFFERS, "MY HUSBAND AND I MET DURING THE REED DANCE. HE HAD SEEN ME DANCING THE PREVIOUS YEAR. FROM THAT TIME ON HE WAS TRYING TO GET HOLD OF ME, BUT IT WAS NOT POSSIBLE. SO THE NEXT REED DANCE CAME. HE FOLLOWED ME DOWN TO WHERE WE WERE GOING TO CUT REEDS. WE MET, WE SPOKE, AND AFTER THE DANCE WAS FINISHED, THE RELATIONSHIP STARTED. I WENT TO COLLEGE FOUR YEARS, RETURNED, WE GOT MARRIED, AND HERE WE ARE.

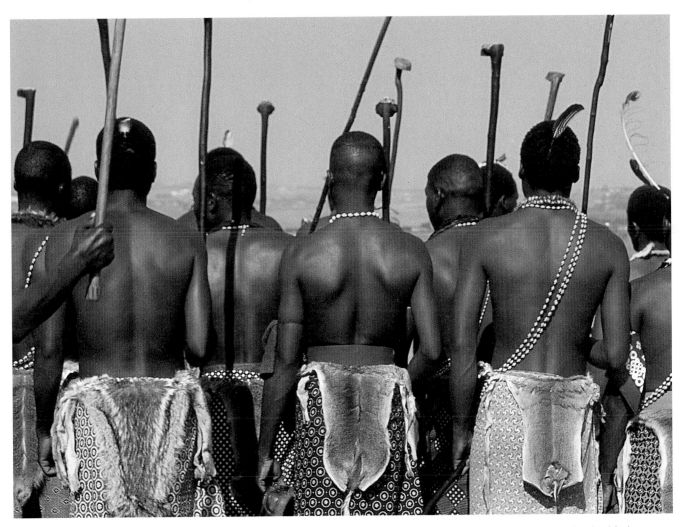

The Reed Dance is part of the portfolio of the director of home affairs, sports, and culture, Maswazi Shongwe. "From a man's point of view, you can choose a very good wife. An outstanding girl. The best of the best. I found my wife at the Reed Dance, of course. I offered to meet her but she said she didn't want to talk to me. I tried to find her friends and eventually got my sister to approach her. Two years after I first saw her, I married her."

When LaNgangaza, who lived in Piggs Peak, married King Mswati in 1995, the new queen's compound took two years to build. Sheila Freemantle and her husband, who own a lumberyard in town, donated silver oak for the ribs of the beehive-shaped palace. A convoy of eighty cars drove from Piggs Peak to the king's residence at Engabezweni for the ceremony. Thanks to police roadblocks, they could break the speed limit and arrived, as expected, exactly at midnight.

A longtime Swaziland resident who is deeply involved in her community, Sheila is among the 3 percent of the Swazi population who are European. So she set about learning how to behave at a royal wedding. "On the second day, beasts were slaughtered. Because I am a vegetarian, I headed for the bean line. Women had to sing in order to eat, so I latched onto a *gogo* (grandmother) to learn what to do."

Above: Royal regiment in full uniform

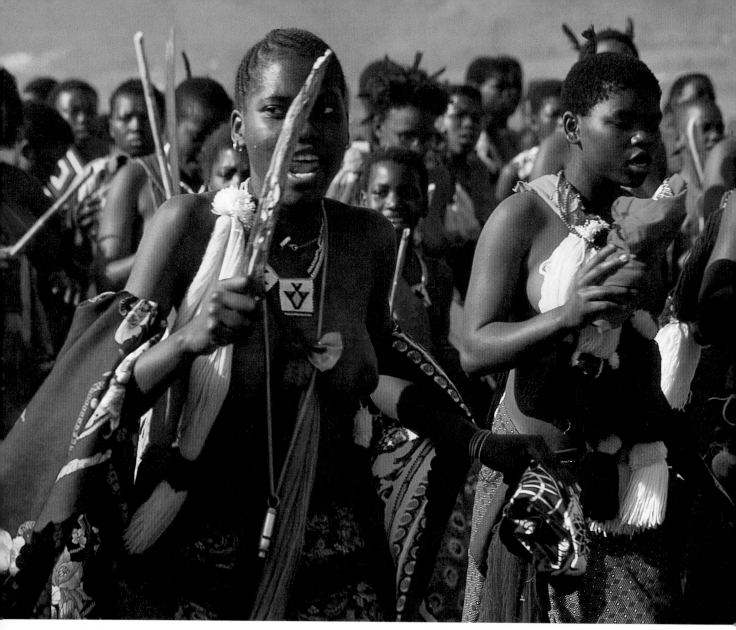

Ndileka describes her brother's traditional ceremony. "At 3 A.M. the groom goes to the bride's home where she cries—if she doesn't cry of her own volition, the women in the groom's family insult her: 'You are lazy and ugly!' For the mother of the bride, the wedding is a bittersweet affair. She mourns for her daughter, knowing the pain she will experience bearing babies, carrying for a sick family, learning the rules of a new family. Part of the *lobola* is a cow for the bride's mother, which is called 'the wiper away of tears.'

"After the crying, the bridal party runs to the river. If the bride is caught before reaching the river, they will bring her back. If she crosses the river, she gets a cow.

"Later that morning, the oldest woman in the groom's family smears the bride with red ocher. The bride sits on the ground and the color is applied to her face, breasts, arms, thighs, legs. The application of earth means the bride is now part of the groom's land. That afternoon, she rinses in the river before changing to her married clothes: a pleated, black cowskin skirt, a goatskin apron, a strand of white wool covering her hairline.

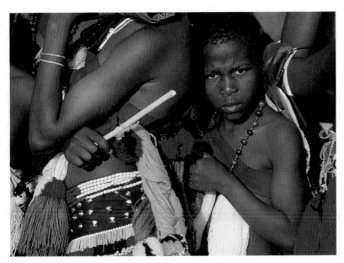

"A child is put in the bride's lap in anticipation of her motherhood. This child teaches the bride how to act in her new family. I played this role during my brother's wedding. Although I was twenty-one, I was as small as a child. If a woman can't have a baby, the marriage agreement says that her sister will become junior co-wife and bear a child for the couple."

Indeed, it seems as important in Swaziland to be a mother after marriage as it is to be a virgin before. Divorce, abortion, and same-sex marriages are considered immoral.

Many relationships are described by the word that a man uses for mother. The word refers to his own mother, her co-wives, her sisters, and the wives of his father's brothers. The term for a man's maternal uncle is "male mother."

AT THE REED DANCE PRESS CONFERENCE, I NOTICE THAT THE KING AND MY OWN SON ARE THE SAME AGE. I ASK THE KING WHAT IT IS LIKE TO RULE THE COUNTRY WITH HIS MOTHER. "SINCE THE MONARCHY WAS ESTABLISHED, THE KING HAS ALWAYS RULED WITH HIS MOTHER. I THINK IT IS VERY INTELLIGENT. THERE ARE NO DIFFICULTIES IN DECISION MAKING. MY MOTHER PLAYS AN IMPORTANT PART HERE, WHICH IS ONE WAY TO SHOW THAT WOMEN ARE RESPECTED."

Harriet Dlamini, the live announcer at the Reed Dance tells me that "women's primary responsibility in this culture is giving birth. In my own family, there were thirty kids with different mothers—my mother herself had seven. Bringing them up, paying school fees to educate them, is of number one importance." She acknowledges that "having a thirty-year career in broadcasting is difficult for a woman because you must be available twenty-four hours a day. That makes home responsibilities impossible." Harriet attends the festival press conference wearing a cotton top that carries a powerful graphic: an elephant ringed with the words "Women United." In 2000, Harriet covered Beijing Plus Five, a United Nations conference on women, in New York. At home, she delivers radio news, and produces programs about women for two channels—one for each of the official languages, English and siSwati.

Other Swazi women are trying hard to combine work and family as well. Some members of the royal family are leading the way. Princess Tsandzile herself is a married mother who works at the National Archives.

Arguably the most controversial renegade is Queen LaMbikiza, who is featured in the August 2001 issue of *The Nation*. The article reports that the queen "refuses to tow the traditional line. She has not only sought her own identity through charity work," but after six years of home study, has earned a law degree and qualified as an attorney. "Quite clearly she intends to be chief legal advisor to King Mswati himself. It may be unheard of in Swaziland for a king to be greatly influenced by his wife...(but) King Mswati is inextricably drawn to this remarkable woman."

THE VIRGIN/MOTHER ROLE THAT HAS LONG BEEN IDEALIZED IN SWAZILAND MAY BE CHANGING.

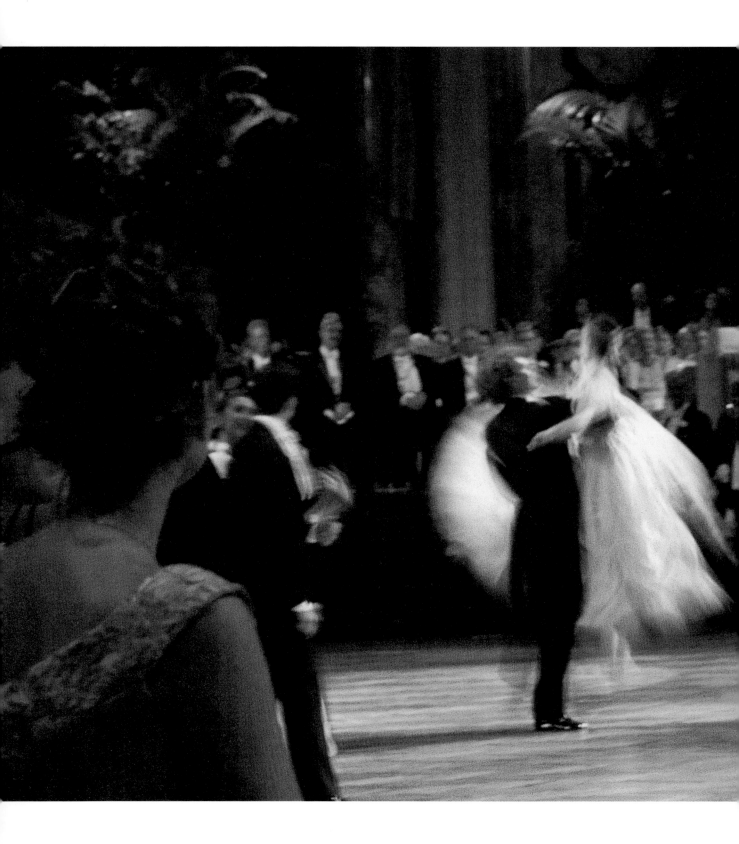

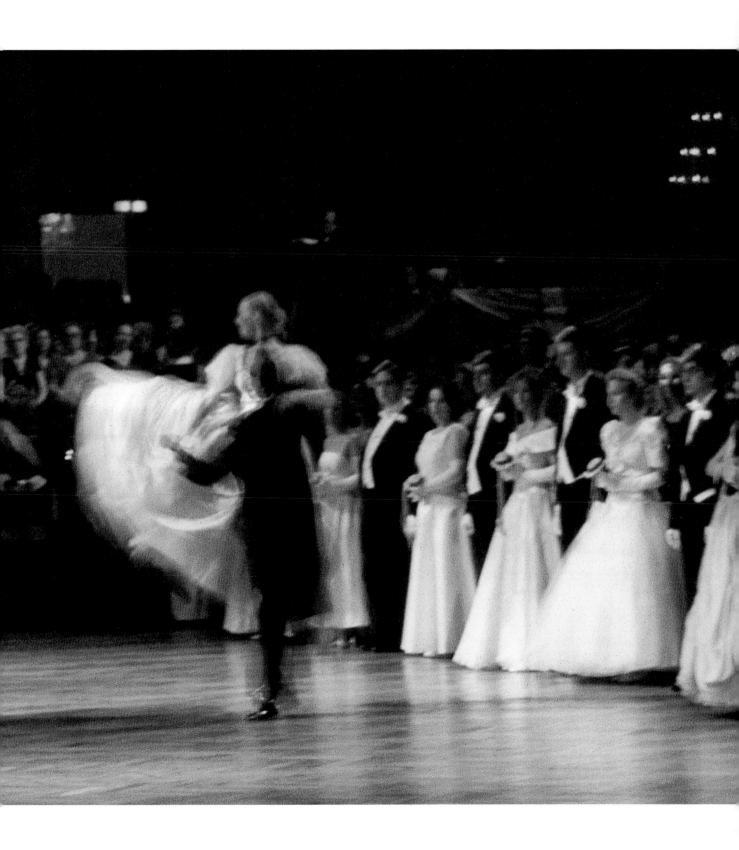

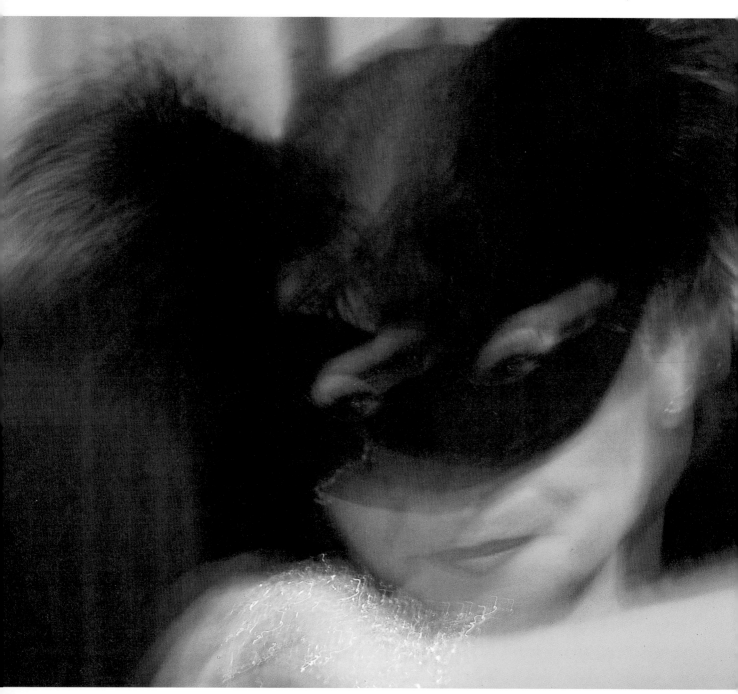

THE RUDOLFINA REDOUTE IS AMONG THE BIGGEST, MOST ELEGANT AND TRADITIONAL OF THE THREE HUNDRED BALLS HELD IN VIENNA DURING THE SEVEN WEEKS AFTER NEW YEAR. ONLY ON THIS ONE NIGHT, ONLY AT THIS TRADITIONAL VIENNESE BALL, DO SINGLE WOMEN WEAR ROMANTIC MASKS AND INVITE MEN TO DANCE. IT'S LADIES' CHOICE UNTIL MIDNIGHT WHEN WOMEN REVEAL THEIR IDENTITIES.

"A gentleman can never refuse a lady who asks him. He must dance with her at least once. This etiquette dates back to the imperial courts," Thomas Schaëfer-Elmayer tells me, holding his book *Good Manners on Demand* that, like his dancing school and lectures, teaches debutantes, diplomats, and tourists the appropriate behavior for Viennese balls.

The University of Vienna, the official name of which is Mater Rudolfina, was named for Duke Rudolf IV, who founded the school in the fourteenth century. Rudolfina, one of the university's student unions, sponsors a *redoute*, which is French for "party" or "ball." The word's use in Austria dates back to the nineteenth century, when French and Italian were court languages while all of Europe from Spain to the Balkans, from Italy to the Netherlands, was the Austro-Hungarian Empire, ruled by the Hapsburg dynasty. But masked dances were first held at the Hofburg Imperial Palace in 1748, after Archduchess Maria Theresa converted the palace's Opera Room into ballrooms.

Ironically, it was also Maria Theresa who prohibited wearing masks on the streets. In 1752, she introduced the Commission Against Immoral Conduct, which she hoped would encourage marital fidelity. No one could identify philanderers if couples covered their faces, so masks were banned unless they were worn indoors by aristocrats.

The waltz was originally judged to be almost as bad as masks. When the dance evolved from the court minuet in the nineteenth century, it was considered immoral; partners danced too close together. Yet the waltz was to become the mainstay of Viennese balls and even now participation is invited with the words, "*Alles Walzer!*"

The controversial waltz gained legitimacy in 1837 when the senior Johann Strauss composed one for the coronation of England's Queen Victoria. Strauss' "Radetsky March" will accompany the processional at the Rudolfina Redoute this year. His son after him wrote four hundred waltzes, many of which will be played by the *redoute* orchestra.

Long ago, the Austrian king ordered that there must be nine *redoutes*, unique in that they each lasted until five in the morning. Today there is only one left, the Rudolfina Redoute, which is held in the Festsaal Banquet Hall of the Hofburg Palace. For about one hundred years—except when it was disallowed by the Nazis—the Redoute has occurred on the Monday night before Ash Wednesday, a date that is already reserved with the Hofburg Palace through 2012.

Catholic students join the Rudolfina fraternity while they are in school and remain members for life. Of the four hundred thirty men who belong today, about eighty are students who socialize at their building in the Josefplatz district, sponsor scientific lectures, and raise money for charity.

The Rudolfina organization was launched in 1898 and was dedicated to Emperor Franz Joseph, who wore a military uniform at all times. In those days military careers were among the most socially acceptable for young men. Military service was mandatory. Uniforms were tailor made. Sabers were mass produced, even sold in toy shops so little boys could played soldier.

Today at the Rudolfina Redoute, members wear uniforms—some even wear full colors, sabers, and ribbons—frock coats, tails, or tuxedos. Women come in long, elegant evening dresses. This is a party full of jewels, furs, fragrance, and formality.

In 1929, one costume-rental manager wrote that although costumes had been worn to the Redoute in the past, cross-dressing had always been strongly forbidden. You bet. Today, students who attend this dance do not arrive pierced, tattooed, or with spiked hair.

VIENNA IS A TRADITIONAL CITY. MOST RUDOLFINA MEMBERS' WIVES DO NOT PURSUE CAREERS. ALTHOUGH ALMOST HALF OF THE CITY'S WOMEN HAVE JOBS, THE PEOPLE I MEET PREFER WIVES TO STAY AT HOME, CARE FOR THEIR CHILDREN, AND SERVE DINNER AT SIX.

THOMAS SCHAËFER-ELMAYER REMARKS, "MY GRANDFATHER FOUNDED OUR DANCING SCHOOL SHORTLY AFTER WORLD WAR I. COMPARING 1919 TO 2002 IS NEARLY IMPOSSIBLE, BUT OUR DANCING SCHOOL HAS NOT CHANGED MUCH. THAT DOES NOT MEAN WE ARE OUTDATED. WE FEEL WE SHOULD KEEP THINGS THAT ARE GOOD AND OF VALUE."

WOMEN, TOO, APPRECIATE VIENNA'S TRADITION OF COURTLY BEHAVIOR. MY INTERPRETER, GERTIE SCHMIDT, ADMITS THAT SHE JUST ASSUMES MEN'S GOOD MANNERS: "I SLIP OFF MY COAT AND LET IT DROP, KNOWING THAT THE MAN I AM WITH WILL BE STANDING BEHIND ME TO TAKE IT. I DON'T EVEN LOOK. ONE TIME I TURNED AROUND TO SEE MY COAT LYING IN A HEAP ON THE FLOOR. MY COMPANION, WHO WAS VISITING FROM GERMANY, HAD ABSOLUTELY NO IDEA WHAT HE WAS EXPECTED TO DO."

THE RUDOLFINA REDOUTE EXISTS AT THE INTERSECTION OF MILITARY CULTURE, CATHOLIC TRADITION, THE RICH HERITAGE OF VIENNESE MUSIC, AND THE LEGACY OF AN IMPERIAL COURT. THAT MIX INSPIRES OUTRAGEOUS FLIRTING, COQUETTISH BEHAVIOR, ROMANTIC MYSTERIES, AND WONDERFUL FUN.

Movie posters on the lobby walls show theater, ballet, opera, television, and movie stars whose costumes came from Lambert Hofer: Zsa Zsa Gabor, Tom Hanks, Brad Pitt, Gerard Depardieu. The costumes for *Seven Years in Tibet* were rented from this collection. Today, a designer from a German film company is selecting outfits from the *damen* section. A television crew is filming people returning the formal apparel they wore to last night's Opera Ball.

Two fitters in white uniforms have already selected dresses in Toby's and my sizes and escort us upstairs to the largest dressing room, which has mirrors and an oriental rug. There, two young women are trying on sexy tops; one puts on a military jacket with her underpants and prances out to model for her boyfriend. An older woman plays dress up with a conical hat from the medieval period. Our interpreter slips into a red velvet Elizabethan gown, arranges her breasts inside the boned bodice, then steps gracefully over her train. Toby and I choose taffeta dresses, her's midnight blue, mine a pink-beige plaid. Both have typically-Biedermeier crinoline petticoats, wasp-waists, puffy sleeves, and scooped necklines.

Outside, hung on double racks that reach the ceiling, organized by size, country, and period, are 109,000 costumes including shoes, hats, hair pieces, and tights. There are headdresses from Egypt; Victorian middies; slinky, red flamenco dresses; a penguin outfit; fringed flapper chemises; gypsy garb; plumed chapeaus; a caterpillar costume from *Alice in Wonderland*. Racks of wedding dresses. Capes. Camisoles. Carmen outfits. Trollop clothes. Cloches. Belly dancer veils and coin-covered bodices. Burlap slave dresses. Beggar's costumes with torn, stained skirts. Dirndls of damask, chintz, and peasant-prints. Tulle petticoats arrayed like a rainbow: green, blue, purple, lavender, pink, yellow, orange, red.

Director Peter Hofer is the fourth generation to manage the business his great grandfather founded in 1862. His daughter, now eight, could become his successor when she grows up "if she wants." Ninety-seven percent of Lambert Hofer's clients come from the world of entertainment. The firm owns fragile original clothing that dates back as far as 1790, which they use for pattern reference. Twenty staff tailors create their multimillion dollar inventory.

"For the balls," Hofer tells us, "there are no single best styles. Biedermeier is most popular with young girls. Those dresses are too big for older women." (I glance in alarm at Toby, wondering whether this is a compliment or if we have made a huge mistake.) Peter confirms the report that if guests are not appropriately dressed at Viennese balls, they are turned away at the door. "No tail, no ball; you have to go to the second gallery." Does he attend the balls himself? "I waltzed when I was eighteen but now if I went to the balls, I would come here the next day with bags under my eyes!"

Our next stop: Zauberklingl, the oldest mask shop in Vienna. It displays feathered, painted, beaded, glittery, and lace masks, cat masks, silver and gold metallic masks. Some are painted with eyelashes and spectacles. Some have veils. We preen in front of the mirrors and kibitz as other women make their choices. I want a mask that will fit over my glasses since I must see to shoot pictures. Toby decides to decorate a plain mask with trimmings she selects from the ribbon shop behind St. Stephens Cathedral.

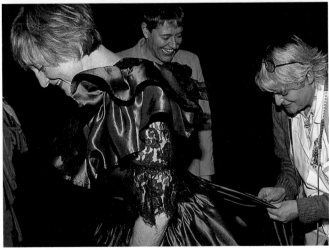

Above, bottom left: Toby Tuttle
Above, bottom right: Paola Gianturco (photograph by Toby Tuttle)

THIS AFTERNOON, TWENTY-FOUR RUDOLFINA STUDENTS AND THEIR DATES ARE PRACTICING THEIR OPENING DANCE NUMBER. WE HAVE BEEN INVITED TO TWO OF THEIR REHEARSALS. THEIR CHOREOGRAPHER AND TEACHER, SIMONE RUEFF, HAS OWNED THE DANCE SCHOOL, TANZSCHULE RUEFF, SINCE 1964 AND HAS DIRECTED THE OPENING OF THE RUDOLFINA REDOUTE FOR MORE THAN TWENTY YEARS.

In addition to waltzes, the students practice the dance to Johann Strauss' "Chit Chat Polka," chosen both because it is traditional and for its hillarious caricatures of Viennese gossiping. It is gay music and Simone has created an energetic, amusing choreography. The young women pause, lean toward each other, and whisper secrets behind their hands before they leap back into action and polka off with their dates. Simone explains, "I do the actual opening without talking. When I see problems, I use American sign language—not like the old dance masters, shouting as I am doing now." She stands on a chair with a microphone, instructing, coaching, and counting: "Ein, zwei, drei, vier, fünf, sechs...."

Toby and I decide to learn the Viennese waltz before the ball. Thomas Shaëfer-Elmayer assures us, "There is nothing easier. All you have to do is repeat six steps time after time. Many visitors learn it in an hour or two." His young instructor, Roman Svabek, makes good on the promise. At age twenty-five, Roman has been dancing ten years and has studied formally for three and a half. His European dance certificate authorizes him to teach everything from hip hop to tap to flamenco, but he's a waltz expert. We trade our tennis shoes for what Toby calls "fairy princess shoes," which have the requisite leather soles. After a one-hour lesson, sure enough, we can waltz.

By Sunday afternoon, Birgit Feichtinger, the floral designer for the past nine Redoutes, is supervising workmen in the Hofburg Palace surrounded by pushcarts full of plants. "The Rudolfina Redoute is one of the very few balls in Vienna that are decorated traditionally. Most important is the first impression, the lobby. There will be six groups of palm trees, which were used for the first time during the [Austro-Hungarian] Empire. People began to travel south to get them; for them, the greatest thing was palm trees." Work is underway all over the building. A different species of palm is being set on either side of the bust of Franz Joseph at the top of the marble stairs. Floral artists are creating a replica of the Rudolfina coat of arms whose red, white, and yellow, reflect both the papal and Austrian colors. Upstairs in the Festsaal, a former throne room,

Birgit plans to put three palm tree groups, flowers on the stage steps, bouquets on the tables, and garlands along the balustrades. The decorations represent a perishable $15,000 investment. The space is vast. The team from Pflanzen Pertl, which Birgit co-owns, must work fast; there was a ball here last night, so they couldn't begin until this morning. Twenty years ago, Birgit was a physical education teacher; perhaps no one else is so well qualified to lead her team's race to finish all this work in a single day.

Upstairs, Harald Willenig, the manager of the Rudolfina Redoute, has brought his two sons to watch the final rehearsal of the opening numbers. A self-employed management consultant who joined the Rudolfina when he was a student in 1984, Harald has directed the ball for four years. "My predecessor ran around with his hair a mess, close to having a nervous breakdown. Although some excitement is part of the evening, I am always calm. Two minutes before we start, if someone says, 'I've got to tell you a joke!' I say, 'Come on, tell me, the ball only starts when I raise my hand.'" The event tonight will be the culmination of six months of planning for Harald, Simone, orchestra leader Wolfgang Ortner, and the student committee. As promised, Harald is calm.

Monday afternoon, Toby has her hair done by a Viennese stylist. Two of his other clients will attend the Rudolfina Redoute, so he is something of an expert on hairstyles that are appropriate for this ball. Determined to balance the dimensions of Toby's hairdo with the billowing skirt of her Biedermeier dress, he looks skeptically at her short crop of American hair—which is, at least, longer then mine. "You must have more volume to go with more dress," he worries. Toby winces as he back combs and teases, but later admits, "He made a lot from a little."

Have you ever tried to get into a taxi wearing a hooped skirt? You sit down and the front flies to the ceiling. We dissolve in giggles and are off to the ball.

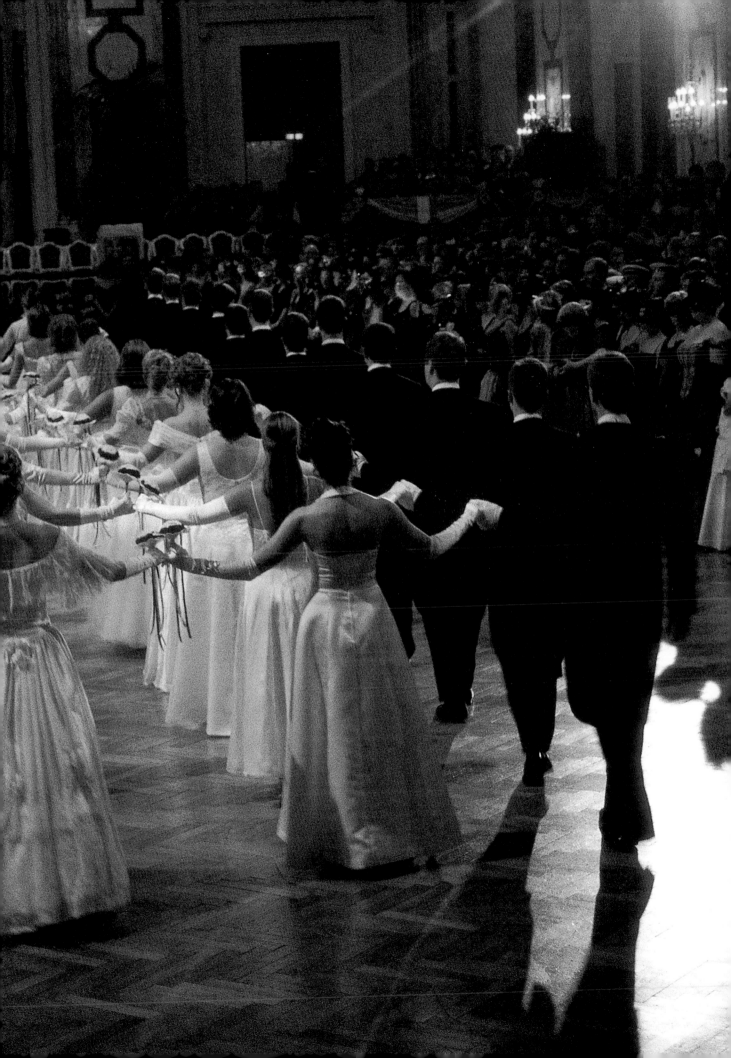

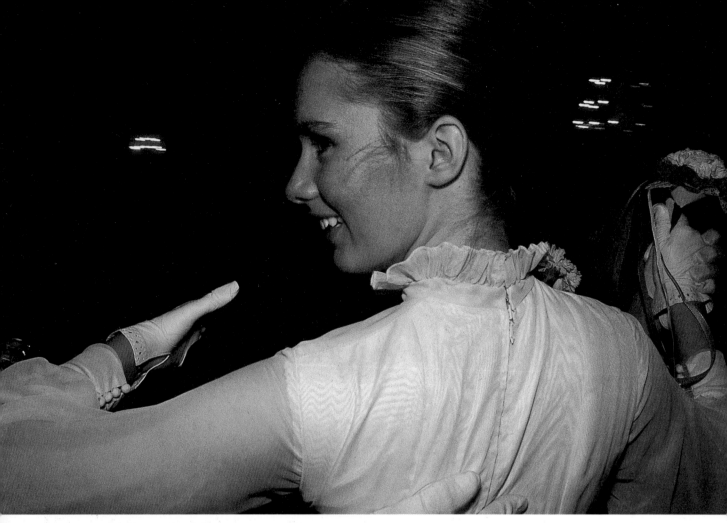

WE ENTER THE PALACE AMID TOWERING PALM TREES—AND FREEZE. WE ARE THE ONLY GUESTS IN BIEDERMEIER DRESSES. ONLY A QUARTER OF THE GUESTS ARE MASKED. TOBY HURRIES UPSTAIRS TO LOCATE OUR ASSIGNED CHAIRS, STUFFS HER MASK INTO HER PURSE AND HER SKIRT UNDER THE TABLE. SHE IS CHARMING, SO PEOPLE MAKE FRIENDS WITH HER EVEN THOUGH SHE LOOKS LIKE LITTLE BO PEEP. I HAVE NO TIME TO THINK ABOUT OUR SARTORIAL GAFF AND MY HOOPED SKIRT ACTUALLY PROVIDES ME WITH LEVERAGE TO PUSH THROUGH THE CROWD. NEITHER ONE OF US INVITES A MAN TO DANCE. I AM TOO BUSY TAKING PICTURES AND TOBY IS TOO ABASHED TO SALLY FORTH. ONE SOLICITOUS STUDENT THANKS ME FOR WEARING "TRADITIONAL ATTIRE." I SUSPECT HE IS AN A+ STUDENT IN THE ELMAYER COURSE ON GOOD MANNERS.

The "Radetsky March" trumpets the processions and the VIPs arrive in the Festsaal Hall. First come military guests in uniform, then masked women, then older members of the Rudolfina union, university professors, deacons, and the "opening committee" of students and their girlfriends whom we watched in rehearsal and, finally, the State Opera Ballet dancers, one of whom is, I notice, clad in a Biedermeier dress. The fraternity students, whose dates wear pure white debutante gowns and carry posies, perform the chit chat polka perfectly. The State Opera Ballet takes my breath away. And then, "*Alles Waltzer*!" Three thousand guests take the floor. The masked women approach the men who catch their fancies, exciting romantic mysteries everywhere. Flattered and laughing, the men waltz away with them. Harald Willenig watches and smiles, "There are a lot of married couples who started their relationship at the Rudolfina Redoute."

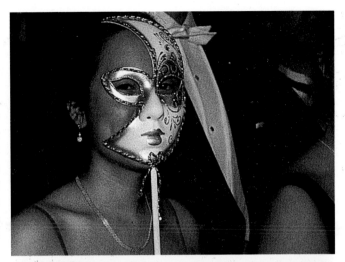

Adjacent to the Festsaal Hall are salons where guests can purchase delicious food and drink champagne. Professional cosmetologists refresh women's makeup in an area sponsored by Nivea, whose product samples are given to each woman as a party favor, *damenspende*.

Just before midnight, I talk with Wolfgang Ortner. He first played at the Rudolfina Redoute in 1964. Fifteen years ago, he progressed to the main room, where he now leads the full orchestra. "Not much is different from thirty-eight years ago," he reminisces, "Women wear masks, people are happy, it's ladies' choice until midnight." Only the music changes from year to year. He recalls for me his favorite opening when the "student committee danced to Mozart's 'Jupiter Symphony' and the ballet to the music of Bernstein's 'West Side Story.' But this year Harald Willenig decided everything was to be traditional, so I selected Strauss, Handel, and Schubert."

Wolfgang hurries off to conduct the orchestra for the *demaskierungsquadrille*. Simone Rueff instructs the guests to line up facing their partners. Technically, two couples dance a quadrille, but there is barely space to move. Everyone is laughing and somehow, amid the revelry, the women slide their masks to the back of their necks. The elastic bands create tiny black necklaces. Their identities are revealed.

The dance ends at 5 A.M., but the night doesn't. Celebrants go on to cafés for their "hangover breakfast." Toby and I suddenly understand what Peter Hofer meant: balls guarantee bags under your eyes!

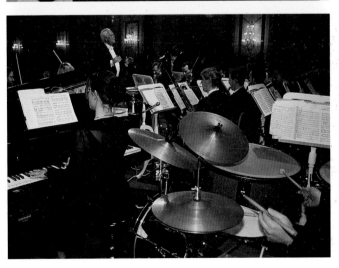

PAGAN DRUMS REVERBERATE IN THE DARK. *DRUM*-DRUM-DRUM-DRUM. PERUVIAN DANCERS—SILHOUETTED MEN CROUCHED OVER THEIR INSTRUMENTS, SILHOUETTED WOMEN STEPPING AND SWIRLING— CIRCLE THE BONFIRES IN FRONT OF THE CHURCH. ECCENTRIC FLAMES REACH FOR THE SKY. MESTIZO ARISTOCRATS DRESSED IN COSTUMES FROM ANOTHER CENTURY RIDE IN FROM THE SIDE STREETS. THEIR HORSES SHY AT THE FIRES, REAR, AND SCREAM, THEN SKITTER BACK-WARD INTO THE CROWD. HEAP AFTER HEAP OF WOOD IS LIT UNTIL TWELVE FIRES RAGE IN THE SQUARE. ACRID INCENSE PERMEATES THE SMOKE AS EACH FIRE IS IGNITED. THE DARK FIGURES CONTINUE TO DANCE. THIS IS THE WAY PEOPLE WORSHIPPED THE SACRED FEMININE HUNDREDS OF YEARS AGO. I AM AFRAID AND FASCINATED.

Before the conquest, both the Quechua and Aymara worshipped Pacha Mama (Mother Earth), who gave them the plants and animals that fed and clothed them, the water they drank, and even life itself. *Pacha*, in Quechua, means "Earth: the land that feeds us, the place we are born, the place we lay our bones to rest." The word *mama*, is ubiquitous in the Indian languages; staple foods are named to reflect their source: *mama sara* (mother corn), *mama uchu* (mother hot pepper), and *acso mama* (mother of the potato). When people eat or drink what Mother Earth produces, they put some on the ground, an offering to Pacha Mama.

In the seventeenth century, Spanish priests seeking Catholic converts told the Indians that Mother Earth was gone—everyone should now pray to the Virgin. Knowing the spirit of Mother Earth would never abandon them, the Indians believed that Pacha Mama's spirit must now reside in the mountain-shaped image of the Virgin Mary. So the Virgin of Candelaria—and her festival— embody both the Catholic belief in the Madonna and the Andean belief in Mother Earth.

In 1675, the Virgin Mary is supposed to have saved the workers at the Laykocta silver mines near Puno, Peru. In the eighteenth century when enemies surrounded Puno, the Virgin of Candelaria is believed to have rescued the city. "The blaring sound of giant seashell horns during the night, the bonfires and constant shouts of those laying siege made the population of Puno tremble," according to one story. "City folk beseeched La Candelaria to save them from doom, and her image was carried from the church in procession. The following day for no seeming reason, the siege was lifted and the city was spared."

Although farmers near Cusco live by the patrilineal Hanan tradi-tion, shepherd communities in the Puno area follow Urin tradition: inheritance is passed from mothers to daughters, and husbands join their wives' communities. Women clear the land, conduct business, manage money, own the household belongings, and are the more important parent. Like Pacha Mama, women are the providers.

Previous pages: During the Festival of the Virgin of Urkupiña, miniatures that symbolize the assets that Bolivians pray for are carried to the top of the mountain where shaman women petition Mother Earth and the Virgin to grant wishes for money and material goods.

POOR PEOPLE WHO LIVE IN ADOBE HOUSES SCATTERED ALONG RUTTY MUD LANES HIGH ON THE HILLS, RICH PEOPLE WHO LIVE IN COLONIAL HOMES NEAR THE LAKE, BUSINESSPEOPLE WHO WORK IN MODERN OFFICES NEAR THE PORT, ALL CELEBRATE THE FESTIVAL OF CANDELARIA. THEY ARE JOINED BY THOUSANDS OF PERUVIAN TOURISTS. THE CITY IS PROUD OF ITS REPUTATION AS THE FOLKLORE CAPITAL OF PERU. CHILDREN ALL MASTER THE TRADITIONAL DANCE STEPS WHEN THEY ARE YOUNG. MEMBERS OF THE DANCE "FRATERNITIES" PRACTICE TWO HUNDRED FIFTY DANCES REGULARLY. ALMOST EVERY MONTH THERE IS A FOLKLORE FIESTA. BUT THE FESTIVAL OF CANDELARIA STANDS OUT— FOUR THOUSAND DANCERS ARE DRAWN FROM ALL OVER THE REGION TO COMPETE FOR PRIZES FOR CHOREOGRAPHY, COSTUMES, MASKS, AND MUSIC OVER THE TWO-WEEK FESTIVAL. JUST AS THE VIRGIN OF CANDELARIA HERSELF EMBODIES A MERGER OF CATHOLIC AND ANDEAN BELIEFS ABOUT THE DIVINE FEMININE, THE DANCES DONE TO CELEBRATE HER NAME DAY ARE HALF MESTIZO AND HALF INDIGENOUS.

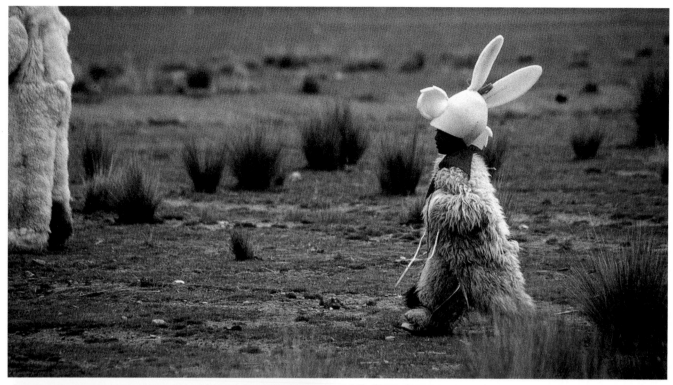

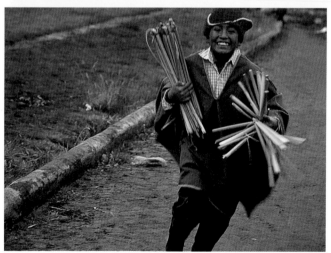

FOR MONTHS, RESIDENTS OF VILLAGES BETWEEN CUSCO AND PUNO HAVE BEEN PREPARING FOR JANUARY 31, THE FIRST DAY OF DANCE COMPETITIONS. IN AYAVIRI, WE SAW FARM FAMILIES IN COSTUMES SITTING ON THE STADIUM FIELD WITH THEIR SHEEP, WAITING TO DANCE AND HOPING TO WIN PRIZES: SHOVELS AND FARM IMPLEMENTS. THEY WATCHED THE BEARS—PEOPLE DRESSED IN WHITE, BROWN, AND BLACK, FURRY HOODED COSTUMES IN SIZES THAT FIT ADULTS AS WELL AS TWO-YEAR-OLD CHILDREN. THEY WATCHED WOMEN DRESSED IN SILVERY TAPESTRY SKIRTS AND FRINGED SHAWLS, TWIRLING LIKE SPINNING TOPS. THEY LAUGHED AS AN ENERGIZER BUNNY BOY SWIVELED HIS RABBIT MASK AROUND ON THE SIDE OF HIS HEAD SO HE COULD SEE WHERE HE WAS GOING. IN LAMPA, URBAN MEN AND WOMEN IN SOCCER UNIFORMS AND EXERCISE SUITS PRACTICED DANCES IN THE STREET, THEN KNELT IN FRONT OF THE CATHEDRAL BEFORE GOING INSIDE TO RECEIVE BLESSINGS TO HELP THEM COMPETE SUCCESSFULLY.

Now, costumes are being rented and fitted in shops all over Puno. For those who sew their own, street vendors hawk bright embroidery floss, multicolored pompons and sequins by the yard. One store displays shiny first prize awards, each taller than the shopkeeper, each like a silver tower.

At 7 A.M. Saturday, it is raining. But the crowd is undaunted and the vendors selling plastic tarpaulins for one sole are getting rich. My photographer-anthropologist friend Stephen Huyler, dispirited by the drizzle, decides he will only stay for the opening ceremonies. As journalists, we are admitted to the stadium field. To reach the puddled, wet grass, we teeter across the rungs of a ladder someone has laid across the running track, which the rain has transformed into squishy, red mud. The first dance group is poised at the edge of the field, barefooted. The women wear embroidered bright blue skirts, jackets, and hats, and carry white cotton banners. As soon as the music begins, the dancers stomp splashes from the grass. As they prance forward, they whip their white flags in full, snapping arcs. Thwump! Thwump! The sound is electrifying. We grab our cameras and forget the rain.

There are men wearing pink-and-taupe plumed crowns three feet tall. People covered with multicolored, fringed, coca leaf pouches. Men in one dance group carry sheaves of wheat that they thresh midfield and cart off in baskets. Men in another group wear looms on their backs, and the women, belts of yarn balls. Full-skirted Indian women stomp and swirl while the Indian men—who help them retain the balance of the masculine and feminine in all endeavors—dance complementary steps. Some women wear twenty petticoats, each as bright as a crayon. Pacha Mama is well represented. Young and old women wear garlands of green leaves around their shoulders. *Brujas* (witches) perform ceremonies for Pacha Mama, pouring liquor into smoking fires of incense and chewing coca leaves. Shepherds shear wool from their llamas and weavers put stakes in the ground to create warps with yarn. Baby deer and foxes dressed in ribbons accompany one group. Some dancers pretend to be mountain spirits hunting vicuñas in the form of other dancers clothed in costumes covered with tufts of fur.

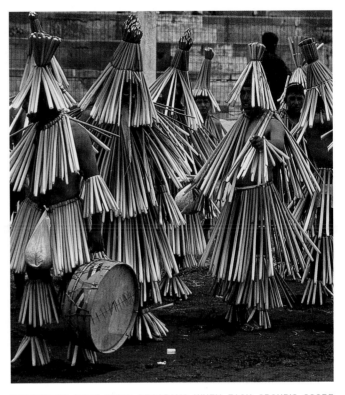

SPECTATORS MARK THEIR PROGRAMS WHEN EACH GROUP'S SCORE IS ANNOUNCED, AND GO CRAZY WHEN THEIR OWN VILLAGERS PERFORM. FEW TROUPES SEEM TO BE POPULAR WITH MORE THAN THEIR LOCAL FANS BUT THE MEN FROM THE ISLAND OF UROS WIN EVERYONE'S HEARTS. THEY WEAR COSTUMES OF THE SAME TOTORA REEDS THAT COMPRISE THEIR FLOATING ISLANDS, THE WALLS OF THEIR HOUSES, AND THEIR FOOD—GREEN STALKS GATHERED INTO CONICAL HATS, CAPES, SKIRTS, AND BOOTS, SHIFTED PROVOCATIVELY, REVEALING LEAN BROWN BODIES (AND SOMETIMES SURFER TRUNKS). WHEN THE UROS DANCERS LATER RETURN TO THE STADIUM WEARING JEANS, THEY HAVE TO SATISFY THE ROARING DEMAND FOR THEIR COSTUMES BY TOSSING THEIR REED SKIRTS AND CAPES TO CLAMORING ONLOOKERS AND COMPETITORS.

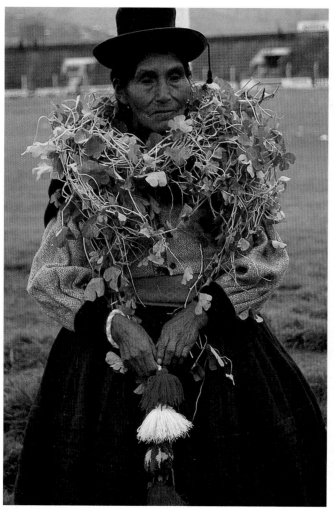

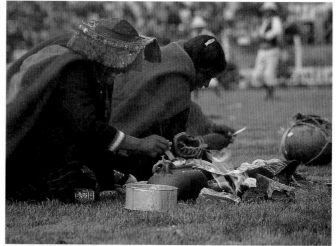

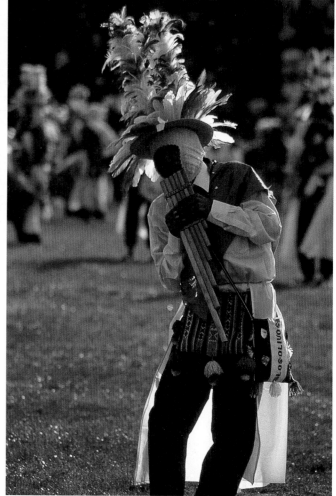

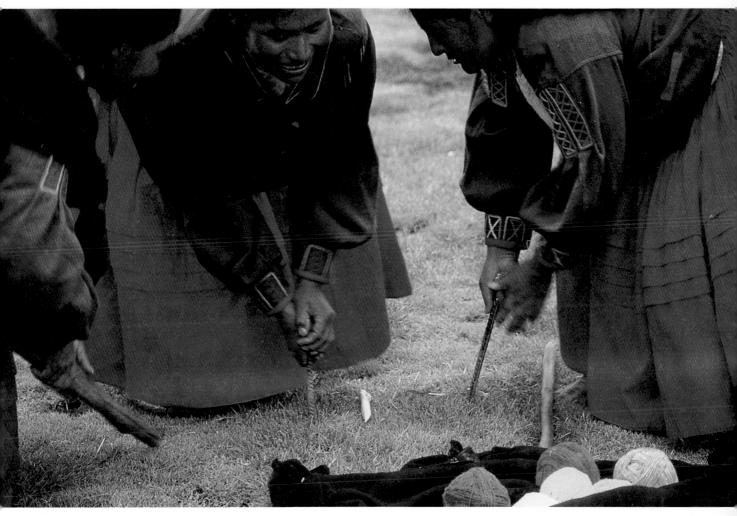

THERE ARE ENOUGH MEMBERS OF THE PRESS HERE TO COVER THE SUPER BOWL. TODAY'S CONTEST, WHICH INCLUDES SEVENTY-FOUR GROUPS, IS BEING BROADCAST LIVE ON RADIO AND TELEVISION. DANCERS ARE TREATED LIKE ROCK STARS—THEY ARE INTERVIEWED AS THEY LEAVE THE FIELD AND ACCOMPANIED IN THE STREETS BY THEIR PROUD FAMILIES. WE TAKE A BREAK FOR LUNCH AT THE INTERNATIONAL RESTAURANT BUT ARE ABANDONED ABRUPTLY AFTER WE ORDER. OUR WAITER HAS HEARD ON THE RADIO THAT HIS DAUGHTER'S GROUP IS ABOUT TO DANCE. WITHOUT NOTICE, HE HAS RUN TO THE STADIUM TO WATCH HER. AFTER EACH GROUP FINISHES PERFORMING, IT DANCES IN THE STREETS. PUNO'S THOROUGHFARES ARE BLOCKED BY BANDS, COSTUMED PEOPLE, AND DELIGHTED THRONGS.

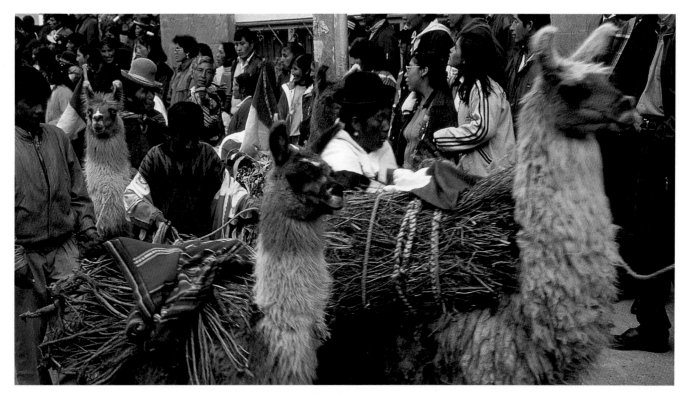

ON FEBRUARY 1—"A DAY WHEN NOTHING HAPPENS"—WE ARE ALMOST RUN OVER BY A GAGGLE OF RIBBONED AND TASSELED LLAMAS, ALPACAS, AND VICUÑAS CARRYING LOADS OF FIREWOOD AND MINT LEAVES. DONKEYS AND HORSES FOLLOW THEM, THEN MEN AND WOMEN BURDENED BY HEAVY BUNDLES OF BRANCHES: FODDER FOR BONFIRES.

That evening celebrants converge at Parque Pino in front of the two hundred–year-old San Juan Church where the Virgin of Candelaria resides. Fireworks explode from the three spindly, bamboo launching towers. The crowd congeals; there are so many people that no one can move. Glittering, golden snakes fall toward us from the sky. Sparks singe the topiary trees in the plaza that have been manicured into tubby animal shapes. Flames flare on the roofs of the colonial buildings, coalescing into balls of fire that blaze down the gutters before they burn out. My friend Joan Chatfield-Taylor and I stand amid the Quechua and Aymara. When sky-rockets blast violently, we jump involuntarily, and everyone laughs at the gringas. The evening fire-and-fireworks fest anticipates the central day of the fiesta.

February 2 is Candlemas, but in Puno it is simply called El Día. In the morning the church holds hourly masses. Today, La Candelaria wears pink robes. She and her angel attendants perch on a pink, net cloud above the altar while pink veils swoop down from the chande-liers. People crowd into the sanctuary to worship the image they call Mamita Candelaria, and each time her name is sung, they raise their candles high.

The 10 A.M. mass is also attended by the Alferados, the prestigious religious brotherhood that organizes and pays for the Candelaria festivities, banquets, and fireworks. These are mestizo families, community matriarchs and patriarchs who decorate the church with fresh flowers and dress La Candelaria in different pastel mantles for each of her many processions. The Alferados lead these parades. Each, almost buried in confetti and streamers, carries a tall, elaborately decorated candle. Puno residents drape their windowsills with tapestries and throw flower petals onto the Virgin who is carried high on her cotton candy–like cloud of tulle.

ONE WEEK AFTER THE FOLKLORIC DANCES, WHICH ORIGINATED WITH THE INDIANS IN THE COUNTRYSIDE, THE MESTIZO *TRAJE DE LUCES* DANCE COMPETITION BEGINS. MUCH OF PUNO'S POPULATION BELIEVES THAT THESE GLITZY CARNAVAL DANCES ARE THE CENTERPIECE OF THE FESTIVAL. CERTAINLY, THE TROUPES ARE LARGER—EVERY GROUP MUST HAVE MORE THAN ONE HUNDRED PEOPLE—AND MORE FRATERNITIES COMPETE—ONE HUNDRED THIRTY IN ALL.

Now, the stadium is full of bears, devils, and angels. The costumes are lush with gold and silver embroidery and pearlescent masks. Dancers in costumes like drum majorettes' wear satin, thigh-high heeled boots. The masks of monsters with bulging eyes, topped with devils, snakes, or gargoyles can weigh eighteen pounds and the fancy embroidered capes can weigh thirty-eight.

Instead of hand-crafted artisanal drums and panpipes, there are kettle and snare drums, French horns and tubas. "I'd like to meet Puno's tuba salesman," Joan says after we've seen about fifty bands full of tubas. "He must drive a Bentley."

Again, the competitors leave the stadium and dance into the streets. Musicians follow the dancers whose boots are covered with chattering noisemakers, who swirl hissing box-rattles, and dress like angels, demons, witches, and bears. Some even look like dancing wedding cakes.

When the two weekends of competition are over, each troupe of Indian and mestizo dancers pays for a mass. The first service begins at dawn, and others follow hourly for days. After each has been celebrated, its sponsors dance for the Virgin to say a personal good-bye to La Candelaria, Madonna, Pacha Mama.

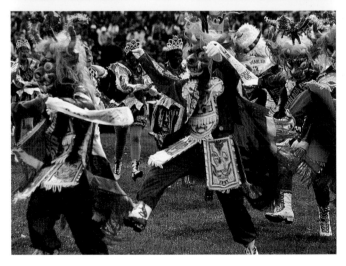

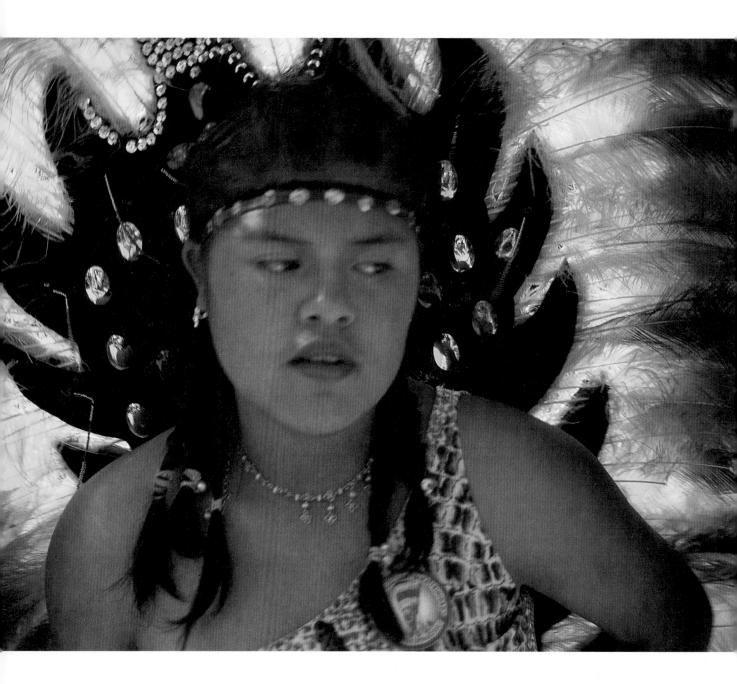

VICTORIA VILLCA POURS BEER ON THE GROUND TO ASK PERMISSION FROM PACHA MAMA, MOTHER EARTH, TO PROCEED. SHE CALLS OUT IN THREE LANGUAGES: QUECHUA, AYMARA, AND FINALLY SPANISH: *"MAMITA VIRGINCITA,"* SHE PRAYS, ASKING FOR WISDOM.

A QUECHUA MAN, LUIS ALBERTO BUTRÓN GUARDIA, SITS WITH VICTORIA AT THE TOP OF A MOUNTAIN OUTSIDE QUILLACOLLO, BOLIVIA. HIS MOTHER NEEDS A NEW CAR, SO HE HOLDS THE REGISTRATION PAPERS FOR HER NOW-DECREPIT VEHICLE, A SHINY MINIATURE CAR TO SYMBOLIZE HER DREAM, PLUS A ROCK HE HAS CRACKED FROM THE SURROUNDING BOULDERS WITH A RENTED SLEDGEHAMMER.

THE SHAMAN WOMAN CIRCLES ALBERTO'S HEAD WITH A SMALL, CHAR-COAL BRAZIER STOKED WITH INCENSE POWDER. THE SMOKE RISES TO THE SKY, CARRYING HER REQUEST FOR BLESSINGS. SHE POURS ALCOHOL ON THE GROUND TO CALL THE GOOD SPIRITS FROM THE EARTH AND POURS MORE ON SOME BOLIVIANO BILLS TO BLESS THE MONEY. SHE IGNITES FIRECRACKERS TO SCARE THE BAD SPIRITS AWAY, THEN POURS BEER ON ALBERTO'S ROCK.

THOUSANDS OF PILGRIMS PARTICIPATE IN SIMILAR RITUALS ON THE MOUNTAIN WHERE A LITTLE SHEPHERD GIRL SAW THE VIRGIN TWO HUNDRED YEARS AGO.

"A little girl used to go to the mountain with her sheep," the legend begins. The head priest at the Church of San Ildefonso has repeated the story often but he leans forward in his chair to tell it again. "One afternoon she saw a beautiful woman carrying a baby. The shepherdess played with the child many times, but kept it secret. The day she decided to tell her parents, they went with her to the mountain but the Virgin was not there. The little shepherdess always maintained that she had seen the beautiful woman "there on the hill," words that translate into Quechua as *urkupiña*.

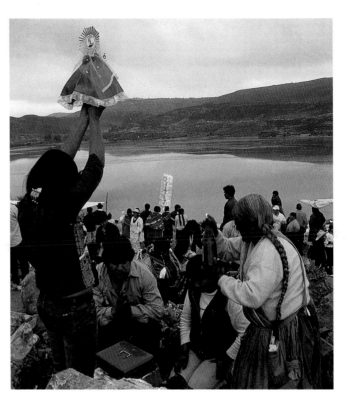

The Festival of the Virgin of Urkupiña was first celebrated in 1670. It is a mixture of folkloric and commercial, pagan and Catholic influences. People whom I talk to say "the Virgin" but they mean "Pacha Mama." And vice versa.

Since the beginning, the Indians have believed that Pacha Mama provides the basic necessities such as housing, food, clothing, and water. Since colonial times, the Indians here have believed that The Virgin of Urkupiña answers prayers for material possessions. This is an irresistible idea for people who live in the second poorest country in South America and lust after cell phones, sewing machines, and silverware, trucks, Tudor houses, and television sets.

ABOUT 10 PERCENT OF THE POPULATION OF BOLIVIA—HALF A MILLION PEOPLE—COME TO QUILLACOLLO EVERY AUGUST. THEY EXPRESS THEIR DEVOTION TO THE VIRGIN BY DANCING IN THE STREETS. WHETHER TO PETITION OR THANK HER, MANY PROMISE TO DANCE FOR THREE YEARS TO HONOR HER. QUILLACOLLO IS THE FOLKLORE CAPITAL OF BOLIVIA. MANY DANCE "FRATERNITIES" PRACTICE THE TRADITIONAL CHOREOGRA-PHIES IN THE PARKS EVERY AFTERNOON TO PREPARE FOR PERFOR-MANCES. THERE MAY BE FIFTY OR TWO HUNDRED TO A GROUP, PLUS PAID MUSICIANS. EACH DANCE GROUP COMMISSIONS NEW COSTUMES EVERY YEAR TO WEAR FOR CARNAVAL AND URKUPIÑA.

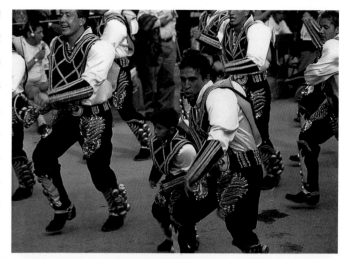

Rolando Perez, a costume designer in Cochabamba, tells me that his favorite costumes are for the *caporales*, a pounding, stomping slave dance in which the men's calves are covered with rattles. "A very good *caporales* costume costs one hundred seventy U.S. dollars. To make twenty outfits takes fifteen people working for three months." His small shop typically makes forty *caporales* and forty *diablada* (devil dance) costumes a year. Now, two of his women employees are working feverishly to finish an embroidered shirt. I ask Isabel what costumes little girls in Bolivia would most like to wear. "*Caporales* or *morenada*." "Men's or women's costumes?" I ask. "Sometimes there are not enough men for the men's part, so we take it on. I would choose the women's costumes. We have to keep our identity as women."

"This year, there will be about sixty groups—about ten thousand dancers," predicts Elizabeth Maldonado, the first woman president of the Association of Folkloric Fraternities for the Urkupiña Festival. Elizabeth, who started dancing when she was twenty-two, special-ized in the *morenada*, a predecessor dance to the *caporales*, and although she can't dance while she is president, "I would like to!" Elizabeth is also second vice president of the entire organization that sponsors the festival, which includes officials from the church and city government. "In our society, there is a lot of machismo but we women are starting to show what we can do," she grins.

On opening day of the Urkupiña Festival, a priest blesses the dancers' costumes. From 10 A.M. to 10 P.M. the following day, the cel-ebrants leap, twirl, and stamp over the six-mile route; coca leaves and beer help some manage four hours of nonstop activity. Others rely on "faith and *alegría* (joy)."

Miss Bolivia dances the *cueca*, a traditional handkerchief dance, with Dr. Hector Cartagena Chacon, the mayor of the city. Stilt dancers have been sent from Sucre. In the *diablada* dance, male and female devils confront Michael Archangel; this dance of good against evil has an economic overtone—devils rule the underground, which holds a wealth of tin and silver.

By early evening, the first dancers reach their destination: the Church of San Ildefonso. Priests standing in the street with buckets of holy water splash them before they veer toward the church entrance and kneel devoutly on the steps before the image of the Virgin of Urkupiña.

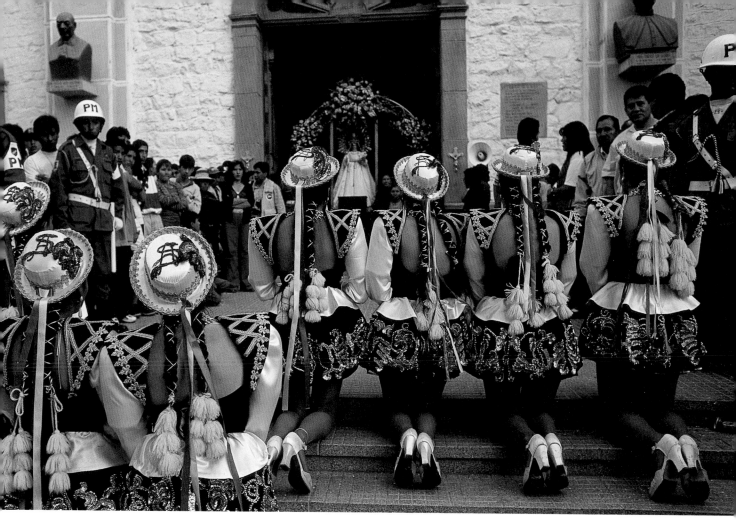

The church bells ring, then are subsumed by the singing: "*Santo,
santo, santo, santo!*" The responsive readings cause earthquake-
like rumbles from the park. The priest prays. More pounding music
is propelled by the drums. Surely this music can be heard in heaven.

The two-hour mass is performed by Cardinal Eminencia Julio
Cardenal Terrazas Sandoval—the recently anointed, first cardinal of
Bolivia. The acting president of the country, Jorge Quiroga Ramirez,
who has been in office only one week, occupies a seat front and
center. The cardinal preaches against excessive use of alcohol and
commercialism during the festival. Indeed, some conservative
Catholics boycott the event as pagan and materialistic.

Communion is carried by lay women who push into the crowd dis-
tributing wafers. "*Muchissima gracias. A Dios.* Maria." Bells ring
from the church and a flock of white doves flies into the sky. Rolling
applause. Finally, the music I associate most with this festival:
"Mar-ee-ahhh!" an infectious, soaring chorus. Then are the final
declarations: "Santa Maria. *Madre de Dios. Gloria a santo.* Virgen de
Urkupiña. Amen."

The band plays in a dignified, minor key as the image of Urkupiña
is carried to her flowery float and driven slowly around the plaza.
Each person waves a white handkerchief to greet her, making a
snowstorm above the devotees in the streets and park, on the side-
walks and balconies. The Virgin is deluged with rose petals that spill
down by the basketful. By the time the procession returns to the
church, the pure white Virgin has turned pink.

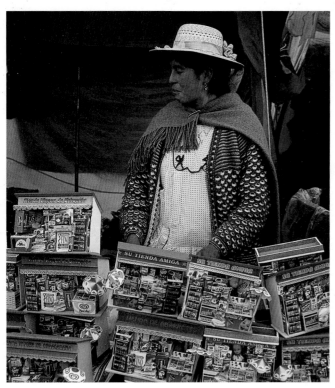

THAT NIGHT EVEN MORE PILGRIMS ARRIVE, WALKING TEN MILES BY CANDLELIGHT FROM COCHABAMBA.

They enter Quillacollo while everything is quiet, everyone else is home, passing the buildings where florists arrange gladiolas, agapanthus, carnations, and baby's breath for pilgrims to heap in the Virgin's chapel of the church. They pass the empty streets where vendors sell cookies, candies, and white, frosted doughnuts stacked in perfect, towering pyramids. They pass the bleachers where people pay thirty bolivianos (six dollars USD) for the best seats to watch the dancers. They pass the market where poor women sell their hair to young women who need long braids for their festival costumes. They pass the food stalls where guinea pigs, ox feet, and beef heart shish kabob are cooked. They pass the platforms where two monkeys dressed as Indian women hand out good fortune messages in exchange for one boliviano. They pass everything in the town, and continue out the other side toward the sacred mountain.

En route, pilgrims have bought *alasitas* (miniatures) from roadside stalls. These symbolize the material goods they most hope to acquire the following year. Vendors sell tiny coats, suits, eyeglasses,

passports, visas, undergraduate diplomas, airplane tickets, suitcases, computers, wedding rings, health certificates, retail stores, toilet paper, cakes, wheelbarrows, ironing boards, plates and cups, pots of gold, packets of $100,000 bills, even twin babies. Each is small enough to fit into the palm of my hand.

During the rest of the festival, the image of the Virgin will reside in a chapel on this mountain. Seven acres have been walled off so no vendors can sell here. There are also new gardens and benches and fresh, lush grass where pilgrims can rest peacefully and meditate. But right now, meditation is not what the pilgrims have in mind. First, they rent sledgehammers and cut rocks from the mountain. Stone is considered sacred in the Andes: Pacha Mama gave birth to rocks and the gods are believed to live in the high peaks.

Each family marks off its own little plot with a line of rocks, and creates a landscape of twigs and pebbles. They build a little stone house and display their *alasitas*—their miniatures, their dreams. They party on "their land," picnic, drink to the Virgin and Pacha Mama, and play music.

When they leave, each pilgrim will take a stone as a souvenir, then will bring it back next year, so the mountain is not depleted. So many people transport rocks to and from the festival that the national airline, Lloyd Aero Bolivia, requires either that stones fit under the airplane seats or get checked. People tote the stones in fiber-reinforced paper bags that they burn on the lower mountain slopes, ensuring that no one else will touch "their" hot rocks.

While we are at the top, the weather becomes apocalyptic. Wild winds whip up so much dust that the air turns tan. Tarp tents flap high above huddled pilgrims. The sky darkens and spits huge drops that sizzle when they hit the paper bags full of rocks.

While masses of people still struggle uphill, others remain below, receiving blessings on the items they prayed for—and obtained—last year. Owners of new trucks and cars decorate them with fake flowers, confetti, and streamers, then park them behind the church waiting for the team of wandering priests to say prayers over the Virgin's miracles.

THE FEMALE VENDORS OF QUILLACOLLO WILL CLOSE THE FESTIVAL. THERE ARE LOTS OF THEM.

Phoebe Johnson, an Australian who works with poor Bolivian women on economic development, observes that "most women sell on the streets. That's become a way of life and they like it. But they can only get about five bolivianos a day. A lot of the men are off looking for work. If the women didn't work, the families would fall apart."

Father Ivan Vargas tells me, "I have been in villages where the women do all the work." Like the Virgin of Urkupiña, Bolivian women are providers.

When they are unable to provide for their children, the women are forced to make painful decisions. My interpreter, Tim Johnson, is known as "the child of the wind" because his mother, who realized she couldn't afford to feed her son, bathed the infant, then placed him at the edge of a windy cliff where she believed he would die of pneumonia. Instead, he was adopted by missionaries. Women in urban areas like Quillacollo become street vendors in an effort to avoid the anguish of Tim's mother.

The festival's closing event will be attended by Victoria Villca, the shaman woman we met at the top of the mountain who conducted the ritual for Alberto's mother's car. Victoria looks forward to August 24. "Woman vendors are affiliated with the Virgin, so a mass will be held in the market exclusively for them. We will thank the Virgin for business in the past year and ask for more during the year to come. Afterwards, we'll have a party with confetti, drink *chicha* (beer) maybe even whiskey, and eat the food we usually sell. Then the Virgin will be returned to the church until next year."

I ask the head priest at Saint Ildefonso in Quillacollo whether he worries about the Virgin's association with material things. "We can't judge people by the things they want. I have been here four years. I have seen people healed, people come together, and people in misery come up in life, people's traumas healed. The big miracle that I see is that the Virgin brings people together from outside and from all over the country. She integrates all of us. And she shows us the way to God."

CELEBRATING WOMEN AS MAGICAL

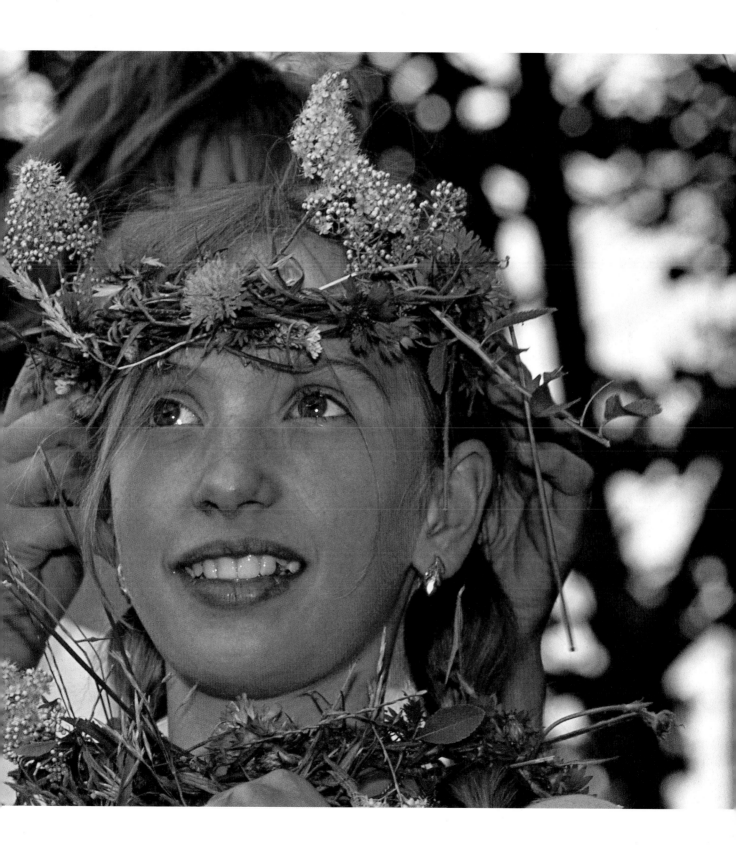

NOC ŚWIĘTOJAŃSKA

I pluck you boldly with
Five fingers, the palm the sixth.
Let the men run after me:
Large, small, let them all pursue me....

In the ninth century, naked virgins chanted this song in secret as they entered the forest. Adder's-tongue, the powerful herb, could only be picked at midnight on the first Thursday after the new moon.

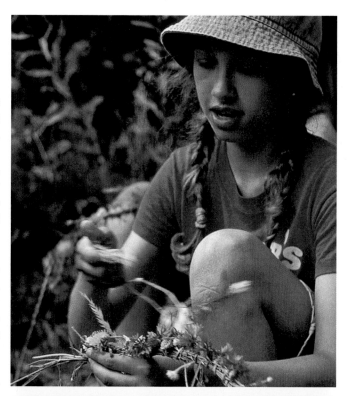

Each woman backed toward a plant so the devil, who protected it, wouldn't suspect she was about to steal his treasure and, with her hands behind her, grabbed the foliage "with six fingers." Once she boiled it and drank the herbal elixir, the bachelor she wanted would fall instantly and passionately in love with her.

She knew that another herb, lovage, was an aphrodisiac and also had the power to inspire love. She used mugwort, the Mother of All Herbs, to foil the witches who slashed the sky with their broomsticks, to repel demons, to stave off bad luck for as long as twelve months, to give travelers safe passage. But she knew mugwort performed its greatest magic on June 23.

June 23. Summer solstice. The shortest night of the year. The border between the seasons, the night that belongs to nobody, the sacred interruption when it is possible to contact supernatural powers and predict the future, the time for magical rites that assure bountiful harvest, good luck—and love.

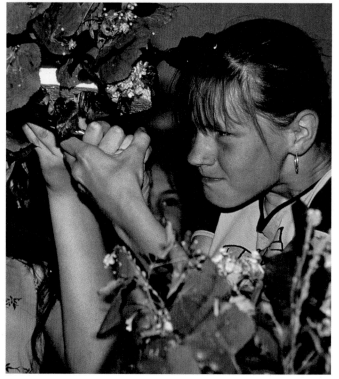

Summer solstice was "the festival of love" in Slavic countries. Herbs gathered on June 23 possessed special power. Young women braided these herbs with wildflowers, then went to the shores of Poland's rivers and lakes to float their garlands on the water. If a wreath circled in the eddies, marriage would occur later. If it floated away quickly, marriage would happen soon. If it bumped another wreath, only friendship would ensue. If it ran aground, a potential lover lived nearby. But if a man removed the wreath from the water, the magic had worked. The lovers would share a night of revelry and perhaps a lifetime of happiness.

On this night, the farmers built bonfires on the dark hills. When they welcomed the sun in the spring, they knew the seeds would sprout, but now the sun seemed to be stalled in the sky. The bonfires were intended to catalyze its movement. Young women danced around the fire with herb-and-flower crowns on their heads. Local people sang and teased each other with riddles that suggested improbable

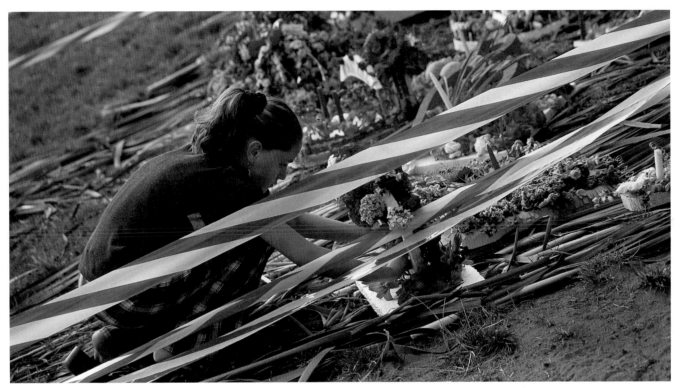

matches between handsome young men and crones. Boys leapt through the flames to show off. When only embers remained, romantic couples jumped over the coals together, knowing that if their hands stayed clasped, they were destined to be married.

Then, couples entered the woods in search of the fern whose miraculous flame-red flower bloomed just once. Legends promised it would blossom somewhere in a wild ravine and that the person who picked it would be able to see treasure below its roots. Each virgin and her infatuated companion knew what they were supposed to do when they found the fern: catch its petals in a silk handkerchief, draw a circle with a rowan branch to encompass the two of them, then light a candle. If they didn't perform these rites, happiness would slip through their fingers forever.

Actually, it didn't matter much if they ever found this flowering fern; who knows if they even looked. They were busy discovering happiness other ways.

After Christianity came to Poland in the tenth century, these pagan celebrations were discouraged and ultimately co-opted. In the few places that Noc Świętojańska is now celebrated, it is coincident with St. John's Eve, which honors John the Baptist, patron saint of all customs associated with water. The Mother of All Herbs, mugwort, has been renamed St. John's wort because it is said that St. John wore a girdle of the herbs when he traveled. In this way, Polish priests reinterpreted the pagan magic—even today, they use herbs to protect and heal their parishioners.

Each June 23 in a few rural Polish towns bonfires are lit, and from the banks of lakes and rivers young girls launch wreaths of flowers and herbs. One of those towns is Ciechanowiec, eighty miles northeast of Warsaw, where the local priest consecrates the River Nurzec before the girls launch their garlands. People say, "On St. John's Eve, the water blossoms."

FLOWERS SPILL THROUGH THE PICKET FENCES IN CIECHANOWIEC. SOME LOG CABINS ARE CENTURIES OLD BUT CURRENT OCCUPANTS HAVE INSTALLED SATELLITE DISHES ON THEIR ROOFS. I WALK TOWARD THE WOODS PAST COWS, CHICKENS, GEESE, APPLE TREES, AND TRACTORS. BIRDS CHEEP, DOGS BARK, CATS TIPTOE. AT NOON, CHURCH BELLS SING INTO THE QUIET.

A man gives me a ride in his horse-drawn wagon. Pumpkins, potatoes, and rhubarb flourish in the fields. Back in town, larkspur, hollyhocks, and foxgloves stand tall. Fragrant roses, tiger lilies, and poppies crowd the yards. It's not hard to imagine how this little farming town inspired a local priest to write one of the first Polish botany textbooks. The statue of the author, Jan Kluk, stands in the churchyard holding a bouquet of herbs.

In the middle of the village, a low dam reshapes the river into a lake. There, children paddle kayaks and teenagers swim. Willows drip into the water, sheltering rowboats tied to wooden docks, while water lilies bloom at the quiet edges. The Wianki Festival—*wianki* means "wreaths"—will take place on an island that is just big enough for a soccer field.

Maria Murawska, one of six sisters, first took part in the Wianki Festival in 1978. Her program at the Ciechanowiec Cultural Center is attended by girls between the ages of eleven and fifteen. At five o'clock, they join Maria, who has brought armloads of posies from her garden. She distributes wheels of Styrofoam perforated with holes for a candle, leaves, and flowers and explains that although old-fashioned floral wreaths sank fast, these will float all night; the sun will rise before the candles go out.

The girls select flowers and arrange them artfully, talking and laughing. Most have taken part in this festival once, twice, or three times before, and consider it great fun, especially this part, making the *wianki*.

My interpreter Paul, a twenty-two–year-old college basketball player, tells me all girls in Poland know how to braid flowers. His sister even taught him.

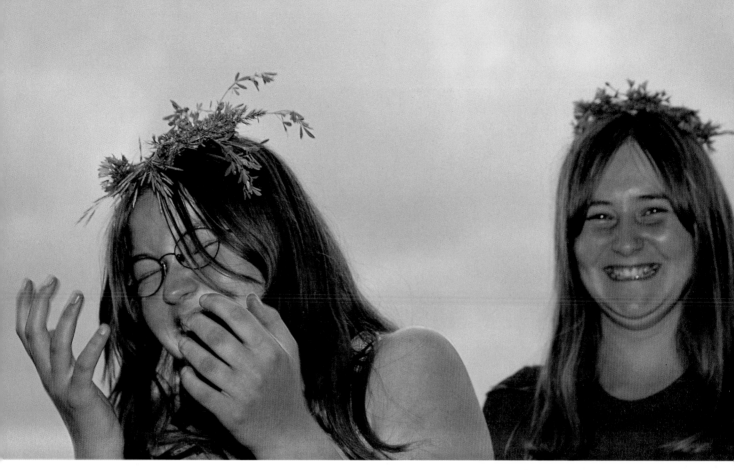

Wondering what contemporary girls think about the festival's sexy, romantic history, I ask them, "Do you have boyfriends?" "Boys?" one says, "Boys are dumb." Paul is neither surprised nor abashed. He explains that in Poland, as in all industrial countries, women are emancipated and don't think of marriage before they are at least twenty-five.

Before the girls go home to change into their white festival dresses, each selects a silk-flower crown. A vociferous contretemps occurs about who deserves the best headdresses: the older girls who have fewer years left to participate in the festival, or the younger girls who are quicker and have grabbed the nicest ones first. The little girls win.

Maria has arranged for me to ride on the "guard boat," which is operated by two firemen who will extinguish the flames if the wianki candles set anything on fire, and save the girls (and the boys assigned to paddle them) if any of the kayaks sink. Our boat putters out into the center of the lake and hovers.

The land program runs overtime and it is now late and dark. Although I can't see it happen, I know the priest is blessing the lake and local officials are awarding prizes for the most imaginative wianki designs. Afterwards, the girls will parade through the crowd to the water's edge, their illuminated wianki candles lighting their path.

It is a bright night, with a full moon and bonfires on both shores lighting the lake. Thousands of blackbirds circle the water, then double back, reversing themselves high in the dark sky, and then circle again.

Finally, as a bugler plays a song called "Silence," the kayaks leave the dock. The girls hold the wianki on their laps and extend their arms to each side of the kayaks, holding flares that shower sparks into the water. When the flares are exhausted, each girl carefully leans toward the lake and places her wianki on the water. The beautiful flower wreaths float, shimmering in the candle light, making mirror reflections on the dark surface. It's as if we are watching poetry.

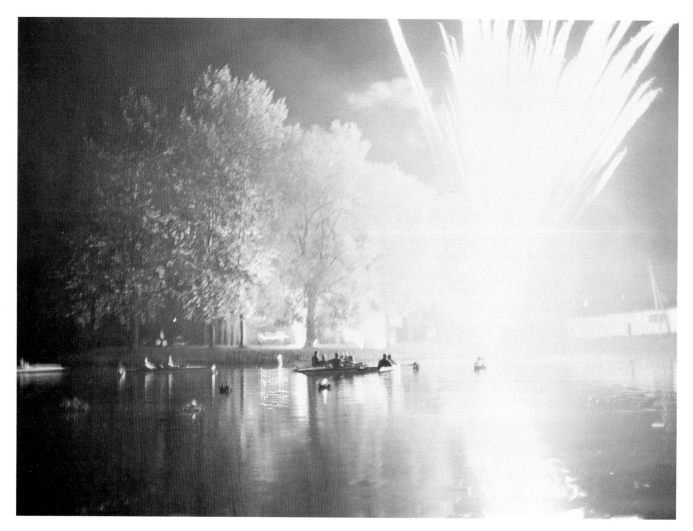

THEN THE FIREWORKS CRASH ABOVE US, POURING COLOR DOWN—RED, GREEN, BLUE, WHITE, GOLD; PLUMES, SPARKLERS, FLOWERS, STARS, LIGHT EXPLODING, EXPANDING, EACH DISPLAY MORE BREATHTAKING THAN THE ONE BEFORE, AND AFTER THE MOST SPECTACULAR SPLASH OF ALL—SILENCE.

Over sundaes the next day, I say, "How was it? Tell me everything!" Aneta, Alicja, and Paulina dip into the ice cream and admit, "Bugs. There were a lot of bugs." "It was freezing in those short dresses thanks to the dew." But they agree the festival was great overall and—with the exception of the bug-hater—everyone plans to participate again next year.

I comment, "As the boat followed you to shore, I noticed that almost all the kayaks were being paddled by girls! How did you take command from those boys who were supposed to be escorting you?"

Alicja laughs, "We paddle those boats all over the lake all the time."

Aneta shrugs, "I just said, give me that paddle or I'll give you a punch."

"Strong characters," smiles Paul with admiration. Worldly, intelligent, and handsome as Paul is, these magical girls have enchanted him.

DOROTA LAPIAK, VICE GOVERNOR OF THE PROVINCE, IS MARRIED TO THE MAYOR OF CIECHANOWIEC. SHE SERVES COFFEE IN FINE CHINA CUPS ACCOMPANIED WITH CHOCOLATE STRAWS. HER LIVING ROOM, FURNISHED WITH ANTIQUES, PROVIDES A COOL HAVEN ON THIS HOT JUNE EVENING.

Twenty years ago, her job was cleaning houses in the United States. "In 1980, Poland went into a State of War." Polish use this horrific title to recall a period when the communist government attempted to quash opposition. People demanding workers' rights were tortured, killed, or imprisoned. "Our family was in financial crisis. My husband and I went to the United States to find work, leaving our three children with my parents. We had no assurance that we would be allowed to return but it was worth the risk. At home where I taught school, I earned twenty dollars a week. In the U.S., I earned twenty dollars a day."

Dorota returned to Ciechanowiec in 1994 and was hired as director of the Cultural Center, which had opened in 1969 in an old movie theater. Growing up, she had attended cultural celebrations at the center. Her brother had learned to play guitar there. Dorota dreamed that she would expand the center's activities to appeal to all ages.

In 1996 she renovated the Wianki Festival. For the first time, the girls wore floral wreaths on their heads and belts of herbs around their waists. "Television covered the event, which had never happened, so we had to be very exact about the tradition. The girls read the story aloud. We made a fake 'blooming fern,' hid it near the river, and invited people to hunt for it. The legend says people used to search for the fern throughout Midsummer Night. But here, in just half an hour, they had found it!" she laughs. "Now other towns and cities, including Krakow and Warsaw, have copied our festival. But their Wianki Festivals are not traditional."

By 1998, Dorota's hopes for the Cultural Center had been realized. She had launched a seniors' center and an orchestra. Citizens of all ages appreciated her work enough to elect her to public office—despite that fact, even now "there are thirty local politicians but only two are women." Among the many accomplishments of her new job, she secured funding for cultural centers in all six districts under her jurisdiction.

What is her next dream? She would like to become director of the Ciechanowiec Museum. As director, she would connect its activities to the Cultural Center and create celebrations that reflect local farming holidays such as the festivals of bread, milk, and honey. Dorota's vision and energy help sustain traditions while she transforms life for her family and community. This ex–cleaning lady, vice governor has mastered modern-day magic.

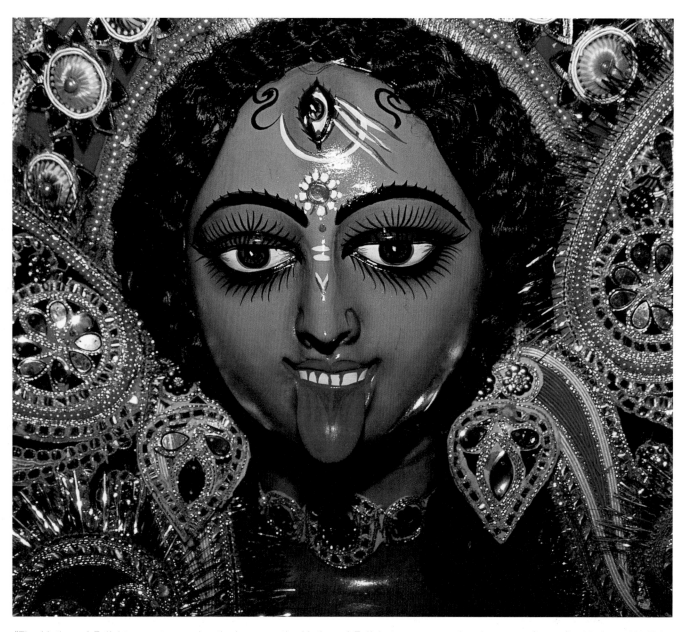

"The Mother of Enlightenment pervades the heavens; the Mother of Enlightenment pervades the atmosphere; the Mother of Enlightenment pervades Mother and Father and child. All Gods of the Universe are pervaded by the Mother, the five forms of living beings, all Life. The Mother of Enlightenment, She is to be known." —KALI PUJA

Previous pages: Kali images always show the goddess stepping on her husband, Shiva, who threw himself in front of her to halt her frenzied effort to kill demons—before she destroyed the world. Above and Opposite: Elaborate, three-dimensional images of Kali (left) and Durga (right) are created for the goddesses' festivals each year.

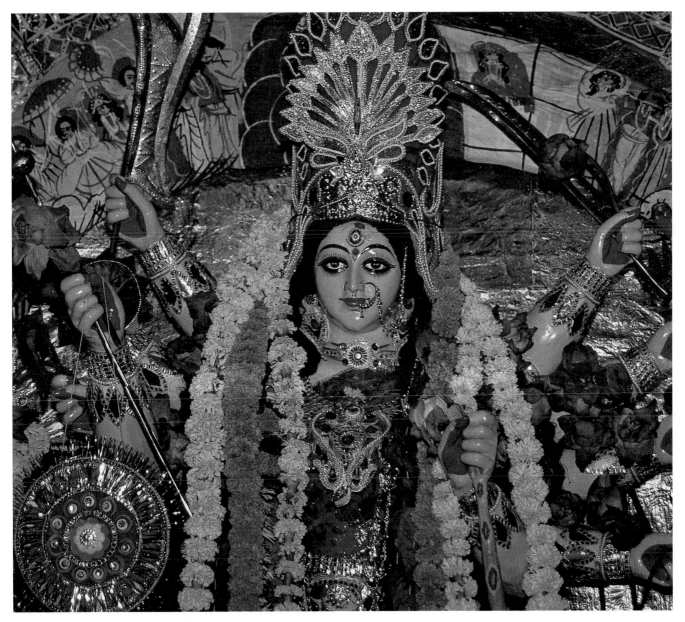

THE MOTHER GODDESS HAS BEEN WORSHIPPED IN INDIA FOR FIVE THOUSAND YEARS. HER NAME, SHAKTI, MEANS ENERGY. HINDUS PRAY TO HER, "O LOVING MOTHER, THOU HAST TWO ASPECTS, THE TERRIBLE AND THE PEACEFUL." HER "TERRIBLE" ENERGY MANIFESTS AS THE WARRIOR GODDESSES, DURGA AND KALI, WHOSE FESTIVALS ARE CELEBRATED THROUGHOUT INDIA. BOTH GODDESSES CONDUCT RELENT-LESS BATTLES WITH EVIL.

DURGA PUJA

DURGA PUJA (*PUJA* MEANS WORSHIP) CELEBRATES THE GODDESS DURGA'S VICTORY AGAINST MAHISHASURA, A SHAPE-SHIFTING DEMON SO INTRACTABLE THAT NONE OF THE GODS COULD STOP HIM FROM DESTABILIZING THE COSMOS. FRUSTRATED BY THEIR FAILURE, THE DEITIES MET TO DEVISE A NEW STRATEGY.

THEY EACH BREATHED FIRE, AND FROM THE FLAMES DURGA APPEARED—A FIERCE DEITY BEAUTIFUL ENOUGH TO DISTRACT ENEMIES AND POWERFUL ENOUGH TO ERADICATE THEM. THE GODS THEN RETURNED THEIR GREAT POWERS TO SHAKTI. EACH HANDED DURGA HIS BEST WEAPON, WHICH SHE BRANDISHED IN ONE OF HER TEN HANDS. HER MOUNT WAS THE ANIMAL-EQUIVALENT OF HER PERSONALITY: A LION.

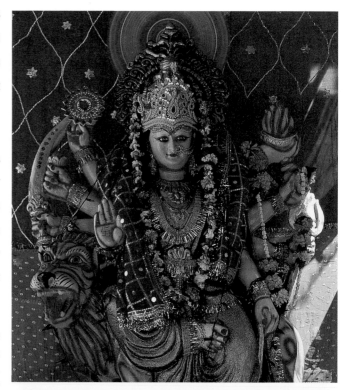

When she rode into battle against Mahishasura, he tried to seduce her with compliments. But Durga just roared with rage. Even though he masqueraded in many forms, she pursued him mercilessly. Ultimately, he assumed human form, stepping from his water buffalo disguise. Wasting no time, Durga slayed him with the trident Lord Shiva had given her, and saved the world.

Durga Puja begins six days into the Navaratri Festival. This day was chosen because Durga sometimes appears as Shasthi, a goddess invoked on the sixth day after childbirth. Durga exemplifies the spirit of a furiously protective mother defending her young.

It is said that Durga resides in the Himalayas with her husband, Shiva, and returns to Calcutta once a year to visit her parents. There, Durga Puja has been celebrated since the twelfth century and is the most important annual festival the city experiences.

Above, top: Durga image at Etlingji's eighth-century Shiva temple

MY PLANE LANDS IN CALCUTTA UNDER THE FULL OCTOBER MOON. EVEN THIS LATE AT NIGHT, STREETS ARE CROWDED IN THIS CITY OF FOURTEEN MILLION PEOPLE. I DOZE UNTIL THE CAR SCREECHES TO A SUDDEN STOP. PASSENGERS, DRIVERS, AND PEDESTRIANS AROUND US ARE TRANSFIXED BY THE ONE HUNDRED–FOOT-TALL FESTIVAL MURALS OF ANIMATED LIGHTS.

High above us, a scene replays that, one month ago, shocked television viewers around the world. A plane flies into the side of the World Trade Center tower, then another. Figures jump from the windows. The towers crumble. The mural goes dark, then begins again. The graphic designers, artisans who wrapped each bulb with colored paper, electricians who wired the panels, and Hindus everywhere, believe that the warrior goddess, Durga, can protect the world from such evil.

APARTMENT HOUSE RESIDENTS, MARKET VENDORS, AND BUSINESS-PEOPLE SAVE FOR MONTHS TO ACCUMULATE THE MILLIONS OF RUPEES IT TAKES TO SPONSOR A *PANDAL*, A TEMPORARY STRUCTURE THAT HOUSES THE IMAGES OF DURGA, HER LION, THE BUFFALO DEMON, AND HER CHILDREN.

Pandal associations compete to build the most creative and extravagant examples of ephemeral architecture. Some *pandals* are made of cloth stretched over bamboo scaffolding. Others are crafted of Styrofoam bricks and look as if they are hundreds of years old. Still another is built from a million and a half terracotta drinking cups. Last night, three million people "*pandal* hopped" to admire the structures and images and to pray.

At auspicious times identified by astrologers, Hindu priests conduct services in the *pandals*. One is the Puja of One Hundred Lights, whose name comes from this legend: when the god Ram asked Durga for the powers required to defeat the demon Ravanna, he petitioned her with one hundred lotuses, symbolizing perfection, and one hundred lights, symbolizing knowledge.

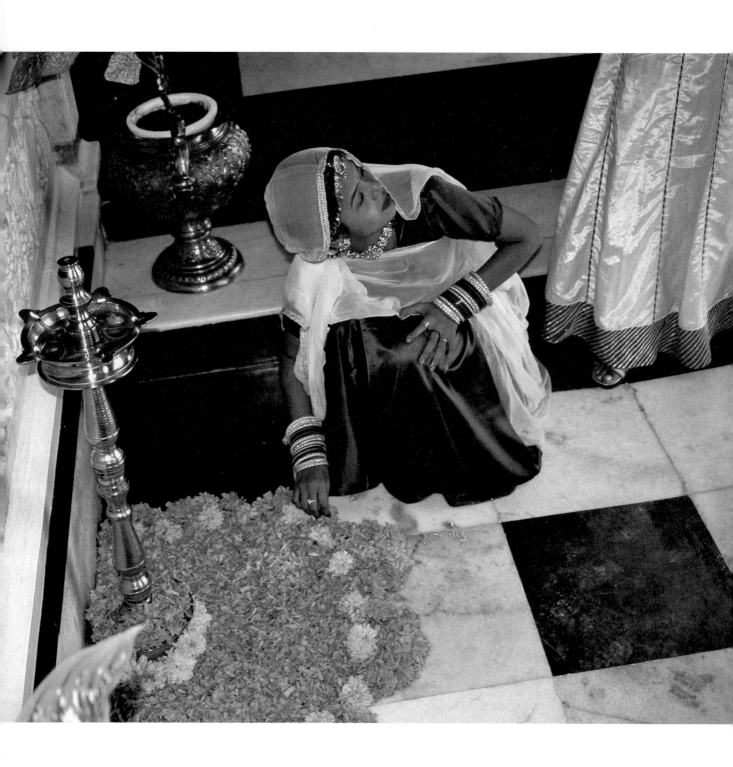

Above: Soneya decorates for Durga Puja at the Lake Palace Hotel, Udaipur, Rajasthan.

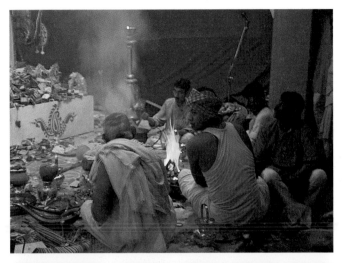

Kumari Puja, held on the eighth day of the festival, sometimes occurs in private homes. Perhaps 1 percent of all families host a Kumari Puja; to qualify, they must have a healthy daughter with the right astrological chart and the priests' approval. I am a guest of the Nikhilesh Choudhuri family when their daughter is worshipped at the propitious hour of noon. Her uncle, a priest, conducts the ritual, which only women attend. In the living room, a full-sized image of Durga is covered with sparkles, and the floor is littered with flowers. This is an exciting day for the seven-year-old girl. She wears a sari, her feet have been painted red, and a floral crown nestles in her hair. The child watches intently and accepts the offerings seriously until candy is proffered. Then she smiles with delight like the youngster she is.

The word *durga* means "fort," which explains why seven Durga temples guard the city of Udaipur in Rajasthan. Late one evening, Anoop Adhikari and I drive down an isolated lane to a temple that is between one and three thousand years old. The entrance is marked by illuminated tridents—the weapon of Durga's husband, Shiva. We climb high, white steps past tigers painted on the walls. A tiger is ridden by Hasti Mata, a version of Durga who is said to grant all wishes. Thinking about Afghanistan and the world's violent places, I ask the goddess for peace. Surely a Warrior Goddess can help stop war.

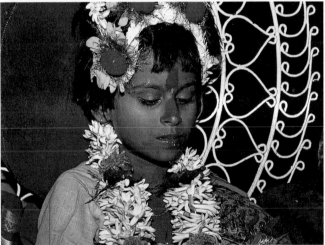

NEAR NARTIANG IN MEGALAYA, I ENTER A SIMPLE, CONCRETE BLOCK BUILDING, A DURGA TEMPLE CONSTRUCTED ON THE SITE WHERE ANOTHER OF HER TEMPLES STOOD TWO THOUSAND YEARS AGO. HERE, JAINTIA PRIESTS SACRIFICE YOUNG, BLACK MALE GOATS TO THE GODDESS—YEARS AGO, JAINTIAS USED TO SACRIFICED YOUNG BOYS WHOSE HEADS WERE PRESENTED TO THE GODDESS ON A TRAY, WHILE THEIR BODIES FELL DOWN A CHUTE INTO THE KOPILI RIVER. IN 1835, HUMAN SACRIFICE WAS OUTLAWED IN INDIA, BUT SINCE HUMAN, ANIMAL, AND INSECT LIFE ARE EQUALLY VALUABLE TO HINDUS, THESE DAYS WATER BUFFALOS, GOATS, AND PIGEONS ARE OFFERED TO DURGA IN TEMPLES ALL OVER THE COUNTRY. A DEVOTEE EXPLAINS, "WE OFFER WHAT WE VALUE MOST. WE VALUE LIFE ABOVE ALL."

Babu Mohapatra guides me to a small, sixth-century temple built for the sixty-four Yogini, minor forms of Durga—her sorceresses. The Yoginis are carved in bas relief, each with an animal face. The figure of Durga has been dressed in silk. Women from the village of Hirapur in Orissa, offer the goddess blossoms and coconuts then touch her with their bracelets before they leave them.

Men congregate in Bhubaneswar, Orissa on the final, tenth, day and worship Durga beside their bikes, pedal carts, rickshaws, motor scooters, pedicabs, cars, and trucks, all of which are potentially destructive. The owners sprinkle water on their festively-decorated vehicles, burn incense, then offer coconuts and flowers, praying for protection from accidents throughout the next year.

In cities and towns, people transport their clay images of Durga from their homes, *pandals*, and temples to nearby waterways where the images are immersed and left to dissolve. There is great sadness as people bid their beloved Warrior Goddess good-bye; some cry as they say farewell.

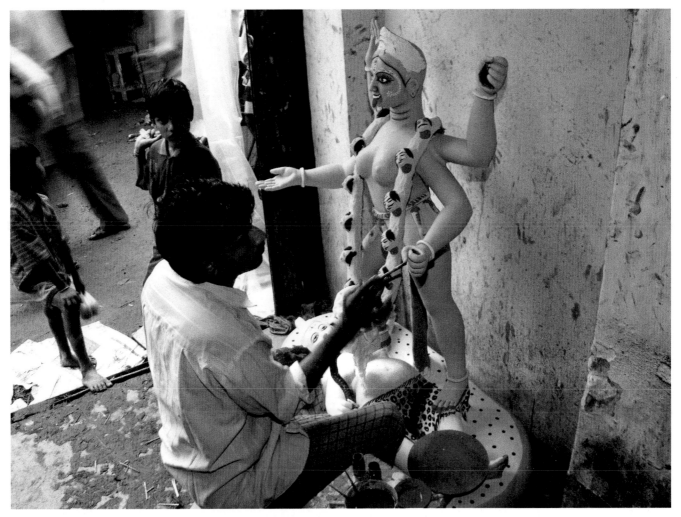

ON THE NIGHT OF NEW MOON, TWENTY-NINE DAYS AFTER DURGA PUJA, KALI PUJA OCCURS. WHO IS THE GODDESS KALI TO BE SO BELOVED IN CALCUTTA, A CITY WHOSE VERY NAME IS AN ANGLICIZED VERSION OF KALIGHAT, THE NAME FOR HER TEMPLE?

Kali bolted to life during a battle Durga conducted with particularly malicious, wily demons. When her enemies brandished their weapons, Durga's face went dark with rage; suddenly the fierce goddess Kali burst from Durga's forehead and hurtled into battle tearing the demons apart, crushing them in her jaws. She grasped two demon generals and decapitated them in one furious blow. After her quick victory, there was more to do. Durga beckoned Kali to help her quash demon Raktabija, whom Durga and her assistants, a fierce band of sixteen called the Matrkas (Mothers) had wounded. He was bleeding and every drop of blood he shed reproduced him a thousand times. There were mini-Raktabijas everywhere. Kali didn't hesistate. She sucked the blood from the demon's body, then gobbled his countless copies.

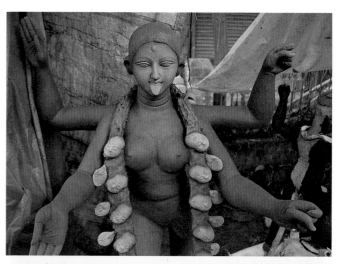

Kali's tongue is always sticking out in her images and illustrations. Her skin is either blue, representing eternity, or black for the absorption of evil. She has three red eyes and is naked except for a necklace of men's skulls and a belt of severed arms. In one hand, she holds a demon's gory head. She wears bracelets of snakes and is accompanied by a blood-drinking ferret.

The word *kali* is the feminine form of *kala* (time) which inevitably brings death. So the goddess is believed to live in cremation grounds like the one I visit in Puri, Orissa. In a vast cinder yard, divided into small plots where dead bodies lie in bonfires, eight tan mongrels bark as I enter. Across the street, sunbathers and camels enjoy the beach. Literally, this is a place where life and death intersect.

Although there are many schools and methods of worshiping Kali, devotees believe that by approaching the divine through her terrifying form, they will realize that "opposites"—death/life, evil/good, destruction/creation, ugly/beautiful, female/male—are different sides of the same coin. Duality is illusion, the world is whole.

This understanding can only result from quelling one's internal demons: greed, envy, lust, and so forth—a list roughly comparable to the Catholic's seven deadly sins. Hindu demons are always portrayed as male, which explains Kali's jewelry and accessories.

THREE DAYS TO GO BEFORE THE FESTIVAL. IN THE RAMPAGAN DISTRICT OF CALCUTTA, THE LABYRINTHINE BACK ALLEYS ARE PURE CHAOS.

Artisans building *pandals* for Kali Puja compete for space with women filling water buckets at the pump, rickshaws, push carts, and sauntering cows. Bamboo structures covered with computer paper begin to take identifiable shapes: a nose, a gargoyle, a dinosaur, a temple top, an airplane. The vendors who sell a hodgepodge of items from their windows have agreed to provide electricity. Long cords snake into the street, feeding fans to keep the fires alive under woks of glue. Men brush the hot adhesive on paper, then smooth it over fragile structures. Children look up from their work helping their families and shout, "Hello, how are you?!" One twelve-year-old brags that she is earning one dollar an hour for painting; her brother is as blue as the set he is swabbing. Six men run to the traffic-filled main street with a piece that looks like the Sydney Opera House, carrying it to a *pandal* that is miles away.

TWO DAYS TO GO. THE FLOWER FARMS ARE SIX MILES SOUTH OF CALCUTTA. FOR MONTHS, MEDIA ANNOUNCEMENTS HAVE INSTRUCTED GROWERS ON HOW TO FERTILIZE AND IRRIGATE TO OBTAIN MAXIMUM CROPS OF MARIGOLDS, THE MAINSTAY OF TEMPLE OFFERINGS. NOW TRADERS STRING THE BLOOMS TOGETHER AND HANG THEM FROM TREE BRANCHES, WHERE THEY DANGLE LIKE ORANGE TAILS. LATER, THE BLOOMS WILL BE PACKED INTO BASKETS AND RIDE ON TOP OF BUSES TO ASSAM, NEPAL, AND BANGLADESH WHERE VENDORS WILL SELL ENOUGH KALI PUJA GARLANDS AT TEN CENTS APIECE TO MAKE A GOOD LIVING.

One day to go. On a typical business day, the flower market near Calcutta's Howrah Bridge sells about two thousand dollars worth of blossoms. But today, sales will catapult to $280,000. Buyers purchase holiday flowers for all regions from Bihar to Manipur. Market stalls are jammed with men stringing flower garlands or braiding cockscomb, marigolds, or tinsel. Traders push through crowded aisles carrying armloads of gladiolas, sunflowers, and lotus blossoms. There are sweet peas, long stemmed roses, fragrant stacks of every flower I've ever seen, plus more. One bunch of tuberoses so large that I can barely reach around it, costs only one dollar. The vendors wear so many marigold strings on their shoulders that they seem to be modeling floral capes.

IN THE KUMARTULI DISTRICT, ARTISANS ARE CREATING KALI IMAGES IN EVERY IMAGINABLE SIZE. CUSTOMERS TOTE THEM OFF ON BICYCLES, PUSH CARTS, AND TRUCKS. STILL, THE ARTISANS PAINT. ONE STALL CONTAINS SIXTEEN IDENTICAL KALIS COVERED WITH WET PIGMENT THAT THE ARTIST IS TRYING TO FORCE-DRY WITH A BLOWTORCH. WORKSHOPS LIKE HIS HAVE BEEN CREATING IDOLS TWELVE HOURS A DAY SINCE JULY.

Nearby shops are full of clothes and accessories for the images. Although technically Kali is naked, on Kali Puja day her image is lavishly accessorized with glittery, fragile crowns of tinfoil flowers and "jeweled" nose rings. Artisans dye feather plumes, paint tin scimitars, cut metallic brocade cloth, and carve "lace" from balsa-light pith.

Tomorrow, no fewer than 589 *pandals* will open, an indication of artisanal creativity and devotion. Each will display a Kali image inside.

One association that has sponsored a Kali *pandal* for many years has commissioned a thirty-one–foot-tall Kali with a real gold tongue, and a nose ring with bonafide rubies, pearls, and emeralds, carrying a silver weapon that weighs at least 176 pounds.

I get a sneak preview of one *pandal*. I enter via a path lined with Chinese lanterns that runs through an immaculately landscaped garden. One hundred men have worked two weeks to create the *pandal*, which will be illuminated inside by a crystal chandelier no less than twenty feet in diameter.

Already, pilgrims walk en masse toward the Dakshineswar Temple carrying baskets of offerings for Kali's manifestation, Bhabatarini, whose name means "takes care of the whole world." In 1847 a Calcutta widow, Rani Rashmoni, rebuilt this ninth-century temple. Vendors outside the gates sell "offerings to go"—leaf-lined baskets of sweets, vermilion, incense, and Kali's favorite flower, the blood-red hibiscus. One woman makes her way from the Ganges to the temple, moving like an inchworm. This is the way she expresses her gratitude that her prayer has been answered: she takes a dip in the sacred river, prostrates herself on the ground, draws a chalk line where her fingertips reach, puts her toes on that line and repeats the process.

Business at Buzi Mela (the Firecracker Bazaar) is down 75 percent thanks to Calcutta's new regulations that limit firework sound levels to ninety decibels and restrict their use to the hours between 6 and 10 P.M. The dispirited vendors fret because rockets, their loudest products, have been the hardest hit. Still, they are promoting "standard" sparklers that are three feet long, plus packages enticingly labeled Twinkling Stars, Rainbow Fountains, Black Serpents, Electric Stones, Submarine Jets, Niagara Falls, Emerald Spinners, TV Towers and, anomalous as it seems, Christmas Tree Fireworks. Tonight at 6 P.M., on cue, the city rocks.

KALI PUJA DAY. REKHA RAMAMURTHI AND I WALK PAST MOTHER THERESA'S HOSPICE FOR DESTITUTES, PAST CLAMORING VENDORS SELLING GARLANDS OF RED HIBISCUS. WE ENTER THE KALIGHAT TEMPLE GROUNDS AT 7:30 A.M. ALTHOUGH THIS BUILDING WAS ERECTED IN 1908, KALI TEMPLES EXISTED HERE FOUR HUNDRED FIFTY YEARS AGO. KALIGHAT IS ONE OF FIFTY-ONE SACRED SPOTS IN INDIA THAT RESULTED WHEN, ACCORDING TO HINDU TEXTS, THE BODY OF SHAKTI FELL FROM HEAVEN TO EARTH IN FIFTY-ONE PIECES AND PLACES. THE LITTLE TOE OF HER LEFT FOOT IS SAID TO HAVE LANDED HERE.

Kalighat is covered with ceramic tiles patterned with green leaves, flowers, and swans. Two hundred twenty-five priests file past us carrying offering baskets above their heads for safekeeping. Many visitors line up to look into the sanctuary and see Kali. Although much of the image is below view, it's just possible to get a glimpse of her three eyes, which have become the graphic emblem of Calcutta.

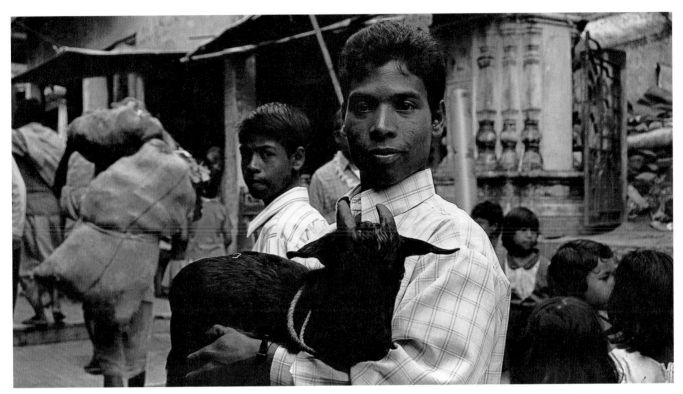

Villagers arrive carrying young, black male goats in their arms. They bathe them gently to purify them, place hibiscus garlands around their necks, then mark their horns and fur with vermilion.

Worshipers pray at the u-shaped form that holds the first kid's neck. A bar is placed behind its head and its owner keeps its back legs steady. The priest beheads the animal with a swift sword strike. Quiet pilgrims touch first the wall that surrounds the area, then their bodies, making a motion much as Catholics do when they cross themselves. Then the pilgrims move forward to place candles, hibiscus, marigolds, and incense, and pour holy water from brass vials on the u-shaped fork. They empty baskets of earth in the area where the next head will drop. Meat from the first goat will be cooked and distributed to everyone in the temple as *prashad* (blessed food). Sacrifices will take place virtually every minute of the day, although all the other goats will be butchered and their meat sold. "People who are strictly against animal sacrifice do not worship the goddess," Rekha explains. "Sacrifices symbolize the idea that we give our lives to Kali."

The animals also represent the internal demons that Kali worshipers intend to quell. "Goats stand for passion," according to Santimoy Bhattacharya who honors me with a private Kali lecture, complete with notes and reference books. "The Markanda Purana, written in the eighth century A.D., required that human sacrifice must be offered to Kali," but that is now morally and legally unacceptable. "In other times, people sacrificed sheep (symbolizing greed), buffalo (anger), boar (pride), geese (attachment), and roosters (envy)."

Above: Kamakyha Temple in Assam is considered the epicenter of Hindu worship of the sacred feminine.

I am invited to sit by the image of Krishnakali, a loving, nonviolent version of Kali that the family has commissioned for the occasion. Surely, this is the position of honor: I face Sumit and all the guests; I am next to the conch shell blower, the singers, and musicians who play cymbals, harmonium, finger bells, and drums. Clapping three times and snapping his fingers above his head in ten directions, Sumit invokes Kali; this is his favorite part of the service.

Extravagant quantities of offerings surround the goddess's image: sandalwood paste, vermilion, river water from the Ganges, incense sticks, hibiscus, lotus, betel nuts, wood apple leaves, fresh fruit, and a wide assortment of delicious foods to be eaten later by the guests. Sumit uses flowers, water, a conch shell, mirror, fan, and whisk as he prays to Kali. Women ignite a beautiful heirloom tree of one hundred eight lights whose cold camphor fire represents the Supreme Being. Throughout, insistent music helps focus the worshippers'

attention, repeats, throbs, builds, demands, ultimately electrifies us. At the end of the ceremony, Sumit's posture signals total submission to the goddess. Hands, chest, navel, both legs, both arms, both hands touch the floor in complete surrender. The conch shell musician blows "the sound from which man comes."

In a distant part of the city, another Kali Puja takes place in an open-air temple in an urban produce market. Neighbors drift toward Haro Gouri Kali Mandir wearing their best clothes, ready to participate in the One Hundred Eight Vegetable Puja. Priests have created an image of Kali's face from a mound of rice that covers a low table; eggplants and tomatoes form her eyes, nose, and mouth. Further, this masterpiece is surrounded by all one hundred eight varieties of vegetables. Hindus believe that the deities and their representations are one, whether the images are posters, statues, or vegetable collages. A Tantric priest performs the Puja, and afterwards, participants feast on the offerings that are cooked in huge cauldrons and ladled over steamed rice.

The next morning, Rekha and I rejoin the guests at the Bhattacharya house to hear devotional songs by a one hundred thirty–year-old Kali chanting group, Andul Kali Kirtan Samity. Twelve musicians settle on the floor with their violins, harmonium, finger bells, cymbals, and various types of drums. A violin introduces the musical theme, soon joined by two voices. The drums, cymbals, and additional voices create slow, soft music. The pace and sound become more complex, deeper, louder, faster. Some of these songs were composed by Rampushad, Kali's human companion. Santimoy recites favorite lyrics by another famous composer: "When you lose yourself, you can enjoy the sweetness of her charm. You can behave like a skylark, enjoy the moon beams."

Above, top: At the One Hundred Eight Vegetable Puja, an image of Kali's face is shaped from rice, eggplants, and tomatoes.
Above, bottom right: After the Kali Puja, the priest places red vermilion on celebrants' foreheads.

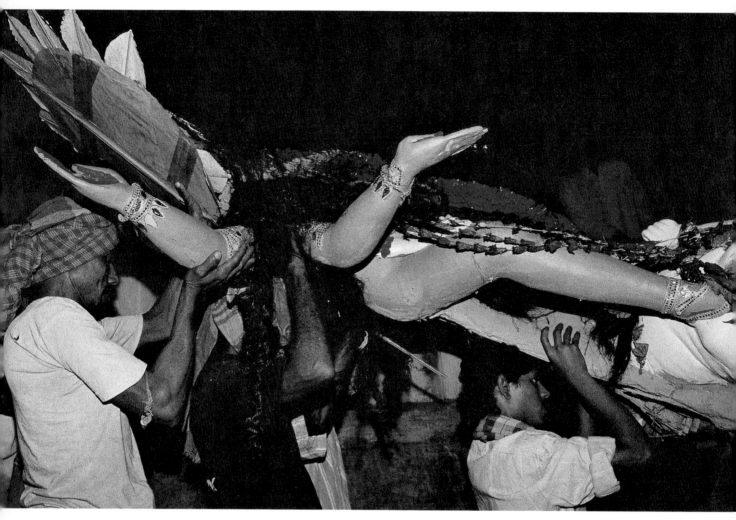

AT FIVE O'CLOCK, FAMILIES BEGIN DELIVERING THEIR KALI IMAGES TO THE SHORE OF THE HOOGHLY RIVER. FATHERS, BROTHERS, AND UNCLES CARRYING KALI FIGURES TURN THEM SEVEN TIMES BEFORE THEY START DOWN THE STEPS TO THE WATER. MEMBERS OF THEIR FAMILIES CARRY BASKETFULS OF KALI'S ACCOUTREMENTS, FLOWERS, AND DECORATIONS. SOON THE CLAY IMAGES WILL HAVE DISSOLVED INTO MUD AND THE BASKETS WILL BEGIN TO DISINTEGRATE. IN JUST ONE HOUR, THREE HUNDRED NINETEEN IMAGES ARE IMMERSED. THE GODDESS'S DEVOTEES WISH HER FAREWELL WITH DRUMS, CYMBALS, FIRECRACKERS, ULULATIONS, AND SHOUTS: "KALI IS VICTORIOUS!"

"O glorious Mother, all women the world over, are Thy forms...."
—DEVI MAHATMYA

KALI AND DURGA WITH THEIR BRAZEN, AGGRESSIVE WARRIOR BEHAVIORS SEEM UNLIKE THE INDIAN WOMEN I MEET. KALI IS NAKED, WHILE MOST WOMEN ARE MODEST. BOTH GODDESSES ARE FIERCE, WHILE MOST WOMEN ARE GENTLE. KALI'S LONG HAIR IS DISHEVELED, WHILE MOST WOMEN WEAR A GLOSSY BRAID. CONTEMPORARY INDIAN WOMEN ARE SOCIALIZED TO BE SUBMISSIVE TO MEN, BUT KALI STANDS ON HER HUSBAND'S INERT BODY AND DURGA WAS CREATED BY THE GODS TO ERADICATE THE DEMON THE MALE GODS COULDN'T TAME. ONLY MALE ANIMALS ARE SACRIFICED TO THE GODDESSES. KALI'S ENEMY DEMONS ARE MALE.

Rekha Ramamurthi disagrees that there is a big difference between the goddesses and present day Indian women. "Durga protects, we do the same thing exactly. If need be, a woman will destroy anything to protect her family." During our time together, Rekha's words and actions signal her power again and again.

"I will not be my family's walking stick. I will teach them to walk, I will teach them to run, but I will not do everything for them. They must do it themselves."

When foreign children laughed at her son because they found his name difficult to pronounce, she advised him, "If you can learn their entire language, they can learn your name. It is not too much to ask."

When her husband requested that she put up religious posters before his mother's visit, Rekha, who is not religious, responded, "I cannot. That would mislead. It would not be the truth."

"I have known for a long time that when I was fifty and my children were grown, I would make time for myself. I have just taken the entrance exam to study for my baccalaureate in sociology."

Rekha comments, "The practice of dowry is degrading and undigni-fied. I will not pass on that tradition." She knows well that others hold different views—about this and many other things—but believes that arguing is a path to understanding others.

Rekha is prepared to violate her culture's long-established expecta-tion that parents must arrange their daughters' marriages. "I may not seek a husband for Rajyashree—now or later. She has a friend. He is thoughtful. Relationships take time to grow, but I am impressed with what is happening." Durga and Kali's power echoes through Rekha's strong voice and opinions.

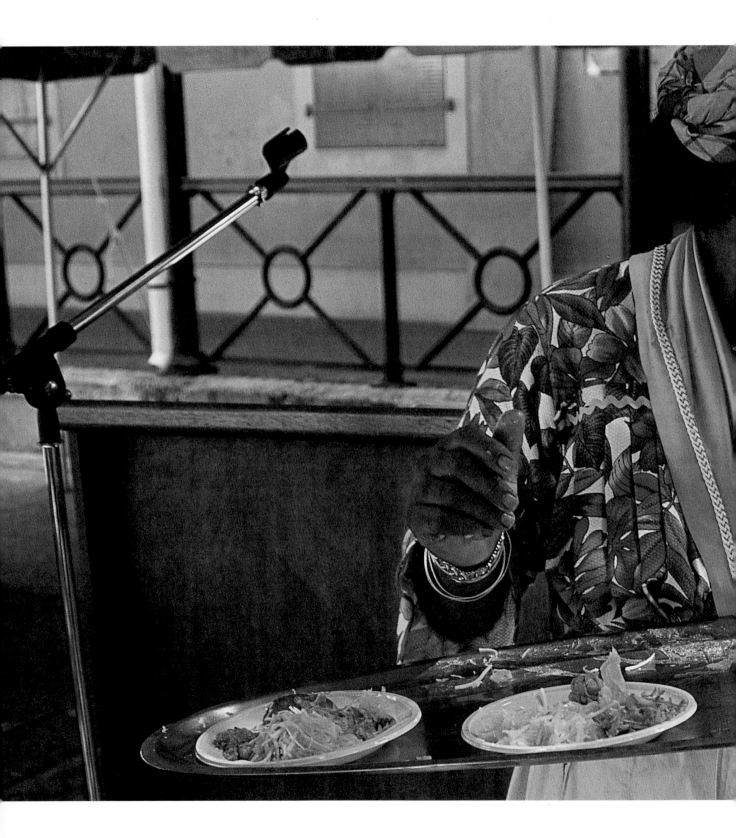

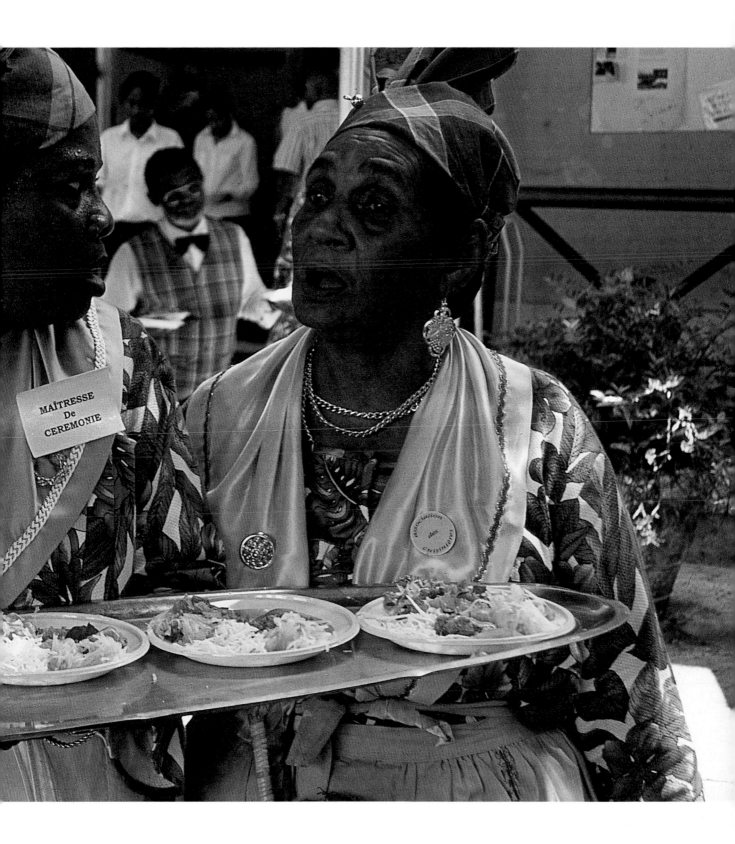

THE BREEZE TOYS WITH THE PAGES OF THE SONG BOOKS AS IT BLOWS GENTLY THROUGH THE CATHEDRAL'S OPEN WINDOWS. LATER IN THE DAY, THE WINDOWS WILL BE LOUVERED AGAINST AUGUST'S ONE HUNDRED DEGREE HEAT. BUT NOW IT'S 6:30 A.M. AND GUADELOUPE'S COOKS HAVE GATHERED IN THE ANCIENT CHURCH FOR A PRIVATE MASS ON THE BIRTHDAY OF THEIR CHOSEN PATRON, SAINT LAURENT, WHO WAS, THEY SAY, *GRILLÉ* AT THE STAKE. THE CUISINIÈRES PRAY TOGETHER AND SING, THEIR ALLELUIAS ECHOING FROM THE VAULTED CEILING. BELLS RING FROM THE STEEPLE AS TRUCKS AND MOTORCYCLES BEGIN TO HUM THROUGH THE STREETS OF POINTE-À-PITRE.

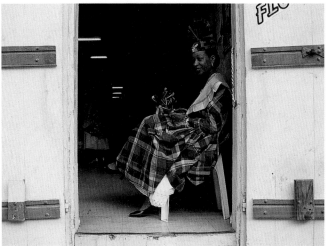

For the next two days, the Fête des Cuisinières will celebrate these Creole cooks and the unique culinary tradition of Guadeloupe, the butterfly-shaped island in the French West Indies that lies almost equidistant from Florida and Venezuela. These women are so expert at delighting the taste buds that they are known as "the professionals of the mouth."

In 1916, their mothers and grandmothers, cooks of modest means, banded together to form Cuistot Mutuel, an insurance association created to provide the medical care and funerals that they could not afford. The cooks prepare meals when members are sick, help each other through family emergencies, and arrange dignified funeral services. After having shared so many difficulties, they yearned to see each other on a more joyful occasion. So they created one: the annual Fête des Cuisinières. While *cuisinière* is simply the French word for a woman cook, the members of Cuistot Mutuel are considered a class apart—they are the Cuisinières.

The Cuisinières first held the festival in 1917, when ten cooks dressed in sumptuous costumes to attend the Saint Laurent mass, then paraded through Point-à-Pitre afterwards carrying their best dishes, which they served at a great public feast. The Fête des Cuisinières has happened every year since, no matter what. Viviane Madacombe, the current president, laughs about the 1948 *fête*: "It was hurricane season and there was a high alert, meaning everyone was supposed to stay home. The cooks were dressed in red. When they paraded, all their dresses were soaked by the torrential rain. Their white petticoats, even their underwear, got wet—and pink!"

The year that I attend, 2001, is the eighty-fifth anniversary of the Cuistot Mutuel. The day after the private mass, the cooks meet at the Maison des Cuisinières, their headquarters, on Rue d'Ennery. They are resplendent in their traditional festival outfits: floral print dresses, starched eyelet-edged petticoats, shining gold jewelry, madras hats, and aprons embroidered with the saint's initials and the organization's emblem (a fish on a grill). Their costumes are as bright as the hibiscus, bougainvillea, and torch ginger that flourish on this tropical island.

I begin to take pictures the minute I see the first cook climb from her car. A tall, handsome Cuisinière, an émigrée from the Dominican Republic, asks if I would like "Coffee? Chocolate?" She honors me by speaking English, and I juggle a cup of coffee and a hot, fresh croissant while I snap pictures and change film, not wanting to be rude but not wanting to stop photographing these beautiful women who are considered national treasures.

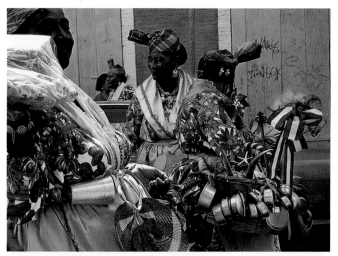

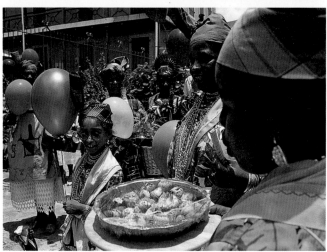

The public is invited to attend the next mass, and the Church of Saint Peter and Paul is jammed with one hundred fifty cooks, local residents, and tourists. The Cuisinières place baskets of food near the altar to be blessed, each one decorated with red ribbons that match Saint Laurent's mantle. The ceremonial mass, which has no communion, is a celebration of songs, prayers, laughter—and applause—that begins when the oldest Cuisinière, a regal one hundred four–year-old woman, walks down the center aisle to her seat. The cooks cluster together on the front pews, a kaleidoscope of color, and the choir rocks the church with joyful songs. Alleluia, Ah-lay-lou-yah!

THE COOKS BURST FROM THE CHURCH CARRYING WICKER MARKET BASKETS TRIMMED WITH CLATTERING MINIATURE SAUCEPANS, MEASURING CUPS, SALT SHAKERS, COLANDERS, AND MILK CANS. THE BASKETS BRIM WITH FRESH FRUIT AND VEGETABLES, EVERY ARRANGEMENT MORE ARTFUL THAN THE ONE BEFORE. THE WOMEN ALSO CARRY THEATRICAL CREOLE DISHES THAT THEY WILL SERVE AT THE FIVE-HOUR FEAST THIS AFTERNOON—TOWERS OF CRAYFISH THE SIZE OF LOBSTERS, TRAYS OF MUSSELS. ALMOST TWO HUNDRED RESTAURANTS ON THE ISLAND ARE OWNED BY WOMAN COOKS AND CHEFS; THE PARADE AFFORDS A CHANCE TO FLAUNT THEIR CULINARY EXPERTISE.

The Cuisinières offer *petits fours* to the spectators who pack the downtown sidewalks to cheer them on. The cooks dance through the city streets past the spice and fish markets where, on work days, they shop for the freshest local ingredients. Finally, they stop at the gates of the Lycée Carnot, the prep school where diplomats, governing elite—and the first black woman to attend such a school in Guadeloupe—have been educated. The school courtyard is full of white tents that shade banquet tables set for six hundred. As soon as the clock stikes noon, helium balloons will be released into the sky.

Strict protocol governs the sequence in which the Cuisinières and their guests enter the school. The image of Saint Laurent is carried in first. Next, Madame Viviane Madacombe starts up the steep steps followed by the vice presidents and member cooks and, finally, the president and prefect of the region, invited guests, and the public, each of whom has paid twenty-five dollars for the privilege of sharing the fabulous feast. Every ticket has been sold.

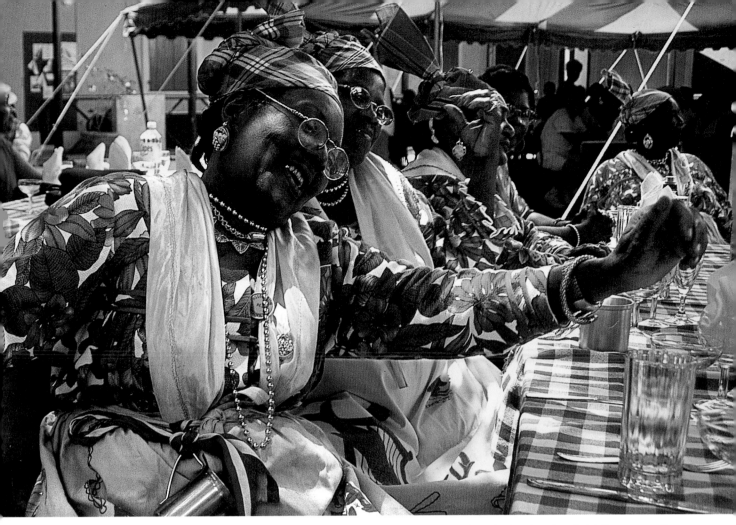

MUSICIANS HAVE COME FROM FRANCE TO PLAY FOR THE FESTIVAL. COOKS FROM THE NEIGHBORING ISLAND, MARIE GALANTE, HAVE COME TO DANCE. THE COOKS SING THE CUISINIÈRE SONG WHILE EVERYONE SIPS *TI* PUNCH (SUGARCANE RUM, LEMON, AND SUGAR) AND NIBBLES HORS D'OEUVRES.

The Cuisinières have converted classrooms into kitchens, and are preparing to serve six different kinds of salad including shredded pumpkin. They have prepared breads, curried chicken, *ouassous* (crayfish), codfish, and rice, *dombrés* (dumplings), sweet potato—and, for dessert, clove ice cream. The final presentation will be the *pièce de résistance*, *pain doux*, a dome-shaped anniversary cake with white icing drizzled into intricate, lacy patterns.

Entertainers wearing Creole costumes dance energetically, undeterred by a surprise shower. There are speeches by the VIPs including a member of parliament from Lyon, France, the mayor of Pointe-à-Pitre, and the president of the Regional Counsel, who observes, "Creole tradition has eternal value." *Islands* magazine would agree, having decreed that Guadeloupe's woman cooks serve "what is widely regarded as the best Creole cuisine in the Caribbean."

In between courses, there is dancing. One Cuisinière moves like a belly dancer, her hand on her stomach, gyrating and undulating. Four Cuisinières do a circle dance in the kitchen. One old Cuisinière dances through the tents carrying a live chicken; she sits on men's laps, teases them, and kisses them on the lips amid yelling and merriment. Under the trees, two Cuisinières perform the beguine while their cook friends clap together two mahogany blocks, a book-shaped percussion instrument. A Cuisinière-to-be, about six, carries her baby brother to dance. The youngest child wearing a Cuisinière costume, about three-years-old, nestles in her father's arms while he dances. Some Cuisinières dance without leaving their chairs, waving their arms gleefully to the rhythm of the music. In the corner of the schoolyard, the image of Saint Laurent watches silently. Surely he would do a little jig if he could.

WINE GLASSES SPARKLE ON THE VERANDAH TABLE; THE HORS D'OEUVRES HAVE JUST BEEN REMOVED FROM THE OVEN. THE CUISINIÈRES HELP EACH OTHER TIE THEIR MADRAS SCARF-HATS AND PREPARE TO WELCOME THE JOURNALISTS TO THE GALA PRESS RECEPTION. MADAME MADACOMBE'S PHONE RINGS YET ANOTHER TIME.

THE SECRETARY OF THE ORGANIZATION, NINEY-THREE–YEAR-OLD PRUDENCE GALAS, HAS DIED. THE WOMEN NOD, SHE HAD SUFFERED ENOUGH. CUISTOT MUTUEL'S MISSION IS TO GIVE CUISINIÈRES DIGNI-FIED FUNERALS, BUT I WONDER HOW THEY CAN ARRANGE A REQUIEM MASS IN THE MIDST OF THEIR EIGHTY-FIFTH ANNIVERSARY FESTIVAL. THE COOKS AGREE WITHOUT HESITATION TO CONVENE AT THE CHURCH OF ST. PETER AND PAUL AT FOUR THE NEXT AFTERNOON.

AS PROMISED, A FEW MINUTES BEFORE FOUR, THE COOKS ARRIVE WEARING THEIR MATCHING MOURNING COSTUMES: BLACK-AND-WHITE MADRAS HATS, BLACK DRESSES WITH TINY BODICE TUCKS, AND BLUE EMBROIDERED APRONS. THEY CARRY THE FLAG OF THE CUISTOT MUTUEL PLUS TWO STALKS OF SUGARCANE TIED WITH BLACK RIBBONS— A REMINDER OF THE ISLAND'S HISTORIC PLANTATIONS WHERE THE ANCESTRESSES OF THE CUISINIÈRES WORKED AS *DAS* (LIVE-IN NANNIES AND COOKS).

Dignitaries attend in full force—Henri Bangou, the mayor of Pointe-à-Pitre; Madame Madacombe, the current president; Monique Vulgaire, vice president; and Axcelie Francoise Lacrosse, former president of the Cuistot Mutuel.

Flowers are delivered by the hearse; one garland of purple mums is wrapped in a navy, satin sash imprinted with the words "*Ma Cousine.*" Parallel lines of family members and cooks face each other holding floral wreaths as the casket is carried between them into the church. They follow it and pay their final respects with the traditional Catholic service of song, eulogy, and incense.

It is guild tradition for the Cuisinières to accompany their members to the cemetery. At every intersection they walk backward, looking toward the coffin, ring two bells, wave the sugarcane, and tap their book-shaped percussion instruments. They also carry two wicker market baskets, each tied with black ribbon. Unlike their festival baskets that spill over with fresh fruit and vegetables, these baskets are empty.

Prudence Galas was eight years old in 1916 when the Cuistot Mutuel began. Every year at a mass held on the day the organization was founded, July 14, her peers will remember her, along with the souls of all past members.

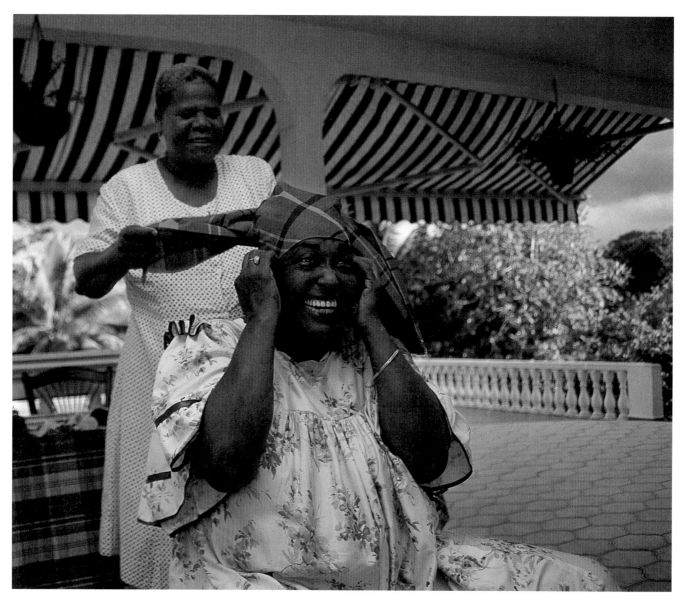

VIVIANE MADACOMBE, FORTY-EIGHT, IS THE YOUNGEST PRESIDENT THE CUISTOT MUTUEL HAS EVER HAD. SHE HOLDS TWO DEGREES, ONE EACH IN HOTEL MANAGEMENT AND CUISINE—AND SHE WAS BEST IN HER CLASS FOR EACH. THESE DAYS, SHE OFFERS LA MAISON BLANCHE, HER BEAUTIFUL WHITE HOME, FOR PARTIES AND WEDDINGS THAT SHE CATERS. THERE ARE VIEWS OF THE VERDANT HILLS FROM THE VERANDAH THAT ENCIRCLES THE HOUSE. THE TILED POOL WITH ITS GARDEN GAZEBO MUST TEMPT MANY BRIDES TO HOLD CEREMONIES HERE.

Above: Ketty Bregmestre and Viviane Madacombe

Cooking is in Viviane's genes. Since her grandmother died young, Viviane's mother began cooking for a wealthy family at age twelve.

Viviane was eleven when her mother began to teach her to cook. "I learned to make mayonnaise first and when I was twelve, bread. I ate so many mayonnaise sandwiches that I got jaundice and had to have cortisone treatments!"

Leonie Melas—the president of Cuistot Mutuel for fifty years, until she died at age eighty—knew Viviane when she was young and dreamed that the girl would grow up to become president of the guild. In 1998, when Viviane, then a board member, was nominated, she accepted despite her reservations: "Life was very busy!" She already owned a restaurant and ran a catering business.

Viviane was also raising a son who, she laughs, really hates cooking. "Mothers here play the roles of both mother and father. We have a matriarchal culture. Most of our elite people have been bred in a family where there was only one parent, the mother. Women give the children food, education, clothing, everything. Women here are the *potomitan* (middle, supporting pillar) of the house."

Like good leaders everywhere, Viviane has a clear vision for the future of the organization she leads. She worries that the Creole cooking tradition may be lost as more women work outside the home and take their families out to eat.

She hopes to write a cookbook to codify traditional Creole cuisine. Recipe books now on the market are either "not her style" or wholly wrong. "A tomatoless dish that has tomatoes? An eggless pasta made with eggs?" She dismisses these recipes as "a crime."

She also has many ideas about how to revitalize the Cuistot Mutuel. First she would like to form a federation of all the food festivals in Guadeloupe—individual towns have crêpe, fish, and crayfish festival days. Next, she will convert the Cuistot Mutuel headquarters—Leonie's house, "a house with many memories"—into a cooking school for tourists. She will hire Mahogany to do the accounting, liberating the cooks from administrative headaches, train young Cuisinières in management, expand the membership, convene a conference with cooks from Martinique and Guadeloupe to compare notes on Creole cuisine. There is a lot of work to be done.

The day before the festival, Viviane drives at top speed in her blue Peugeot to RFO Guadeloupe, the number one radio station. She tells the host who interviews her, "People will see 2001 as a turning point for Cuistot Mutuel." She describes plans to create a Museum of Cuisinières and to invite hotels and restaurants to demonstrate their expertise at Creole cooking during next year's festival.

This woman not only bubbles with strategies but also with energy. She was up at three in the morning to prepare catered lunches for the cyclists who are racing on the island this week. Then she prepared the breakfast that the Cuisinières enjoyed after mass this morning. This afternoon, she will cook the anniversary cakes for the festival feast and the *petits fours* that will be given to the parade spectators tomorrow. Sometime, she will write her speech and plan how to preside over the opening ceremonies for the eighty-fifth anniversary feast.

VICTORINE MADACOMBE, VIVIANE'S MOTHER, IS ONE OF THE SECRETS BEHIND THE PRESIDENT'S ABILITY TO KEEP SIX BALLS IN THE AIR AT THE SAME TIME.

Victorine, seventy-three, confesses that she fell asleep on the table after having helped serve twenty people on Saturday and fifty more on Sunday at Maison Blanche. Although Victorine taught Viviane to cook, she is not a member of the Cuistot Mutuel and claims to be retired. She doesn't look retired.

At the moment, Victorine is supervising the preparation of white land crabs, which a client will take to Paris on a flight that leaves in a few hours. Land crabs are delivered live with their legs tied by long leaves so they can't run or pinch. With a few deft moves, Victorine subdues them. She cooks them as all Creole cooks do, free hand—"a little oil" (a careful slurp), "a little pepper" (enough to cover the tip of a large wooden spoon). She skips the garlic so the taste won't become too strong during the eight-hour flight to France. And she adds a green sauce. Without skipping a beat, she turns to instruct an employee stirring onions, tomatoes, and oil and directs the delivery-man about where to put the *pommes cannelles*.

When I interview Victorine, I realize she is answering my questions before Hedwige Kelly, my interpreter, has a chance to translate them into French. Victorine confesses that she grew up before compulsory education came to Guadeloupe, and longed to go to school. When her mother arranged for her to work in the house of an English teacher, she dreamed that she could learn a new lan-guage. Instead, she was expected to clean the house and even wash the family tombstones. Undaunted, she listened carefully and taught herself. "Yes. No. Close the door. Thank you." She pronounces each word proudly in English, and wins my heart.

MONIQUE VULGAIRE, WHO JOINED THE CUISTOT MUTUEL IN 1958, BECAME ITS FIRST WOMAN VICE PRESIDENT THREE MONTHS AGO— ALTHOUGH THE MEMBERSHIP OF THE CUISTOT MUTUEL CONSISTS ALMOST ENTIRELY OF WOMEN, ITS BOARD HAS LONG BEEN DOMINATED BY MEN. TODAY, SHE IS COOKING FOR THE FESTIVAL FEAST: 135 POUNDS OF BLACK PUDDING, PLUS *MATÉTÉ DE CRABE*, AND HORS D'OEUVRES OF BREADFRUIT, CUCUMBER, AND AVOCADO. AS IF THIS PRODIGIOUS AMOUNT OF COOKING WEREN'T CONTRIBUTION ENOUGH, TOMORROW, IT WILL BE MONIQUE WHO ANNOUNCES THE NAMES OF THE GUESTS AS THEY ARRIVE AT THE LYCÉE CARNOT.

Monique tried other jobs before she found cooking. Laundry. Cleaning houses. Then one year she took cooking lessons while she was visiting her daughter in Paris. The cooking instructor inspected Monique's first dish, *pot au feu*, and asked why she had enrolled in the course. "You already know more than I do."

Monique has never used recipes, but she quickly mastered entrées, hors d'oeuvres, desserts, "a lot of things." Soon, she began invent-ing. She decided to make salted conch, but since her husband disliked salt, she substituted onion and added rice, inventing the Guadeloupean favorite, *matété de lambri*.

"What's the most difficult thing you ever made?"
"Nothing is hard for me."

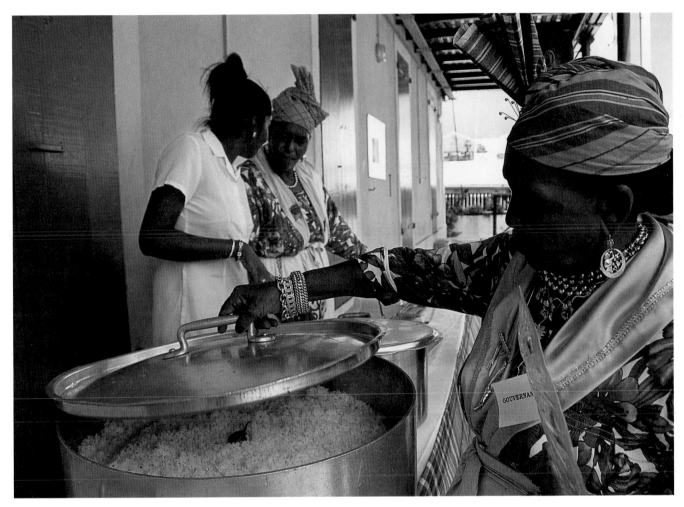

"Do you have a favorite dish?"
"Breadfruit with codfish and *blaff de poisson*."

"What is the dish you have most fun cooking?"
"Dombrés."

"Is there anything you'd like to tell me that I don't know to ask?"
Monique hikes up her skirt to show scars on her legs and feet from
a cooking accident—she was standing at the stove and twenty liters
of boiling water fell on her, burning her so badly that she was hos-
pitalized for two and a half months.

"Was that the end of the cooking?"
"No! I love cooking. I am now seventy-three and retired, but I still do
catering. And my daughter and four grandchildren are all very, very
good cooks."

The waterfront in Pointe-à-Pitre is busy with fishermen selling the morning catch directly from their boats: tuna, red snapper, and catfish. As Guy Claude implied, fish are the superstars of Guadeloupean cuisine, but native fruit, vegetables, spices, and herbs flourish on the island and help define its specialties. The Marché Couvert is full of vanilla, cinnamon, curries, clove, cumin, ginger, peppers, pimentos, saffron, and nutmeg. Stalls in La Darse Marché are packed with locally grown mango, guava, yams, bananas, coffee, pineapple, coconuts, melons, sugarcane, breadfruit, and star fruit. Everything on this island seems to grow in profusion. UNESCO has named the Guadeloupe National Park a biosphere reserve—three thousand species of trees, two hundred seventy ferns, and ninety orchids prosper in this rich soil and humid air.

IN 1973, LUCIENNE SALCEDE AND HER MOTHER OPENED A RESTAURANT ON THE BEACH OF GRANDE ANSE DESHAIES. THEY NAMED THEIR RESTAURANT KARACOLI—THE AMERINDIAN WORD FOR NECKLACE—AND IT SOON BECAME THE ONLY RESTAURANT ON GUADELOUPE TO WIN THE MADAME COMMERCE DE FRANCE SERVICE AWARD.

Now, Lucienne and her brother Robert own the restaurant whose courtyard tables are shaded by cool trees that spread onto the beach. Chic families eat lunch here, and afterward change for a swim in the warm sea where a few fishing boats bobble.

I accept the Salcede's menu recommendations, sampling and enjoying many dishes: *accra* (crispy breadfruit and yellow banana fritters), *grande gueule* (red fish). Beans and rice. Kid curry with white rice and pumpkin. Coconut flan with coconut ice cream garnished with star fruit.

Robert, one of the few male chef members of Cuistot Mutuel, invites me into his kitchen. His white uniform and hat are as immaculate as the room. All the ingredients he has prepared for *court bouillon de poisson* are isolated in small, white dishes: chopped chives, lime, cloves, salt, garlic, thyme, hot pepper, tomatoes. Within minutes, all this has been combined into a perfect sauce; he spoons a little of it into his palm to taste. Perfect.

He turns off the burner just before the water boils under the *poisson Creole*, removes the whole red fish and ladles the sauce on top. Done. I am astonished. Never have I seen such a mouthwatering dish result with so little *fol de rol*. It is as if he waved a magic wand and the *court bouillon* just appeared. The secret of how to make these delicious dishes seems to spring from the minds of the cooks and chefs who create them.

AFTER THE FIVE-HOUR LUNCHEON, A YOUNG MAN CARRYING A HUGE CANVAS BAG INVITES ME TO FOLLOW HIM TO MEET ARY EBROIN, NINETY-ONE, WHO WANTS TO SHOW ME THE TWENTY-THREE BOOKS HE HAS WRITTEN ABOUT CREOLE CUISINE. ALL DAY, THROUGH THE STREETS AND HEAT, THIS YOUNG CHAP HAS BEEN CARTING ALL TWENTY-THREE BOOKS IN HIS SATCHEL.

I have been eager to speak with Monsieur Ebroin, an erudite man who graduated from the National Academy of Cooking in Paris, won their grand prize for his cookbooks, earned a Ph.D. in the United States, is a member of the New York Academy of Sciences, and has written about ichthyology for encyclopedias.

Ary is proud of his two-volume epic work, *Art Culinaire Crèole d'Antilles Francais*, which was published in 1977. Each volume contains more than two hundred recipes, including a dish named for John F. Kennedy that was served at the White House.

From Ary, I begin to understand the link between Creole cuisine and Guadeloupe's history before, and after, Christopher Columbus landed here in November 1493, seeking fresh water, lured by the sight of waterfalls tumbling from the high peaks in the island's rain forest.

The food legacy of the indigenous people, the Arawak and Caribbean Indians, includes jellied apple and guava, cassava, and barbecue style cooking, as well as many dishes made with rooster-tail conch, snails, oysters, and shellfish.

The Spanish brought *matété*, a variation of paella and jambalaya, and a style of preparing land crabs that originated in Galicia. The English contributed tortoise soup and punch.

The French who settled in Guadeloupe in 1633—the archipelago is now one of ninety-six departments of France—donated *ouassous*, *court bouillon*, and *pain doux*, the lacy anniversary cakes served at the eighty-fifth Fête des Cuisinières.

Dutch Jews, who took refuge here from Brazil in 1634, introduced *blaff*, which gets its name from the sound the fish makes when it's dropped in boiling water, and *dombrés*.

The Africans who came to work on the sugarcane plantations brought *accras*—crusty fritters that were named for Accra, the capital of Ghana—and *calalou* (green vegetable soup) plus many other sumptuous delicacies.

Guadeloupean slaves were emancipated in 1848 and after that, sugarcane workers emigrated to Guadeloupe from India and China, and brought with them *le colombo* (curry) and *moltani* (saffron soup).

Ary Ebroin writes: "Any Creole dish holds the glamour of the past, the poetry of the land, and the sweetness of our most distant memories. It harmonizes with the brightness of our sun and the splendor of our landscape."

The Cuisinières who create the Creole dishes that are so evocative and delicious deserve to be proud of themselves.

GREEN MEADOWS; HILLS COVERED WITH HAYSTACKS AND STRAWBER-
RIES; BLUE AND WHITE LUPINE, BUTTERCUPS, AND PURPLE PLUMES
CLUSTERING NEAR TWO-LANE ROADS; PINE FORESTS; LAKES DYED
PINK BY THE SUN, WHICH SETS AT MIDNIGHT. SILENCE. IT'S SUMMER
IN THE NORTH SAVO REGION OF CENTRAL FINLAND.

But it wasn't always so peaceful. During the nineteenth century, men who wanted to join Robber Ronkainen's group had to prove their strength by carrying a one hundred fifty–pound bag of rye on their backs and running through stones in the forest. Once qualified, the bandits stole food, animals, and the women who would become their wives, raiding villages throughout Karelia, which is now part of Russia.

Their Russian counterpart, named Vornanen, stole food, animals, and women from central Finland. A classic case of "the grass is always greener."

Eero Pitkänen, the cultural secretary for the Commune of Sonkajärvi, didn't know all that history when he lay down to take a nap at home one afternoon. He'd been worrying about the village's summer market and fair. Leena Juntunen had dreamed up the marketplace in 1986. At first, fifty farmers sold produce but the number of vendors grew quickly. Six years later, when Eero took his nap, the marketplace was a great success. To draw more people, the summer fair needed a new angle. He thought and dozed.

Eureka! Eero imagined a race track 253.5 meters long, exactly that, with water obstacles and hurdles. The course should be run by about thirty couples, with the men carrying their wives on their backs. Only later did Eero learn that local robbers had the same idea two hundred years earlier.

The first Wife Carrying Contest was held during the marketplace fair in 1992. Eero invited the press. Reuters, AP, Lonely Planet, CNN, ABC, BBC, ESPN, NPR, *Sports Illustrated*, and *Runner's World* all covered the wacky proceedings—inspiring other countries to start wife carrying competitions, a germinal international movement.

The first World Championship was held in Sonkajärvi in 1996. By 2001, national winners were entering from Korea and Japan, which sent a sumo wrestler and his wife. Meanwhile, the Finns, inspired to see how much silliness they could cram into the few months when the sun shines, cooked up a raft of smaller, equally crazy, summer competitions: swamp soccer, boot throwing, and cattle calling. *Eukonkanto* (wife carrying) required that women participants be at least seventeen, which is marriageable age. "If you haven't got a wife of your own, you can borrow one," the rules say.

The *eukko* of *eukonkanto*, the peasant or farm wife idealized as "big, soft, and cuddly," was hardly the shape of the women who competed. In 2001, the winning woman weighed thirty-three kilos (seventy-three pounds). Not wanting to encourage anorexia, festival organizers levied a minimum weight requirement for women, forty-nine kilos (one hundred eight pounds), because that's what Armi Kuusela weighed when she became the Finnish Miss Universe in 1952.

At first, Eero worried about what Finnish feminists might say. But in 1998, the region's woman governor pooh-poohed those who thought the event was Neanderthal, arguing, "If anything, it's uplifting." A woman competitor told a journalist, "I came here because it's the only time it's okay for me to get on his back." As I interviewed women contestants and residents, I concluded that Finnish competitors feel certain enough about their equality that they forget gender issues and have fun.

There is ample evidence of the emancipation of Finnish women—suffrage was granted here in 1906. This year, the heads of the country, the Finnish Bank, Parliament, and Marimekko, one of Finland's largest corporations, are all women. The mayor of Helsinki is a woman. By law, 40 percent of all appointed office holders must be women. The only woman on the board of the European Central Bank is a Finnish woman. Seventy percent of Finland's medical students are women.

I remember the 1960s and 70s in the United States when women were not getting the jobs and salaries they deserved. It was not a funny situation and the fledgling women's movement was faulted for being humorless.

Women's willingness to enjoy a slapsticky, goofy, laughing-out-loud good time may be correlated with equality.

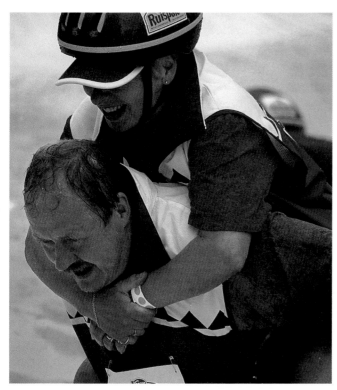

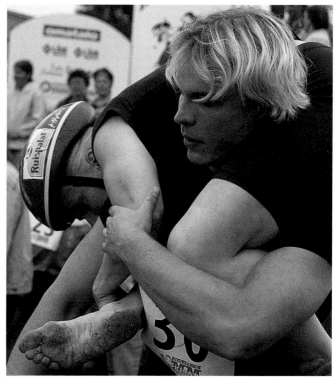

Johanna is not his wife—whom Johanna describes as tall, dark, beautiful, and passionate—but Johanna and Joni have been best friends since they were children in Sonkajärvi. When Joni invited her to be his teammate, Johanna thought, "I'm too tall and I'm ten kilos over forty-nine kilos." But then, her weight might earn them a bigger prize: winners receive the woman's weight in beer. "We haven't practiced, and the race starts in two hours," she laughs. "We are just going to have fun."

Sanna Rantala and Markku Kemppainan, also born in Sonkajärvi, haven't been practicing either. They work for the municipality, which has entered a team of three men—two firemen plus Markku—to carry Sanna in a relay. Each man will have to chug a full bottle of beer before his successor can take off. Sanna, who does aerobics and dance, will have to be nimble; each of her partners will carry her a different way.

I ask the team to tell me about the Wife Carrying cartoon logo. "What's going on? What is the relationship between these people?" "The man is carrying a fat lady who is the boss," according to Sanna. "The man is carrying his wife. She's in charge. He's exhausted," Markku interprets.

Riitta Väisänen, twenty-one, who has studied music for twelve years, was promoted from festival balloon lady to festival violinist two years ago. She was recruited at the last minute in 2001 to be a "wife" for the relay race. "I was performing. One of the festival organizers, my friend Hannele, said, 'You want to be carried?' 'What? Why me? Okay, maybe. Let's go,' I said. Hannele brought me my violin every time we stopped, and while my last partner was hurrying to drink his beer, I played music. The TV people filmed it. Afterwards, they

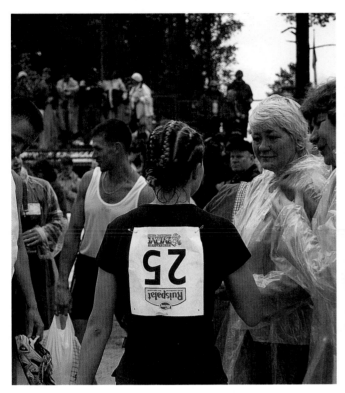

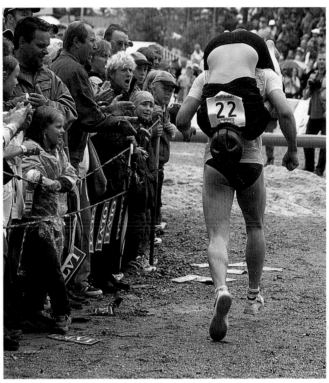

said, 'What were you doing?!' and I said, 'It was Finnish fun!' They said, 'You are crazy.'" But she concedes, "This is really a sport. While you are on the course, people are yelling and the atmosphere is fantastic. It's work. But fun work."

Michael Tohey, a housepainter, and Nicole Freese, a bartender, won the North American Wife Carrying Championship at Sunday River Resort in Maine a year ago, and although they set a new American record, neither is sanguine now. Michael worries, "This is the cream of the crop of wife carriers. We'll have to work out some signals so Nikki doesn't squeeze me too tight. My stomach is already too nervous." I ask whether the man's or woman's role is more important in this sport. Michael defines it as "collaboration. Definitely. She's fit and athletic. It takes real strength for her to keep from bouncing, to hold on. You'll see that. The winner will look like one unit running." Nicole, who's a college senior studying physical education, admits, "You have to be strong to do well. To hold still against your partner's body so he doesn't have to spend time, energy, or a moment's thought worrying about whether you'll fall off."

It's raining hard. Six thousand spectators—a thousand more than the town's population—huddle under umbrellas, their spirits undiminished by the downpour. Thirty-five couples have entered from Denmark, Estonia, Finland, Norway, Holland, the United States, and England. Competitors from different countries have perfected their own carrying styles. Finnish women ride piggyback. Danish women curl around their partner's necks. Estonian women ride inverted.

The Estonian women pin their race numbers upside down on their backs, knowing the numerals will read properly when they mount and press their noses to their partners' spines. They know it takes two to ten seconds to cross the water obstacle and promise themselves they won't slip off in the pond—and incur penalty points. They trust that their partners are tall enough to avoid dunking them, hoping that if they go underwater, they will be able either to wait to breathe or to crane their necks above the surface. It's actually not much wetter in the pool than out. It's pouring.

Two by two, the couples tear away from the starting line and enter the pond so fast that sheets of water spray up like transparent wings. They lunge through the pool (a hole in the ground lined with plastic and filled with fifty-five thousand gallons of water) then race through the trees while the crowd screams. Two more obstacles to go: the hurdles (a fairly high wood barrier that stretches across the width of the track and brings every couple to a full stop), then a bed of deep sand that defies the need for traction in the final stretch.

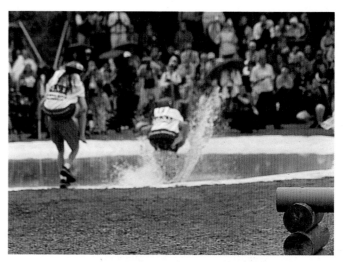

Estonians, who have won for the past five years and hold the world's record of 55.5 seconds, take both first and third place. First prize winner Anna Zilberberg, Meelis Tammre's "wife," confesses to weighing forty-six kilos under normal conditions, but stoking up on chocolate, today she weighed in at forty-nine kilos. Heidi Yliharju and Taisto Miettinen, the Finns who took second place, carried a one kilo weight to bring Heidi up to the required minimum. The third place winners: Jaanus and Anneli Undrest, who weighs fifty-two kilos.

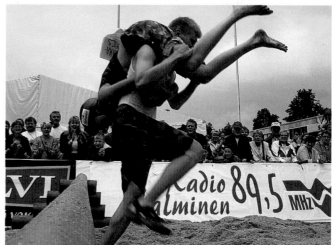

David White, a spindly photographer from England's *Daily Mirror*, decided at the last minute to carry Jane, his reporter wife. "We're probably the only ones where the runner weighs less than the wife." He falls exhausted at the finish line, sleeps through the press conference, and awakens just in time to watch the award ceremonies. As the winning runners toss their partners to their shoulders and enter the winners' circle, David gasps enviously, "How do they do that? I can't even lift my camera." Riitta had it right: "It's the women who enjoy this competition. The men get too tired."

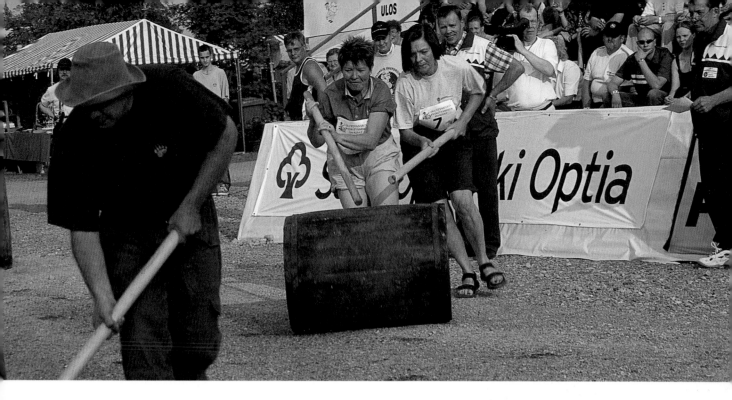

THE "LOUNGE ACT" FOR THE WORLD WIFE CARRYING CHAMPIONSHIP IS THE FINNISH BEER BARREL ROLLING CHAMPIONSHIP, WHICH OCCURS THE DAY BEFORE. DURING THE LATE NINETEENTH CENTURY TAR, BUTTER, AND BEER WERE SHIPPED IN BARRELS FROM THE NORTH SAVO DISTRICT. TODAY, COUPLES RACE USING METER-LONG WOODEN STICKS TO ROLL ONE HUNDRED SIXTY-LITER BEER BARRELS, TRYING TO GET THEM DOWN THE TRACK AND OVER THE BRIDGE—AND BACK—FAST.

Bridget Maasland, a television star from Amsterdam, travels the world doing local jobs to show viewers what life is like in other countries. Today, she spent the morning building barrels, then competed in the barrel roll, teamed with Finn Tero Maksimainen. She explains, "People used to roll barrels with their bare hands, which would be much easier. Our barrel fell into the water, a fifteen second penalty, and we had to put it back with our hands, another penalty—thirty seconds in all. Then you have to go through the water, which makes things very heavy—I was afraid my pants would stay in the water, get sucked in there! Maksimainen told me I was strong and fast, but it was tough, actually, even though it looks simple. We were seventh out of thirteen."

Bridget competed against the festival mascot, Eukko. In real life, Eukko is Tuula Isokytö, a local baker—president of the region's bakers association in fact—who lives in an octagonal house. Stuffed with pillows to look soft and cuddly, and made-up as a peasant woman, she remembers, "I had the idea of having a living Eukko three years ago to make the audience happy and cheerful, but I couldn't find anyone to play the role, so I do it." Not only does Tuula participate in the barrel rolling, she attends the festival dance ("I am very popular. The men want lipstick marks from my kisses.") and competes in the Wife Carrying Championships. "One year, the

Lonely Planet journalist volunteered to carry me but he couldn't make it to the end; I was too heavy and my clothes were full of water. So a local man took over. By the time we approached the finish line, the only thing that man could still carry was my purse!"

Only two women enter the barrel rolling as a team. The sisters, Tuija and Arja Rantalainen, forty-five and fifty-three, didn't grow up as athletes, but they have competed together in long-distance ski races and half marathons. They have never tried barrel racing and their only strategy is to wear rubber-soled shoes so they won't slip if they fall into the water as virtually everyone does. They emerge laughing and dripping. "Women should be encouraged to do these things, these sports. You can't make too much fun of yourself." The crowd roars as the emcee announces that they are the first all female team ever to compete in the Barrel Rolling Championships. Tuija and Arja make history in Sonkajärvi.

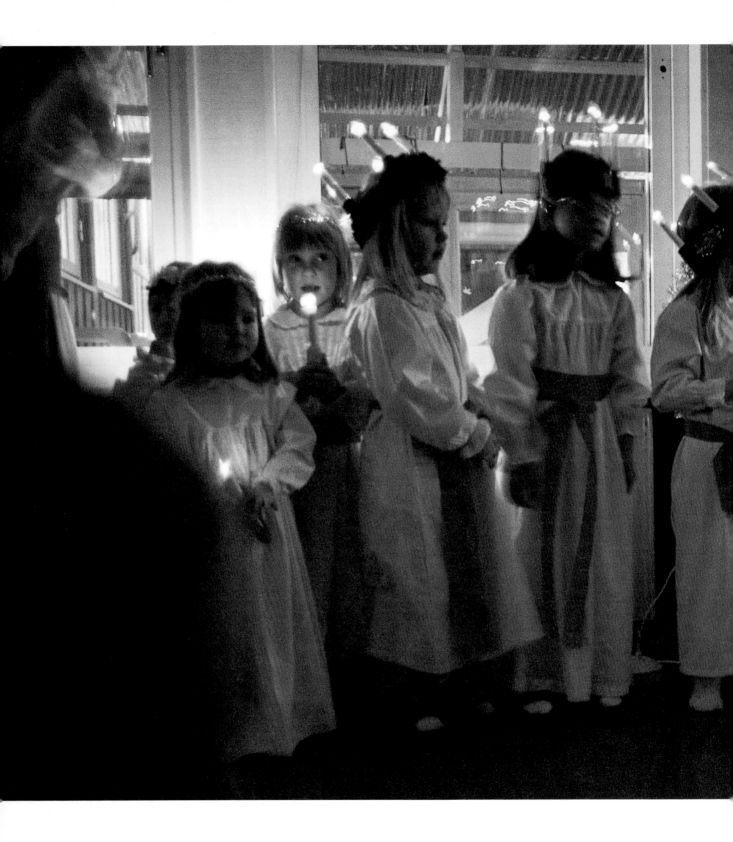

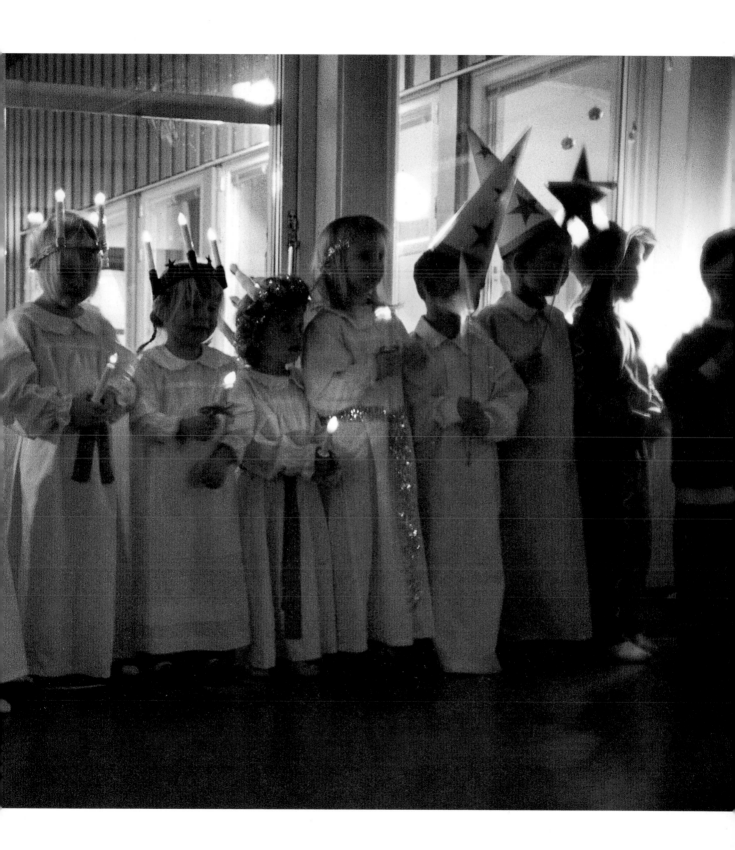

Night paces 'round our house and field,
Shadows press the earth,
By the sun abandoned.
There! In our darkened house
She comes with bright shining candles.
Sankta Lucia, Sankta Lucia.

The night was vast and mute.
Now hear in all our silent rooms
A flutter like rustling wings.
There she stands on our threshold
In white gown with lights in her hair.
Sankta Lucia, Sankta Lucia.

"Darkness soon shall take flight
From all the earth's valleys,"
This is her wonderful word to us.
"The day shall rise to shine in rosy skies."
Sankta Lucia, Sankta Lucia.
—TRANSLATION, BEVERLY ALLEN

SNOW BLANKETS THE DARK VILLAGE THREE HUNDRED FIFTY MILES
SOUTH OF THE ARCTIC CIRCLE. LANTERNS LIGHT THE PORCHES OF
THESE HOUSES THAT WERE BUILT A HUNDRED YEARS AGO. INSIDE,
WOMEN WEARING LONG DRESSES CREATE TREES OF BUTTER CURLS.
TRIANGLES OF ADVENT CANDLES REFLECT MOUNTAINS OF STARS IN THE
DOUBLE-PANED WINDOWS. OUTSIDE, COUPLES WARM THEIR MITTENED
HANDS OVER BONFIRES, THEN WALK THROUGH THE CANDLELIT STALLS,
THEIR BOOTS PRESSING FRAGRANCE FROM THE EVERGREEN BOUGHS
ON THE GROUND. THE SAAMI PEOPLE ARE SELLING LEATHER PINS
AND BARRETTES EMBROIDERED WITH FILIGREES OF SILVER THREAD.
HEART-SHAPED GINGERSNAPS TIED WITH RED RIBBONS HANG NEXT TO
CURTAINS OF CLOVE-COVERED LEMONS, ORANGES, AND LIMES. BUNDLED
VENDORS OFFER KNITTED GLOVES, FELT SLIPPERS AND HATS, TREE
ORNAMENTS, CHEESE, AND JAMS. ÖSTERSUND'S CHRISTMAS MARKET
AT JAMTLI IS ONE OF THE LARGEST IN SWEDEN.

Although it's as dark as midnight, it is actually three o'clock in the afternoon. A crowd gathers as eight young women come forward dressed in white. Sankta Lucia has been chosen by the citizens of Jämtland County. The finalists stand like angels with their hands held prayerfully, their heads bowed. Anna Sorensson, the millennium year Sankta Lucia, is about to crown the 2001 winner. Anna lifts a brass crown threaded with lingon berries—and fits it on Therese Haggman's head as people murmur in surprise, "A brunette Lucia!" Thump-thump-thump, hundreds applaud with gloved hands as Anna lights the five candles on the crown, and Therese and her attendants sing the lilting Sankta Lucia song. After the coronation, Lucia and her court collect coins from people who press near to donate money to the poor. Suddenly, the crowd divides and a huge, skittery brown horse pushes through pulling a sleigh, followed by another. Lucia and her attendants climb into the sledges and vanish across the snow.

ON DECEMBER 13, THERE ARE SANKTA LUCIAS IN ALMOST EVERY HOUSE IN SWEDEN. GIRLS WEARING WHITE DRESSES WITH RED SASHES AND CROWNS, AND BOYS DRESSED AS STAR BOYS WITH CONICAL HATS AND WANDS, WAKE THEIR PARENTS WITH COFFEE AND SAFFRON BUNS, CALLED LUCIA CATS.

The Swedish Institute, a government foundation that disseminates information about the country's cultural life, alleges that the Swedish Lutheran Sankta Lucia is not related to Santa Lucia of Syracuse, Sicily, who in the fourth century wore candles on her head as she walked through underground caves carrying food for starving Christians.

No, this Lucia originated in Germany. When the Reformation came to northern Europe, the adoration of saints was prohibited. The Germans replaced their favorite, Saint Nicholas, with the Christ child—and shifted the exchange of gifts from St. Nick's name day, December 6, to December 25. During the seventeenth and eighteenth centuries in Germany as well as in German-influenced areas of Sweden, the role of the Christ child was played by a girl dressed in a white tunic with a wreath of candles in her hair. This holiday spread throughout Sweden in the early twentieth century but was celebrated on December 13, a day when Swedes, since medieval times, had eaten as many as seven breakfasts to prepare themselves for the Christmas fast.

Not everybody accepts the Swedish Institute's history. Some suspect that the Sicilian Lucia came from Sicily to Sweden before she died in 304 A.D. Others link the holiday to the Viking goddess Freya, who drove a chariot pulled by cats—why else would those Lucia breakfast buns be called Lucia cats, *Lussekatter*? Some think Vikings brought back the tradition from the Mediterranean in the fifth century. Some argue that Winter Solstice undergirds Sankta Lucia. When the Gregorian calendar was adopted in 1300, the December 13 Winter Solstice slid to later in the month. Others claim the holiday was never pagan, saying that "Christian missionaries brought Lucia's stories to Sweden." Some people don't even think Lucia was a saint and tell about a terrible famine, during which a beautiful woman named Lucia, dressed in white and wearing a halo, sailed a ship full of food across Lake Vänern in southwest Sweden to nurture those who were starving. Others insist Lucia was associated with Lucifer and lived underground where she subdued the devil's cats (hence those Lucia cats). They believe that she, not Eve, was the first wife of Adam.

In Östersund, these theories are the last thing on anyone's mind. Every year, the population celebrates a Sankta Lucia who brings hope to their community and the world. And they celebrate her with profound joy.

"Lucia Day," Kerstin Englund says, "is even more important here than Christmas."

Above: Liana Hassan creates Lucia cats one afternoon with her twin, Roza, and her mother, Jelena.

LUSSEKATTER (SANKTA LUCIA BUNS)

1/4	TEASPOON SAFFRON THREADS
8	OZ (1 CUP) MILK
1	TABLESPOON YEAST
1/2	CUP SUGAR
4	OUNCES (1 STICK) BUTTER
5	CUPS ALL-PURPOSE FLOUR
1	TEASPOON SALT
1/2	CUP SUGAR
2	LARGE EGGS, BEATEN
1	BEATEN EGG WHITE FOR EGG WASH

Using a mortar and pestle, pound saffron threads to break down the strands • In a small saucepan, heat milk to lukewarm • Mix yeast with 1/4 cup milk and 1 tablespoon sugar • Set aside • On low heat, melt butter in saucepan with the rest of the milk • Add crushed saffron • Let cool • In large bowl, mix together flour, salt, and remaining sugar • Stir yeast mixture into cooled milk mixture • Mix in to dry ingredients, beating to mix well • Add beaten eggs • Knead in bowl for 5–7 minutes • Turn onto floured board and knead another 7–8 minutes • Put dough in lightly greased bowl, turn to coat all sides, cover, and put in warm, draft-free place to rise for about 1 hour • When dough has risen, knead lightly to push out air and divide into about 10–12 small pieces • Using the hands, roll each small piece into a strip about 8–10 inches long • Shape each strip into an S or a figure eight • Place on lightly buttered cookie sheets • Cover with clean cloth and let rise again until double in bulk, about 1–1 1/2 hours • Preheat oven to 375 degrees Fahrenheit • When dough has risen, brush lightly with egg white • Bake in preheated oven for 15 minutes or until lightly browned • Let cool on wire rack • Yields 10–12 buns.

—BY KERSTIN BERGSTROM (PROVIDED BY INMAMASKITCHEN.COM)

Above: Ruth Erikssonn bakes flatbread the traditional way.

SWEDISH COUPLES ENJOY VARIED LIVING ARRANGEMENTS, ALL SANC-
TIONED BY THE STATE. FOUR MILLION SWEDES ARE REGISTERED
AS *SAMBOER*, CO-INHABITANTS. UNMARRIED COUPLES WITH CHILDREN
ARE CATEGORIZED AS *TRULOVEN*.

Others, like Jelena Zjeliabovskaia are *särbor*—married but living separately, at least for the time being. Jelena and her twins will occupy her modern house in Östersund until the girls finish the school year. Then they will join Jelena's new husband in his one hundred fifty–year-old house in a nearby village.

Jelena introduces her ten-year-old daughters, Roza and Liana, to the traditions of their complex cultural legacy. Their father was a Kurd from Iran, Jelena was born in Moscow, and their stepfather is Swedish.

This afternoon, the girls and I learn how to make Sankta Lucia buns while Kerstin Englund, my interpreter/guide, and my friend Beverly Allen cheer us on.

Every woman in Sweden must be cooking today. Kerstin invites Beverly and me to join her, her mother, Ruth, and her aunt, Märit Antonsson, to cook flatbread at a neighbor's house in Hara, a village near Östersund.

Kerstin's friend's house was built in 1895. We work in the kitchen building, which has a wall-sized oven heated by firewood. Ruth uses a long-handled wooden paddle to slide thin circles of dough towards the heat. When the crispy bread has cooled, Kerstin folds it into delicious snacks. We return to Kerstin's farmhouse for a holiday supper. As in other homes and offices we've visited, every room is lit with tiny halogen bulbs, small lamps and candles that create just enough illumination to make the rooms cozy, yet keep the corners dark enough that people can relax.

Even Swedish horses get holiday treats. Kerstin's husband, Per, takes us to the barn to meet his five mares: tall, long-coated muscular horses. When he offers the powerful two-year-old, Hara Snowrace, a sugar cube from his own lips, the animal nibbles it gently away, never nipping.

We ourselves relish course after traditional course. Beets, apples, horseradish, and sour cream are mixed with shredded carrots. Boiled potatoes, *lutfisk* (dried ling), and sauce. Swedish meatballs, veal gelatin, and a special almond custard that was made with the first milk given by a cow after it had birthed a calf.

Ruth moved to Hara sixty-two years ago, one year after the Sankta Lucia festival began in Jämtland County. Her favorite celebration happened in the 1940s when Lucia and her attendants would carry torches and walk behind horses, stopping at hospitals and military barracks.

Ruth, Kerstin, and Beverly sit at the table drinking coffee and singing Lucia songs in Swedish for an hour after dinner. Then Kerstin and Ruth accompany Beverly and me to our car, which is parked beyond the pool of light that surrounds the house.

Suddenly, we hear horses galloping and whinnying in the impenetrable darkness. Have Kerstin's mares escaped? Are there horses in the field across the road? There is no moon or movement. Robbed of depth perception and orientation, I can neither see nor sense things; reality is distorted. Kerstin describes Winter Solstice not as "the longest night," but as "the darkest night."

By law, cars must use headlights twenty-four hours a day. Ruth, who is seventy-eight, straps reflective bands on her arms and legs and strides into the cold blackness toward home.

FIVE BABY CARRIAGES, EACH LINED WITH SHEEPSKIN, ARE PARALLEL-PARKED IN FRONT OF A LOG HOUSE THAT WAS BUILT IN 1750 BUT IS NOW A SCHOOL ESTABLISHED BY THE JAMTLI MUSEUM AND THE ÖSTERSUND COMMUNITY. ANY PARENT WITH CHILDREN YOUNGER THAN SIX CAN BRING THEM HERE TWO MORNINGS A WEEK FOR FREE. THE CITY'S PRESCHOOL AND ELEMENTARY TEACHERS CAN BRING WHOLE CLASSES. THE ROOMS ARE FURNISHED LIKE AN 1890S FARMHOUSE—A DOUBLE-DECKER BED WITH A FUR BLANKET, A WOODEN CRADLE, A SMALL, BLACK STOVE WITH A WOOD FIRE, AND A DECORATED CHRISTMAS TREE HANGING FROM THE CEILING, WHICH IS WHERE PEOPLE USED TO PUT THEIR TREES SINCE FLOORSPACE WAS LIMITED.

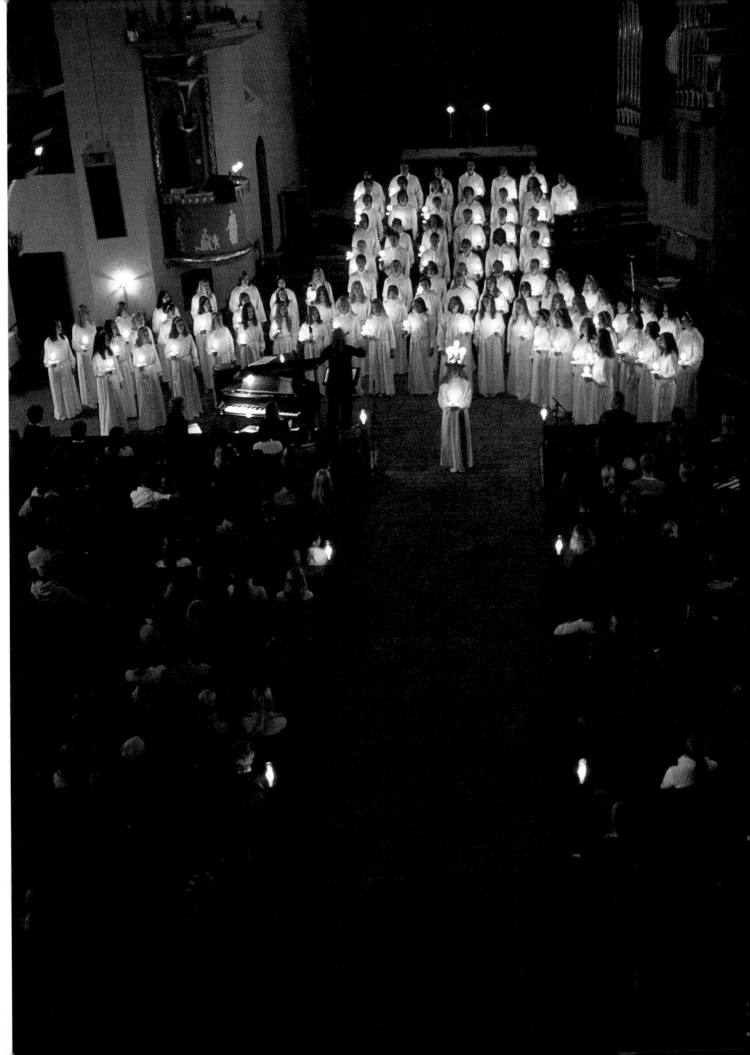

BEVERLY, A PROFESSOR AT GÖTEBORG UNIVERSITY THIS YEAR, FLEW NORTH TO ÖSTERSUND TO INTRODUCE ME TO KERSTIN, ENJOY THE FESTIVAL, AND SHARE HER UNDERSTANDING OF LUCIA, WHICH ARISES FROM HER SCHOLARSHIP IN ITALIAN LITERATURE, HER EXPERTISE IN WOMEN'S STUDIES, AND HER LIFE AS A SWEDISH-AMERICAN.

"In the fourth century in Sicily, there was a young woman, Lucia, whose mother, Agnese, was seriously ill. Lucia prayed to God to heal her mother and vowed her chastity to Him if her mother got well.

"Lucia was being pursued by a pagan Roman proconsul named Pascasius but, because of her vow, she would have nothing to do with him. He sent her poems that praised her beauty, especially her eyes. (When Italian poetry began at the court of Frederick II during the eleventh century in Sicily, eyes were described as the passageway of love, carrying the beloved's image from the outside world to the heart.) Pascasius wrote that he wanted to possess Lucia's eyes, and legend has it that, when she read this, she plucked out her eyes and sent them to him on a silver platter—literally satisfying his request although it had been metaphorical. Furious at her rejection, he had her arrested and tortured to death.

"Her remains are in the Church of Santa Lucia in Venice. She became the patron saint of those with troubled vision. Statues and iconography in Italy show her holding a platter with two eyeballs on it; paradoxically, however, she is always very beautiful and has eyes in her head as well.

"Sweden was the last country in Europe to be converted to Christianity. When the monks came in the tenth and eleventh centuries, Santa Lucia's feast day, December 13, was already an established feast day in the Catholic Church.

"From what I know about the meeting of cultures in other places, I believe the Swedes adapted their Winter Solstice festival to Santa Lucia Day. After the solstice, days grow longer. Light and hope return to the earth.

"Neoplatonism came to Sweden from Europe in the 1600s and 1700s, and that philosophy equates lightness with good and darkness with evil, but my guess is that, for the pagans, the return of light meant the coming renewal of the dead earth, the hope that crops would grow again.

"We're very far north. Light is simply the most important thing as December draws to a close because there is so little of it. When light comes for a couple of hours at midday, the zenith of the sun may be twenty-five degrees above the horizon. If there are no clouds, the light can be brilliant. But the long shadows are not like dusk anywhere else. And the darkness is deeper than any I've seen; it takes on a peculiar quality, like tar.

"Lucia's virginity probably had particularly symbolic appeal back when pagan and Christian beliefs were first combined. The red sash Lucia wears may be the vestigial symbol for sacrificial blood—pagans honored the god Odin with sacrifices in sacred groves, although they did not use knives. Or perhaps the red represents menstruation.

"What Lucia symbolizes in this culture is moral fortitude. Moral fortitude here is not a Mediterranean sense of purity; for Swedish women today, virginity matters not at all. Being upright is all about helping each other. The ideal Swedish woman is willing to help others over and over.

"When I was a little girl, I learned about Lucia in our Swedish community in Oakland, California. I learned to love this tradition because of its beauty, simplicity, and meditative tone. Lucia is a happy coincidence of Italian and Swedish, the two cultures most dear to my heart."

Before she was crowned, Anna taught business administration at Mitthögskolan University in Östersund and used her spare time for skiing and mountain biking. Eight months after her reign, she interrupted her studies as a law student at Stockholm University to become an advisor to a Swedish member of the EU parliament in Brussels. She is visiting her hometown this week to crown her successor and escort the 2001 winners through their hectic calendar of appearances.

"Most county winners are eighteen, but I was twenty-three—a grandma!" she laughs. "Maybe one hundred or one hundred fifty women apply to the local newspaper to become Lucia, and thirty or forty finalists are chosen, mostly on looks. The finalists spend several weekends modeling outfits from a local department store and collecting money for the poor people who would have no Christmas presents or even shoes. Then there is an onstage interview. Everywhere you go, people are voting for Lucia. Then the department store, the newspaper, and Knights of Templar select Lucia and her seven attendants.

"You are supposed to stay at home between 4:30 and 5:30 one afternoon so the newspaper can photograph you if you win. But I biked into town to buy gift wrap for Christmas presents and returned to find everyone waiting on my doorstep!

"I was crowned in the Big Church. Every day for a week after that, we got up at 6 A.M. and there was something every minute. One day—the hospital, all thirteen floors, every room, every door. You're so tired of the Lucia song you want to puke," she laughs, recounting how the young women sing hour after hour at schools, corporate offices, hospitals, and elder care facilities. "We visited hospice care—people dying of cancer. We just sang in the corridors because they were too sick for visits but they wanted to hear the music for the last time."

Later, I discover that Anna and her court were criticized for acting "too human" while visiting hospital patients. "Lucia is supposed to be like an angel, heavenly, untouchable. But to be distant would be rude. If someone was crying, we stayed with them and held their hands and waved at them as we left. They were lying in bed waving back, so happy."

"Right before I became Lucia, my grandfather had a bad fall in the kitchen. I was so busy during Lucia week that no one told me. So I came into one of the hospital rooms, and there was an old man who looked like my grandfather sitting in bed. He died this autumn, but you couldn't mention Lucia without his crying because he was so proud.

"In one private nursing home, an old man had written a speech for Lucia. He wanted to stand but he was in a wheelchair and he would have landed on his knees if he'd tried. His nurse held him up while he spoke to us, 'I'm sorry I cannot stand up like a gentleman. I probably won't live until next year, so I am happy that Lucia took the time to come.'

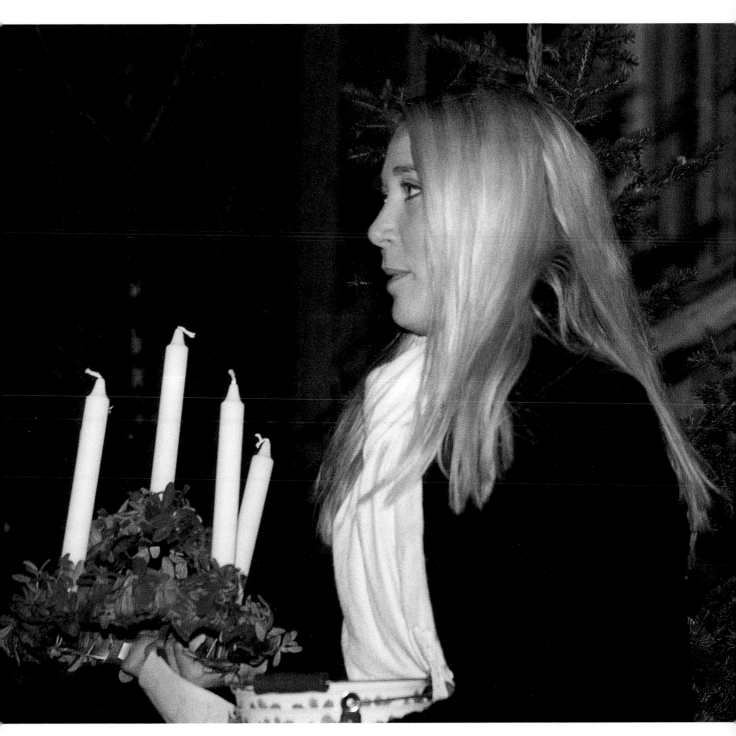

"THEY SAY LUCIA COMES TO SPREAD THE LIGHT. THAT'S TRUE. IF SOMEONE TAKES TIME TO VISIT PEOPLE, IT MAKES A DIFFERENCE. IT WAS REALLY NICE TO BE LUCIA," ANNA SMILES, "IT WAS ABOUT BEING KIND."

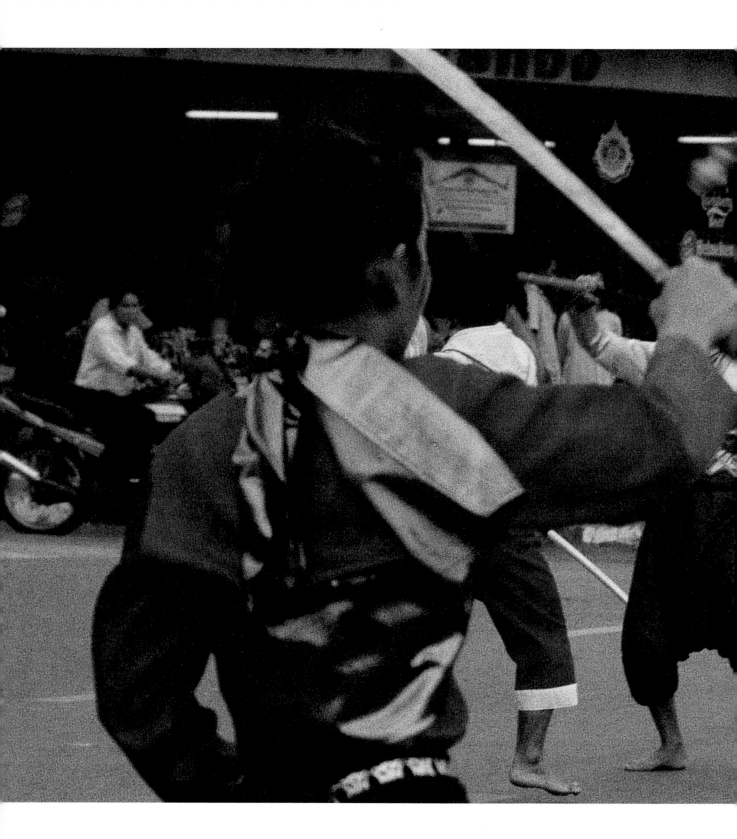

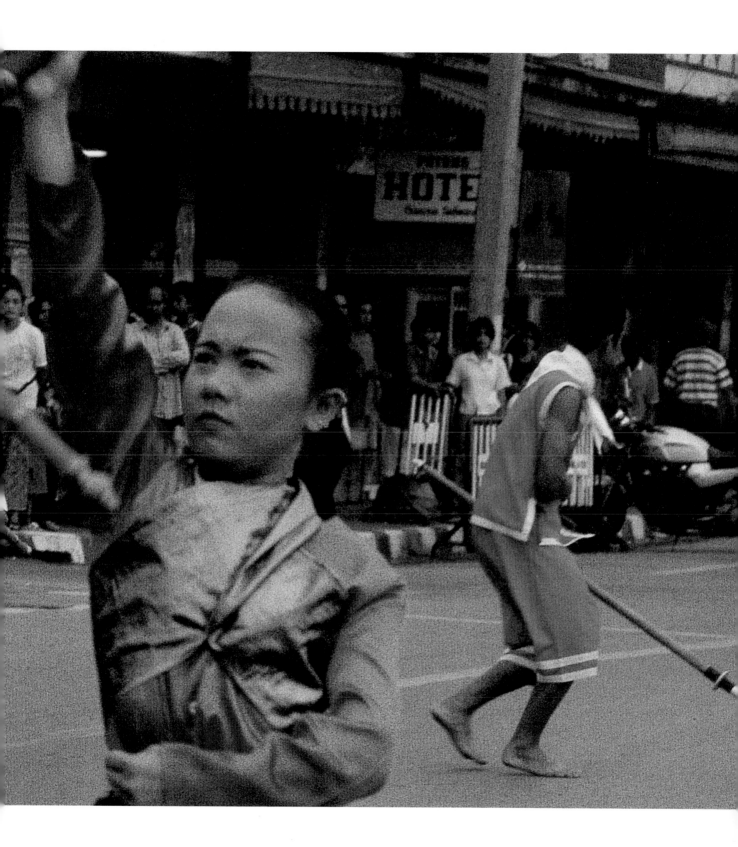

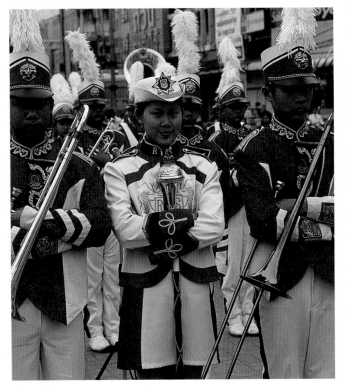

Ya Mo used the women's charm to kill the Laotians....
Used her brain as a weapon....
Very brave. Very clever.
The next generation will be safe forever.
The next generation will be safe forever.

Thai women are brave;
They fight without fear.
People will know our names everywhere.
One hand rocks the cradle, the other holds the sword.
One hand rocks the cradle, the other holds the sword.
—VICTORIES OF TUNG SAMRIT

THIS HUGE PROVINCIAL CAPITAL WOULDN'T EXIST WITHOUT YA MO, THE CITY'S SAVIOR WHO WAS LATER TITLED THAO SURANARI.

Almost two hundred years ago, the men of Thailand's Nakhon Ratchasima province left their capital unguarded when they marched with their troops to Nakon Kukaan to clear riots and calm civil conflict.

Laos was part of Thailand at that time, but its king, Anuwong, lusted for independence. Anuwong's men swept down from the north and captured the remaining citizens in Nakhon Ratchasima.

When the governor's wife escaped, the next most senior person among the captives, the deputy governor's wife, took charge. Named Mo—there were no last names in Thailand until 1909—and nicknamed Ya Mo (*ya* means "grandmother;" she was fifty-five), this woman defied destiny.

The Laotians imprisoned the city's men on the far side of the Mun River and, to separate the sexes and prevent collusion, set out to take the women to the barren, country region, Tung Samrit.

Every day as the women marched farther into the countryside, Ya Mo cunningly offered the Laotians new directions, creating a "long cut" to Tung Samrit, buying time in hopes that the provincial army would return and rescue them. During the sweltering days, the prisoners and their captors zigzagged over a distance that should have been a two-day walk. During the evenings, the women charmed the enemy.

A Thai poem describes their strategy: "They told the Laotians they were tired. / 'Let's stop here and we'll give you good food and drink. / We will massage and entertain you. / No need to hurry. / We will sing for you. / Just one night. / Wait until the sun rises.'"

On March 23, when they arrived at Tung Samrit, the women tricked the soldiers into relinquishing their swords so the women could "kill animals and cook a great feast" in their honor. They seduced the men to distract them and gave them so much to drink that they were incapable of self-defense. They decapitated the soldiers, threw the heads in a pond, and went home.

Previous pages: Teenagers perform sword dancing demonstrations—the girls vanquish their opponents and the performance ends with the boys crumpled in the street.
Above: Eleven hundred children perform in the bands that march in the festival's opening ceremony.

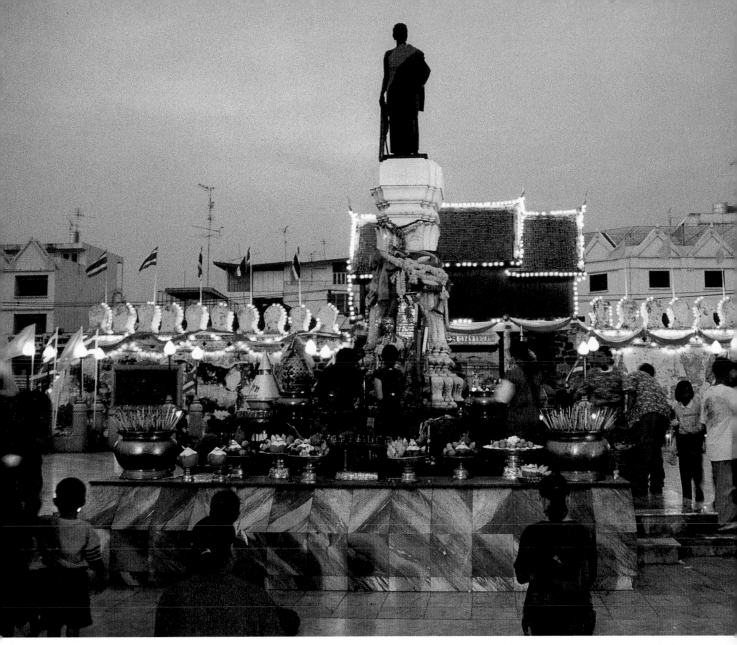

THAILAND'S KING RAMA III REWARDED YA MO WITH SILVER—SHINING URNS, ENGRAVED TEA SETS, FILIGREED TRAYS, EMBOSSED BOXES, POLISHED VASES. HE GAVE HER THE HONORIFIC THAO SURANARI, WHICH MEANS "BRAVE WOMAN." NAKHON RATCHASIMA BECAME FAMOUS AS "THE CITY OF BRAVE WOMEN." THE POND AT TUNG SAMRIT IS CONSIDERED SACRED TODAY. VILLAGERS WHO LIVE NEARBY OFTEN SEE APPARITIONS ON FOGGY MORNINGS: THE LAOTIAN ARMY MARCHING A FEW FEET OFF THE GROUND, WEARING THEIR ANCIENT UNIFORMS. EVERY YEAR IN MARCH, NAKHON RATCHASIMA EXPLODES FOR TEN DAYS WITH CEREMONIES, PARADES, PERFORMANCES, AND CONTESTS THAT HONOR THE CITY'S COURAGEOUS DAUGHTER AND HEROINE, THAO SURANARI.

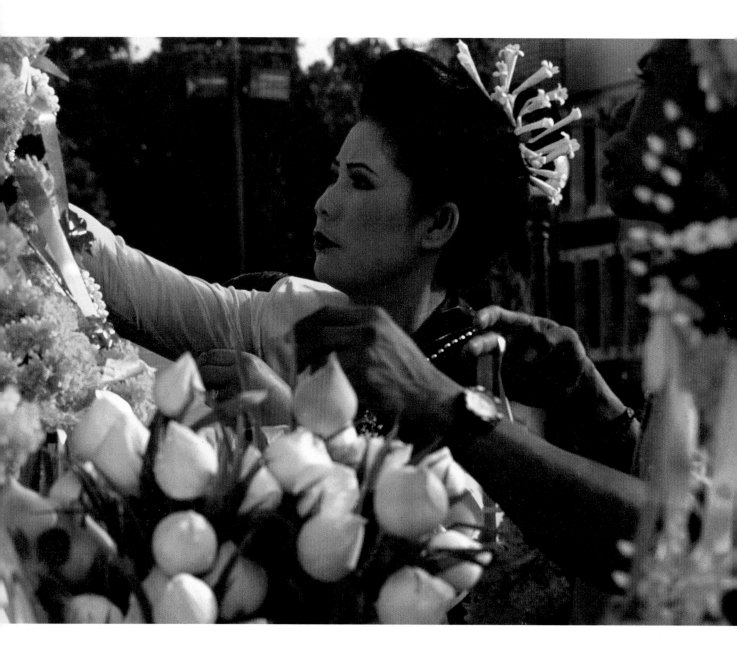

An elegant woman who speaks perfect English invites me to sit with them. Certainly my appearance doesn't merit the invitation: a long cotton skirt, T-shirt, and waist-pack bulging with lenses and film. Maybe she asks because I am the only foreign visitor, I have grey hair, it is too hot to stand up, or because Thai hospitality is resolute. The matrons smile as a breeze begins to blow. We are grateful for the relief.

Performers wearing purple and yellow silk costumes sing, "Our grandmother saved us from suffering as slaves. The victory of Ya Mo will be remembered in our hearts....She was not afraid of men.... On her anniversary, we respect her, we salute her."

They kneel in the street to face the statue of Ya Mo, which is banked with lotus buds, offerings, and incense. Impervious to the smattering of raindrops, the dancers sway their arms above their heads, then create butterflies with their graceful hands.

I was told that it rains every year during the opening ceremony. But there has been drought for eight weeks so I left my umbrella in the hotel. The storm gathers force. "A miracle!" people shout. "Sacred rain!" The devout unfurl their umbrellas. The dancers' outfits are saturated and turn dark. Torrents make the world invisible; I remove my streaming glasses and try to continue photographing, but moving becomes impossible. My soggy skirt continually trips me and I slide off my sandals. Worried that my camera's electronics may be ruined for the ten-day festival ahead, I wrap my equipment in a plastic bag offered by a flower vendor and give up.

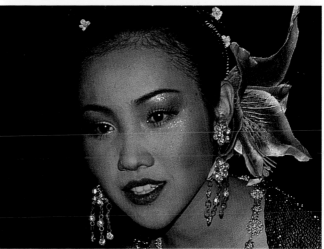

Later, I meet Tiyaphan Praphanvitaya who composed the song, choreographed the dance, coached the performers for eleven weeks, and designed the costumes that were inspired by carvings at the ancient Khmer ruins nearby.

I ask whether any of the women hesitated to submerge themselves in the water. "Oh, no," she responds in surprise, "It was their honor."

The dancers continue their blissful tribute to Thao Suranari. The women's dance will end in an obeisance: they must prostrate themselves in the street where rainwater now overflows the curbings. Not a single dancer balks. They lie face down to salute the statue of Thao Suranari.

I decide to take the public's pulse. My microphone identifies me as a member of the press so people agree to talk with me before they approach the statue of Thao Suranari where other pilgrims kneel, light incense, and pray.

A toothless eighty-one–year-old woman considers Ya Mo a goddess:
"She grants every wish. I ask for good health and long life."
A middle aged woman says,
"She was successful in battle. A goddess. My son would like to be such a good soldier."
Next, a young entrepreneur confesses,
"I come here to ask the goddess whenever I need something, not just during the festival. She gives me business success."
Yet another woman tells me,
"I had many problems in my life and marriage. I prayed to the goddess one evening and the next day I felt as if a great weight lifted from me."

Government officials and Thao Suranari's own family disagree vehemently on whether this woman was a goddess. They have ample evidence that Ya Mo was a real person. Furthermore, they point out, Buddhists do not worship goddesses.

Nevertheless, this impressive heroine, like the Western Joan of Arc, is celebrated by local people as if she were a goddess. Whether anyone approves or not.

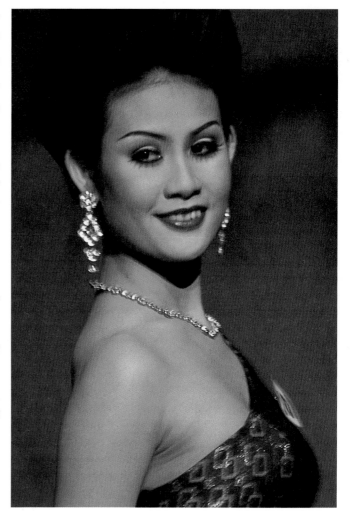

"ONE HAND ROCKS THE CRADLE, THE OTHER HOLDS THE SWORD," THE "VICTORIES" MUSIC POUNDS AT TOP VOLUME AT THE MISS NAKHON RATCHASIMA FINALS WHILE A VIDEO, PROJECTED ON A WALL-SIZED SCREEN, REVEALS CONTESTANTS CLIMBING WALLS, RAPPELLING, AND PARA-CHUTING. FOR A MONTH BEFORE THE PAGEANT, THE EIGHTEEN COMPETITORS HAVE TRAINED TOGETHER, DOING FITNESS EXERCISES AT THE NEARBY AIR FORCE BASE. JETS BLAST OFF FROM THERE AND FLY IN FORMATION OVER THE CITY SEVERAL TIMES A DAY.

During the Vietnam War, an important American post was also located near Nakhon Ratchasima. My interpreter ventures that this is the reason many of Thailand's tall, good-looking rock singers, movies stars, and beauty contestants are Amer-Asian.

The Miss Nakhon Ratchasima contestants model clothing made entirely of Thai silk, sometimes appearing in matched groups of apricot, red, green, or aqua, sometimes appearing in traditional Thai costumes, sometimes in evening clothes.

The three finalists answer the same questions, including "What do you think of women's rights?" Nusara Mromprasert, who takes first place, stands gracefully on her towering, transparent high heels and answers, "Women can do what men can do. Sometimes, they do it better."

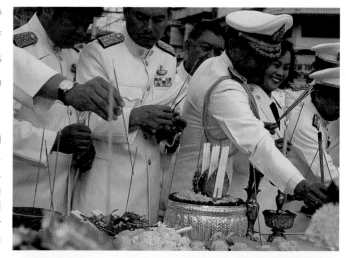

Lua, a neighbor whom Ya Mo loved as if she were a niece, had long black hair and wore her halter and gathered pants with style. She pretended to be infatuated with the most senior Laotian officer, Pear Ram Picha. On the night of March 23, 1826 Lua was flirting with him at the edge of the encampment that was barricaded with ammunition carts. When she ignited the nearest cart with her torch, forty-nine others exploded, killing them both, destroying the enemy's arsenal as well as their leader.

After Lua became a martyr, the honorific Boon, which means "merit," was added to her given name. The Boonlua Wittanusion School honors her.

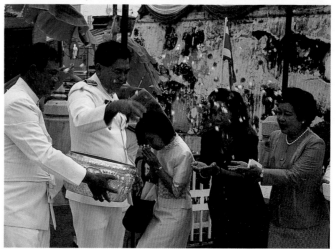

In 1986, helium balloons lifted the red veils that concealed the school's new statue of Boonlua. Since then, every March 4 two thousand students create a solemn ceremony in her honor, all wearing new clothes and offering wreaths, food, candles, and incense.

Mrs. Prapason Kewtrairat, the English teacher, describes how every school day begins with a campuswide broadcast of the marching song, "Victories of Tung Samrit," which the school's second director commissioned for the students to sing. Its beat is infectious and I have heard the music often: "One hand rocks the cradle, the other holds the sword."

"How do the boys feel about Thao Suranari?" I wonder. "They appreciate that, in her husband's absence, it was her role to assume the responsibility."

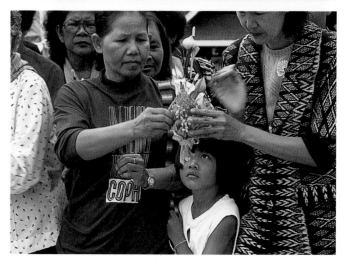

"For teenagers, 1826 must seem like ancient history," I venture, amazed at the currency these events hold. "Today, Thailand is peaceful," the director muses, "But given a chance, today's women would behave bravely, too."

NINETY-NINE PERCENT OF THAILAND'S POPULATION IS BUDDHIST, BUT THE KHMERS WHO ORIGINALLY INHABITED THIS AREA COMBINED HINDU AND BUDDHIST BELIEFS, SO PRIESTS HAVE BEEN IMPORTED FROM BANGKOK TO CONDUCT A HINDU SERVICE.

AS THE SUN RISES, WOMEN SET A TABLE WITH BRASS PLATES AND SILVER TUREENS. THEY CREATE ARTFUL ARRANGEMENTS OF COCONUTS, GRAPES, WATERMELONS, PAPAYAS, KUMQUATS, AND MANGOS. OTHER WOMEN BRING CONTAINERS OF PRAWNS, EEL, A PIG'S HEAD, A WHOLE DUCK. STILL OTHERS SET OUT PLATTERS OF HARD-BOILED EGGS, RICE, AND BETEL NUT WITH TOBACCO.

THAO SURANARI IS WORSHIPPED BY THE HINDUS AS A GODDESS. THE PRIESTS BLOW CONCH SHELLS, PUT SMOKING INCENSE STICKS IN THE OFFERINGS ON THE TABLE, AND PASS CANDLES DECORATED WITH ROSES SO EACH WORSHIPER CAN TRACE A CIRCLE IN THE AIR WITH THE FLAME. A PRIEST SHOWERS DEVOTEES WITH FLOWER PETALS FROM A SILVER BOWL. AS HE STRIKES THE FINAL GONG, THE CROWD SURGES FORWARD TO CONSUME THE BLESSED FOOD.

THE FINE PRINT ON THE GOVERNOR'S ENGRAVED INVITATION TO THE FASHION SHOW SAYS "WEAR SILK." QUICKLY, I PURCHASE A BLACK, THAI SILK JACKET TO GO WITH MY BLACK, CHINESE SILK SKIRT.

Krit, my interpreter, stops me as I step off the elevator, "Black is bad luck here; we wear it only for funerals." I run into the lobby shop, buy a silk scarf patterned with shocking pink and turquoise elephants and hope it makes me look jolly enough.

I've met the letter, but not the spirit, of the invitation. Guests arrive in formal evening garb; diamonds, rubies, and emeralds are embedded in earrings, necklaces, bracelets, rings. The event is a fundraiser for the Red Cross held in a shopping mall auditorium, but everyone looks as if they are going to the Oscars. Many couples wear matching silk outfits, both in lavender, or in flame red. Little girls and old women alike are gussied up.

Once in the door, everyone stands in line holding places so their friends can visit the buffet to fill plates with finger sandwiches and éclairs, and eat while they wait. And wait. I stroll to the front of the line to investigate what they are waiting for.

Portrait photographers have set up living room furniture scenes complete with studio lighting. Before posing in their elegant evening-wear, the women visit cosmetician booths to have their makeup touched up—their shine powdered off, their cheeks blushed, their lipstick refreshed.

Then the same women walk across the stage to show off their finery. They parade, preen, and pose, each competing to be acknowledged as the most beautiful, the most glamorous of all.

THE GATE IS ALMOST HIDDEN BY STALLS AND STORES WHOSE MER-CHANDISE SPILLS ONTO THE SIDEWALK—BROOMS, CAGES OF BIRDS, AND MANGO CLIPPERS.

I slip through, into a cloistered garden. Above the small, well-kept house, a mango tree's branches spread wide. Mysteriously, every ripening fruit is protected by a clear plastic bag.

Ladavan Vannaburana is descended from Thao Suranari's sister, although five generations separate them. She is old now, dignified, and dressed in grey. Between a Kit Kat clock and a Chinese plate in her cabinet, there is a postcard of the Thao Suranari statue.

Although Ladavan now sits on the Thao Suranari Foundation board, she claims she didn't give much thought to her ancestress until about twenty years ago, when a friend told her that Ya Mo had appeared to him during a meditation and asked him to confirm that the silver King Rama III gave her was all right. Ladavan's inheritance is locked in a bank vault but she shows me photographs of the silver teapot and cups on a shiny serving tray, part of the king's reward to Ya Mo.

Ladavan's picture frames are enclosed in saran wrap. Her linen din-ing room tablecloth is covered with clear vinyl and each silk rose in the vase nests in a cornucopia of transparent plastic. I remember the mangos in baggies outside; this woman is a careful preserver of valuable things.

Later, as she escorts me to the gate, Ladavan points out the location where Thao Suranari lived until her marriage. Her mud house and others like it were condemned due to an infestation of rats that could carry plagues. Ladavan frets, remembering the day the structure was destroyed, "What was I to do?"

Before we part, Ladavan, a retired kindergarten teacher, stops for a minute to confide, "I taught the children about Ya Mo. And I learned the other day that one of my students has dedicated a room in her house to Thao Suranari. She wants to grow up to be just like her: brave and courageous."

Thanks to Ladavan, Thao Suranari's legacy of history, stories, and silver are safe.

Opposite: Thao Suranari died when she was eighty-one. Her ashes now rest in a monument that seems to float above a lake near this quiet Buddhist chapel.

As he comes through the door, I extend my hand and try not to sound annoyed. "Good morning, I am Paola Gianturco and I would like to interview you for a book." "Of course," he responds in English with no accent at all, smiling, "I have been looking forward to welcoming you. Come with me to my meeting." "Where did you learn to speak such excellent English?" I ask in astonishment as I lope down the hall at his side. He smiles, "I went to school in Lawrence, Kansas."

Fifty people sit at desks arranged like the United Nations General Assembly. My chair is between the governor and the mayor. I have no idea who the people in the room could be. The governor explains to them that he didn't have time for an interview before, and intends to do it now.

This is news. I fumble, hurriedly assembling my minidisk recorder while assistants put place mats in front of the governor, mayor, and me, then serve tea and sticky rice. I don't know whether this is a snack or a first course, can't imagine a meal at 9:30 A.M., and have no idea what etiquette is required to consume sticky rice. I glance over my shoulder at my interpreter, Krit, and mimic his manners: the fork scoops the glutinous mass into the spoon. Nobody else has food—the anonymous group watches silently while we eat. Members of the press are taking notes and the television cameras are whirring. The governor asks me to describe my book.

I acknowledge that most nations are not like Thailand, where the 1997 constitution guarantees that women are equal to men. "I offer you my book as a way to teach people all over the world about Thao Suranari," I say. "What would you like them to know?"

The governor responds, "Thao Suranari and her bravery will always be remembered and honored in the capital of this province."

Indeed, already her name is on the lake, the conference center, the college, the ballroom at the Royal Princess Hotel. There is a Thao Suranari Industrial Zone. Suranari Ratchasima is even the name of a country music star.

But there is more to come. A local monk, Luang Por Koon, has offered to finance a movie about Thao Suranari. Provincial officials are conducting historical research for the script, and the governor sends me off with them.

Deputy Governor Pracha Chitsuthipol escorts me to his office. He holds the same title that Ya Mo's husband, Thong Kum, held almost two hundred years ago. Pracha and the chief information officer, Suep Pong Kairerk, explain that Thao Suranari's story is not written in Thailand's historical documents, so they are using Laotian military records to piece together the details. Now, they spread thick volumes all over a long table. Suep Pong translates from Lao to Thai. Pracha and Krit translate from Thai to English.

The movie project has kindled a worrisome diplomatic controversy. The Laotians do not want it produced and their ambassador has filed an official complaint.

Those who oppose the movie are in the minority—there is avid interest in films about brave Thai women. In 2000, Queen Sirikit sponsored one titled *Suriyothai*, about a sixteenth-century queen who dressed in men's clothes to defend her country. It was the most expensive movie ever made in the kingdom, and it was hugely popular in and outside Thailand. "Is anyone considering making a movie about Thao Thepsati and her sister Thao Sisoonthon, who defended their city in the southern province, Phuket?" I ask. No one knows.

But when a movie about Thao Suranari comes to a theater near you, don't miss it!

STUBBORNNESS BROUGHT ME HERE. I WAS FASCINATED WITH THAO SURANARI WHOSE WARRIOR/STRATEGIST BEHAVIOR WAS SO DIFFERENT FROM THE WAY MY GENERATION OF AMERICAN WOMEN WERE ENCOURAGED TO ACT. I WAS DETERMINED TO VISIT, EVEN THOUGH FRIENDS ATTENDED THIS FESTIVAL A FEW YEARS AGO AND REPORTED, "IT'S NOT MUCH." NOW I KNOW WHY THEY DREW THAT CONCLUSION. IT'S A CHALLENGE TO LOCATE THE ONE LITTLE DESK IN CITY HALL THAT DISTRIBUTES FESTIVAL PROGRAMS—AND PROGRAMS ARE PUBLISHED EXCLU-SIVELY IN THAI. HOW COULD AMERICANS GUESS WHEN EVENTS OCCUR, MUCH LESS WHERE, IN THIS HUGE CITY THAT COVERS MORE LAND THAN ANY OTHER URBAN AREA EXCEPT BANGKOK?

Above: Competitions of every kind occur all over the city. Bodybuilders prepare to flex to music, their skin frosted with bronzer painted on by their mothers and girlfriends. Arm wrestling is a televised sport here—Srinuen, the country's superstar champion, challenges local contenders.

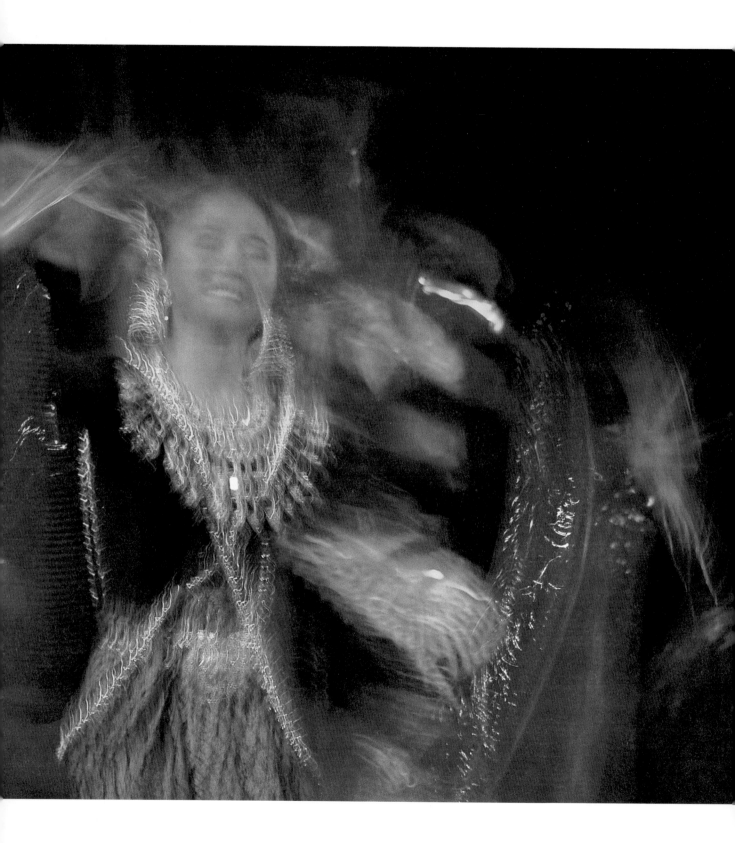

IT'S EASY ENOUGH TO FIND THE OPENING EVENTS. RELAY TEAMS RUN THROUGH THE STREETS WITH TORCHES THAT IGNITE FIREWORKS AT THE CITY GATES—THE FLASHING DISPLAY IS VISIBLE FOR MILES. NEAR THE STATUE OF THAO SURANARI THERE ARE MARCHING BANDS AND DANCERS PERFORMING IN THE STREETS, RELIGIOUS CEREMONIES, A NIGHT MARKET AND CARNIVAL.

BUT AFTER THAT, COMPETITIVE ACTIVITIES SPREAD TO VENUES ALL OVER THE CITY. THERE IS A HEALTHY BABY CONTEST AT THE HOSPITAL. THE MOST SKILLFUL SHARPSHOOTERS WIN PRIZES AT THE POLICE ACADEMY. AT THE SHOPPING MALLS THERE ARE BODYBUILDING COMPETITIONS, A THAI SILK FASHION SHOW, PING PONG AND *TAKRAW* PLAY-OFFS. THE SCHOOLS' SPORTS FIELDS HOST SOCCER MATCHES. JUDGES SELECT THE BEST HOMEGROWN, SEEMINGLY-PERFECT FLOWERS, FRUITS, AND VEGETABLES. IN THE EVENINGS, THERE ARE BEAUTY PAGEANTS PLUS SINGING AND DANCING COMPETITIONS.

The Thao Suranari statue is the scene of continuous action. Students pose for pictures on the steps of the monument, still wearing their graduation gowns and carrying armfuls of roses.

Food vendors sell fried worms, crispy scorpions, crackling-hot crickets, tiny pancakes, and taco-shaped pastries that fold over meringue.

Korat singers, whose performances Ya Mo loved in the nineteenth century, still hold forth inside the boxlike stage-on-stilts. On stage four men wearing lipstick earn money by singing thanks to Thao Suranari for granting a pilgrim's prayers.

Volunteers for the Thao Suranari Foundation sell replicas of the heroine's statue. Proceeds from the sales of souvenirs and festival tickets fund scholarships for the poor.

As I said, the Thao Suranari festival is the biggest event of the year in this provincial capital. Nothing else even comes close.

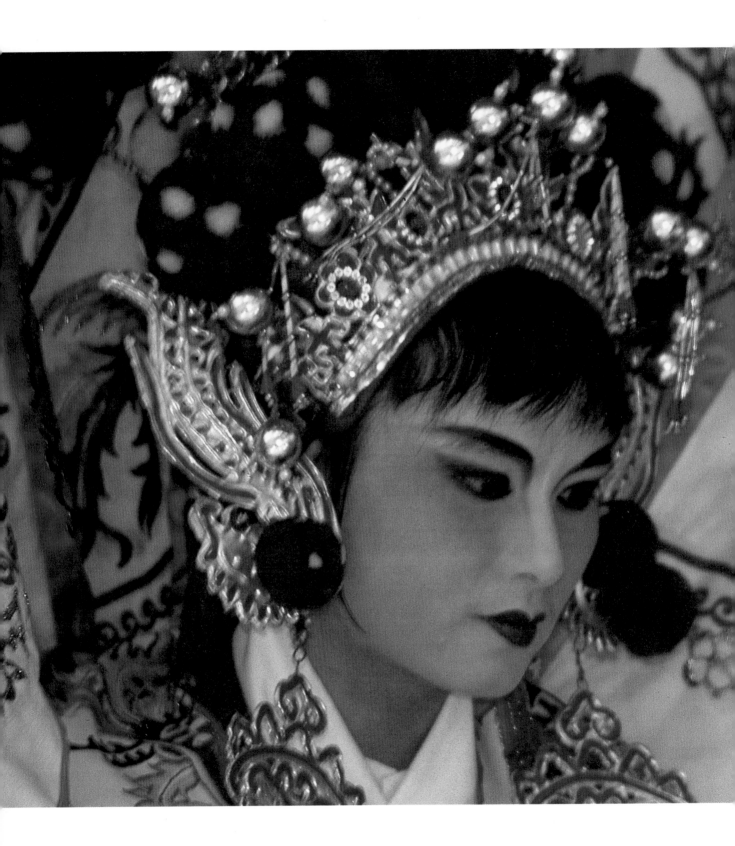

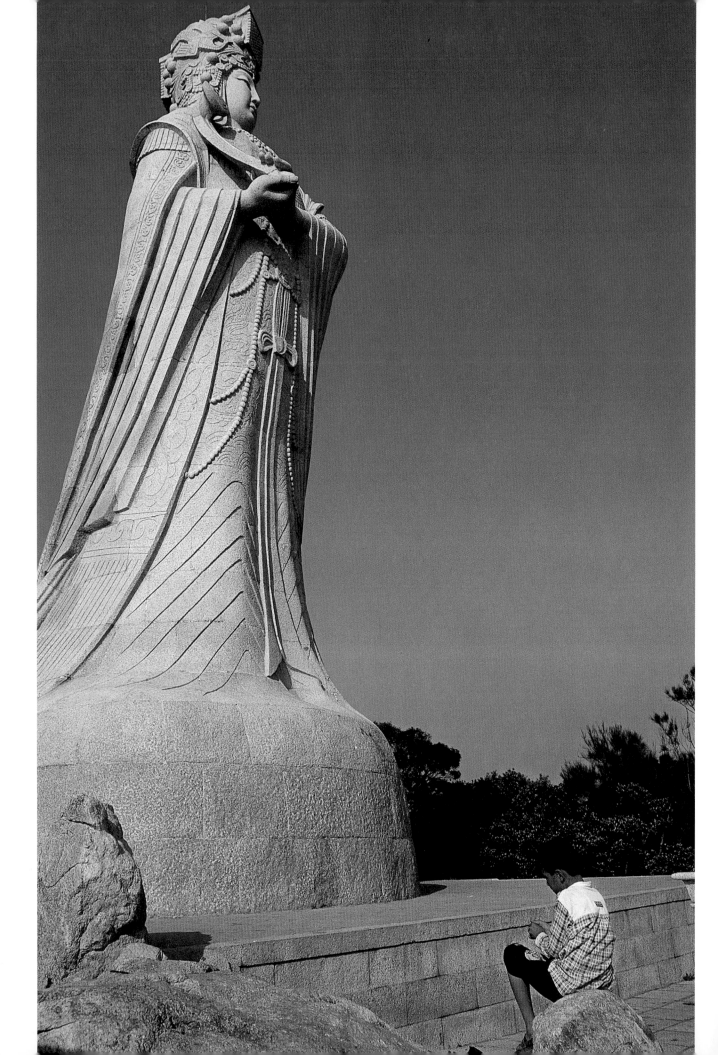

MAZU FESTIVAL

WHEN SHE WAS BORN, SHE DIDN'T CRY SO HER PARENTS NAMED HER MONIANG, "THE SILENT ONE." THE LIN FAMILY HAD LIVED IN THE FUJIAN PROVINCE FOR FIFTY-THREE GENERATIONS AND MANY HAD FISHED FOR A LIVING THEMSELVES. MONIANG'S FATHER, A VILLAGE OFFICIAL, WAS RESPECTED FOR SOLVING PROBLEMS FOR THE LOCAL FISHERMEN WHO WORKED THE WATERS OF THE EAST CHINA SEA. MONIANG WOULD COME TO HELP THE FISHERMEN AS WELL.

Moniang was born in 960 A.D., so what is known about her life is a mixture of legend and history, but it's clear that she was both precocious and intuitive. By age eight, she was writing poetry. By eleven, she began meditating. At twelve, although her family was Buddhist, she was accepted to study with the Taoist priest, Hsuan T'Ung. At sixteen, a spirit appeared to her near a well and gave her a potent charm. From that moment on, Moniang demonstrated supernatural powers that related to water. It is said that she could convert a straw mat into a sail and ride the ocean waves.

One day when Moniang was nineteen, she dozed off while she was weaving. The men in the family had gone fishing, leaving her at home with her mother and five sisters. She had a nightmare—the boat carrying her father and brother capsized and she watched her father slip below the water's surface. When she awoke, she searched the beach and found his body.

Thereafter, she was able to anticipate danger and spare fishermen from cyclones, storms, reefs, tides, rogue waves, and all kinds of watery catastrophes.

The typhoon season lasts from May to November in this coastal region. Of course, since tenth-century fishermen had no technology to forecast the weather, their work was perilous. So Moniang's weather predictions were invaluable. (Fishermen in other times and other places could have used her help. Over the last half of the nineteenth century, the city of Gloucester, England, lost thirty fishermen per each thousand—a death rate more than triple that of Americans who died in combat in the Second World War.)

Moniang had two assistants, brothers who originally served a tyrant general, and so had the experience and skills that helped her to locate fishermen in trouble a long distance away. The brothers' names translate as "Eyes that See a Thousand Miles" and "Ears that Follow the Wind." These piratical fellows are always portrayed with ill-kempt beards, pointed teeth, and wild eyes. Moniang never married and there are stories about her spurning these characters—although from the appearances of these rogues, romance seems mightily improbable.

In 987 A.D., at twenty-seven, Moniang celebrated the Double Yang Festival, which is held on the ninth day of the ninth month of the lunar calendar. On this holiday, everyone climbs hills to admire the scenery. But Moniang decided to sit at the summit of Mount Mei Feng on Mei Zhou Island and look at the beautiful blue water below. From this location, according to legend, she rode the wind to heaven and joined the immortals. The spot where she sat is now called Ascension-to-Heaven Rock.

The main Mazu Temple on Mei Zhou Island stands at the very spot where Moniang last enjoyed the view. At the top, a forty-five foot tall statue of her continues to survey the terrain. Stone statues enact her legends in a mountaintop garden of trees, rocks, lantana, and bougainvillea.

Sometime during the Ming Dynasty (1368–1644), Moniang was given the name Mazu—from *ma*, meaning "mother," and *zu*, which means "ancestor"—and became a goddess, Protectoress of the Fishermen. Over time, Mazu was given twenty-eight honorific titles—Goddess of the Sea, Almighty Protector, Guardian Angel of Seafaring People.

It is said that Mazu helped Kublai Khan's navy conquer Taiwan in the thirteenth century. Goddesses who make historical contributions are given promotions, so in 1683 Mazu was named Tian Hou, Empress of Heaven.

Over time, people who had nothing to do with water began to petition her for fertility, health, and wealth. Then, Mazu's titles became even more encompassing—Ancient Mother, Queen of Heaven.

Yan Jin Zhou, the temple scholar at the main temple, describes Mazu's transition from Protectoress of the Fishermen to Queen of Heaven: "She sets a good example for women to be caring, warm-hearted and benevolent."

Mazu's folk religion, which encompasses both Buddhist and Taoist beliefs, spread as Chinese citizens emigrated. The first Chinese temple in the United States honored her—the T'ien Hou Temple on Waverly Place in San Francisco. It was built in 1852 by abalone and shrimp fishermen who came from the Pearl River Delta near Hong Kong and wanted to express their gratitude for Mazu's protection while they crossed the Pacific in wooden boats. The temple is still active.

Today, Mazu has 100 million followers who worship in more than 3,500 Mazu temples all over the world.

On Mazu's birthday, sea creatures large and small, even whales, are said to swim near her temple in the Pescadores Islands to pay their respects.

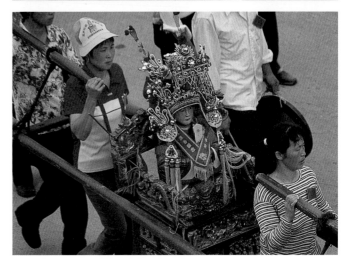

THE FAMILIES OF FISHERMEN CLEAN AND FOLD THEIR NETS, PAINT THEIR BOATS, AND HAUL THEIR CATCH. MY HOTEL OVERLOOKS THE MEI ZHOU ISLAND HARBOR AND I WATCH A FISHERMAN COMMUTE, STANDING ON A LITTLE RAFT AND PADDLING OUT TO HIS BOAT THAT IS SHAPED LIKE AN ISOSCELES TRIANGLE WITH PEAKS AT THE TWO BACK CORNERS—A JUNK WITHOUT A SAIL. FISHWIVES USE THE SIDEWALK BELOW MY WINDOW AS A STAGING AREA TO ARRANGE THE DRY FISH THEY SELL FROM FLAT BASKETS. UP THE BLOCK, DINERS AT OPEN-AIR RESTAURANTS RELISH THE DISHES MADE WITH FRESH OCTOPUS, CRAB, SEA SCALLOPS, OYSTERS, AND FISH.

Pilgrims begin to arrive for Mazu's birthday festival. The ferry from the mainland docks brims with so many people that its bumpers are submerged. During the twenty-minute ride, people on the lower decks have taken off their flip-flops to cool their feet in the water. People on the upper decks toss paper money, which represents good luck and happiness, then watched the red and gold squares float on the waves.

For three days, boat after flag-flying boat appears to ride into the harbor on a cloud of smoke created by the firecrackers that pilgrims on board toss to celebrate their arrival. They bring Mazu images from their local temples and immediately parade them to the main, ancestral Mazu temple, which is just behind my hotel. At 5:15 A.M., I am awakened by gongs, cymbals, drums, and laughter in the street. I run to the window to see a spontaneous parade of pennants and

people setting off so many firecrackers that they are soon ghosts, barely visible in the predawn light and smoke. I watch, delighted, then climb back into bed.

Now drums and yelling. I run to the window and see a horde of Taiwanese who wear yellow costumes, carry umbrellas, and play their instruments exuberantly. Gone. I climb back into bed.

Now women from Huian County assemble their parade. Originally part of the distinct Sminyue nationality, they have been integrated into the Han culture, but still wear their signature indigenous headscarves.

Now, a group carrying bamboo, each stalk longer than the next, signifying that each day is better than the one before.

Above: Arriving Taiwanese pilgrims' passports are checked by Mei Zhou Island guards.

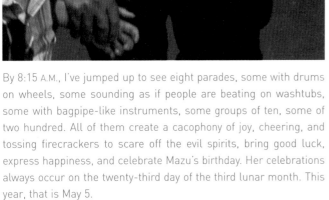

By 8:15 A.M., I've jumped up to see eight parades, some with drums on wheels, some sounding as if people are beating on washtubs, some with bagpipe-like instruments, some groups of ten, some of two hundred. All of them create a cacophony of joy, cheering, and tossing firecrackers to scare off the evil spirits, bring good luck, express happiness, and celebrate Mazu's birthday. Her celebrations always occur on the twenty-third day of the third lunar month. This year, that is May 5.

Imagine that it is ninety-seven degrees Fahrenheit and you are carrying your temple's Mazu image. You arrive at the main Mazu Temple to see the "Ladder to Heaven" steps, which climb steeply uphill, flanked by towers and pavilions.

After one hundred fifty steps, you enter through ornate gates past colorful statues of Mazu's two scary-looking assistants. The next level up is the vast ceremonial terrace, which will be the site of tomorrow's ceremonies. More steps—you climb between the drum and bell towers. And yet more steps to the Princess Mazu Hall, where pathways angle left to Mazu's dressing room, the rock from which she ascended to heaven, and a small hall to honor her parents. Further up, and you reach Tianhou Hall, the temple's inner sanctum. On your right is a plaza used only for firecrackers, and their thundering is as resonant below on the waterfront as it is in the woods above, where firecracker smoke blows like mist through the trees.

Later, perhaps you will go further, up more steps, to the prayer pavilion. More steps, this time to the Mazu statue that, despite her youth, represents the goddess as a matron, as it was sculpted during a dynasty whose aesthetic equated plumpness with beauty. Most of the other Mazu statues show her more accurately as a slender young woman. Up more steps and, finally, you reach the sculpture garden. I am transfixed by the performances of the local Chinese opera company that entertains visitors on the ceremonial terrace. Older women with hairstyles like Mazu used to wear, swept back into wings, watch the show with me—and watch me. As a Westerner, I am a curiosity; although ten thousand people are expected to celebrate tomorrow, I have only seen one couple from Europe and another from Australia. Between opera acts, the women with the Mazu hairstyles inspect my calloused elbows and show me their elbows, which are admirably smooth. They offer to share their parasols and we pantomime questions and answers. Their grandsons are fascinated by the rewind mechanism on my camera. The boys clamor to monitor it, then chant as the numbers fly past, "36, 35, 34, 33...." Here, students start studying English when they are five, and I am delighted to find that there isn't a child around who can't speak a few words in my language. How I wish I could reciprocate!

Throughout the day, pilgrims enter Tianhou Hall to pray for business success, good marriages, and long life. They leave paper money offerings, which women later collect and burn. Smoke from the temple incinerators carry prayers to Mazu in heaven. In between the firecracker volleys, women with brooms sweep away the red litter; then a new ear-shattering round begins. The scene is set.

THE MOST SACRED PART OF THE FESTIVAL OCCURS ON THE NIGHT BEFORE MAZU'S BIRTHDAY. TAOIST PRIESTS ARRIVE AT TIANHOU HALL AT ABOUT 7 P.M. MAZU'S IMAGE IS DRESSED ESPECIALLY TO WELCOME HER 1,042ND YEAR. THE "CLOTHES CHANGING CEREMONY" IS ATTENDED BY VERY RESPECTED OLD MEN WEARING DEEP BLUE SILK AND WOMEN DRESSED IN DARK RED. TAOIST PRIESTS HAVE SACRIFICED A GOAT AND A LAMB WHOSE BODIES, DECORATED WITH GOLD GLITTER, ARE DISPLAYED INSIDE THE HALL ENTRANCE. A TAIWANESE MAN IN A TRANCE STUMBLES AND STUTTERS IN FRONT OF THE MAZU IMAGE THEN LICKS A PATTERN ON HIS SILK FLAG. JACK, MY INTERPRETER, LATER TELLS ME THAT PEOPLE BELIEVE THAT MAZU ACTED THROUGH THIS MAN, GUIDING HIS BEHAVIOR. THE PRIESTS CONTINUE TO PRAY UNTIL ONE IN THE MORNING. OUTSIDE THE HALL, THOUSANDS OF PILGRIMS COMPETE TO LIGHT INCENSE ON THE STROKE OF MIDNIGHT AND BECOME THE FIRST TO WISH MAZU A HAPPY BIRTHDAY. FIRECRACKERS EXPLODE IN DEAFENING, CONTINUOUS BLASTS, THEIR SMOKE FILLING THE PLAZA AND ENVELOPING THE MOUNTAIN. FINALLY, AS ALWAYS, MORE FIREWORKS.

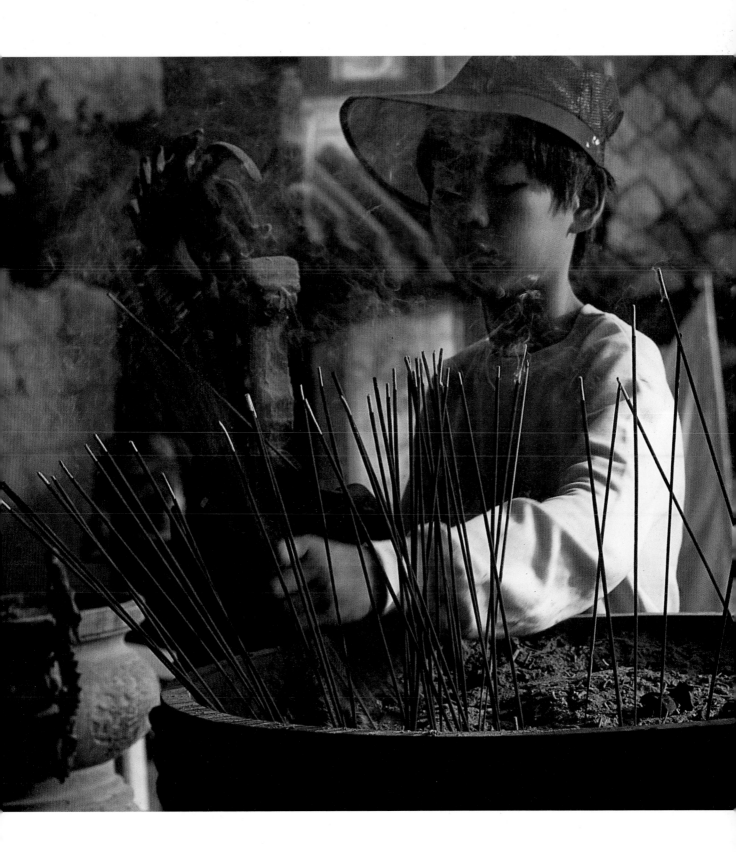

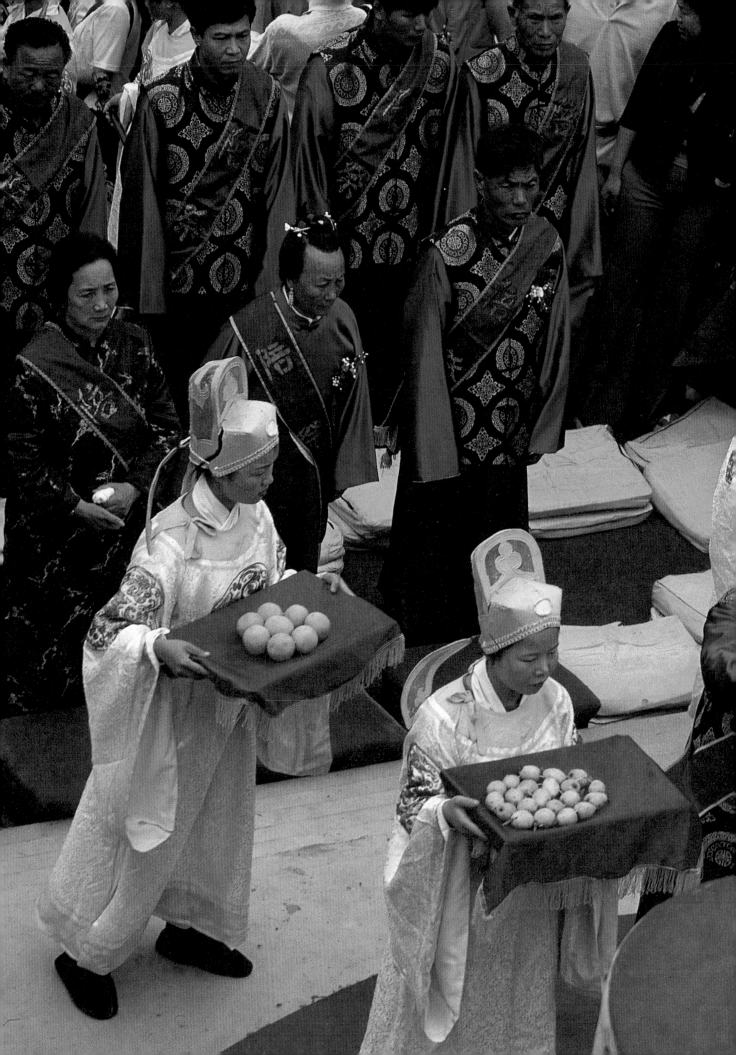

At seven the next morning, individuals and costumed pilgrim groups return, stopping every three steps on the temple's "Ladder to Heaven," to prostrate themselves. Mazu's image has been moved into the open air and surrounded by offerings, flowers, and gifts. People kneel to pray on the pillows in front of her altar. Even tots barely old enough to sit alone are placed on the pillows to bow to the goddess.

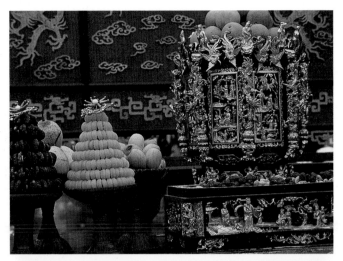

Thousands stand on the ceremonial terrace, but the venturesome ones sit on the rock outcroppings or high in the trees. Girls and boys scramble to the top of the temple rooftops, and perch, one leg on either side of the peak. I have been given access to the highest floor of the bell tower—literally, a bird's eye view.

At 9:30 A.M., a woman enters the drum tower and, using two long sticks whose ends are bound with red cloth, sounds a hanging gong that must be eight feet in diameter. It reverberates, perhaps for miles. The offering ceremony has begun.

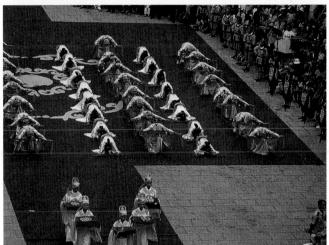

Women costumed as ancient soldiers clear the terrace, which is carpeted in fuchsia. Hundreds of dancers carrying streaming pennants parade up the steps—the men arrayed in robes of frosted gold, the women elegantly adorned in frosted pink. They use long feathers to create arches between them, seeming to swirl and float, integrate and atomize, cluster and glide in a graceful, sophisticated choreography.

Finally, women bearing trays of fruit and packages of noodles present these offerings to Mr. Gnag Jin Lin, the chairman of the temple, who dedicates them to Mazu with incense and prayers.

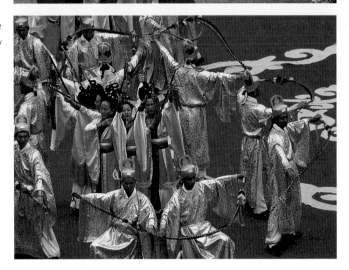

The entire performance is so beautiful that I actually forget to take pictures for long stretches of time. Never have I attended a birthday party nearly as grand.

FESTA DA NOSSA SENHORA DA BOA MORTE

IN THE SLAVE MARKET OF SALVADOR DA BAHIA DURING THE NINE-
TEENTH CENTURY, A SUGARCANE PLANTATION OWNER COULD BUY
THREE SLAVE WOMEN, A MAN, TWO CHILDREN, AND A BABY FOR
THE PRICE OF A HOUSE. HELD IN THE PELOURINHO SQUARE, SLAVES
WERE FLOGGED PUBLICLY UNTIL WHIPPING BECAME ILLEGAL IN 1835.
BRAZIL WAS VIRTUALLY RUN BY THE PLANTATION OWNERS—AND
BY THE CHURCH.

When slaves began arriving in the sixteenth century, they were bap-
tized Catholic as they disembarked from the ships that delivered
them from Africa. The Portuguese believed slaves had no souls, so
the blacks were never instructed about the new religion they were
forced into, although they were expected to attend mass. On the
plantations, slaves usually spent Sunday morning in a chapel near
the "big house"—the priests were paid by the plantation owners
and often had their own slaves, concubines, and children. In the
city, slaves were not allowed to enter the white people's churches.
Ingreja Nossa Senhora do Rosário dos Pretos, in Salvador, was built
for, and by, freed blacks.

After work on hot, humid evenings, free blacks met in Salvador's
senzalas (slave quarters) to discuss strategies to free their fami-
lies, their friends, and the tribal kings and queens who had been
captured along with everyone else and shipped to Brazil as slaves.
Not only did the freed slaves know that everyone should live free,
they believed that only if slaves died free could they have a *boa morte*
(good death). But they believed in one other kind of "good death"—
the Assumption of the Virgin Mary. Asking Mary to grant them
abolition, the blacks promised in exchange to commemorate the
August 15 holiday of her Assumption. Although a handful of white
churches in Salvador celebrated this event, in 1821 Rosário dos Pretos
became the first black congregation to celebrate the Festa da Nossa
Senhora da Boa Morte—the Festival of Our Lady of the Good Death.

Publicly, the Afro-Brazilians were Roman Catholic. But secretly, they
practiced Candomblé—a religion based on African beliefs that was
illegal in Brazil until 1970. Candomblé rituals, then and now, involve
dancing and trances but there are strong similarities present between
Candomblé and Catholicism: beliefs in a Supreme Creator, afterlife,
and ritual sacrifice. Candomblé devotees' fidelity to personal *orixás*
(deities) seemed similar enough to Catholic practice that blacks
were able to perpetuate their traditional beliefs by worshiping their
orixás in the guise of saints.

The first Candomblé temple, Casa Branca, opened in 1789 just
behind Barroquinha Church in Salvador. Casa Branca was led by
Iya Nassô, a powerful *mãe-de-santos* (mother of the saints).

Brazilian anthropologist Luiz Cláudio Nascimento has spent his
scholarly life studying the Sisterhood of Boa Morte, which grew from
Casa Branca. He is such an expert that, as we sit talking in his liv-
ing room, an ice cream vendor pokes his head in the window to find
out the date the sisterhood began. Luiz tells me that Candomblé
devotees "used the image of devotion, but behind that, they had a
political position: to preserve African culture here in Bahia." Casa
Branca not only preserved African beliefs, music, food, and dance, it
spawned many other Candomblé temples, and that network became
the nexus of the efforts of blacks to free more slaves.

Previous pages: Descendants of Brazilian abolitionists celebrate the Assumption of the Virgin as
members of a lay Catholic sisterhood. But their necklaces, a tangle of African tusks and beads,
hint at their long-secret roles as Candomblé priestesses.
Above: Ingreja Nossa Senhora do Rosário dos Pretos, in Salvador's Pelourinho square

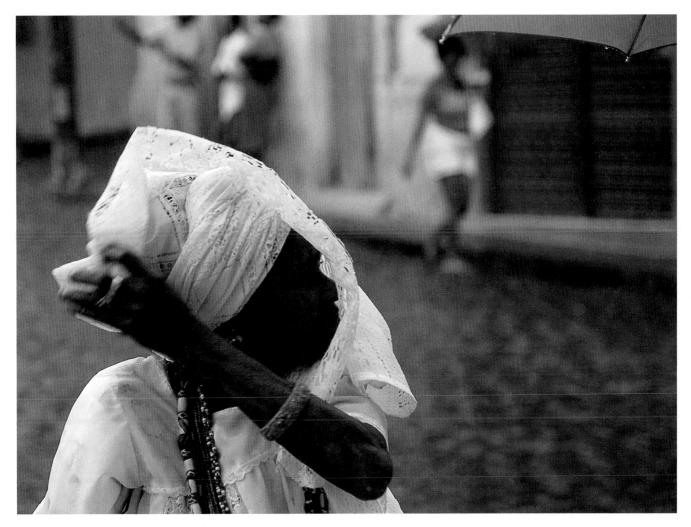

Women assumed powerful roles in Bahia, just as they had in Africa. In Benin during the 1700s, the highest-ranked woman was involved in public affairs as diverse as war and commerce. In the Nago-Yoruba kingdoms, women administered palaces, held senior leadership positions, and supervised operations of state.

SOON THERE WERE CANDOMBLÉ TEMPLES THROUGHOUT NORTHEAST-ERN BRAZIL, MOST RUN BY WOMEN, ALL LINKED TO CASA BRANCA— A VITAL RELIGIOUS-SOCIAL NETWORK THAT CONNECTED THE BLACKS WHO ARRIVED IN WAVES FROM CENTRAL AND WEST AFRICA. EACH CULTURE BROUGHT ITS OWN RELIGIOUS PRACTICES THAT FUSED WITH CATHOLICISM AND INDIGENOUS INDIAN RITUALS AND GAVE RISE TO FIVE MAIN TYPES OF CANDOMBLÉ.

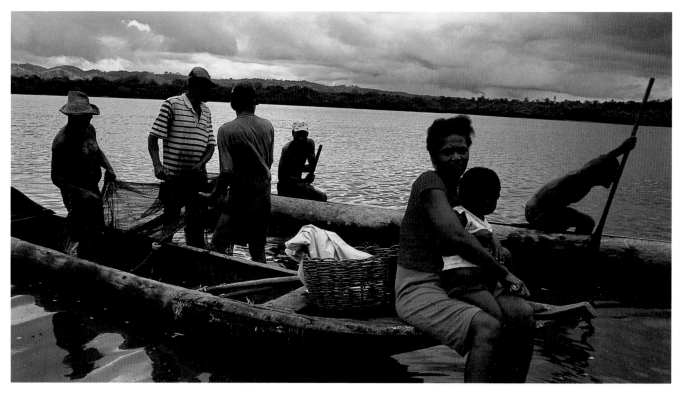

As compensation for having helped expel the Dutch from Brazil in the seventeenth century, blacks were granted the right to form Catholic confraternities, the first of which began at Salvador's Barroquinha Church.

The women associated with that church—and the Casa Branca house of Candomblé behind it—began planning to organize a sisterhood. The timing seemed bad. In the early 1800s in Brazil's patriarchal society, the idea of a sisterhood must have been heretical. Strong anti-Portuguese tensions had flared into armed skirmishes between slaves and masters. In an effort to suppress Candomblé, *terreiros* (temples) had been raided and members persecuted. Yet when the women petitioned the Catholic Church for approval to start a closed, black lay sisterhood, the Sisterhood of the Boa Morte was approved. For more than one hundred years, the church did not realize that the organization was secretly affiliated with Candomblé.

At the end of the nineteenth century, steamships began navigating the Paraguaçu River, heading west from Salvador to the city of Cachoeira. The ships carried slaves into Bahia's interior to mine gold and cut Brazil nut wood. Some woman leaders from the Sisterhood of Boa Morte traveled up the river, re-established the organization in Cachoeira and launched Candomblé houses throughout the surrounding Recôncavo region, forming an abolitionist network. And there was much to be done. In 1878, Nascimento estimates, Cachoeira had seven thousand inhabitants, of whom two thousand were slaves.

The Sisterhood of the Good Death used their social and spiritual power to give sanctuary to escaped slaves, and helped them reach *quillombos* (back country communities). The women provided money so slaves could buy *cartas de alforria* (emancipation papers) from their owners, who were required by law to free anyone who could pay the price. Among the slaves who were freed by the woman were many who had been powerful in Africa, and who joined forces to support the sisterhood's surreptitious, effective efforts.

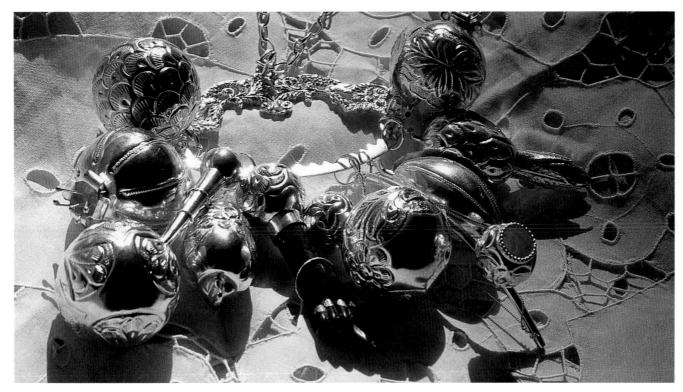

Just as in Africa, where women were effective traders, many Sisters in Brazil sold *acarajé* (fritters), *abaré* (beans wrapped in leaves), couscous, snacks made with corn, and fruit—all of which are, by the way, foods Candomblé worshippers offer the *orixás*. Some Sisters organized laundry businesses, others formed groups of women who pooled their earnings. Both men and women who secretly supported their cause made anonymous contributions. Some Boa Morte women already had personal funds. While still enslaved, they collected silver *balangandás* for hard work and sexual favors given to plantation owners—dangling collections of large, pure silver charms shaped like pineapples, grapes, pomegranates, cashew nuts, and coconuts—fruits that symbolized the *orixás*. Since silver was worth three times as much as gold in the

eighteenth and nineteenth centuries, slave women could sell these trinkets one by one, to buy their own—and then others'—freedom.

The network of Candomblé houses run by Boa Morte members made it easy for women all over the region to coordinate their activities. But to the Catholic Church, the Sisters seemed to be doing only what confraternities had done since the sixth century in England, where such groups began: praying for dead souls and arranging members' funerals.

The first slave ship had landed in Brazil in the 1500s. Of the twelve million Africans captured and imported to the Americas, 40 percent landed in Brazil. By 1850, when transatlantic slave shipments were prohibited, 3.5 million slaves had been delivered to Bahia (eight times the 430,000 who were imported by the United States). Incrementally, laws freed slave children, then slaves who had served in the military, then slaves older than sixty-five. In 1888, abolition was enacted and the remaining 750,000 slaves were liberated. Brazil was last country in the world to outlaw slavery.

Above: *Balangandás*, bunches of large silver charms copied from the woven straw and ivory amulets that were worn for magical protection by women arriving from Africa, according to Marigita Pudell of Simon Joalheiros, Salvador

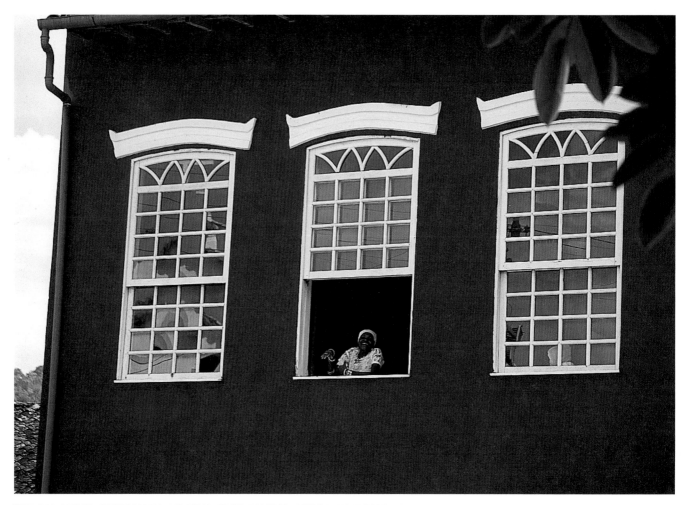

THE BOA MORTE SISTERHOOD'S COLONIAL-STYLE COMPLEX COVERS AN ENTIRE BLOCK ON A STEEP, COBBLESTONE STREET IN CACHOEIRA. EACH OF THE THREE BRIGHT, IMMACULATE BUILDINGS IS TRIMMED IN WHITE. THE RED BUILDING AT THE TOP OF THE HILL CONTAINS THE KITCHEN, DINING AREA, AND ACCOMMODATIONS WHERE THE SISTERS SLEEP DURING THE AUGUST FESTIVAL. THE PINK BUILDING IS A MUSEUM OF ART AND ARTIFACTS. THE YELLOW BUILDING HOLDS THEIR CATHOLIC CHAPEL, WITH ITS BLACK-AND-WHITE HARLEQUIN-PATTERNED FLOOR, WHITEWASHED WALLS, AND PASTEL ALTAR. EIGHTEEN YEARS AGO, THE SISTERHOOD DIDN'T OWN ANY OF THIS. IN FACT, WHAT THEY DID OWN WAS IN JEOPARDY.

In 1985, some of the Boa Morte's religious artifacts were stolen from the church in Cachoeira, where they were always stored between the annual festivals. The priest did not report the robbery to the police. Gone were a costume encrusted with diamonds that fit the figure of the Virgin, some rings, and two precious objects that had Mary's image on them: a silver belt and a sandal. Resistance against injustice was in the blood of the Boa Morte women—it was embedded in their history and their philosophy. Their loss was symbolized by the sandal. As a protest, they wore no shoes at all during their festival procession. Thousands of spectators watched them march barefoot over the town's painfully uneven cobblestone streets.

The late 80s were years of paradox in the Brazilian Catholic Church. On one hand, the National Conference of Catholic Bishops dedicated their Fraternity Campaign to the plight of poor Afro-Brazilians. On the other hand, the reigning Catholic bishop decided to close the lay brother and sisterhoods in his diocese, many of which were run by poor Afro-Brazilians. But the Sisterhood of Boa Morte refused to close.

In August 1989, the Sisters went to the church to collect their stored images of the Virgin Mary, the centerpieces of their festival ceremonies and processions. A new, young priest refused to relinquish the eighteenth- and nineteenth-century figures of the Madonna, much less the Virgin's crown or the Boa Morte women's gold jewelry, always worn proudly in the festival parades.

Enter a tiny, energetic, forty-six–year-old woman named Celina Maria Sala. She is not a member of Boa Morte, but describes herself as "their friend, their mother, their lawyer." Celina, who began practicing law in 1976 and took over the management of her family's Texaco franchise in Cachoeira when her father died, could afford to give her legal services pro bono to the sisterhood, and she was outraged by the church's behavior.

As she describes what happened during the next few years, her eyes sometimes fill with angry tears. "They thought they would close the festival. Our first reaction was to say, 'Well, it didn't close.' But over fourteen years (1985 to 1999), it became a fight!

"Even with a justice official going with the women to get the things, the priest didn't give them back. It was necessary to have the police with guns to go into the church and retrieve their possessions. Cardinal Dom Lucas brought a case against the sisterhood, saying

they stole the things. He claimed everything belonged to the church, which just loaned them to the sisterhood for the festival."

Although the judge decided in favor of Boa Morte in the lower courts, the church appealed and the State Supreme Court did not resolve the case for five years. Between 1990 and 1998, Boa Morte members staged their festival without Catholic priests at the masses and the doors of the church were closed to the sisterhood.

The turning point came when Celina located original documents written in the 1800s that proved that the Sisterhood of the Boa Morte did, indeed, own the artifacts. The ancient papers had been saved by a family in Cachoeira. Even today, Celina revels in her victory: "A small, black woman with no traditional name—I fought and won against the church!"

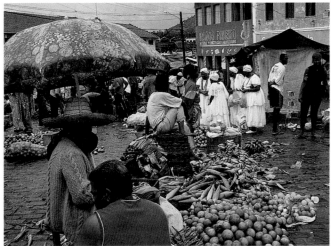

In 1999, the auxiliary bishop of Salvador offered an official apology. Cardinal Dom Geraldo Magella opened the door for the sisterhood to re-establish its original association. But by this time much had changed. The Sisters had some assets, and they didn't want to risk them. Jorge Amado, the renowned Brazilian novelist, had helped start a bank account to pay for Sisters' medical emergencies. The attractive Boa Morte headquarters complex that opened in 1995 had been funded by the mayor of Cachoeira, Celina, and African-Americans in Atlanta, Detroit, and Washington, D.C. And of course, the Sisters did not want to risk losing the religious artifacts they had fought to keep.

They decided to maintain their distance from the church. They now store their artifacts in a bank vault and pay a priest once a year to visit and conduct their festival services. In addition, they declared a new membership requirement: initiates must believe in the Virgin, but need not be Catholics.

The Sisters found a way to sustain the legacy of the free African slave women who founded Boa Morte—and to deliver on their ancestors' promise to celebrate the Assumption of the Virgin Mary.

MY FRIEND, JOAN CHATFIELD-TAYLOR, AND I SIT IN THE SISTERHOOD'S HEADQUARTERS WAITING FOR CELINA, WHO HAS RUN TO THE MAYOR'S OFFICE TO REMIND HIM TO TURN ON THE STREET LIGHTS DURING FESTIVAL EVENINGS. OUR INTERPRETER, CARLOS SCORPIÃO, CHATS WITH FOUR OR FIVE SISTERS WHO ARE RELAXING AFTER FINISHING FESTIVAL PREPARATIONS.

THE WOMEN ALL WEAR THEIR TRADITIONAL WHITE *BAIANA* DRESSES: LONG, STARCHED, FULL EYELET SKIRTS AND TUNICS WITH MATCHING WHITE TURBANS. SUDDENLY, ONE OF THEM BEGINS CLAPPING, THEN ANOTHER, THEN ANOTHER. A WOMAN SINGS OUT: "I LIVE IN JACOBINA, BUT I LOVE CACHOEIRA!" THE STRONG VOICE OF ANÁLIA DA PAZ SANTOS LEITE DEMANDS A RESPONSE. IN TURN, OTHER WOMEN SING BACK, INVENTING VERSE AFTER VERSE, HOLDING THE RHYTHM. THE SPONTANEOUS AND INFECTIOUS MUSIC DRAWS US IN. JOAN AND I JOIN THEIR CLAPPING. SUDDENLY WE ARE ALL STANDING AND DANCING TOGETHER. THEY ARE TEACHING US THE FAMOUS *SAMBA-DE-RODA.*

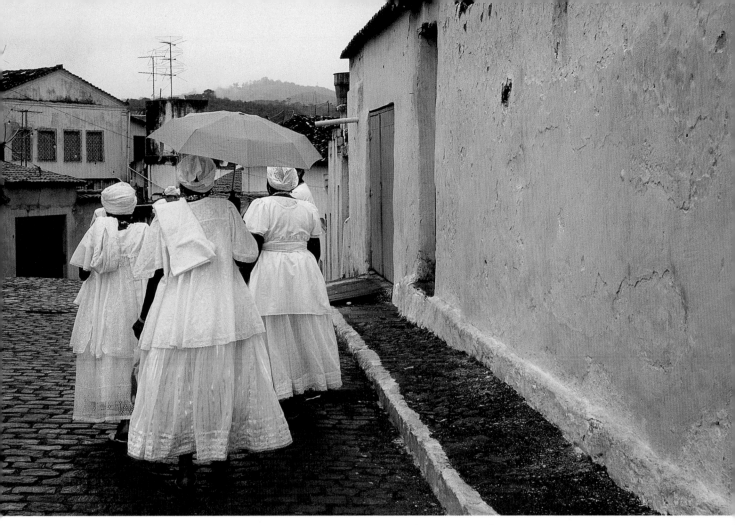

The samba originated in the Recôncavo region as a leisure-time, backyard dance done by slaves. Since they came from different tribes, music and dance gave them something they could do together. The *roda* (circle) connected them. They used their wooden sandals as percussion instruments.

Today, hand-clapping participants form a ring and take turns dancing in the center. This is not exhibition dancing—twirls are controlled, steps are done with the body quiet and the feet close to the ground. Locals are proud to tell us that only when Tia Ciata, a Boa Morte member and Candomblé priestess, introduced the *samba-de-roda* in Rio de Janeiro, did it become the inspiration for Carnaval and nightclub sambas, giving rise to the samba schools in the capital and to an international infatuation with the dance.

Later, when I ask the sisterhood's board of directors what part of the Boa Morte festival is the most fun for them, each one lights up and echoes the same words: "The *samba-de-roda*!" The dance will be the finale of the Assumption Day celebration.

This afternoon, as the women settle back into their chairs after dancing, they have an animated disagreement. "If you clap with flat hands," Anália challenges, "you lose the power." She cups her hands to demonstrate the proper way. The power. Suddenly, I remember that these women are priestesses in the *terreiros*, either *mães-de-santos* and *makotas* (the two most senior leaders) or experienced initiates, *filhas-de-santos*. The women discuss the fact that they are not supposed to wear their African jewelry during the Assumption celebration—but of course, they do.

We accompany a group of the Sisters one morning to the market to buy food since on four of the five festival days they serve meals to invited guests. It is raining, yet they walk through the streets in their eyelet regalia looking, Joan says, "like white clouds." We walk past displays of squash, lettuce, coconut, onions, dried fish, and bananas. One vendor wears garlands of garlic bulbs that are for sale. The Sisters carefully select the best okra to make *caruru* (a thick sauce that also includes shrimp and palm oil) plus potatoes and herbs. Every purchase is negotiated. The women fill sacks with vegetables, then argue vigorously for a fair price, scowling at the vendor, looking increasingly offended at his insistence on charging more. Dramatically, they put the bagfuls on the ground and turn away. Their strategy works.

IN THE EARLY 1900S THE SISTERHOOD HAD TWO HUNDRED MEM-
BERS, BUT NOW HAS TWENTY-FOUR—A POWERFUL, EXCLUSIVE CLUB.
ALL ARE BLACK WOMEN WHO ARE CONNECTED TO CANDOMBLÉ
HOUSES AND AS SUCH ARE ALL OVER FORTY-FIVE YEARS OLD: NO
MENSTRUATING WOMEN ARE ALLOWED IN THE *TERREIROS*. ALL ARE
DESCENDANTS OF SLAVES, AS ALMOST ALL BAHIANS ARE. ALL MAKE
A PROMISE TO THE VIRGIN, THE SINCERITY OF WHICH IS ASSESSED
BY EVERY SISTER BEFORE A NEW MEMBER'S CANDIDACY IS APPROVED.
ALL GO THROUGH A THREE-YEAR INITIATION PERIOD AND PARTICIPATE
IN COOKING, COLLECTING FUNDS, AND ORGANIZING CEREMONIES,
SUPPERS, PROCESSIONS, AND FUNERALS. BETWEEN ANNUAL FESTIVALS,
THE SISTERHOOD HOSTS BAPTISMS, WEDDINGS, AND FUNERALS IN ITS
CHAPEL, SPONSORS ART EXHIBITIONS IN ITS MUSEUM, AND OFFERS
HANDICRAFT CLASSES FOR CHILDREN AND, FOR ADULTS, A COURSE IN
YORUBA, THE LANGUAGE SPOKEN IN NIGERIA AND BENIN THAT IS USED
FOR CANDOMBLÉ SERVICES.

Members of the sisterhood collect money for the festival by carrying
red, cotton purses through the streets. Funds promised by the state
have not arrived and support from Cachoeira citizens is limited,
perhaps due to racism, we're told. The women raise only seventy-
four dollars although the festival budget is $3,500. Out of necessity
and generosity, Celina pays the difference.

Five women sit on the sisterhood's Board of Directors. The woman
with the most tenure in the organization is titled the perpetual
judge and serves a lifelong term. Every seven years, the Virgin Mary
is said to give her spiritual guidance to help create the festival.
The next time that will happen is 2008 when the perpetual judge will
be one hundred three.

The other four board members are elected by consensus each
August. For reasons that are secret, votes are cast with corn kernels
and beans.

One evening, Boa Morte's top executives honor us by accepting
our dinner invitation. They are accompanied by Valmir Pereira dos
Santos, who "was brought up by them" and is the only man allowed
in their company during festival week. Since 1995, his official title

has been Administrator of the Boa Morte Museum, but having
previously managed the best hotel in Cachoeira, he contributes
many business skills. He treats the women with love and respect, as
if he were their son. Tonight, he reads them the menu and serves
them from the platters the waiter delivers—fish and potatoes for
all, a menu dictated by the festival's dietary restrictions.

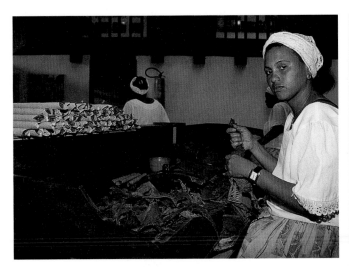

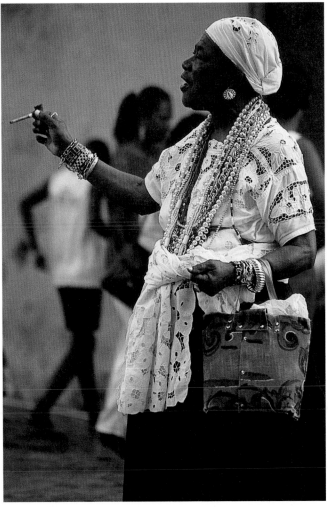

Almerinda Pereira dos Santos is the purveyor, the second most senior officer. At seventy, she is a diminutive woman with twinkling eyes and an engaging smile. Almerinda, who joined the sisterhood when she was thirty-five, has retired from work but still sells at the market. In addition, after her mother died last year at ninety-five, she has taken care of her brother and sister in Muritiba, outside Cachoeira.

Maria das Dores da Conceição, the attorney general, is responsible for organizing the festival. At eighty-two, she has fifteen children plus thirty-six grandchildren and great-grandchildren. She remembers that her grandfather, a slave, managed a sugarcane mill that made schnapps. "He followed all the rules, and was never whipped." Maria das Dores "does Candomblé a lot." She has two memories from her childhood in Muritiba: a poem about Papa Xango, the *orixá* of storms, and eating a fruit that had seeds "so sticky we couldn't open our mouths to ask blessings for our parents."

Maria das Dores' younger sister is the treasurer of the sisterhood. Sixty-three-year-old Renildes Rodrigues da Conceição joined the sisterhood when she was twenty. She has eleven children and four grandchildren. Now her husband is bedridden, but she makes us laugh by remembering how they got so many children. "I would be doing the laundry or the cooking and he would call and say, 'I want to show you something.' Or we would take a shower and he would say, 'Wash here, wash there.' And suddenly, eleven children!"

And all three women worked in the local cigar factory, as did Maria das Dores' mother and grandmother. Later I talk with another Sister, pipe-smoking Cassemira Moreira Gomes, sixty-five, who is the sec-

ond most senior leader in her *terreiro*. She joined the sisterhood when she was twenty. When her husband left her, she supported her ten children by preparing leaves for cigars.

In the 1900s, Cachoeira's *charutos* (cigars) were so fine that they were sought by rulers as far away as China. The cigar factory across the river in Saint Felix has now been incorporated into a cultural center. About twenty young women work at wooden desks arrayed in two rows facing a small shrine to Jesus where candles burn. The forty-one-year-old manager tells me that she started working here when she was fourteen. The only hint of what yesteryear's cigar factory might have been like is the salary. Every woman earns $2.50 a day.

Above, left: Worker at the San Felix cigar factory

"For us, God is natural things—the sun, the day, the night, the animals, the plants, sweet and salt water, the trees, salt, iron. Candomblé links the energies of humans and the earth," explains Valdina Olivera Pinto, who is second in the leadership hierarchy of an Angola-Congo Candomblé house in Salvador.

Valdina's role is not to enter trances and be ridden by the deities, as others do. Instead, she is responsible for preparing the services and teaching initiates the oral knowledge of Candomblé, a job she describes as "keeping the secrets." Now sixty, Valdina was initiated in 1975 and began her spiritual work with the title and responsibilities she still holds.

I ask her why it is necessary to keep Candomblé rites secret since its practice has been legal since 1970. "Many do not wear the necklaces of the deities because they do not want to be recognized as Candomblé followers. In Brazil, we have invisible racism. It's more dangerous and difficult to fight than declared racism. We are shown not as different, but as wrong. For example, why is this religion not respected by the institutions? When the tourist organizations want to sell Bahia, it's the black culture they sell. They give our deities' names to hotels and restaurants. Our religion is the philosophy of a people who were not slaves before they arrived here. It has a cosmic vision, a pantheon, and a mythology."

An abstract metal sculpture sits on Valdina's desk by her computer. As she shows it to me, I notice that its design matches the pendant on her necklace—a circle over a cross, with beads at the points of intersection. "With this you can explain the genesis of the Congo, of life, of community, of projects. Everything is here. The points represent the four phases of the sun."

She puts her finger on the lowest point. "Imagine: in the beginning, the big bang, the explosion, the fire, the frozen state. The mystery age—nobody was there. We associate this stage with yellow."

She points to the bead on the right. "This is the second stage. Many millenniums later, not seven days. It is where life begins, the moment of birth. Where you begin to be. Black is its color.

"Here," she touches the top point, "is the noon sun. At its zenith. The human being is in full plenitude. Prepared with everything, knowing, healthy, powerful, energetic. The color is red."

Finally, she indicates the point on the left. "Everything that is born must decline and die. The white color, the color of the chalk used in Candomblé. When we complete the cycle of the earth's life, man comes. The prototype human being, the first form, our first ancestor—one being with two faces, the feminine and the masculine. Unified. The Congo people called them Lungu (Man) and Musita (Woman). Men and women are always trying to find each other, looking for the part they lost, to be complete again." She traces the entire circle again and stops on the left point. "Life continues, even after death. We do not die, we are transformed, we become."

She focuses attention on the center of the design. "When you are here, at the intersection, you are at the *nzila*, a kiCongo word that means "the ways." You can go forward, back, right, left, up, down, in. You have seven chances, opportunities. There are good and bad ways. The choice and consequences are your fate."

Above: Makota Valdina Olivera Pinto explains the philosophy of the cycle of life, the foundation of Angola-Congo Candomblé.
Opposite: On the final night of the Boa Morte festival, Sisters are free to visit Candomblé houses and participate in the services, which often last all night. Three of the four Boa Morte members dancing in this picture play leadership roles in their own *terreiros*. Candomblé means "dance of the Gods" and when dance becomes trance, the *orixás* become one with the devotees.

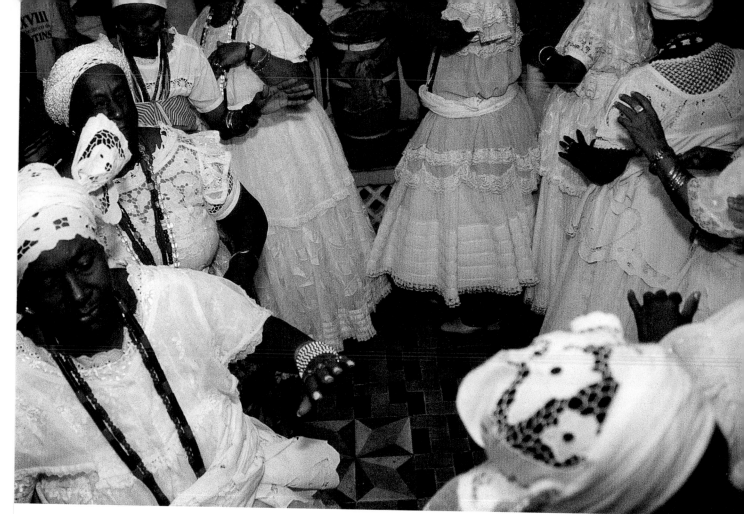

I ASK WHY WOMEN ARE THE PRIMARY LEADERS OF CANDOMBLÉ HOUSES AND CEREMONIES. "IN THE AFRICAN TRADITION, WOMEN KEEP THE CULTURE, KEEP THE HOME. THE MOTHER FIGURE IS MAGICAL. IN AFRICA, CHILDREN MEAN RICHNESS. CHILDREN KEEP THE CULTURE, THE ETHNICITY, THE LINK WITH THE ANCESTORS."

VALDINA ACKNOWLEDGES THAT CANDOMBLÉ DID AND DOES PROTECT AFRICAN CULTURE IN BRAZIL. "WHEN PEOPLE TOOK US FROM AFRICA, OUR RELIGION BECAME POLITICAL. TO KEEP THE NAME YOU HAD BEFORE THEY TOOK YOU...TO MAKE FOODS THE WAY YOU KNEW TO MAKE THEM. CANDOMBLÉ WAS VERY IMPORTANT TO MAINTAIN THOSE THINGS."

Knowing that Valdina is a poet, I ask if she will read something she wrote. The poem she selects is titled "Memories" and describes a honey infusion that used to be prepared when a child was born. Mothers drank it as medicine; family and friends drank it to ensure the health of the baby. Valdina's rich descriptions of the preparations for home-birth with a midwife—the camphor, the incense—are so evocative that our interpreter, Carlos, weeps. "I remember preparing for my three brothers," he says. "We have lost the smell of children being born at home. The smell of camphor and alcohol. We have lost that." Valdina's poetry, like her spiritual work, keeps tradition alive.

Valdina has lectured at universities in Brazil and the United States. She confides that when she read *The Mists of Avalon*, she recognized similarities between those ancient beliefs and Angola Candomblé. A small sculpture symbolizing world peace sits on a shelf. An appliquéd map of Africa hangs on her wall. A ceramic snake stretches along a shelf of her cabinet.

Candomblé is based on Vodun, a religion that originated in Benin and Nigeria; its roots go back six thousand years and it is currently practiced by sixty million people worldwide.

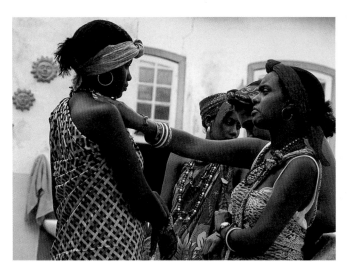

THE SISTERS ARE HEROINES TO MEMBERS OF THE BLACK MOVEMENT IN THE AMERICAS, WHO SWARM TO THE BOA MORTE FESTIVAL WHERE THEY FIND INSPIRATION, LEND SUPPORT, AND HONOR THE SISTERS' HISTORICAL AND CONTEMPORARY POLITICAL ACHIEVEMENTS. LUIZ CLÁUDIO NASCIMENTO CALLS THE SISTERHOOD "A REFERENCE POINT" FOR BRAZIL'S BLACK MOVEMENT, WHICH BEGAN IN 1974.

Today, Brazil's population is almost entirely mestizo. Paradoxically, although racism is still rampant, miscegenation has been common here for almost five hundred years, ever since plantation owners used Indian and black women for their own pleasure. In modern times, interracial marriage became a strategy. Carlos explains, "Middle class families told their children, 'Try to marry white people because we don't want your son or daughter to have the same problem we had. Let's bleach our family." Recent official statistics report, "38% Mixed" and "6% African," both gross understatements that result, in part, from a census form that offers only three options—white, brown, or black—and in part because so much social disapprobation and economic discrimination is associated with being black that few mark that box.

In reality, northeastern locals—indeed, most Brazilians—can easily identify twenty-six different racial categories based on skin, eye, and hair color. Carlos Scorpião, who has been involved with the movement for more than twenty years, asserts that "the myth of racial democracy is a lie." To be dark is to be poor and uneducated.

Job number one for the Brazilian black movement was consciousness raising. Inspired by the Black Panthers, leaders began teaching that "Black is Beautiful," African heritage is valuable, and resistance to racism is mandatory to create social change.

Carlos reminds me that "Boa Morte represents one example of the fighting we have done over the centuries. The moment Portuguese began to buy slaves in Africa, it was a fight. Many pregnant women aborted their babies rather than have them born into slavery. It's old, the fighting of black people against racism."

OBVIOUSLY, RACISM IS NOT LIMITED TO BRAZIL. VALMIR IS THOUGHT-FUL: "ALL OVER THE WORLD, DISCRIMINATION IS A DISEASE THAT MUST BE CURED. PEOPLE NEED CITIZENSHIP JUST BECAUSE THEY ARE HUMAN. WE MUST FIGHT FOR OUR DAUGHTERS AND SONS, OUR GRANDDAUGHTERS AND GRANDSONS. WE NEED BETTER HEALTH, EDUCATION, AND DIGNITY FOR EVERY CITIZEN. WE ALL SHARE ONE BELIEF: A HOPE FOR BETTER DAYS."

IN BRAZIL, THE WOMEN OF THE SISTERHOOD OF BOA MORTE SYMBO-LIZE THAT STRUGGLE.

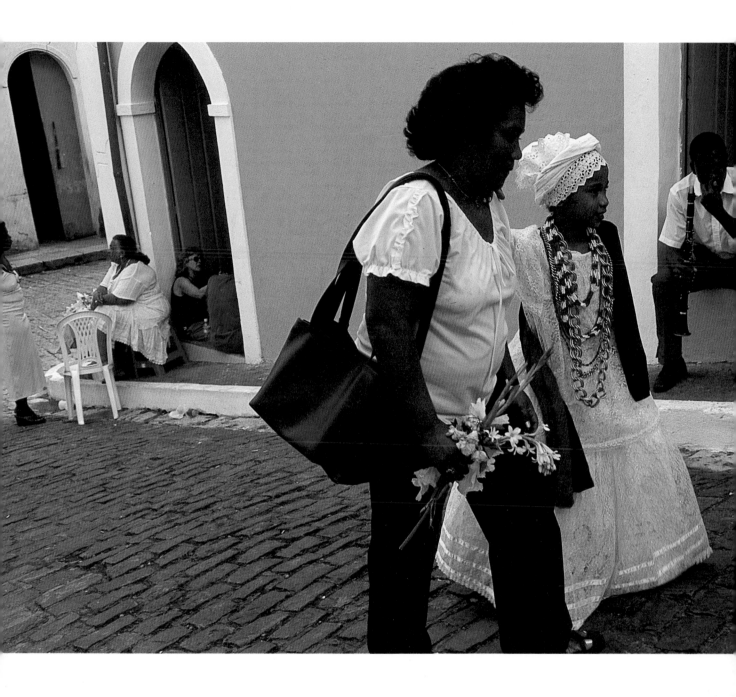

ROMERIA DE SANTA MARTA DE RIBARTEME

SOMEHOW, THEY MADE IT—FLOATED ACROSS THE MEDITERRANEAN FROM PALESTINE TO FRANCE IN A BOAT THAT HAD NO RUDDER, NO SAIL, AND NO ANCHOR. IN 48 A.D., THEY REACHED SAINTES MARIE DE LA MER IN THE CAMARGUE REGION.

After Jesus died, many Christians were killed but people suspected that Lazarus and his family might be impervious. After all, he'd already come back to life having been dead four days. The solution was to set Lazarus adrift with his sisters Martha and Mary Magdalene.

The siblings spread out to evangelize France. Martha worked between Tarascon and Avignon. One day when she was preaching on the banks of the Rhône River in Avignon, the local people brought her the body of a young boy who had drowned while swimming. Her prayer brought him back to life.

Martha's reputation as a miracle healer spread to Spain. Perhaps the news was transmitted immediately over the well-established trade routes. Or later, perhaps pilgrims discussed Martha as they trudged from Provence, France, to Galicia, Spain, where the apostle James' remains were found in 813 A.D.

In 1728, the archbishop in Tui, Spain, which is near the Portuguese border, made a pastoral visit to a tiny Galician parish, San Jose de Ribarteme, where he saw a decrepit, unused chapel. He opened an account to refurbish it and after the roof had been rebuilt, the interior painted, and an altar and cross installed, it was rededicated as the Church of Santa Marta of Ribarteme.

That little stone church still nestles in the crook of the winding road that leads through vineyards and red tile-roofed houses. Just six hundred people live here. The gentle hills are verdant with eucalyptus, citrus trees, evergreens, and ferns. Corn, grapes, kiwi, and roses flourish in the fields. The vineyards grow so energetically that tendrils spill through the fences and grab granite buildings nearby.

Here, Santa Marta's power as a healer is celebrated annually on the anniversary of the day she died: July 29, 68 A.D.

Villagers who have survived near-death experiences each year, are carried in open coffins by their relatives who sing novenas as they walk through the countryside. When they arrive at the church, they give thanks for their very lives.

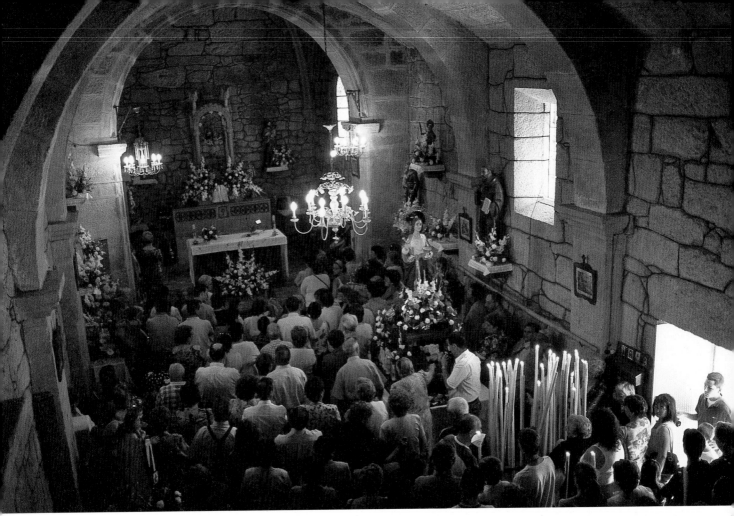

THE BARREL-DOMED SANTA MARTA CHURCH BRIMS WITH YELLOW AND WHITE FLOWERS ARRANGED BY LOCAL WOMEN. MASSES ARE CELE-
BRATED HOURLY, AND ALTHOUGH THE CARILLON PLAYS ELECTRONICALLY DURING THE REST OF THE YEAR, TODAY A MAN RINGS THE BELLS BY
HAND. CANDLES FLICKER INSIDE AND OUT, LIT BY PILGRIMS WHO CIRCLE THE CHAPEL ON THEIR KNEES. THE SAINT'S IMAGE, DRESSED FOR
HER FESTIVAL DAY, WEARS A GOLD CROWN AND NECKLACE. A CHAIN OF COINS FORMS A LEASH FOR HER DRAGON. AT HER FEET, PEOPLE HAVE
LEFT OFFERINGS—EVERYTHING FROM EUROS TO A THICK SHINY BRAID OF BROWN HAIR.

In the street on both sides of the church, stalls display pictures and pendants of Santa Marta, plus candles and molded-wax legs, arms, hands, and breasts—offerings that symbolize giving a part of oneself to a saint, gifts of gratitude.

It's a surprise to hear a band of bagpipers playing outside the church. But not if you know that Galicia was at a time occupied by Celts. Even today, 80 percent of the people speak Galego, a Celtic language. Before the 11 A.M. mass, the musicians play their *gaitas* (Galician bagpipes) so enthusiastically that the priest, about to start mass, shouts, "Maintain control! The band is too loud and must go away! This is not a carnival. Be quiet or I will leave!" Not for nothing is this festival called a *romeria*, which means a religious festival, as opposed to a party. Peace returns.

At noon, the procession leaves the church, led by the image of Santa Marta followed by the Virgen de Carmen, the Galician flag, the priests, and the coffins. The pilgrims follow wearing net robes—representing that they are dedicating themselves to Santa Marta—and carrying tall candles topped with paper cones to catch dripping wax. The tapers remind me of calla lilies.

SEAFOOD IS THE CENTERPIECE OF SANTA MARTA'S AFTERNOON PICNIC FEAST, WHICH INCLUDES HOMEMADE BREAD, SAUSAGES, CHEESE, AND LOCAL ALBARIÑO WINE. BUT THE SEAFOOD! *PULPO A FEIRA*, OCTOPUS BOILED IN COPPER CAULDRONS, IS SLICED INTO WHITE DISKS ARRANGED ON A WOODEN PLATE AND DRIZZLED WITH OIL THEN SPRINKLED WITH SEA SALT AND PAPRIKA. SAN JOSE DE RIBARTEME SITS ABOVE THE MIÑO RIVER THAT FORMS SECTIONS OF THE BORDER BETWEEN SPAIN AND PORTUGAL, AND SPILLS INTO THE ATLANTIC OCEAN. MORE THAN TEN THOUSAND FISHING VESSELS WORK IN THE GALICIAN WATERS. *PULPO A FEIRA* IS JUST ONE OF MANY TRADITIONAL FOODS THAT ARE CREATED WITH DELICIOUS, FRESH FISH.

Sunset and dinner happen late on this warm summer night. Afterwards, on the hill above Santa Marta's church, fireworks bloom in the sky, music spreads over the adjacent forest, couples dance, and children visit the merry-go-round, video arcades, and shooting galleries that are set up by itinerant gypsies.

"Pepe!" He roars by on his motor scooter and my interpreter hails
him to join us for a glass of wine as we relax under the trees in
the town square.

"I was born between the vines," he laughs as the waitress fills our
glasses with the dry white, Albariño Fillaboa. Pepe is a vintner who
produces two thousand bottles of fine wine each year. He tells me
that Galicians drink more wine annually than anyone in the world.
He notes proudly that in 1998, Rias Baixas (Denomination of Origin)
and Alberiño began to rival Ribeiro as the best white wine in Spain.

For years before Pepe turned his attention exclusively to wine, he
was a construction and building contractor who worked with
asbestos. One night, he sneezed a hole in his lung, and after a
forty-minute ambulance ride from his home in Arbo to the city
of Vigo, he was rushed into surgery. The doctor asked him later,
"Who is this Santa Marta you talked to continuously even though you
were anesthetized?"

Now sixty-five and healthy again, Pepe wears a Santa Marta amulet
every day. He rides his motor scooter to Santa Marta's church in San
Jose de Ribarteme. And he never misses the Romeria Santa Marta.

Five generations ago, Sean's ancestors emigrated from Ireland
to Scotland. He speaks authentically about Celtic culture, lore, and
history, and understands its influence on Europe, particularly Galicia,
where the Celts settled five thousand years ago.

Sean is fluent in the local language, Galego, which he mastered in
order to marry Angela, a beautiful Galician woman. Their children
were baptized in a church in the middle of Arbo's vineyards, and the
family vacations in their own wing of Angie's family's home.

I have never before entered a house via a corridor of dense vines
dripping with golden grapes. Vines in Galicia are propped high on tall
granite poles, perhaps eight feet above the moist earth. Adjacent
rows grow together into a leafy umbrella whose cool, green light
make me feel as if I am in a fantasy underworld. The vines give way
to the foliage of an orange tree under which Tiernan and Megan,
ages three and two, play. I ask Angie whether Santa Marta is a role
model for Galician women. "All the women look up to her. She is my
mother's saint."

In addition to being celebrated for her healing powers, Santa Marta
is the patron saint of housewives. The Bible (Luke 10:38) tells how
Martha served Jesus dinner. As a consequence, she became the
patron of housewives, restaurateurs, inn keepers, cooks, and waiters.
Angie is the first one to mention this aspect of Santa Marta. "Galician
women are very hardworking. The men go fishing and the women
are left with the children. They must manage the money, take care
of the vineyards, cook, sew, plant the vegetables, and be 'the man of
the house.'" Sean elaborates, "In the Celtic tradition, the women are
always the 'man of the house.'"

CYNTHIA BARREIRO LIVES IN CARBALLIÑO, THE TOWN OF OCTOPUS
LADIES WHO COOK AND SELL THEIR SPECIALTY THROUGHOUT GALICIA
AT SUMMER CELEBRATIONS. "IT'S NOT A FESTIVAL WITHOUT THE OCTO-
PUS LADY," LOCALS SAY.

Cynthia is the third generation to work at the Santa Marta festival;
she has done so since she was a child. The wooden plates she
serves on carry the initials of her father. Her brothers work with
and for her.

Octopus ladies lay claim to specific festivals and guard their right to
them jealously since these events represent their revenue. Cynthia
usually rents her space for $135, and may earn as much as four
hundred dollars a day, depending on the weather and the size of
the crowd.

Two other octopus ladies sell at the Romeria de Santa Marta, but
they all maintain a respectful distance. The crowd is big—and hun-
gry—enough to keep all three very busy.

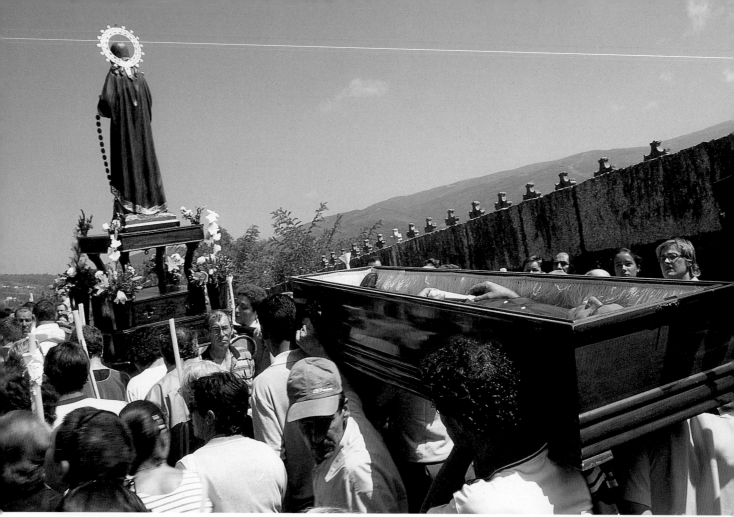

THE DAY BEFORE THE FESTIVAL, I WATCH WOMEN ARRANGING GLADIOLAS, ROSES, AND LILIES IN THE NARTHEX OF THE CHURCH. SUDDENLY, ONE RUNS OVER, GRABS MY HANDS, HUGS ME, AND SPEAKS EXCITEDLY IN GALEGO. THIS IS ROSA, WHOM SANTA MARTA SAVED FROM PARALYSIS WHEN SHE HAD POLIO. TO PETITION SANTA MARTA TO HEAL HER, ROSA WALKED ON HER (BLEEDING) KNEES FROM HER HOUSE TO THE CHURCH FIVE TIMES. SHE IS NOW HEALTHY AND ALMOST FIFTY.

Rosa's mother's wish a few months ago was to become well enough to ride in a coffin during the Santa Marta festival. On her death bed, she asked one of her children to ride in a coffin on her behalf. "So Manuel will ride in the coffin for our mother. He will be carried to the church and in the procession by six relatives."

As it turns out, Manuel is the only person to ride in a coffin this year. His family carries him two kilometers as the sun rises in the sky and the *romeros* (pilgrims) sing novenas. When we arrive at the church, Manuel climbs out and confesses, "They should put a fan in there! I'm so hot I'm dizzy!" Then he lights a cigarette and has a smoke.

The formal procession begins after mass, Manuel climbs back into his coffin and is lofted again. The noon sun has heated San Jose de Ribarteme to ninety degrees. Because I am photographing from the hill above him, I can see Manuel, who believes he is unobserved, reach into his pocket for a Kleenex and mop his perspiring brow. It's the last thing I would expect someone lying in a coffin to do.

THE ROMERIA OF SANTA MARTA IS THE OLDEST RELIGIOUS FESTIVAL IN GALICIA, AND AT SIXTY-FIVE, MANUEL JANEIRO LOPEZ, THE BUSY PRIEST OF THE MUNICIPALITY OF AS NEVES, HAS CELEBRATED SANTA MARTA'S FESTIVAL MASSES FOR THE PAST TWENTY-THREE YEARS.

He observes that there are fewer coffins now than there used to be, but riding in a coffin is voluntary. Although fewer people chose to do it, that does not indicate that fewer believe in Santa Marta's ability to help them. "Santa Marta's power to perform miracles relies on the strength of people's faith and belief," he reminds me.

I tell him about a local woman whom I spoke to as she lit a candle outside the church. She had meningitis as a child, and said that although most people cannot walk after having the disease, Santa Marta saved her from paralysis. She will always be grateful, and attend the festival and make her own net robe every year.

Father Lopez sighs. He hears many such stories. But his responsibilities include four parishes in addition to San Jose de Ribarteme, and he is too busy to fulfill his greatest dream—that one day he will have enough time to help all those who have experienced Santa Marta's miraculous recoveries share their stories with each other at a meeting on the day before the festival.

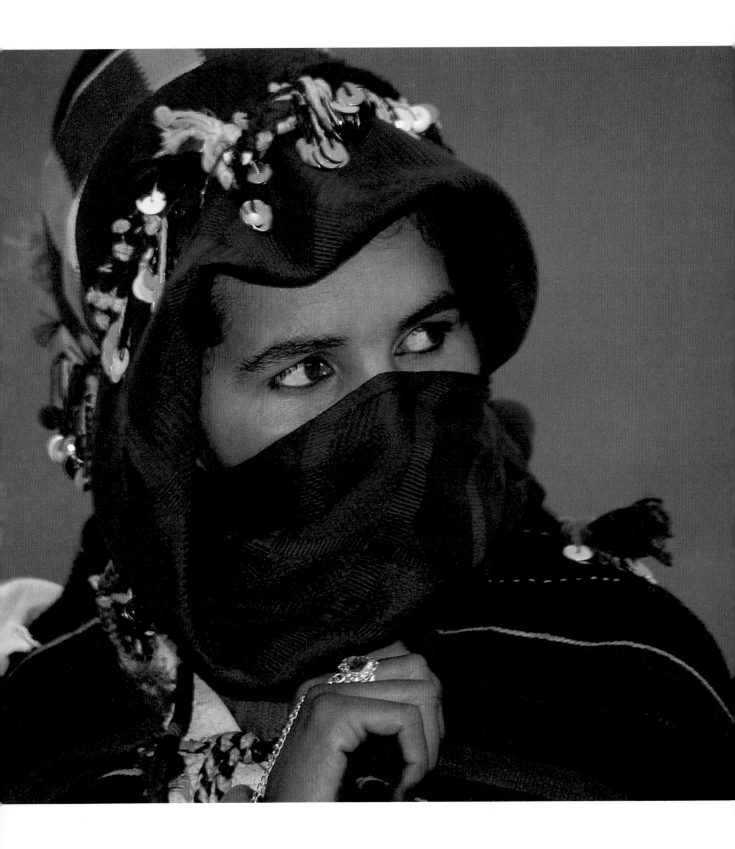

MOUSSEM OF IMILCHIL

WE STOP TO ASK DIRECTIONS IN THE HIGH ATLAS MOUNTAINS OF MOROCCO. TWO YOUNG BERBER WOMEN WEAR VIBRANT, BLUE SCARVES THAT SHOW ONLY BEAUTIFUL EYES OUTLINED IN KOHL. PROUD, TALL, SHY, THEY APPROACH THE WINDOW OF OUR SUV. INSTEAD OF SPEAKING THEIR NATIVE TAMAZIGHT, THE WOMEN SPEAK ARABIC WITH SARHAN, MY HANDSOME YOUNG INTERPRETER FROM TANGIER. THE WOMEN OFFER A GREAT DEAL MORE INFORMATION THAN WE ASK FOR. ONE REPORTS THAT HER MARRIAGE LASTED A MONTH, THE OTHER'S, A YEAR. BOTH SOUGHT DIVORCE QUICKLY, "BEFORE THERE WERE CHILDREN," BECAUSE THEIR HUSBANDS BEAT THEM. THEY INITIATED THEIR SEPARATIONS, SAYING, "I WANT NOTHING FROM YOU, KEEP THE GIFTS. I WANT A DIVORCE." NOW, ENOUGH TIME HAS PASSED THAT BOTH WOMEN HOPE TO FIND ANOTHER HUSBAND. EYEING SARHAN FLIRTATIOUSLY, ONE SAYS, "WILL YOU MARRY ME? IN FACT, YOU COULD HAVE TWO OF US!" SARHAN LAUGHS AND SAYS THANKS, HE ALREADY HAS A WIFE.

"A lifetime ago, all women, not just widows and divorcées, asked men to marry them," an old man squints, watching children play outside his tent. The wind blows dust into our nostrils and wisks the moisture from our eyes, but we don't move. The old man is going to tell us the story.

"Twenty kilometers away, near the town of Imilchil, there are two lakes. One is named Tislit (engaged girl), the other is Isli (engaged boy). The lakes are named for two lovers, a boy named Moha, a member of the Ait Brahim clan and Hadda, who was Ait Yazza. Their clans, different branches of the Ait Hadiddou tribe, hated each other. When the lovers' parents prohibited their marriage, they cried ceaselessly. The lakes were created by their tears.

"The Ait Hadiddou have lived in this part of Morocco since 1100 A.D. During the sixteenth century, they came here to Agoudal for the Moussem (pilgrimage) of Sidi Ahmed ou Mghanni, a Muslim holy man who was venerated for mounting resistance against the Portuguese. He admonished Ait Hadiddou parents to allow sons and daughters who were in love to get married. Everyone believed that if Sidi Ahmed blessed their betrothal, they would be happy for the rest of their lives.

"For many years, Ait Hadiddou girls and boys grew up together and if the girls proposed marriage, boys were required to accept. If both sets of parents approved of the idea, the fathers negotiated the dowry contract and the official papers were signed during the Moussem of Sidi Ahmed. No one married outside the tribe.

"When other tribes started to attend the Moussem (which was renamed the Moussem of Imilchil after the death of Sidi Ahmed), the rules changed. If a man proposed, a single girl could exercise her right to refuse. If she and her parents agreed to the proposal, she would be courted for a year.

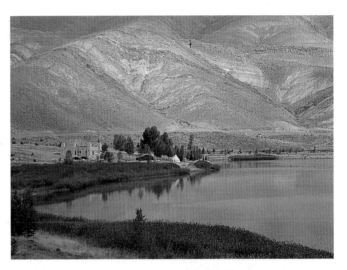

"But it is different for widows and divorcées. Three months and ten days after their husbands die or their divorces are final, they are free to remarry. There are many such women among the Ait Hadiddou. I have met a man who has been married and divorced nine times. At the Moussem, if a divorcée meets a man she likes, she can invite him to marry her. They can sign the papers in the official's tent and go home together."

Opposite: Ait Hadiddou women do not observe *purdah* (the practice of covering women so that they are not seen by men who are not relatives) but they veil their faces completely during wedding ceremonies. They are partially veiled at other times to protect their skin from the elements, respect strangers, or avoid spirits of "the unknown."

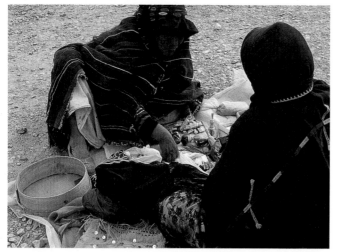

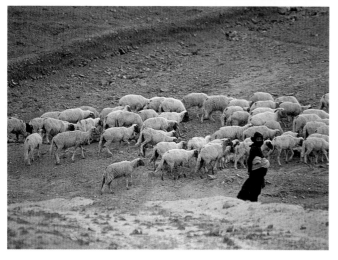

BERBERS IN MOROCCO'S HIGH ATLAS MOUNTAINS ARE FARMERS AND SHEPHERDS. EVERY YEAR, AFTER SPENDING SUMMER IN THE PASTURES, THEY CONVENE AT THE THREE-DAY MARKET IN AGOUDAL TO STOCK UP ON TOOLS, LIVESTOCK, AND PROVISIONS FOR THE WINTER, DURING WHICH THEIR VILLAGES ARE ISOLATED BY COLD AND SNOW. THEY CREATE A TENT CITY WITH THIRTY THOUSAND INHABITANTS. BUTCHERS AND BARBERS CONDUCT BUSINESS IN TENTS, AS DO MERCHANTS SELLING HARDWARE, EGGS, ICE CREAM, ASPIRIN, JEWELRY, AND CLOTHING. FOOD STALLS OFFER MINT TEA, GRILLED LAMB, AND COUSCOUS. ITINERANT VENDORS HAWK TAPES AND CIGARETTES. A NEARBY HILL TURNS DARK WITH HERDS OF CAMELS, COWS, MULES, SHEEP, AND GOATS, ALL OFFERED FOR SALE. EACH NIGHT THE TENTS, LIT BY LANTERNS, LOOK LIKE PEAKED PARCHMENT LAMPS. DRUM BEATS THROB THROUGH THE DARKNESS FROM THE MANY TENT PARTIES.

Although the Ait Hadiddou converted to Islam, they exist as a culture within the Moroccan culture, retaining their tribal traditions and beliefs. Not far away from Agoudal a hidden cave conceals water that locals claim cures sterility. When women approach strangers, they pull their veils over their mouths to keep bad spirits out. In the market, crones sell "women's magic"—rouge made with honey to neutralize the evil eye, powders to deflect the demons that cause spouses to argue, and love potions.

The ephemeral city is a perfect place for romantic encounters. Young widows and divorcées stroll among the market tents in two's and three's, wearing *handiras* (striped tribal mantles), scarves glittering with paillettes, seeming to shop for merchandise—but actually shopping for an ideal man: one who is four to six years older than they are, a hardworker who earns good money and does not use alcohol or drugs.

Above, center: All Ait Brahim women wear dark, striped *handiras*. Here, one stocks up on women's magic at the festival market.

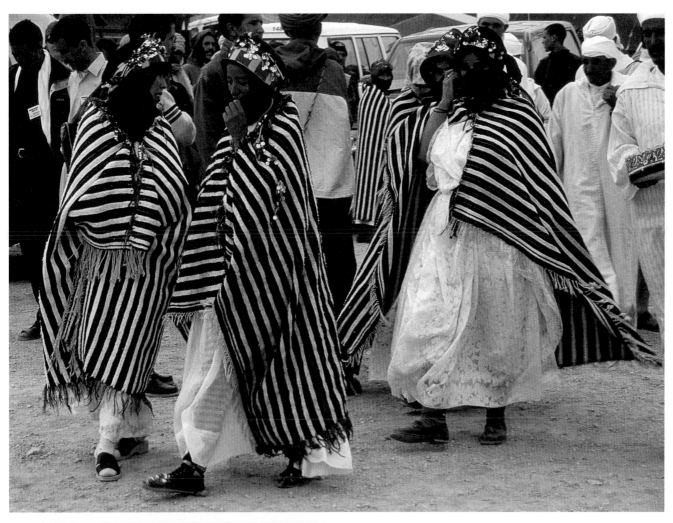

IF THE DIVORCÉES AND WIDOWS FIND MEN THEY LIKE, THEY MAY INVITE THEM TO SIT AND TALK IN THE VERDANT FIELDS NEAR ASSIF MELOUL, THE WHITE RIVER. NEARBY, THEIR VIRGIN SISTERS ARE CHATTING WITH THE MEN THEY ARE ENGAGED TO MARRY. COUPLES DOT THE GRASS LIKE BRIGHT FLOWERS.

Above, top: Ait Yazza women dress in black-and-white striped mantles.

IT IS DIFFICULT TO FIND AIT HADIDDOU WOMEN WHO WILL ALLOW THEMSELVES TO BE PHOTOGRAPHED. MEN HAVE CONVINCED THEM THAT IT WILL DESTROY THEIR REPUTATIONS. EVEN LITTLE BOYS TAUNT LITTLE GIRLS, "IF YOU LET THEM TAKE YOUR PICTURE, YOU ARE BAD!" SARHAN REMINDS ME, "THE MEN ARE CONTROLLING THE WOMEN WITH THIS RULE."

When I learn that a German television crew has paid one family two thousand dollars to allow them to film a wedding documentary, I decide to try their method. I offer seventy-five dollars to a family whose sixteen-year-old daughter has just reached marriageable age, is engaged, and will sign a marriage contract at the Moussem tomorrow. Sarhan negotiates with her male cousin, asking for an appointment to interview and photograph the fiancée and her mother. The girl protests, "My fiancé will not marry me if he finds out. I will be divorced before the wedding." I compromise and agree not to take photographs.

Hadda Oushba lives in the town of Timaryine, which looks over a valley. Below, a river irrigates geometric fields of crops. Here, dwellings are created from the same stone as the steep mountains. Families live in windowless rooms. Hadda's family's room is clean but bare except for some floor pillows, a rug, and a low table. There is an open fire on the floor where Hadda's mother, Fatima Gout, is brewing mint tea, which she pours into glasses.

I ask to record our conversation so I can quote Hadda and Fatima accurately. They agree but when I take out my recording gear, their neighbors burst through the open door shouting "She is unpacking a television microphone. She is going to take pictures!" Fatima explains, argues, and finally closes the door firmly.

Fatima wears violet cable-knit tights and a teal cable-knit sweater, layered over by a yellow tunic sweater. Hadda is "feeling special today, like a princess, better than the other girls." Her white, cotton dress is pinned closed with a silver fibula inlaid with a coral stone. Underneath, she wears a shocking-pink cable-knit sweater and navy cable-knit tights. She has painted kohl around her eyes and saffron under her eyebrows.

The conversation that ensues is laborious. Every question is translated from English to Arabic to Tamazight and the answer relayed back through all three languages. This awkward communication system doesn't keep us from chatting about Hadda's wedding.

Fatima likes the twenty-year-old man whom Hadda will marry. "They met each other in the fields where the men work and girls bring water. They talked there day after day and found each other good. He said, 'I like you, I love you,' and she said, 'I like you, I love you, too.' It is fine for me and my daughter, to find a man like that. He is a good worker, and they agree with each other."

Fatima, thirty-five, reminisces about the way she and her husband of seventeen years "talked with our eyes before we were married. My husband saw me lots of times. Too many times. We looked at each other, just looking. I liked him. He went directly to my parents to ask if he could marry me."

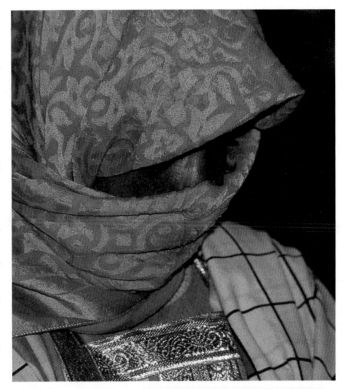

In preparation for tomorrow, Hadda will bathe, put henna on her hair, and do her makeup. Although tomorrow she and her fiancé will register an *acte de fiancailles* at the Moussem tent with many other couples, their wedding celebration will occur months from now. Then, her fiancé and his friends will bring his gifts to her house. The dowry contract her father negotiated includes henna, leather shoes, a scarf, a dress, a *handira*, soap, and oil for her hair. For two hours, musicians and dancers will perform. Fatima will serve the feast—soup, couscous with barbequed lamb, tea, and pastries.

Hadda will move to her husband's parent's house, where she hopes she will "live with him without problems." She will do the housework, cook, fetch water, and help her husband bring grass from the fields for the animals. Later on, she hopes to be the mother of two boys and two girls "and that," she bobs her head definitively, "is all."

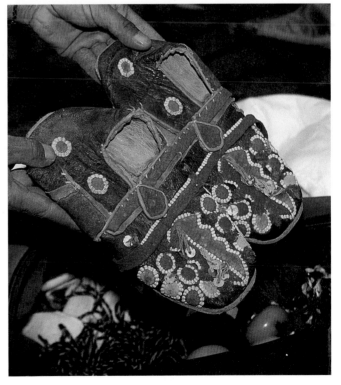

Fatima shows me how to tie the red-and-yellow plaid scarf and spangles that Ait Hadiddou virgin brides wear. She does it deftly but we laugh as I fumble with the complicated folds.

She explains that although women buy some fabrics in the market, she and Hadda weave wool from their twelve sheep when they want garments like *handiras*. She demonstrates carding and shows me a drop spindle she made, which has a piece of rubber truck tire for ballast.

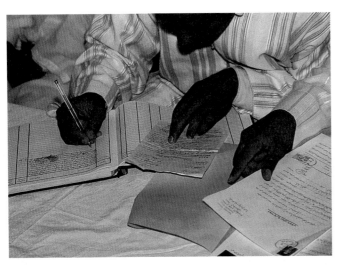

The next morning the fathers of all betrothed couples collect near Sidi Ahmed's tomb where Moroccan officials have pitched a huge notary tent. Inside, functionaries prepare the documents Morocco requires to register marriages. I scrutinize the numerous engaged women who are sitting next to their husbands-to-be. The women's silk scarves cover their faces almost completely. One by one, the couples approach the table and sign the registry. Although Hadda is surely among them, I never see her again.

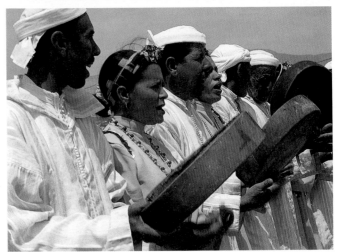

After the signing service, Ahidous dancers perform to tambourines, each standing shoulder to shoulder in a line chanting in response to the leader's words of Tamazight, dipping from the knees as the rhythm quickens, clapping, ululating, and celebrating with infectious exuberance.

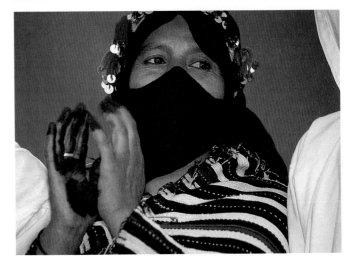

Above, top right: Tribe-specific tattoos signal social status and are drawn only by women who use a needle dipped in soot and water, then herb juice, which fixes the design and tints it blue.

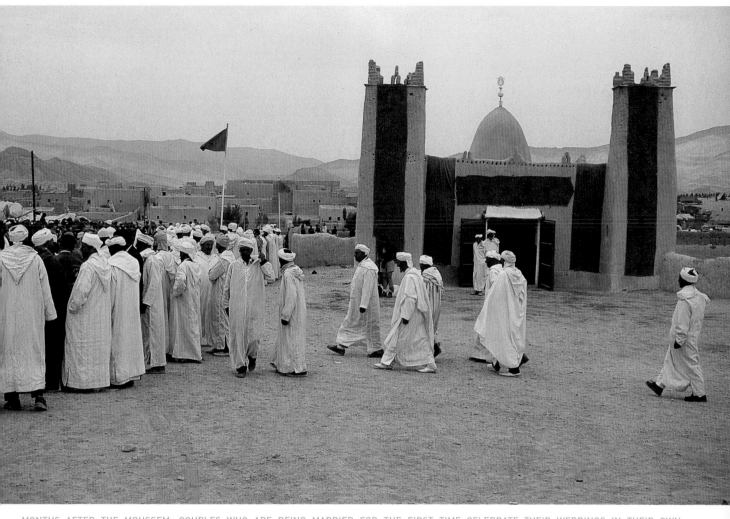

MONTHS AFTER THE MOUSSEM, COUPLES WHO ARE BEING MARRIED FOR THE FIRST TIME CELEBRATE THEIR WEDDINGS IN THEIR OWN VILLAGES. TO HELP JOURNALISTS AND TOURISTS UNDERSTAND THE EVENTS THEY WILL NOT WITNESS, THE MOROCCO TOURIST BUREAU SPONSORS A THREE-HOUR "ENACTMENT" OF THE AIT HADIDDOU WEDDING RITUALS THAT, IN REALITY, MAY TAKE FIVE DAYS. THE DRAMA OCCURS IN AN OPEN-AIR ARENA IN THE VILLAGE OF IMILCHIL. "*AVANTI!*" THE ITALIAN JOURNALISTS YELL. "*ASSEYEZ!*" THE EMCEE BARKS IN FRENCH TO THE PHOTOGRAPHERS WHO BLOCK THE VIEW. THE EUROPEAN PRESS IS HERE IN FULL FORCE DESPITE THE FACT THAT IMILCHIL IS SIX HOURS EAST OF MARRAKECH IN A PART OF THE ATLAS MOUNTAINS THAT IS ACCESSIBLE VIA ONE-LANE ROADS SANDWICHED BETWEEN HIGH CLIFFS AND TERRIFYING DROPS. THE LAST FEW HOURS OF THE TRIP MUST BE MANEUVERED THROUGH A RIVERBED OF ROCKS, INCLINES, MUD, DUST, WATER, RUTS, AND CRACKS. NEVERTHELESS, AT LEAST A HUNDRED JOURNALISTS MADE IT.

Above: Fathers and grooms gather outside the tomb of Sidi Ahmed ou Mghanni before they enter the *adouls* (notary tents).

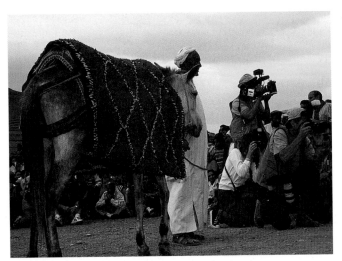

A woman in the groom's family sits with the couple. First, she performs a henna ceremony for the man. He puts some henna in the bride's hand as a symbol of peace, love, and good wishes for their future. Next, the couple is symbolically united—the woman intertwines the groom's fingers with red silk thread, and the bride's with yellow.

Songs, music, and dancing occur during each of these ceremonies. Ahidous line dances are accompanied only by the *bendir*, a tambourine about twenty inches in diameter and five inches deep that is hit from below. But special wedding dances also include the *gaieta* (oboe). The rhythms quicken, shifting from binary to compound to passionate to convulsive, then change completely and become haunting and smooth. Alternatively, the music is as rhythmic as a belly dance—and as melodic as a song the Ait Hadiddou believe "stops gazelles in the forest. When they hear it, they cannot move."

The wedding drama begins as a man makes his way through the crowd throwing dates into the air to announce, and invite people to, the wedding.

Women in the bride's family perform a henna ceremony, coloring the bride's hands, singing to ask Allah to give the girl a good new life, peace with her husband, children, clemency, prosperity, and continued fidelity.

Women in the groom's family knead dough for a loaf of crusty, circular wedding bread that is three feet in diameter. It will be delivered with the dowry, and shared among as many as forty of the bride's family and friends.

Now, the men in the groom's family wave olive branches for peace as they parade to the bride's home with a white donkey that carries the bread and a suitcase filled with the dowry gifts.

The bride is lifted onto the donkey's back. A little boy from her family accompanies her and these two are escorted to the groom's house, where many people welcome them. The groom's mother carries the bride into the house on her back because, according to Berber tradition, the bride's feet must not touch the ground.

Throughout the wedding enactment, photographers fight for prime positions aggressively, pushing and shouting. In a culture where women have been taught that photography is anathema, paparazzi are dreaded.

Yesterday, Hadda told me, "Many of my friends do not want to take part in the Moussem any more. Too many photographers, too little privacy." Although the Moroccan government invited journalists here for the first time forty years ago, hoping that publicity would kindle tourism, in fact, the journalists may be destroying this rich tradition. It is possible that, after five hundred years, the Moussem of Imilchil may not exist much longer.

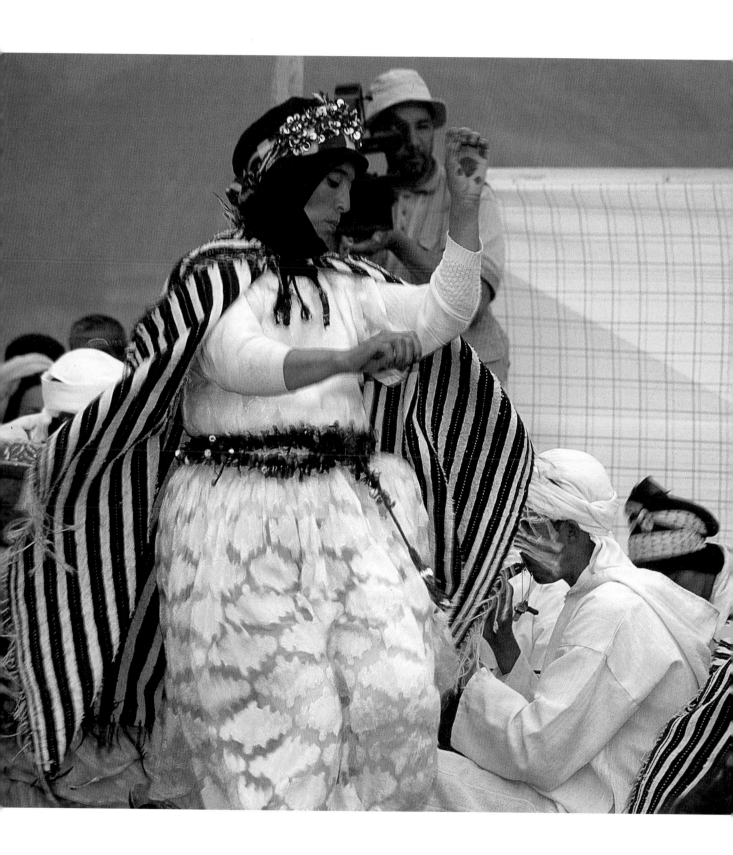

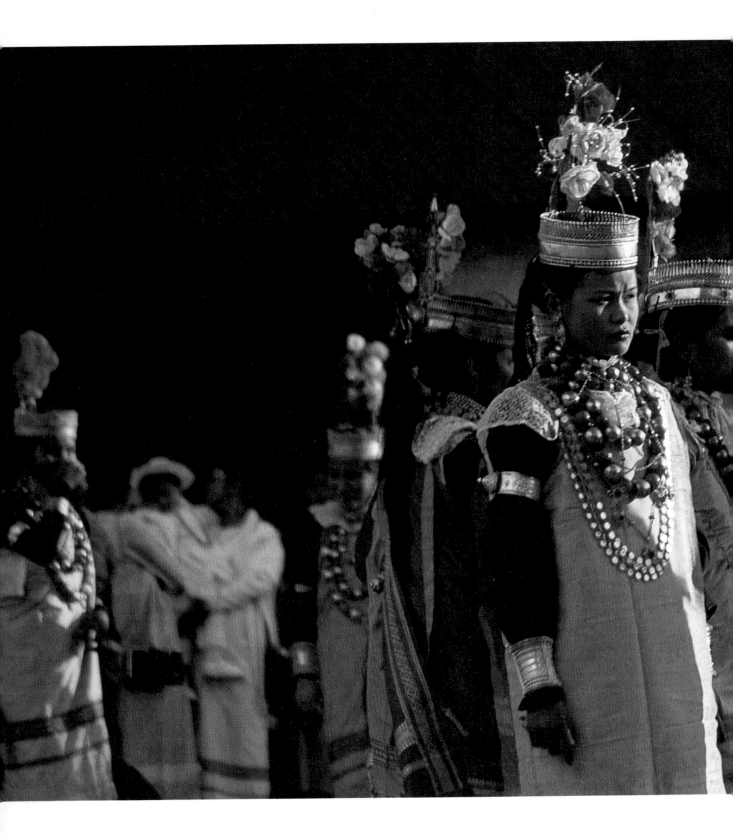

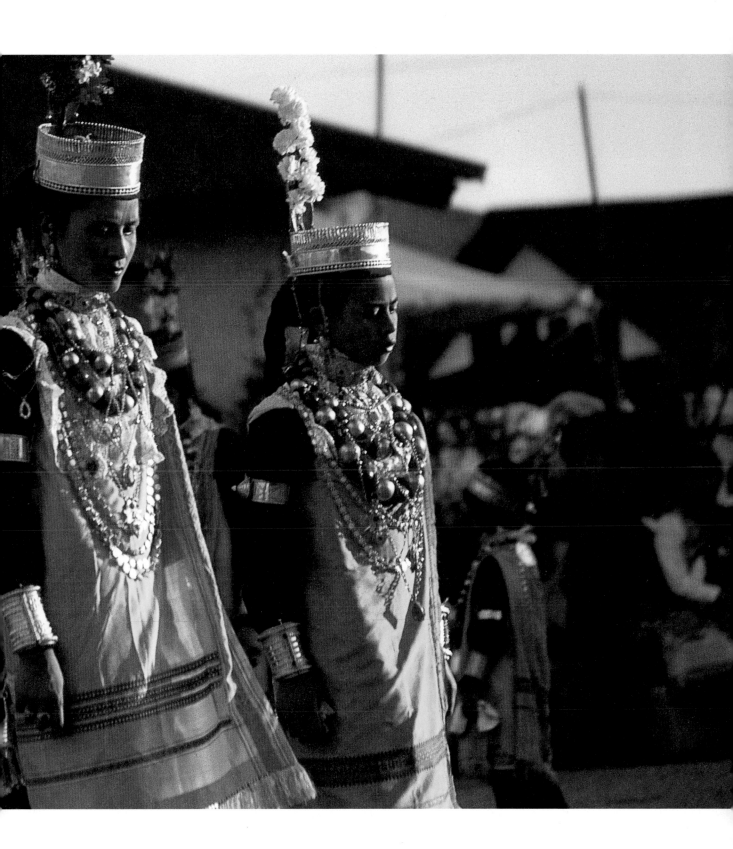

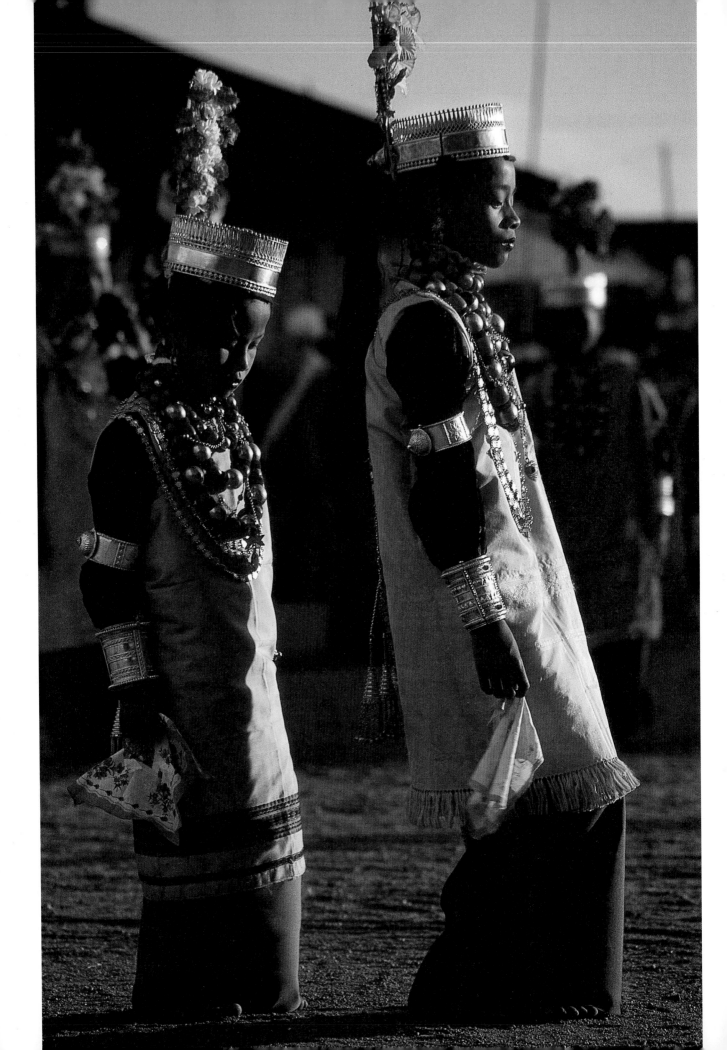

KA POMBLANG NONGKREM

THIS IS THE YEAR OF WOMEN'S EMPOWERMENT IN INDIA, BUT KHASI WOMEN ALREADY HAVE MORE POWER THAN MANY WOMEN IN THE WORLD.

In this matrilineal society, children take their mother's clan name and descent is linear from mother to daughter. Within the family, the youngest daughter becomes the custodian of her family's property—the eldest daughter assumes that responsibility in the ruling family. For each home, the woman is the guardian spirit. And the cooking and eating area, which is considered the sacred, is where religious rites occur. After marriage, grooms move into their mother-in-law's home.

The Khasi's omniscient, omnipresent, omnipotent God is addressed both as "She" and "He." A high priestess is responsible for the community's spiritual life. Her brother or son serves as king and is addressed by the honorific "Mother-Father."

Even the language reflects women's power. You can hear how many more feminine than masculine nouns exist because they are preceded by the article, *ka*.

The first written reference to the Khasis appeared in 1500 A.D. Since the beginning, the Khasi celebrated a great religious festival—the goat killing ceremony, now called Ka Pomblang Nongkrem, which takes place annually over five days at Smit, south of Shillong in the northeastern state of Meghalaya, India.

At the festival, the priest invokes the blessings of the ancestral mother of the ruling clan and her maternal uncle, God Shillong. They ask for the well being of the Khyrim kingdom and foretell the fortunes of their community for the following year.

Festival timing is set by the king, Balajied Sing Syiem, a physician by profession, and his council. The date is announced once a week by pipe and drum music at the home of the king's sister, Batriti Syiem, a high school principal. Some call her the high priestess, but she is more properly titled as the custodian of the community's spiritual life because, although she prepares all the articles for the festival ceremonies, she deputizes a priest to execute the rites. Her residence, the tribe's ceremonial house and one of the last, traditional turtle-shaped houses, is the festival site.

On the first night of the festival, the high priest sits near the hearth in the custodian's home. She gives him a gourd of rice beer, which he pours for the first ancestress and the first maternal uncle. Music and dancing take place in front of a holy pillar in the house.

The second day is spent cleaning the dancing courtyard in front of the custodian's house, and the path from the courtyard to the hill where the first goat sacrifice will occur.

The third and fourth days feature dances and sacrifices. There are twelve kinds of Khasi music, including distinct types for women's and men's dances. Both sexes wear costumes of embroidery and silk, plus heirloom jewelry, crafted by local artisans from coral, silver, and pure gold.

The most significant part of the women's costume is the crown, which symbolizes her dignity and the glory of the family. It carries a special fragrant flower that flourishes in distant, inaccessible places in the Khasi Hills. The blossom alludes to a favorite myth about the legendary progenetrix who, as a child, abandoned the cave where she lived because a man offered her this flower. He adopted her as his niece and took care of her until she became an adult. The flower symbolizes purity and beauty, attributes that the festival dancers embody.

Young unmarried maidens dance alone or in groups, moving almost imperceptibly, their arms still and their eyes downcast. They dance barefooted, pulling themselves forward with their toes. Some say they are collecting and conserving power from the earth. Others say they are demonstrating the modesty and dignity that Khasis value in women.

Men and boys of all ages, married or single, dance in a circle around the virgins, symbolizing the Khasi expectation that men will protect the women. Each wears a silver quiver that contains three arrows—one each to protect family, community, and state. Dancing in small groups, the men flash their swords and brandish goat-hair whisks. The dance is rhythmic, repetitive. Every once in a while, they kick backward.

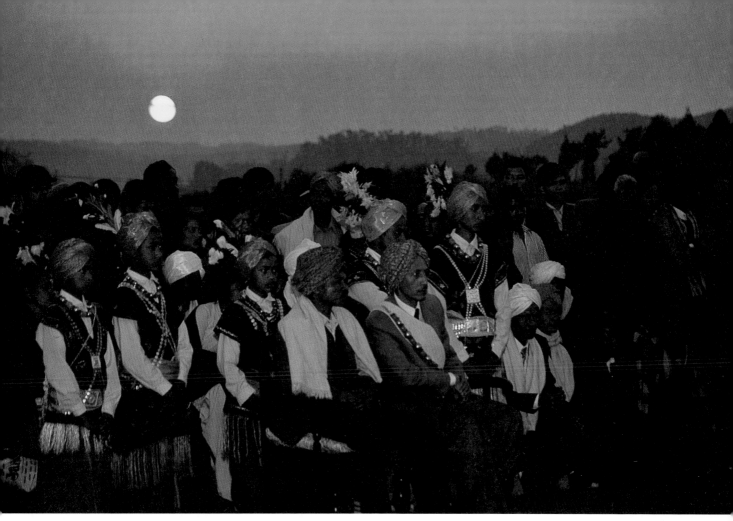

On the third day, dancers, musicians, the high priest, and the public accompany the king and the custodian's oldest daughter, who will ultimately succeed her, to the hillside. They carry basketfuls of ceremonial materials that have been prepared by the custodian who remains inside her house to fast and pray.

The high priest sits at a low, open altar, puts rice powder on a rooster, then smoothes its feathers gently with water and, using a single humane stroke, beheads it with a sharp knife. The priests examine the cock's intestines. Their position and markings tell him whether the next year will be good or bad for the community.

Later, a long-haired white goat that has been bred for this purpose, is allowed to crop grass and wander quietly until it, too, is beheaded with one stroke. Men shoot rifles into the air as the goat's body is whisked away. After it has been butchered, its lungs are inflated and the priest inspects them, again looking for omens of good or bad fortune. If there are signs of problems ahead, prayers will help identify the cause so they can be rectified.

That evening, village priests join the high priest in the custodian's courtyard to continue the cock and goat sacrifices, reading the future by the flickering light of torches and bonfires. People who live in the *raids* (counties) have brought sacrificial goats to assure community prosperity and honor the king. Ultimately, the animals are consumed with relish at a great feast.

The most sacred night is the fifth. The king, sitting on a raised platform facing east, proclaims complete silence. No one can sleep, talk, cough, sneeze, enter, or leave the courtyard. Everyone participates in silent prayer. Later, the king removes his turban, kneels, and prays aloud to God the Creator, asking for the wisdom and strength to look after his people without discriminating between women and men, rich and poor, powerful and weak. He asks for blessings, peace, and happiness.

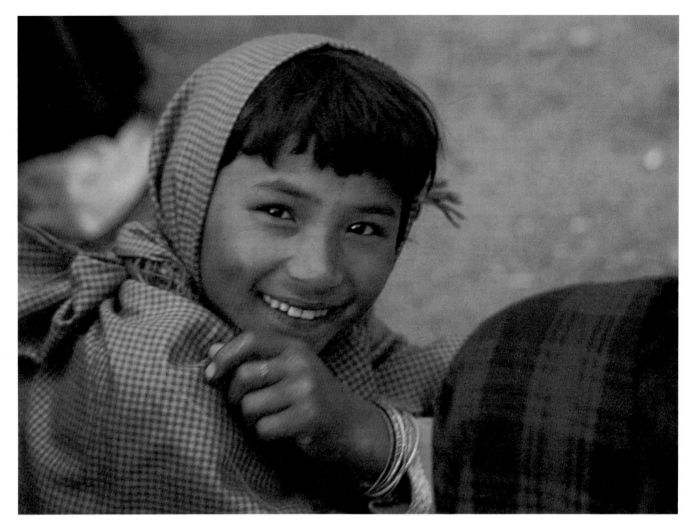

"Aims and Objectives: To give full authority to the father....lineage shall go down from father to son...."
—THE CONSTITUTION OF SUNGKHONG RYMPEI THYMMAI, 1990

"Traditionally, the Khasi man was a breeding bull to help produce children for his wife's clan," alleges Keith Pariat, the president of Sungkhong Rympei Thymmai, which may be the only men's liberation movement in the world.

"When I got married, I didn't want to stay in my mother-in-law's house. It would have killed my sense of myself as a man not to be head of the family. My children would listen to my mother-in-law and her sons. Her brother would be even more important than my father-in-law, who would come fourth or fifth in line. I would come maybe sixth or seventh in the hierarchy. My children would take my mother-in-law's name. Suppose they have a clan meeting—my wife could go, my children could go, I couldn't even peep through the window. If a father wants to say, 'I'm the boss here. Nobody bosses but me,' the custom doesn't allow him to do that.

"We hope to move the Khasi legislative assembly to frame new laws for lineage. Not the laws the district counsel made, which are foolish. They wanted to bring back such old customs as *rap iing*— if you don't have a daughter, you adopt a girl from the clan and give her your wife's name. The daughter produced by this girl will inherit your wife's property. The son is forgotten totally!"

"Did your wife understand these opinions before you were married?" I wonder.

"She refuses to understand, actually. Her sentiments are that we should not change rules that have been made by our elders. She agrees she should be Mrs. Pariat, but not that the children should be Pariat. At one stage, the report cards from school came home and I saw that our daughter's said Bethlene Kharkongor. I rubbed out Kharkongor and put Pariat."

"There must be tension about these issues in your family," I imagine out loud.

"Within my family I think I rule the roost."

"Does your wife think she rules the roost?"

"You've got to ask her that when I'm not around."

"How is your relationship with her maternal uncle?"

"Off and on we have a drink together. He understands it's not his duty to take care of my children—he has his own children. But in my in-law's house, basically they disagree with me totally. They feel that if everything is left as it was traditionally, it's quite all right.

"But it is not. A Khasi boy has no responsibility at all. Eat, drink, and be merry. Play the guitar. The men here are sinking so low morally and economically that Khasi women don't want to marry Khasi men, whom they say are useless drunks. Khasi ladies are marrying outside our society and even though their children have only 50 percent Khasi blood, they take their mother's name and are called Khasis so they can get reserved seats at colleges, scholarships, and jobs. [India's Schedule for Tribals designates quotas.] Sungkhong Rympei Thymmai is working for the betterment of Khasi society. Without change, Khasis are going to go extinct.

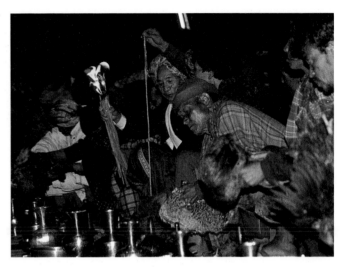

"The person to lead the family is the husband. Man is endowed by nature with more physical strength and—this may be controversial—a man's mind is more stable than a woman's. When someone dies, the womenfolk sit next to the dead body doing nothing but crying their heads off. If you get affected sentimentally, when there's a crisis I don't feel you can make good decisions.

"We are finding a lot of difficulty trying to change the Seng Khasi. They are total traditionalists and would like to carry on with the full custom of sacrificing chickens, reading entrails, breaking eggs to read signs about whether it's a good or bad year. You can't base scientific, intelligent life today on such things. You might as well go live in caves, eat from the jungle, and walk naked. If customs don't serve us, amend them so they suit the life you are leading at present."

Later, Lorna Marbaniang tells me, "If we changed to a patrilineal system, no one would know whom to marry. It would be chaos. It will not occur. It's no threat." "How's Keith's marriage?" I ask, since she is related and must know. "Happy," nods Lorna, "His wife just ignores him. If he changes their daughter's name on the report card, her sister, who teaches at the school, will change it back again and life goes on."

Prabhat's mother's maternal uncle was the first secretary of the Seng Khasi, which was founded in 1899 to guard Khasi customs against the Welsh Presbyterian missionaries who had been converting locals for more than fifty years—and insisting that their followers abandon tribal dances, traditions, archery, and funeral practices. But when they attacked Khasi kinship customs, the Seng Khasi mobilized to "revive true faith in our forefathers, to understand the true meaning of conscience and truth they handed down."

Bijoya Sawyan, Prabhat's sister, has translated Khasi folktales and the traditional Khasi code of conduct, which was written in poetry: "Marrying those forbidden by custom don't dare. / It's a sacrilege beyond compare," references how profoundly unacceptable it is for Khasis to marry a member of their own clan. These and many other Khasi books were published by the Sawyan family press, which was founded in 1896 and still exists.

It used to be obligatory to learn Khasi dancing at the Seng Khasi Hall and Prabhat continued to dance at festivals until he left to attend university in Delhi. "I was brought up in an orthodox family with rules and regulations. Parteii and I try to be more modern. We tell our children the basic tenants of the Khasis—and all civil societies. In the last few years there has been a resurgence and everyone wants to get back to the culture. Why? We are coming face-to-face with rapid, radical change. Some part of the subconscious says, 'Let's not get totally marooned.'"

Prabhat has just completed a restoration project at the top of Mount Sohpetbneng, a six-thousand foot peak near Shillong that towers over a misty range. He tells me that "the mountain is held sacred by the Khasi community and is referred to as 'the navel of the universe' because it used to be the umbilical cord between man and God.

As legend has it, thousands of years ago there were sixteen families on earth and in heaven. They used to visit both realms via a golden ladder. There was perfect harmony between man and God due to this direct communication. However, man became materialistic and selfish, earning the wrath of the divine power. After several attempts to bring man back, God severed the ladder and, in the process, nine families remained in heaven and seven on earth. Today, it is believed that the Khasis are still yearning to rebuild the bridge.

"The sacrosanct rocks remain on the mountain. Although traditional Khasi chieftains used to perform ceremonies there, they could not continue after the tribe was proselytized by the Christians. There was no one left to celebrate and the place fell into disuse. Ten or twelve years ago, the Khasi chieftain gave this sacred spot to the Seng Khasi. We walled it off, keeping in mind the vernacular concept of wall building. We cut the stones from that area, and brought in nothing from the outside. We tried our best to make it as pristine as ever, a heritage spot, open for everyone."

The next morning Parteii accompanies my guide, Tapoti Barooah, and me to the top of the mountain. We pass a field of ginger on the lower slope, then head steeply uphill, feeling fortunate to be in the Sawyan's jeep as our vehicle fishtails in the slippery mud. Suddenly the driver cuts directly into the woods, where the wild grass is higher than our roof, and stops. He slashes at the grass with a machete, beating it back, cutting it so we can pass.

The peak is a tangle of orange and red lantana and purple and yellow wildflowers. Bamboo platforms remain where the musicians sat to play for last January's pilgrimage. On the rocks, there are impressions of ancient footprints. Then silence. We look down on the other peaks. The Lake of Tears fingers out below. This is a sacred place.

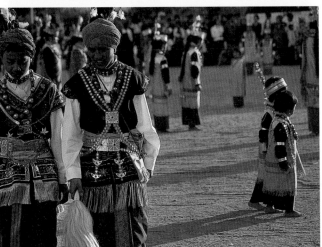

SILVERINE SWER, WHO WILL BE NINETY-ONE NEXT WEEK, SERVES ME TEA AND CRACKERS SPREAD WITH GUAVA JELLY THAT SHE HAS CONCOCTED FROM FRUIT THAT GROWS IN HER GARDEN. I INVITE HER TO REMINISCE.

"My mother considered me her cheapest daughter because I had no medical expenses. Then, in 1947, I started the rationing system here during the war, and walked every day in the rain and sun to educate people about it. One day I couldn't get up, I had a sheer breakdown and was in the hospital for two weeks! Imagine me, the nomad of the family!

"I think I am entitled to be called a nomad girl. I have been to Arunachal Pradesh for fifteen years promoting education among the tribal people. We moved through forests and deep waters and rivers, rocks and mountains. My job took me to the cities of India for meetings. I've been to Myanmar [Burma]. In 1973, I went to England and eleven countries in Europe. I've been to every creek and corner of the Khasi Hills.

"In 1953, I got an appointment as chief education officer in Arunachal Pradesh. I accepted. My mother didn't like it: 'No communications at all and you'll be touring around with the tigers and snakes and elephants.' That was the first time I had been on a plane: a chartered flight with bucket seats, goats, potatoes, supplies for the army, kerosene, groceries for all the population. I was an alien. Anyone who didn't dress like them, didn't speak like them, didn't eat from a leaf as they did, was considered an alien.

"In 1947, we started the first Khasi women's welfare organization here in Shillong at my house. Then I started a Girl Guide movement all over Assam, which included what is now Assam, Meghalaya, and Bangladesh, and traveled to the schools so girls could learn things outside the classroom—first aid, camping, outdoor activities.

Despite being a "nomad girl," Silverine Swer had never seen snow until she went to a meeting in Sweden. "I watched it come down and couldn't concentrate on the meeting at all. I told them, 'Excuse me, I just want to watch the snow in action.'

"After I retired in 1968, I never sat. I was chairman of the Central Social Welfare Advisory Board and traveled to help women organize themselves, get education, water, sanitation—the program was endless. I must say, everywhere I went, I started women's organizations. Can I say that I am all for women?!

"We have no sex inequality. The law tells us what women and men can and cannot do. Khasi women cannot perform sacrifices. The woman does not ask the man to marry her. Women must not sit on a village counsel. I think it's time they change that. I would like able women to be there—women who know the tricks of the trade and have wisdom and a moral character. I would like that very much. I would like half the parliament of India to be women.

"There is quite an open fight now against this old Khasi inheritance law that says women get everything. It's time to give some favor to the boys. Parents must give opportunities for both boys and girls—to get education, and to divide the family property half and half. Boys must have a share so they can have a start in life. It's a move with which I thoroughly agree."

I ask to take her picture. She perches on her front steps as if she were a little girl sitting among the pots of lady slippers, orchids, and ferns.

QUEENIE RYNJAH is now eighty-two. She has four sons but no daughter to care for her in her old age, so her youngest son has assumed responsibility and will inherit her property.

She is the president of Synjuk Kynthei, which translates as "Gathering of Women," whom she represented at the United Nations Fourth World Conference on Women in Beijing in 1995. "Eighteen of us attended from the northeast. There were school buildings, halls, apartments, and a printed catalog. Well organized, I must say. I attended a program about indigenous medicines. In the olden days, women went into the forest, but now this woman grows them. Khasis use this kind of medicine even for fractures and burns."

An English teacher, Queenie is proud that when her organization launched in 1947, they founded "a preschool for the little tots so they could learn the three R's and singing, which is a great specialty of the Khasis." The organization later branched out into income generation projects: "In a center here in town, we got some machines, an instructress, and she taught women how to cut and sew garments for children. We taught knitting and took orders to produce school uniform sweaters for the children." And recently, "seventeen kilometers from Shillong, we opened a maternity center with a midwife and a doctor who comes once a week. Medicine in the villages, a very sad condition. Education, a problem. Housing—the government talks about giving money but somehow there's a mess up and the money doesn't reach the people.

"The village woman farms bamboo, gets water, dresses and bathes the children, cleans the house, washes clothes, cooks vegetable soup: often without meat, she has so little money. She carries her baby on her back, works fourteen hours a day, and doesn't have time to stitch a button on."

City Khasi women live very different lives. "In town, we have become quite affluent. We have servants; if we don't have servants, we have gadgets for our kitchens. Lots of women are government employees, teachers, or engineers who conduct technology programs." But Queenie does not think that is enough.

"Here, only men vote. We've been saying that we should have representation. From the women's point of view, there are certain things men do not observe and cannot understand or appreciate. It may take years for men to feel that women are part of the society. Now they feel 'her kingdom is the kitchen.' We shouldn't ruffle them too quickly. Women in Western countries took many years to get the vote. If the ladies and men work together, it will be a much stronger force."

Above: Women are active vendors at the traveling markets. The days of the week are named for the towns in which markets occur.

"EVELYN NORAH SULLEI IS MY NAME BUT NO ONE WILL KNOW WHO YOU ARE TALKING ABOUT. I AM KNOWN AS RANI KONG. *RANI* MEANS 'QUEEN.' *KONG* MEANS 'ELDER SISTER,'" SMILES THE WOMAN I'VE BEEN TOLD HEADS A KHASI CLAN. "AMONG THE SULLEI FROM MY GRANDMOTHER'S SIDE, I AM THE ELDEST WOMAN NOW, EIGHTY-FOUR YEARS OLD."

I ask what changes she has seen in this culture. "When I was young, we followed the advice given by our elders strictly. That is gone now. I attribute the change mostly to television."

I confess, "I talked with a man who feels the changes can be attributed to...." She finishes my sentence: "The matrilineal system? If that is their feeling, I keep telling people, 'Why don't you make a hue and cry and the constitution can be changed! You just sit around the fireplace and criticize your own society. Gather all the men and put forward your reasons why this should be changed!' I do not want the system to change, but if they do, they must come forward."

She has witnessed young people changing. "Counting my grand-daughters, there are four generations of educators in my family. I was inspector of schools. My youngest auntie was a head mistress and I followed her footsteps. Most of my cousins also were teachers, but government retirement age is fifty-eight here and most of them have retired, of course." "Of course?" I tease, since she is still teaching twenty-six years later.

"Before, children would sit in the classroom like dumb animals," Evelyn goes on. "They wouldn't even raise their eyes to look at the teacher because the system did not allow them to participate. That has changed completely and the students are the ones to say, 'What happened in Russia?' 'What happened on September 11?' Another change is the huge percentage of dropouts. Also, drinking at a young age—and drugs, I believe they are rampant.

Nine years ago, Rani started a school in her house for underprivileged children. Tuition is one hundred rupees a year (two dollars USD) because "children do not value what is free," and 553 boys and girls are enrolled, ages three to sixteen. "Sometimes for a whole year, these children of day laborers would not be able to attend school. Now, they can come." I ask what inspired her to start a school. "I don't need anything more. God has blessed me with a lovely daughter, son-in-law, and grandchildren who take wonderful care of me. I want to give to others whatever talent God has given me, as long as I can."

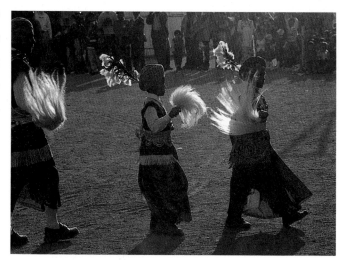

SITIMON SAWIAN LIVES IN THE HOUSE WHERE SHE WAS BORN, WHICH WAS BUILT IN 1897. I VISIT HER SEVERAL TIMES AND, AS A PROMINENT KHASI FAMILY MEMBER WHOSE CLAN IS LISTED IN THE HISTORY BOOKS, SHE GENEROUSLY SHARES WITH ME HER UNDERSTANDING OF THE FESTIVAL, THE CULTURE, AND WOMEN'S ROLES. SHE SERVES TEA TO TAPOTI AND ME IN HER LIVING ROOM, WITH ITS BLUE AND WHITE TOILE CHAIRS, BRASS COFFEE TABLE, WOOD FLOORS, AND CABINETS. ITS BOOKCASES REACH THE CEILING. AT SEVENTY-EIGHT, SITIMON USES A WHEELCHAIR SO SHE INVITES A YOUNG HELPER TO FETCH BOOKS. SHE WANTS TO GIVE ME ACCURATE ANSWERS FOR EVERY QUESTION, AND SPEAKS CAREFULLY, FOLLOWING THE KHASI QUEST FOR TRUTH. HER KNOWLEDGE IS THREADED THROUGHOUT THIS CHAPTER. IN FACT, WITHOUT HER, THIS CHAPTER WOULD NOT EXIST.

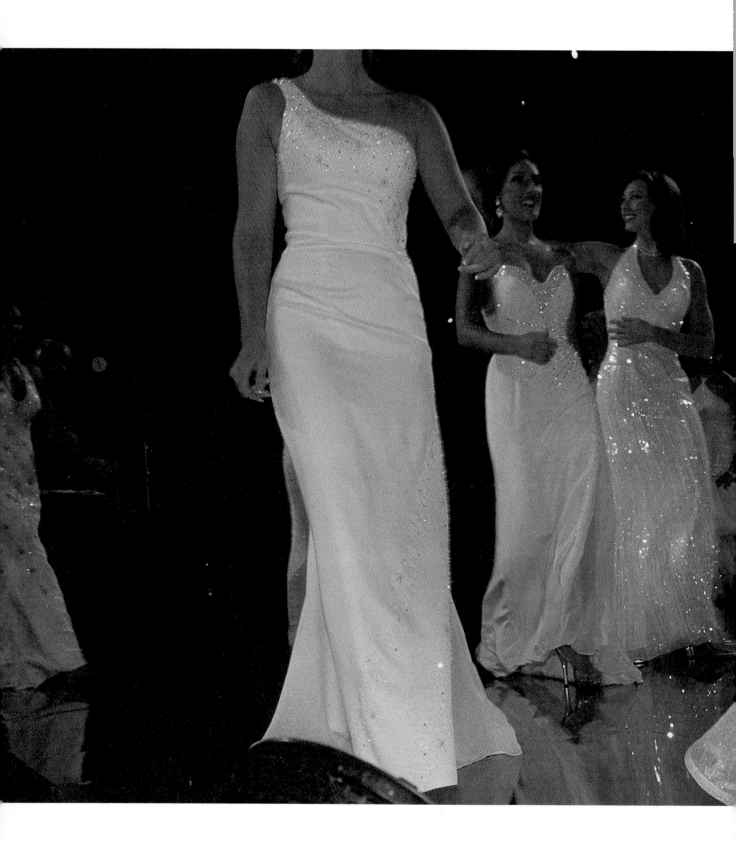

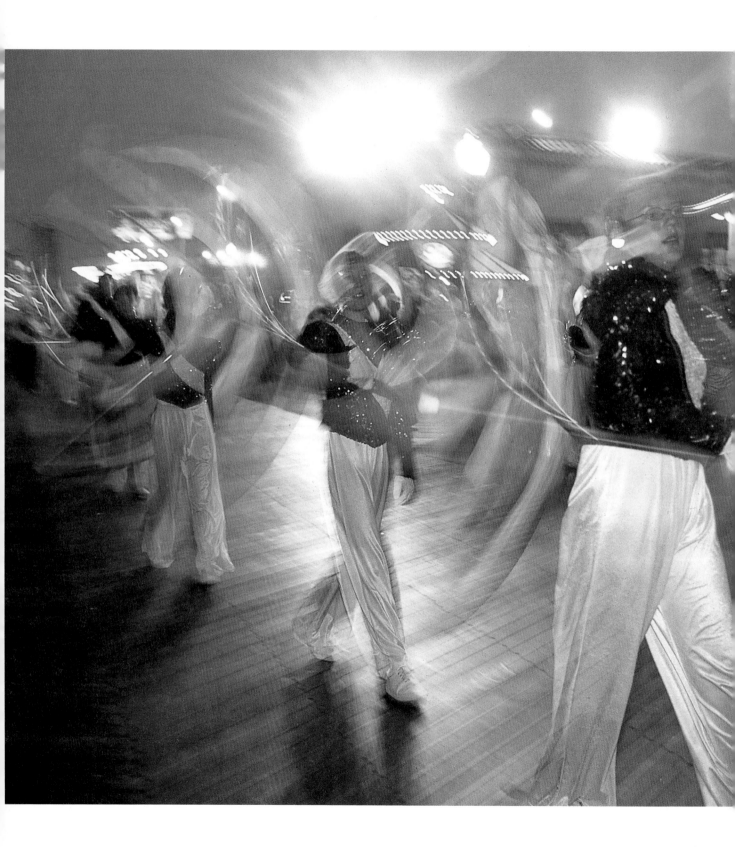

There she is, Miss America!
There she is, your ideal!
The dream of a million girls who are more than pretty
May come true in Atlantic City
For they may turn out to be the queen of femininity!

There she is, Miss America!
There she is, your ideal!
With so many beauties she'll take the town by storm
With her All American face and form!

There she is,
Walking on air she is,
The fairest of the fair she is,
Miss America!
—BERNIE WAYNE

In 1920, merchants in Atlantic City, New Jersey created a new promotional event, the Fall Follies, which they hoped would extend the Atlantic City resort season beyond Labor Day. That event was the precursor of the Miss America Competition. Bathing beauties were pushed in rolling wicker chairs along the boardwalk. The first winner of what was then the Golden Mermaid award, was wrapped in the American flag. Samuel Gompers, head of the AFL, told *The New York Times*, "She represents the type of womanhood America needs—strong, red-blooded, able to shoulder the responsibilities of homemaking and motherhood."

Eight decades later, most Miss America contestants plan to become senators, lawyers, or doctors, if not the President of the United States of America. Being pretty, poised, and nice only gets them into the game. The swimsuit competition, like an appendix, contributes little.

TODAY'S MISS AMERICA IS DEDICATED TO COMMUNITY SERVICE, SOCIAL CHANGE, AND SCHOLARSHIP, AND SHE IS A TALENTED PERFORMER. FOR THOSE ATTRIBUTES, SHE IS REWARDED HANDSOMELY.

Every year, the Miss America Organization provides contestants with $45 million in scholarships. That's more scholarship money than women receive from any other institution in the world.

Twelve thousand seventeen to twenty-four year olds enter local Miss America competitions each year, and are winnowed through the state and national competitive process.

The centerpiece of the final competition is a twelve-minute private interview with the judges in which contestants field questions mostly about their "platforms"—social issues they contract to promote while they travel all over the country as Miss America, logging twenty thousand miles a month. This interview counts for 40 percent of their score. It's even more important to speak well about their platform than to be accomplished at their talent, which counts for 30 percent. After all, later on, the "Today Show" or the Boise Rotary Club will want Miss America to talk to their audiences, rather than perform a two-minute Rachmaninoff prelude or demonstrate Tae Kwon Do, as contestants do during the competition.

In preparation for the finals, contestants submit a page describing their platforms. This year's winner wrote an action plan that mapped out a yearlong campaign of events, contests, speeches, and handouts. She identified public policy objectives and partners who had earmarked organizational funds and agreed to meet in New York the week after she was crowned.

So, interview and talent components total 70 percent of the score. Contestants model evening gowns to demonstrate poise (10 percent) and swimsuits in which they are judged on fitness (10 percent), not pulchritude. The final 10 percent is earned during an onstage quiz that tests, under intense pressure, contestants' awareness of current events and American history.

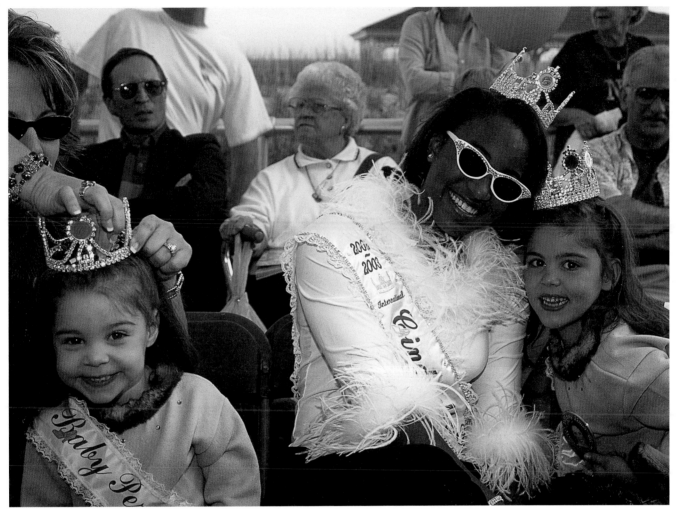

WHAT DOES THE NATIONAL PUBLIC GET TO SEE OF ALL THIS? ONLY THE ELEMENTS THAT MAKE "GOOD TELEVISION." EARLY IN THE TV SPECIAL IS THE SWIMSUIT COMPETITION. THEN EVENING GOWNS. FIVE OF THE FIFTY-ONE CONTESTANTS PERFORM, AND BECAUSE TWELVE-MINUTE INTERVIEWS WOULD BORE VIEWERS, NOT ONE IS SHOWN. THE MISS AMERICA COMPETITION IS TRUNCATED, CHERRY-PICKED IN AN EFFORT TO REGAIN GOOD TELEVISION RATINGS—EIGHT MILLION WATCHED IN 2002 BUT TWENTY-SEVEN MILLION TUNED IN DURING THE 1970S.

Many people wrongly believe that Miss America is an irrelevant, sexist beauty pageant for blond bimbos with big hair. Thirty years ago, feminists vehemently protested those attributes.

But today's cognoscenti see the competition differently. During Finals Week in Atlantic City, rhinestone crowns teeter on the heads of former winners and wannabes—little girls, teens, and even grandmothers.

The contestants themselves set their hearts on the title and invest months, sometimes years, in preparation. A constellation of volunteers in the nonprofit local, state, and national Miss America organizations raise money for scholarship prizes and, with consultants, train and polish the contestants. On television, the state winners look almost equal: perfect and glamorous. As Olivia Barker of *USA Today* wrote, "Think Las Vegas. Think Ice Capades."

I INTERVIEWED TEN CONTESTANTS DURING THE WEEK OF PRELIMINARY COMPETITION IN ATLANTIC CITY IN 2002. THEIR WORDS WILL TELL YOU WHO THEY REALLY ARE.

TERESA FRANCISCA BENITEZ, Miss Nevada

"The first papers I signed as an adult, three weeks after my eighteenth birthday, were to file with the IRS for 501c3 status for the nonprofit I co-founded, the Nevada Empowered Women's Project. We advocate for families that need resources and help. And we bring to policy makers the voices of the true poverty experts, the women who live in poverty, take the bus to drop off their three kids at childcare, and go to a job that won't even cover the cost of the childcare. I was president of the project for four and a half years.

"I'll be heading off to the University of Michigan to get my masters in social work, then I hope to become a senator and write public policy on social welfare issues like Medicaid, food stamps, healthcare, education. I have done internships with the Nevada state legislature and lobbied on Capitol Hill four times. I can't wait to set the agenda.

"My father was from Guadalajara and came to this country at sixteen. Mother is caucasian from Washington, D.C. Although she married a man who was wonderful, handsome, and charming, he developed a problem with alcohol. Because of domestic violence, my mother had to make a decision to take me and both my sisters and leave when I was four years old. My father is not part of my life. He took his culture with him. I felt he couldn't do that because the heritage was part of who I am. I won a $5,000 Miss America service award for the work I did with the Nevada Empowered Women's Project. I used it to hop on a plane to Santiago, Chile, to brush up on my Spanish and see what life is like outside the United States. I lived with a host family and took seventeen credits, had classes five hours a day, four days a week.

"I am the first woman, and the second person, in my family to get a degree. My mom thought the idea was great, but she said, 'College costs money, honey.' Here's my mom slinging hash in casinos and restaurants around Reno to make ends meet. When we couldn't make them meet, my sisters and I lived with my maternal grandparents. My boss at Junior Achievement told me about Miss America. When I walked in, I wondered why everyone looked scared. Then they began talking about being Miss Sparks, Miss Nevada, Miss America, and I thought 'Whoa, wait a minute!'

"The Miss America Organization has funded my entire undergraduate degree. I now have about $15,000 to apply toward graduate school. Whether I walk away with the crown or not, mission accomplished."

Teresa stunned the judges and audience with her dramatic monologue from The Laramie Project, *a two-minute excerpt from Matthew Shepherd's father's testimony during the trial of the men who murdered his gay son in 1998. She was named third runner-up to Miss America, and won $44,000 in scholarships during the competition in Atlantic City.*

Above, top: Teresa Francisca Benitez
Above, bottom: Vanessa Short Bull

VANESSA SHORT BULL, Miss South Dakota

"I'm from the Oglala Sioux tribe, a direct descendant of Short Bull, who brought the Ghost Dance religion to South Dakota. Ghost dancers believed dancing would bring back the buffalo and the lands, making it possible to return to their normal lives before they were placed on reservations. The cavalry saw the Indians dancing at Wounded Knee and thought it was an uprising. They massacred three hundred fifty women, children, and men.

"I am also a direct descendant of Chief Red Cloud, a great diplomatic leader who saw that being placed on reservations was a way for his people to survive. He asked the government for education and health care for his people. We are, as a result, some of the most cultured and educated people around, I think.

"Our culture is a matriarchy. We talk about Mother Earth. Women are the teachers. My grandmother secluded me and taught me that women, the life givers, are protected by the men so women must support men, whose lives might be lost. I had to feed my brother before I could eat, but I understood my role as supporter and his as protector. I learned how to do Indian dances from my grandmother, went to powwows with her, learned stories from her. I love Indian dancing. I dance to my own drum beat.

"When we lived on the reservation, we had television but my father didn't want us to watch the sexual, violent shows. We only got to see classics. I saw *Million Dollar Mermaid* with Esther Williams and Maria Tallchief, who inspired me to be a ballerina. When we moved off the reservation, we found my dance studio before we found a house.

"LIKE EVERYONE ELSE, I AM HERE FOR THE SCHOLARSHIPS. WHY ELSE WOULD ANYONE WEAR THESE RIDICULOUS SHOES?!"

Vanessa danced The Dying Swan *from "Swan Lake" as her talent. Her platform, Political Participation, focused on increasing voter turnout. She intends to be a tribal lawyer. She won a $5,000 scholarship during the Atlantic City competition.*

SHOHA KIRTI PAREKH, Miss Delaware

"My father came from a poor family in India. His father died when he was nine so his mother raised five children including a mentally retarded daughter. He came to the United States in the early seventies to find work so he could send some money back. After a few years he returned to Gujarat, got married, and my mother followed him to the United States. Within a few years my brother and I showed up. This is the American Dream.

"Photography comes naturally to me. I come from a long line of musicians and artists. I needed to get into something to say, 'Hello, please listen to me.' Image was the way to do that. It began with self-portraits about complications of being a woman: how difficult it is to be feminine and powerful without being aggressive. As I got more comfortable with myself, I was able to photograph the people around me. I did my senior thesis on my family in Baroda, India.

"I've been doing community service since I was twelve. My family understands that being a good person will take them into the next lifetime as a better person. I teach photography in Boys and Girls Clubs once a week. I begin teaching by saying: 'Know that this world you live in is art. Everything you breathe, speak, eat, is art. You can appreciate the beauty in everything. So go photograph.' At first, they're going, 'What is this mumbo jumbo,' but I want to show boys and girls how to appreciate the life they've been given. To be honest, not all of them have been given a bowl of cherries. A wonderful thing just happened. The Boys and Girls Club decided to send ten girls to watch the Miss America finals Saturday night. They're bringing their cameras.

"I was not raised on pageantry. I contacted the local Miss America people to ask if I could photograph one of their pageants to compare it with the Indian pageants I had been documenting in this country. It interested me that women of Eastern heritage were conforming to Western ideals without including themselves in the actual organization. This subculture was rising, separating themselves, doing the same thing as Miss America. The women on the local committee reviewed my portfolio and agreed I could shoot—then asked me to compete. I thought, 'Yeah, right. Are you kidding me? This is not my style at all!'

"Then I thought about it. Why wouldn't I use this opportunity to put the word out that Boys and Girls Clubs exist and that with the arts we can really make a difference?

"AND TO SAY TO LITTLE GIRLS, 'YOU DON'T HAVE TO HAVE BLOND HAIR AND BLUE EYES. THERE ARE LOTS OF WOMEN WHO LOOK OTHER WAYS AND ARE JUST GORGEOUS.' I'D NEVER SEEN YOUNG WOMEN WHO REFLECTED MY APPEARANCE OR ANY OF MY BELIEFS IN THE MISS AMERICA PAGEANT. I DECIDED TO TRY IT. I HAVEN'T MET AN UNINTELLIGENT WOMAN HERE, NONE WHO ISN'T BEAUTIFUL IN PERSONALITY AND CHARACTER. IT FEELS AS IF I HAVE A SISTERHOOD I'VE NEVER HAD BEFORE. IT'S WONDERFUL."

Shoha, who started dancing when she was nine, performed a classical Bharatnatyam dance, which is indigenous to South India. She won a $5,000 scholarship during the competition, which will help fund a Ph.D. in South Asian Art History. A few weeks after the pageant, her first one-woman photography exhibition opened in a Delaware art gallery.

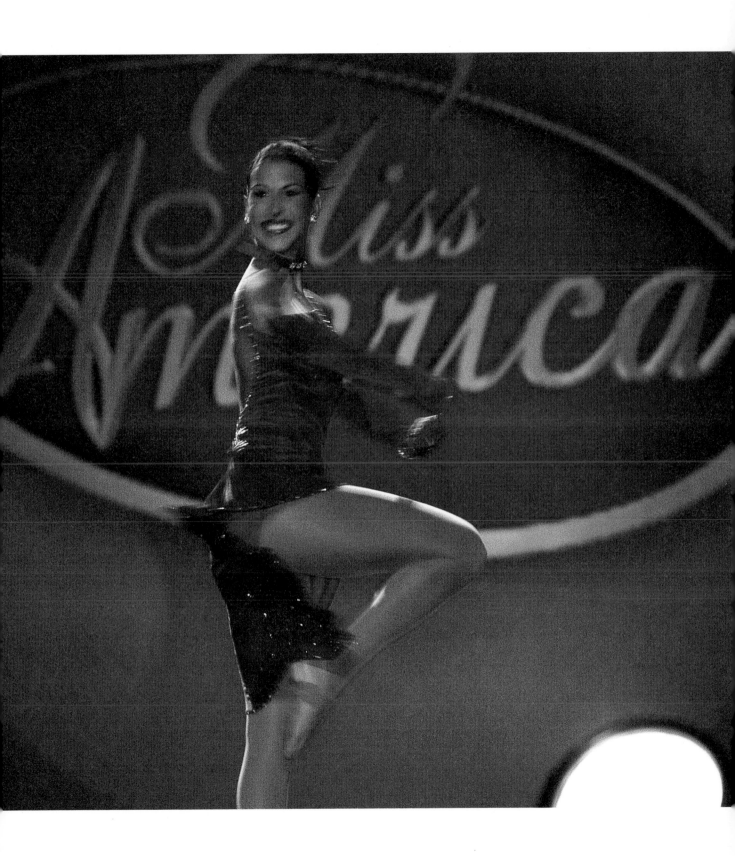

KEHAULANI CHRISTIAN, Miss Hawaii

"I lived in Japan, dancing with Tokyo Disneyland for a year as a Polynesian dancer in Mickey and Minnie's Polynesian Paradise. For three weeks, we had an interpreter. After that we had to pick up the language.

"My roommate told me everyone climbs Mt. Fuji in the summertime and asked me to come. I'm scared of heights but ended up going. We started at midnight in thunder and lightning. We couldn't see the top of the mountain behind the dark clouds. There are pathways in some places, but some of it is like scaling a mountain; you hang onto a chain and pull yourself up. My flashlight burned out.

"At one point I was so tired I had to lie on the ground. Old Japanese women were telling me, "Go! Go! Go!" as they passed me by. Once we got above the storm clouds, it was nice. I saw my first shooting star. We saw the sunrise at the top at 4:30 in the morning. I'm really glad I did it. I will never do it again.

"You have to be strong and independent to compete here. To stand up and give a speech about your platform that you believe in wholeheartedly, not knowing how the audience will react and not even caring. My platform is A Child's Right to Read. People told me that children's literacy wasn't a platform issue. I said, 'That's because you can read.' I work in the ESL classroom of a middle school. The children, mostly ages eleven to sixteen, are from other countries, so they are grades behind. I work with autistic students—a lot of the students have multiple life challenges—and with students at the community college to involve them in programs like mine.

"For me, this pageant is about scholarships. I was either going to win a scholarship in the Miss Hawaii competition or return to Japan and dance. Because of 9/11, the casting at Disneyland Japan was postponed until a week after the Miss Hawaii preliminary. Something like 95 percent of the state population watches Miss Hawaii on TV, so I wanted to do a good job and win. I didn't want to be the 'Pageant Perfect Girl,' I wanted to be myself. I'm an entertainer and a performer and I thought, 'Even if I don't win, I can be happy that I showed them the person I am.' It worked out perfectly.

"I came to Atlantic City to watch last year's finals, but I never thought I would be on that stage. Never in a million years."

Kehaulani performed a Tahitian dance that astonished the audience, and won a $5,000 scholarship, which will help this National Dean's List student complete her B.A. in public relations.

ERIKA HAROLD, Miss Illinois

"In the ninth grade, I was a victim of pervasive racial and sexual harassment. My mom is African-American and Cherokee Indian. My dad is Greek, German, and Russian. Our home was vandalized, eggs tossed through a bedroom window, electricity was cut. I overheard a conversation in which kids discussed pooling their lunch money to buy a rifle and kill me.

"The experience caused me to become very withdrawn. I always loved to sing, but the voices of those kids were in my head making me think that I couldn't. To be on that stage last night in the preliminary competition, realizing that I'd come so far to be able to sing 'Carmen,' one of the most flamboyant characters in all opera, was very gratifying.

"Now, I work against bullying and violence in high schools. Teachers and school officials look on it as normal adolescent behavior. So I talk to kids and share my story, break the silence. As Miss America, I'm going to work to get more states to implement anti-harassment policies; only twelve states have them. And I will work with Title Nine and sexual harassment. Each school that receives federal funds is mandated to have a sexual harassment policy and distribute it to the students. A lot of schools don't have this. I'm talking about issues that resonate for kids; the American Association of University Women did a 2001 survey and found that 80 percent of students are harassed at some point during their school lives.

"Miss America is more an icon than a woman. The icon is perfection. Someone who says all the correct, PC things. Someone vanilla. My ideal Miss America is someone who chooses to define the job. I see the role of Miss America as an activist, a leader, a role model and, most of all, an agent of social change. You have an incredible opportunity at the age of twenty-two, to have the world listen to what you say. If you chose to squander it by talking about issues people already believe in, then you have missed your chance to make a mark.

"My sister was the third runner-up in the Miss Illinois pageant. We competed against each other. It was her first time, my third. When it got down to four of us, we realized there was a 50 percent chance that a Harold was going to be Miss Illinois! On the video, we are talking together, in this zone, our own little family moment. Her big goal was to win the academic award and I really wanted to win the community service award. We both won the ones we wanted and we were overjoyed.

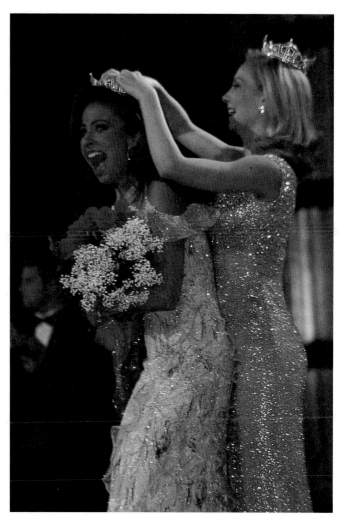

"It took so long to get to be the person I am today. It took time to realize that the things said to me in middle school had no bearing on the person I am now, and that I could use the empathy I found in those experiences, to touch the lives of young people."

Erika Harold opened her twelve-minute interview with the seven judges by acknowledging, "I have come to apply for the job of Miss America." She got the job and was crowned Miss America 2003. A Phi Beta Kappa student whose mother homeschooled her through the fourth grade and taught her to read at age three, Erika will use her $58,000 scholarship to attend Harvard Law School.

JENNIFER PITTS, Miss Virginia

"To finally get here! I'm here! My first pageant was at age seven. Little girls in my dance class entered. We walked around in our party dresses. My sister won twice and crowned me when I won five years later. I learned to lose long before I learned to win. I competed five years to get to Miss America. I had to learn to appreciate the judges' constructive criticism and to want to win enough to go back the next year.

"My father's the Englishman who says he's Italian by marriage. My mother's parents came from Rome and Capri. My mother grew up in an Italian ghetto in Providence, Rhode Island. When I go there, it's as if I've never been away. Italians have a unique culture, bonded together, family oriented.

"I was inspired to volunteer with Make-A-Wish when my sixteen-year-old cousin Christopher was diagnosed with non-Hodgkin's lymphoma. He didn't get his first wish (to meet the wrestler, The Rock) because his cancer was so advanced there wasn't time. He got his second wish, a video camera. I figured he'd just film himself with his buddies and his wrestling memorabilia...and he did. But he also left a message for me and all the members of my family, a memorial I'll have for the rest of my life. I want to be sure every child has their first wish before they pass away.

"I'd like to see every citizen in America helping one another. That's what we owe each other, to help our neighbors, community, and country. I would like to be a U.S. senator representing Virginia. That's where I can make the biggest impact on politics and society. I'd like to put it in legislation to encourage that kind of volunteerism, then provide the states and their schools with funding via federal grants."

Jennifer, who is national spokesperson for Volunteers of America and the Make-A-Wish Foundation, was on the National Dean's List in college and graduated cum laude. She danced a contemporary ballet during the Miss America competition. Her third year of law school will be funded in part, by the $5,000 scholarship she won.

AMY MULKEY, Miss Georgia

"Sure people give you grief about being part of this pageant, joke about it. But meeting these incredible women, moving toward the scholarship and community service has changed my life. I think it's funny too, the makeup and the hair and the high heels—it's tough to walk! But that's just a part of it. If you play baseball, you've got to put on the uniform.

"While all the contestants were in Philadelphia two weeks ago, I visited the headquarters of Big Brothers and Big Sisters because my platform is Mentoring. I help children identify achievable goals, which builds self-esteem. Competence helps people feel confident.

"I mentored a girl in middle school, the second oldest of seven children. I was her mentor for three years. During that time, she moved three times, her phone number was changed ten times. She was from a single-parent family and her mother didn't work because she was on disability. They lived in Athens, Georgia, where the University of Georgia is, but she'd never seen it. A magical moment was showing her the campus. No one in her family had even graduated from high school, and I don't think she ever imagined the possibility of going to college.

"When I was nineteen, I got a scholarship at the University of Georgia, the Foundation Fellow Scholarship, which pays tuition, room, and board as well as travel studies. Every summer and spring break I studied in a different country—seventeen countries on six continents in all.

"The first summer, we went to Tanzania. I've never considered myself athletic, but I really wanted to make it to the top of Kilimanjaro. It wound up being a huge mental challenge. You hike four days through four different climate zones. On the final day you go to bed at five o'clock. The air is thin and you're nauseous and feel sick and achy. They wake you at midnight and you put on all those layers of clothes and do the final six hours in the dark. They said it was

minus forty degrees wind chill. At 6 A.M. when we reached the top, the sun was coming up below us. It was amazing. I'd do it again in a heartbeat.

"The one thing you see traveling is how similar people are. You'd see little kids with big bellies because they were so hungry running on the beach. They probably didn't realize they were in the most beautiful place in the world. And you'd see mom watching them. You'd know the most important thing was that sense of family, of belonging. That exists no matter where you are in the world."

Amy, who graduated summa cum laude with a four point grade average and highest honors, hopes to use the $8,000 scholarship she won at the Miss America pageant at one of the top five business schools. She wants to be the CEO of a nonprofit organization, but has a secret dream of becoming the first woman President of the United States—although, she says with a smile, "If that doesn't work out I hope to marry Prince William."

TANISHA NICOLE BRITO, Miss Connecticut

"My mother was a teen mom. She provided me with wonderful things and I look up to her for that. My aunt took on the role of being my mom when my mom was still trying to be sixteen. Both are incredible, resilient women and have always maintained.

"I've always been in need of scholarships. I did pageants my whole life since I was eight years old. My first title was Little Miss Connecticut, a modeling pageant, just basically how pretty you were. I didn't get into scholarship programs until I was about twelve. There are college scholarship programs for young women—they give saving bonds you can save for the future. Those programs have talent, community service, issues of concern, an interview, very much like Miss America.

"The Miss America program exemplifies everything I hold near and dear: being able to voice my opinion, do community service, showcase my talent (I've been tap-dancing since I was three). And I really think I can make a difference. Having Miss America's national platform to facilitate change is a wonderful opportunity. The contestants are very supportive of each other and will support whoever becomes Miss America for the entire year.

"This pageant has changed. Rule seven used to say that white women were the only ones allowed to compete. The first black contestant was in the seventies, and the first black Miss America was in 1983 to '84. I don't remember ever seeing such a variety of ethnicities as are represented here this year.

"But it has a long way to go. Success depends on [the outreach of] the state Miss America organization boards....I spoke about it at my college, an historically black university, and a lot of girls were like, 'I never knew how to get into the program.' They didn't know that Miss USA is a beauty pageant or that Miss America gives scholarships regardless of whether you win, place, or (in some cases) show.

"When I won Miss Connecticut, there were only two of us left standing there. I was very nervous. It came over me that this was going to happen. It was very, very exciting. My family had snuck a video tape into the pageant, which was illegal. When they announced the first runner-up and I was left, that camera went flying—you can't see anything on the video. It turned itself off."

Deans Listed with one class to go before she receives her B.A., Tanisha will use the $10,000 scholarship she won at Miss America to get a masters in public policy and urban planning.

Above: All week, state titleholders participate in dress rehearsals, practicing with the ABC television crew even though the three preliminary competitions are not broadcast.

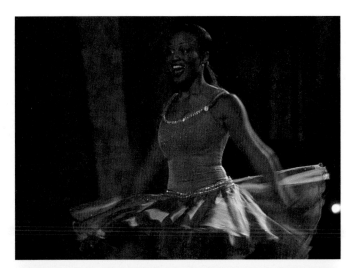

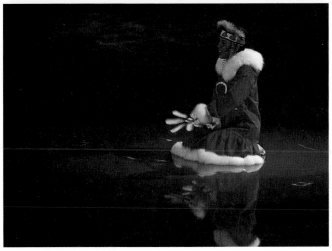

PEGGY WILLMAN, Miss Alaska

"I'm Inupiak Eskimo, the northernmost Eskimos in Alaska. Of the fourteen who competed in the state contest, I was the only Alaskan native woman. This was my third year competing for Miss Alaska. The first two years were strictly for scholarship money—I put myself through college. This year, I competed because I really wanted to represent my culture and state on a national level.

"I have so many relatives I can't even tell you. My house was always full when I was a child. My mother alone has five sisters and a brother. So many cousins—over twenty, maybe. In any village in Alaska, the kids run and play and if they come to your house you feed them all. There is no word for 'hello' or 'goodbye' in the Inupiak language. You're just there.

"My mother's family lives in Ambler, in northwest Alaska. Once a year, we hunt there. Last summer was my first time skinning a caribou. My oldest aunt, Mira, taught me. That's what she had to do when she was thirteen or fourteen because they needed the food. Everything is used, nothing is wasted. The fat in the intestines is a delicacy, we dry it. The skin is used to make mukluks, hats, parkas. We are resourceful and respectful of the animals, the land. We respect Mother Nature, life.

"My platform here is Cultural Awareness. I want to get into the schools, to share who I am with the kids. I'd like there to be programs for people in workplaces surrounded by minorities, so they'd understand these people better. I'm like a sponge—I love to hear about other cultures. I'm minoring in Spanish, I have close friends from Japan and Hawaii.

"Once I receive my nursing degree, I want to travel throughout [rural] Alaska. There are lots of issues facing young people. Suicide is huge. Drug and alcohol abuse. Inhalation abuse. Diabetes. Cancer. But more: our culture really is dying. A lot of the youth don't feel the need to learn anything about it. I'd like to say, 'Hey. This is your culture right in front of your face, grab hold of it before it is gone.'

"I'm going to perform a traditional Eskimo dance as my talent, which has never been done on the Miss America stage. I choreographed my own dance and wrote a little story to explain. The first time I performed it, nobody understood what I was doing.

"Getting ready to come here, I sent a letter to every native corporation requesting funds for my wardrobe and for scholarships for the ladies next year. I got a great response. I didn't have to pay for my wardrobe. I certainly would not have been able to.

"The competition so far? I've let myself shine. It's a rewarding feeling to know that people respect and admire you just for who you are. For me, that's a very big step.

"I worked night-shift as a laborer one summer at Red Dog Mine in northwest Alaska. I remember watching the sun go down behind one of the storage buildings and come right back up on the other side. We have a lot of sunlight now."

Peggy, a Dean's List student and sixth-generation descendant of Maniilaq, an Eskimo prophet, won a $5,000 scholarship in Atlantic City. She will use the scholarship to earn a masters degree and become a nurse practitioner.

Above, top: Tanisha Nicole Brito
Above, bottom: Peggy Willman

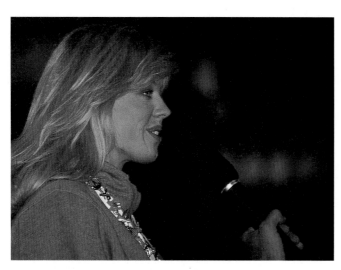

JENNIFER GLOVER, Miss California

"When I was fourteen, I went with twenty others from my church on a mission trip to Mexico to develop a vacation bible school for the children. One young boy wanted to hang out with us. We took him to an amusement park, and rode horses on the beach. It was great as a first experience outside the country!

"As Miss San Francisco, I was ambassador to Tokyo for the San Francisco Travel and Convention Bureau. The most international travelers come to San Francisco from Japan. I took part in various radio events, morning shows, talk shows. That eventually inspired me to study broadcast journalism.

"More than fifty contestants competed in the Miss California finals. After you've won, you immediately pack up your things and move to San Diego, where the Miss California organization is headquartered. You live with a family that has hosted the past seventeen Miss Californias. My hostess has a wall of eight by ten inch photos of all the past Miss Californias who have stayed in my exact same room with the exact same view. I was there for three months preparing for Miss America. Going to the gym. Getting facials. Working on my platform with Bob Arnum, president of the state organization.

"Once a week, I flew home to the Bay Area because my vocal coach was in northern California. I've been singing since I was four. My father has sung in a gospel trio for about thirty years and sang at one of the Billy Graham crusades back east a few years ago. That had a big impact on me as far as performing.

"I had competed for Miss California when I was eighteen and again when I was nineteen. Then I had an opportunity to compete for the title of Miss USA. Afterwards, I was still in school and needed to pay for it someway. As a little girl, I watched Miss America on television and knew it was something I wanted to do.

"Probably I have won a total of $12,000 in scholarships for this year alone. Over my pageant career, I've probably won more than $50,000 in cash, wardrobes, and scholarships. You are paid for personal appearances, so probably it's more money than that.

"Miss America should be an awesome role model for young women. But she is not getting the media coverage she deserves. Other people like Brittany Spears are taking their clothes off left and right to sell CD's. That's what young girls are seeing, and I think that's really sad.

"I'm in school now, taking twenty-two units on Tuesday and Thursday from about eight to six. Typically, my travels as Miss California start on a Friday and end on a Monday.

"Nine-tenths of the time, I write my own speeches, but occasionally a woman volunteers. I was just keynote speaker at the National Crime Prevention Summit in Los Angeles.

"Recently, I also had an opportunity to speak on behalf of Mervyns' welfare-to-work program. They have a seventy-two–foot big rig that's outfitted like a store on wheels, stocked with shirts, ties, shoes, nylons, and jewelry for women, everything a person on welfare would need to walk into an interview feeling prepared. It was awesome."

As Miss California, Jennifer will travel on behalf of Wente, a California pageant sponsor, to France, the Virgin Islands, and Singapore before she graduates and relinquishes her title in June. She plans to pursue a broadcasting career as an on-camera personality, and will be married in December.

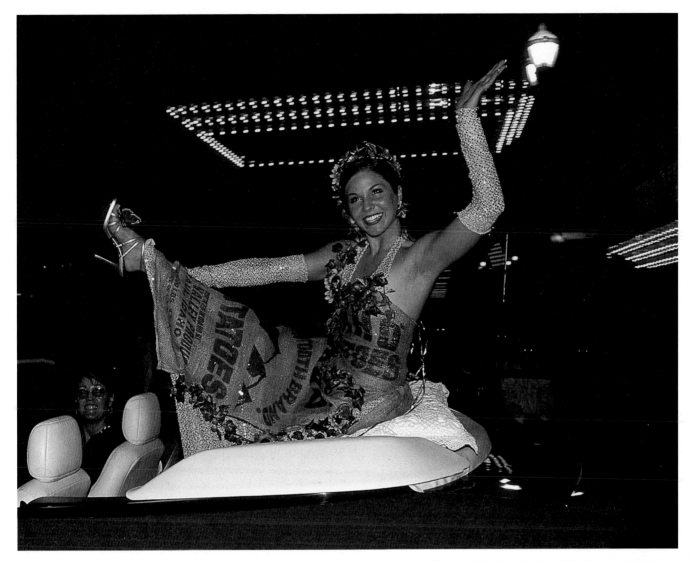

IN THE 1970S, SPECTATORS AT THE ANNUAL MISS AMERICA BOARDWALK PARADE DISCOVERED THAT CONTESTANTS RIDING IN CONVERTIBLES WENT BAREFOOT OR WORE BEDROOM SLIPPERS SINCE THEIR LONG DRESSES HID THEIR FEET. "SHOW ME YOUR SHOES!" THE CROWD TEASED.

Ever since, when the crowd challenges, "Show me your shoes!" contestants reveal fantasy footwear made just for the occasion. This year, Miss Michigan's hat and shoes are covered with cherries. Miss Vermont's high heels carry huge, lacy snowflakes. Miss New Jersey's outfit is decorated with live flowers. And Miss America 1997 promotes literacy with book-shaped shoes that have "Read More" scrawled on the soles. In the spirit of fun, many also wear special costumes. Miss Idaho sports a fashionable potato sack.

State delegations of family, friends, and fans stage rowdy demonstrations for their favorite contestants. Three hundred pink-clad Miss Ohio supporters sing and cheer. Other groups carry posters, balloons, or sandwich boards to promote state titleholders.

Since the 2001 parade was cancelled due to 9/11, contestants from that year occupy a whole float. More than a dozen former Miss Americas join the fifty-one 2002 contestants. Twenty-four bands participate and a hundred thousand spectators line the five-mile route.

Tomorrow night at this time, they will watch the crowning of a new Miss America.

Following page: A mother helps her daughter dress to dance at the Festival of Urkupiña, Quillacollo, Bolivia.

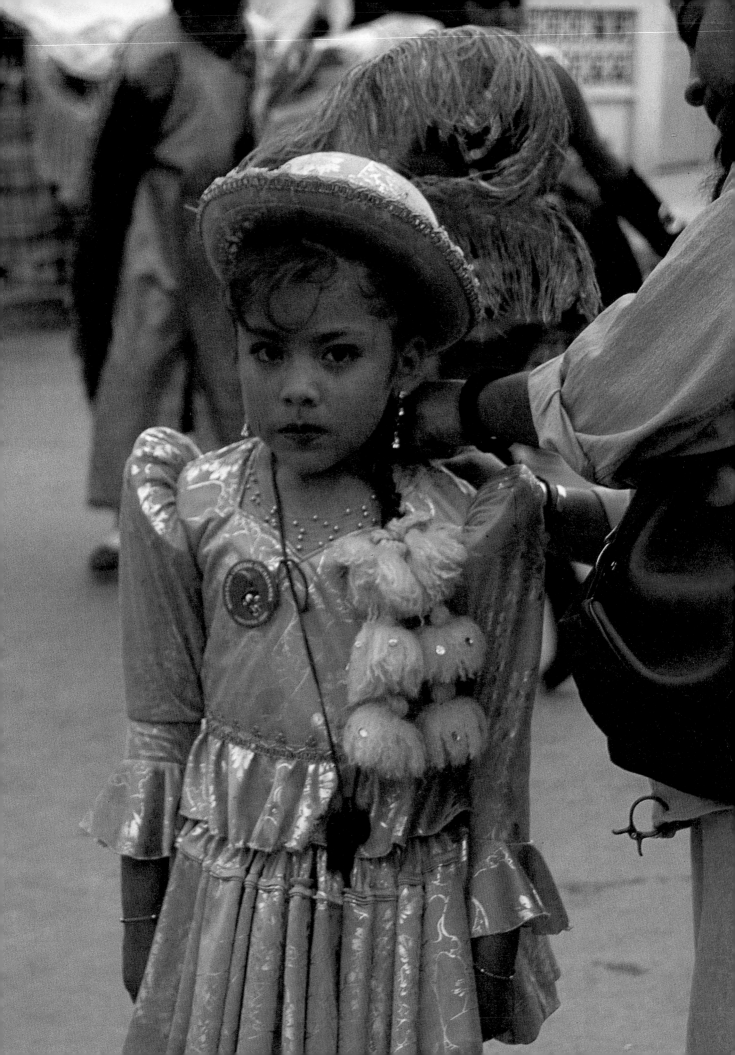

FESTIVALS THAT CELEBRATE WOMEN

ANYONE CAN ATTEND ANNUAL FESTIVALS ALL OVER THE WORLD THAT CELEBRATE WOMEN'S ATTRIBUTES, ACCOMPLISHMENTS, RIGHTS OF PASSAGE, AND SPIRITUAL LIVES. A SAMPLING, 155 EVENTS, FOLLOWS; THE ONES THAT ARE FEATURED IN *CELEBRATING WOMEN* ARE INDICATED*. HOLIDAYS ARE CELEBRATED IN DIFFERENT PLACES IN DIFFERENT WAYS, AND DATES MAY CHANGE, SO SCHEDULES SHOULD BE CONFIRMED WITH EACH COUNTRY'S TOURIST BOARD. ENJOY!

JANUARY

BRAZIL: Lavagem do Nosso Senhor do Bonfim. Daughters of the saints (*filhas-de-santos*) wear white, carry vases of holy water and flowers on their heads, march for seven miles singing and dancing, then wash the steps of the church of the Lord of Bonfim. (*Salvador, Bahia*)

GREECE: Gynaecocratia. Celebrating female dominion, women congregate in cafés while men perform the household tasks. (*Monoklissia; North Petra; Strimi; Xilagani; Nea Kassani; Aspro*)

GREECE: Midwife's Day. Village women bring food to the midwife's house for a noon feast at a table set by her daughters and granddaughters. The only man allowed to attend is a bagpiper who provides music for their singing and dancing, but he must cover his eyes and ears. Men do not talk for this whole day. Women make the decisions and women always win the games played with men. (*Varna region*)

INDIA: Teppam (Float) Festival. At a many-tiered temple in the middle of a reservoir, on the night of full moon, fantastically dressed and jeweled images of the goddess Meenakshi and her consort are floated on rafts decorated with flowers and hundreds of oil lamps. Crowds on shore chant hymns. (*Mariamman Teppakkulam Tank Reservoir, Madurai, Tamil Nadu*)

INDIA: Vasanta Panchami. Honors Saraswati, the goddess of learning, arts, dance, and music. Worshiped in homes; processions of her images, which are immersed at the finale (*Bengal*). People wear yellow clothes and eat yellow food. (*northern India*)

NEPAL: Shree Panchami. The goddess of learning, Saraswati, is worshipped. Offerings include the tools of education: pens and ink. Rice is also offered, since it is believed that eating seven grains of rice will increase wisdom. At school, young children are first taught the alphabet on this day. (*Swayambhunath Shrine, Kathmandu Valley*)

PHILIPPINES: Sinulog Festival. Elderly women perform the Sinulog dance daily, inspired by the river's current. Brilliant costumes, feasts, marches, horse fights, dances to celebrate the Christianization of their community. (*Cebu City; Kabankalan, Island of Negros*)

POLAND: Mother of God of the Blessed Thunder Candle. Candles decorated with ribbons and liturgical symbols are brought to the priest for blessings, then burned at home until sunrise the next day.

SPAIN: La Tamborrada. In 1720, young girls stopped to accompany a singing baker by drumming on the water barrels he was filling at a fountain. That impromptu jam session evolved into a festival with 24-hour-long drum parades; each drum corps represents a different gastronomic society. (*San Sebastian*)

FEBRUARY

*AUSTRIA: Rudolfina Redoute. At this traditional, formal ball held in the Hofburg Palace, women wear masks and have their choice of dance partners until midnight. (*Vienna*)

BRAZIL: Festa de Yemanja. Hundreds of people in white bring gifts for Yemanja, the goddess of the ocean—jewelry, perfume, flowers, soap, mirrors, champagne—which will be set forth on rafts. Candomblé ceremony. Priestesses dance, chant. Fireworks. (*Rio Vermelho Beach, Bahia; also New Year's Eve, Rio de Janeiro; August 15, Fortaleza*)

ENGLAND: Olney Pancake Race. Local women wearing aprons dash 415 yards while flipping the pancakes they carry in skillets. The festival began in 1445 on the day before Lent (pancakes were a final sweet indulgence) so winners get their prizes at the parish church. Olney competes for best race time with Liberal, Kansas, USA, a pancake-race challenger. (*Olney, North Buckinghamshire*)

GERMANY: Weiberfastnach (Women's Carnival). In the thirteenth century, Cologne's market women protested that men had all the fun during Karneval. They stormed Town Hall, and the lord mayor turned over his keys in submission. Ever since, the Thursday before Ash Wednesday belongs to women who process in costume through the streets, make all the decisions, and poke fun at the opposite sex. (*Cologne*)

IRELAND: Wives Feast. Women are honored as the preservers of home and community. Their families prepare dinner and give gifts. (*also northern England*)

MALAYSIA: Chap Goh Meh. Chinese maidens and spinsters throw mandarin oranges into the sea, signaling to the 30,000 observers that they are available for marriage. Boys compete to collect the most oranges in their boats. (*Esplanade, Penang*)

*PERU: Festividad de la Virgen de Candelaria. Four thousand Amayra and Quechua dancers compete for two weeks in celebration of the Virgen (aka Pacha Mama) said to have appeared to the Indians. (*Puno*)

SPAIN: Feast of St. Agatha. Women rule the town this day, and ceremoniously burn a stuffed figure of a man. This act may be a symbolic retribution for the past torture that was reportedly done to Agatha, a beautiful Sicilian virgin whose breasts were cut off because she spurned a Roman senator. (*Zamarramala*)

SPAIN: Fiesta del Gallo. Young women in white take a live rooster to the town's mayor and ask for permission to kill it. They bury it alive with its head showing, or beat it with a wooden sword while its legs are tied to a pole. (*northern Spain*)

SPAIN: Santa Agueda Festival. Governor's wife dresses in a sumptuous gown and leads the procession, followed by married women dressed in farm clothes. After a banquet in which the priest is the only man present, the celebration ends with the ancient Wheel Dance. (*Zamarramala; Segovia*)

THAILAND: Chao Mae Lim Ko Niao Fair. Locals pay homage to Chao Mae Lim Ko Nieo, a goddess believed to possess a formidable capacity for magic. The region's wizards descend on Pattani's shrine for seven days of wild stunts. (*Leng Chu Kiang Shrine, Amphoe Muang, Pattani*)

MARCH

BULGARIA: Baba Marta (Grandmother March). Peasant women embark on spring cleaning and give friends *martenitsa*, red-and-white wool threads with tassels that they wear until they see the first migrating stork or the first budding bush (in which case, they hang the *martenitsa* on its branches).

CHINA: Noroz (Nero) Festival. On horseback, Kazak girls chase boys who ride away as fast as they can. If a girl catches a boy, she can whip him (he is not allowed to fight back) but if she loves him, she will only wave her whip in the air. (*Xinjiang*)

INDIA: Chithirai Festival. Ten day celebration. About 100,000 people attend the reenactment of Goddess Meenakshi's wedding to Sundereswara (incarnation of Shiva). Meenakshi, a king's daughter, was born with three breasts, one of which was promised to disappear when she met the right man to marry. (*Meenakshi Temple, Madurai, Tamil Nadu*)

INDIA: Gangaur. This celebration dedicated to Goddess Gauri (Parvati) begins during the Holi Festival. Young girls pray for men to marry; married women pray for their husband's long lives. Women gather flowers, then carry them on their heads in brass water pitchers while chanting hymns to the goddess. The 18 days culminate in the arrival of Lord Shiva to escort his bride home; there are grand processions with elephants, camels, horses, dancers, and drummers. (*Mandawa Temple, Jhunjhunu District, Rajasthan; also Bikaner; Jodhpur; Nathdwara; Jaipur; Jaisalmer*)

INDIA: Holi. The villainess is the evil sister. Long ago, a child was sent by the gods to deliver the land from its demonic king. The king's sister (who claimed to be immune to fire) offered to hold the boy in her lap and sit in a raging bonfire that would kill him but not her. But the sister was torched and the child, who was devoted to Vishnu, survived. Bonfires and offerings are a big part of this seven-day festival. Colored powders are thrown on friends, relatives, and strangers. Dyes are mixed with water and dumped from balconies. Parades, feasts, dancing, and fireworks. At the Lathmar Holi in Barsana (near Mathura, home of Krishna's consort Radha), women dare the men of Nandgaon (home of Krishna) to douse them with color.

INDIA: Karaga Festival. A clay pot is balanced on a devotee's head; it embodies Shakti, the mother goddess, and must not be dropped during the 12-mile procession; if it falls, colleagues are sworn to stab the carrier to death. This festival also features stacking many clay pots on heads and limbs of devotees to test strength of character. (*Sampangi Reservoir, Bangalore*)

INDIA: Mewar Festival. To honor Parvati and welcome spring, a procession of women carry images of the goddess by boat from the Lake Palace Hotel to the Ganguar Ghat on Lake Pichola. There are songs, dancing, devotional music, and fireworks. (*Udaipur, Rajasthan*)

JAPAN: Girls Festival/Hina Matsuri. Little girls wear kimonos and eat rice cakes at parties, surrounded by their families' festival doll collections that are displayed for the occasion to bring health to their daughters. (*Kyoto; Okinawa*)

SPAIN: Las Fallas. A procession of 150,000 women wearing baroque costumes and bringing flowers to a statue of the Virgin punctuates this weeklong festival, which ends with the burning of more than 350 multicolored structures, some 75 feet tall, that combine surrealism, political satire, and Disney. (*Valencia*)

SRI LANKA: Sri Pada Vandana (Pilgrimage to Adam's Peak). A woman who successfully maneuvers to the top of Adam's Peak is said to be born a man in her next life. For 1,000 years devotees have bravely climbed the mountain at night guided by the moon and lanterns. At the top one is supposed to see a footprint of Adam or Buddha or Lord Shiva. (*Dalhousie*)

SWEDEN: Easter Eve. Little girls dress up as Easter hags, wearing their mother's aprons, handkerchiefs, and hand-drawn freckles. They visit neighbors and ask for candy. This practice springs from the ancient belief that on Maundy Thursday, witches flew on broomsticks to meet with Satan and returned on the night before Easter.

***THAILAND:** Thao Suranari Festival. The City of Brave Women was saved by its women in 1826, when it was attacked by Laotian invaders. Leader Ya Mo is celebrated with ten days of competitions: contests give prizes for beauty, muscles, shooting, fruit and vegetables, healthy babies. There are fireworks, dance performances, Buddhist and Hindu ceremonies. (*Nakhon Ratchasima*)

VIETNAM: Binh Da Festival. Au Co is said to have miraculously given birth to 100 sons after a gestation period of three years and ten days, providing the original population of the Ha Son Binh region. This fifteenth-century temple-festival pays homage to Au Co, her husband, and Buddha. Teenage girls carry platters of fruit and flowers through the narrow streets. Traditional music. (*Au Co Mother Saint Temple, Hien Luon, Thao River district, Phu Tho province, Huong Tich mountain range*)

VIETNAM: Moc Duc. Trieu Thi Trinh was 19 when she declared, "I want to ride over strong wind, sail over strong waves, hunt fierce fish off the East Sea coast, chase the Ngo invaders out of the country, regain independence, shatter slavery, but will never give in to becoming a concubine." In 248 A.D. she led an uprising against the Ngo and killed the Chinese governor. The temple festival that commemorates this heroine includes a procession, battle reenactment, luncheon of cold dishes in remembrance of the rations her soldiers ate, and a hot victory dinner. (*Ba Trieu Temple, Quan Yen district, Cuu Tran prefecture*)

WORLDWIDE: International Women's Day. March 8, a date designated by the United Nations, whose charter was the first international agreement to proclaim gender equality as a fundamental human right. The day is rooted in the centuries-old struggle of women to participate in society on an equal footing with men. The first International Women's Day took place in 1911 in Austria, Denmark, Germany, and Switzerland, but today it is celebrated all over the world.

YEMEN: Purim. This holiday celebrates the biblical story of Esther, who was taken into the court of a Persian king and found herself in a position to save her people. Jews paint eggs, send them to friends, and consume them at the Purim meal.

APRIL

CHINA: Jie Mei Jie (Sisters Festival). Black Miao (Hmu) people celebrate this courtship rite near the river—single women dye cooked rice: blue, pink, yellow, and white represent the four seasons. If a young man serenades a girl, which signals his interest, she gives him a packet of rice with her reply inside. A hot pepper means refusal, two chopsticks mean "I love you." (*Taijiang county, Chnog'an region, Guizhou*)

INDIA: Vasant Gauri Festival. The goddess Gauri visits her parental home and is welcomed with a month of *pujas* (ceremonies of worship) in homes, groups, and clubs. Married women visit their parents who invite friends and relatives to greet their daughters and Gauri.

INDIA: Yanga (Holy Fire). This ninth-century Sixty-Four Yogini temple has sculptures inside and out of the yoginis, all of whom have women's bodies and animal heads and are believed to have magic powers to destroy enemies. Villagers burn ghee and chant in Sanskrit to honor the goddesses for bringing peace and harmony. (*Hirapur, Orissa*)

JAPAN: Flower Picking Festival. Since the eighth century, children and women have picked flowers and carried them to shrines. (*Otori Shrine, Sakai, Osaka prefecture*)

JAPAN: Kanamara Matsuri. More than two centuries ago, the city's prostitutes supposedly prayed for protection from syphilis and prayed for successful business. The Festival of the Steel Phallus responds to the second wish: celebrants parade images of huge penises and eat penis-shaped lollipops. Today, this Shinto fertility festival raises money for AIDS research. (*Kawasaki*)

JAPAN: Miyako Odori (Cherry Blossom Dance). As the cherry blossoms flower, geishas play music and perform this famous dance, which was presented for the first time in 1872. (*Gion; Tokyo; Osaka; Arashiyama; Kyoto; Yoshoino*)

NEPAL: Mata Tirtha Snan (also known as Mata Trtha Aunsi and Matri Auncy). Mothers Day is celebrated on the night of the full moon. Children give their mothers gifts, mothers bless everyone with good wishes, and orphans of all ages pray for their dead mothers. (*Matatirtha, near Kathmandu*)

NETHERLANDS: Koninginnedag (Queen's Day). In 1948, Holland's Queen Beatrix decreed that the birthday of her mother, Queen Juliana, would always be celebrated on April 30. The party starts the night before and continues with parades, boat parties on the canals, fireworks, games, flea markets, palm readers, bands, beer, dancing, and dunking for oranges. (*the royal family descends from the House of Orange Nassau*)

PAKISTAN: Joshi (Spring Festival). Girls collect flowers on the hillside and before dawn the women decorate the houses, Jesktakan temples, and cattle sheds with flowers, then milk the cows, dance, and sing. The third day of the festival includes a ceremony to purify mothers and one-year-old babies. Festivities continue for two more days. (*Kalasha Valleys: Mumret; Rukmu; Biriu*)

PHILIPPINES: Turumba Festival. This festival began with Pakil priestesses, healers who performed animal sacrifices and went into trances. Catholic priests prohibited the practice. Today, the festival commemorates the seven sorrows of the Blessed Virgin Mary and hence takes place seven times during April and May. (*Pakil, Laguna*)

SPAIN: Feira do Encaixe (Lace Fair). Women who make bobbin lace compete, demonstrate, exhibit, and offer their traditional work for sale. (*Camariñas, Terra de Soneira region, A Coruña province*)

SWEDEN: Walpurgis Night Festival. Bonfires flame all over the countryside, inspired by the Viking belief that witches gathered on this night to worship the devil. Students remember the ancient witches' sabbath with torchlight parades and songfests to celebrate the death of winter, the birth of spring. (*Uppsala; Lund*)

UNITED STATES: Red Hat Hoot. Red Hat Society members, all over fifty, are inspired by Jenny Joseph's poem, "When I'm an old woman, I shall wear purple with a red hat." They do just that, and convene by the thousands once a year for tea and hijinks. (*location changes, see redhatsociety.com*)

VIETNAM: Dau (Thua) Pagoda Festival. Man Muong, a goddess who stopped drought, is celebrated with lion dances, wrestling, and a human chess game. This festival is dedicated to the four "lady geniuses": the spirits of clouds, rain, thunder, and lightning. (*Thuan Thanh district, Bac Ninh province*)

MAY

***CHINA:** Mazu Festival. Mazu, a woman who became a goddess, rescued fishermen at sea and was later elevated to Empress of Heaven. Decorated sampans and junks filled with devotees set off at dawn for Taoist temples to honor her, bringing offerings of pink dumplings and fruit. Her image is paraded through the streets. Outside her temples: lion dancers, fortune tellers, Chinese opera performances. (*Meizhou Island, Fujian Province; also Hong Kong; Beigang; Taiwan*)

FRANCE: Gypsy Pilgrimage. Two-day festival honors the gypsy's patron saint, Sarah. Sometimes 10,000 Romany people gather to sing, dance, and attend the candlelight vigil in church. The image of Sarah is decorated with flowers and carried in a procession to the sea. (*Les Saintes-Maries de la Mer*)

GHANA: Dipo (Puberty Rites). After their first menstruation, young women of the Krobo ethnic group are secluded for two or three weeks while prominent women teach them about sex, birth control, how to maintain a good marriage, and personal dignity in society. Afterwards, the girls are presented to their community at a durbar (gathering) attended by the chief, where young men select their wives.

GREECE: Anastenaria (Firewalking Festival). Barefoot villagers clasp icons of Saint Helen (whose saints day it is) and dance on embers without getting burned. (*Agia Elleni; Langada*)

JAPAN: Aoi Matsuri (Hollyhock Festival.) A local, single woman is appointed to perform a purification ritual on forty women at the sacred Mitarashi River. (*Kamigamo-jinja Shrine, Kyoto*)

KOREA: Tano Festival. For twenty days, female shamans perform a variety of rituals designed to drive away evil spirits and encourage deities to bestow good crops, good health, and long life. Many shamans enter trances to report human wishes to the gods and relay divine instructions. Mask dancing, swinging contests, fireworks, parades, and circuses also occur. (*Kangnung, Kangwondo province*)

LAOS: Boun (Bun) Bang Fai Festival. This two-day festival, connected with ancient fertility rites, features erotic songs and dances. Prizes are given for the best processions. Women parade with carved wooden phalluses painted red—and live turtles, the symbol of the female sex. Men are disguised as women to shock the heavens into producing lightning and rain. Monks set off rockets on the banks of the Mekong River to provoke rain. (*Phonmy, Phonhong district, Vietianne province*)

MEXICO: Santa Rita de Casia. Towns in the Isthmus of Tehuantepec are matriarchal and often, during all-night saint-day parties, tentloads of women dance together while men drink and talk outside. This four-day festival includes a procession of people who toss gifts to spectators, fireworks, and feasts; it ends when the women wash the pots. (*Ixtaltepec*)

PHILIPPINES: Flores de Mayo (Flowers of May). Monthlong festival to Virgin Mary. Daily floral offerings are presented by little girls dressed in white. Procession on the last day: the town's beauties wear white gowns, carry flowers. Star of the procession is Queen Elena (mother of Constantine the Great, discoverer of the true cross). Parades of women clad as female figures from the Bible occur throughout the country. (*Manila; Mindanao; Santacruzan; Zamboanga*)

PHILIPPINES: Pilgrimage for Peace and Good Voyage. The pilgrims are infertile women who want to become mothers. The event opens with a religious procession of muses riding on decorated hammocks; elderly devotees dance and pray all the way from the Virgin's shrine to the cathedral. A mass and feast complete the activities. (*Negros, Visayas*)

PHILIPPINES: Sayaw sa Obando (Obando Dance). It is said that if women who want to have children do this dance, Saint Clara, patron saint of the childless, will grant their wish. (*Manila*)

PORTUGAL: Festival of Our Lady of the Roses. Women parade through town carrying

beautiful rose tapestries above their heads. (*Viana do Castelo*)

SPAIN: Holy Cross. Crosses of flowers are posted. Love songs are offered to the Virgin. Single girls are serenaded. People dance and sing satirical songs. (*Castile La Mancha*)

SPAIN: Romeria del Rocio. This is Spain's biggest festival. Pilgrims transport an image of the Virgen del Rocio (Our Lady of the Dew) through Andalusia on foot, and by horse-back and ox cart (no motorized vehicles are allowed). Gypsy caravans covered with flowers travel through the woods and ford the Guadiamar River. Accompanied by tambourines, flutes, and guitars, the pilgrims cross the plain. In the marshes, the oxen run up the steps of the El Rocia shrine to deliver the Virgin's image before mass. For the next few days, there are fireworks, dancing, singing, local food, and wine. (*Huelva*)

TUNISIA: Lag B'Omer. During this Jewish holiday, women ensure fertility by crawling into the grotto in the historic Ghriba Synagogue and placing raw eggs with their names on them around the temple stone. A scarf-bedecked menorah is paraded through the streets, decorated with flowers and sprayed with perfume. (*Djerba*)

VENEZUELA: Devil Dancers of Corpus Christi. Although usually only men promise the Virgin to be devil dancers in exchange for divine intervention, in this village female devil dancers perform for the health of their children. (*Naiguata*)

JUNE

CHINA: Water Splashing Festival and Dai Tribal New Year. The festival was inspired by a legend about seven beautiful Dai women who destroyed a fire fiend. For three days, girls sprinkle water on each other and throw scented, decorated, fringed bags at prospective lovers. Dragon boat racing, young girls' peacock dance, giant hot air balloons at night. (*Jinghong City, Xishaungbanna prefecture, Yunnan province*)

JAPAN: Ta-ue Matsuri (Rice Planting Festival). This eighth-century shrine is dedicated to the rice goddess and has "thousands" of red gates. Women dressed in ancient court costumes perform a Shinto dance, young women plant rice seedlings in a sacred field, rituals petition the goddess for a good harvest. (*Fushimi-inari Taisha Shrine, Fukakusa, Fushimi-ku*)

INDIA: Vat Savitri. Married women observe a fast, tie red threads around a banyan tree, and pray for their husbands. They are celebrating the selflessness of beautiful Princess Savitri who, having decided to marry a prince then learning he would die within a year, stuck with her decision and negotiated for his life.

INDONESIA: Usaba Sambah Festival. Bali Aga women and girls wrap themselves with the red double-ikat cloth that can take five years to weave—and crown themselves with flowered, golden headdresses. The women perform ritual offering dances. Unmarried women ride creaky wooden Ferris wheels built and powered by men: an ancient ritual that represents the unification of sun and earth. (*Tenganan, Bali*)

ITALY: Palio. Before this race that has honored the Madonna of Provenzano since the eleventh century, horses are blessed in the chapels of the districts that sponsor them. After a lavish, three hours of medieval pageantry, ten horses race around the Piazza del Campo twice (which takes less than two minutes), competing to win the coveted *palio* (banner). (*Siena; also held in August*)

MEXICO: Feast Day of San Juan. Legend says a mermaid left the river to comb her hair on this day, setting a precedent for local women to cut theirs. (*Oaxaca*)

*POLAND: Nóc Świetòjanska. Single women make wreaths of flowers and herbs, put poems in them, and float them down the river hoping eligible bachelors will find them irresistible. (*Ciechanowiec and other small villages near rivers and lakes*)

SOUTH KOREA: Tano Festival. Shaman women conduct rituals and enter trances to assure good crops, good health, and a long life. On Tano day, women wash their hair with fragrant flowers to drive out evil spirits, and swing standing on ropes looped on trees; girls' competitions are held villages. There are masked dances during the twenty-day outdoor festival. (*Kangnung/Gangneung-si, Kangwondo province*)

SPAIN: Corpus Christi. Festival floats travel over pavements of petals, artistic designs of flowers that local women have created. (*Ponteareas*)

UNITED STATES: Betty Picnic. This event celebrates "the Bettys of this world for their vivacity, impulsiveness, and similarities." Usually about fifty women named Betty relish Betty-favorites such as tomato soup with basil, smoked salmon with asparagus. (*Grants Pass, Oregon*)

UNITED STATES: Judy Garland Jubilee. The star's hometown event includes three days of screenings of *The Wizard of Oz*, panels of scholars and authors discussing Garland's career, a collector's forum (chaired by the man who owns Dorothy's red shoes), tours of her childhood home, and a gala dinner with a silent auction of memorabilia. (*Grand Rapids, Minnesota*)

UNITED STATES: National Women's Music Festival. Since 1974, this four-day festival sponsored by Women in the Arts, showcases women's music, art, and culture. (*Kent, Ohio*)

UNITED STATES: Sheep Is Life. Sheep play a central role in daily life and spirituality for Navajo women who own sheep and shear, spin, and weave their wool. All of these activities are demonstrated at this five-day festival, which includes weaving and felting workshops. (*Tsaile, Arizona*)

UNITED STATES: Mermaid Parade. This parade opens the Coney Island beach for the summer; costumed mermaids of all shapes, sizes, and ages (plus a few mermen and Neptunes) march in front of 500,000 spectators on the boardwalk. (*Brooklyn, New York*)

JULY

*FINLAND: Eukonkannon (World Wife Carrying Championships). In the nineteenth century it was common practice for men to steal wives from neighboring villages, which they trained to do by carrying sacks on their backs and negotiating an obstacle course. Today, men from many countries carry women and race down a 253-meter track, over hurdles and through a pond. Participating couples need not be married, which allows men to select the lightest women to carry—although there is a disincentive to do this: first prize includes the woman's weight in beer. (*Sonkajärvi*)

FRANCE: Feast Day of Mary Magdalen. Thirteenth-century costumes, ancient hymns, dances inspired by flutes, drums, and cymbals are all part of a procession in which Mary Magdalen's skull is carried in a reliquary by twelve men from the church of Saint Maximim to the Monastery of Saint Mary Magdalen. (*Saint Maximim, Provence*)

INDIA: Ambuchi Festival. Pilgrims celebrate the earth's menstrual cycle at the temple they believe is the epicenter of the feminine: the pith where Sati's yoni fell to earth while her bereft husband carried her through the heavens. At this time of year, monsoons cause the water in the temple's lower chambers to flow through iron, so it is rust-colored; Goddess Kamakhya is menstruating. (*Kamakhya Temple, Nilachal Hill, Guwahati, Assam*)

INDIA: Nag Panchami (Thapan Festival). This festival, which began in the seventeenth century, honors Mansa, the queen of serpents, and is linked to fertility. Devotees catch live cobras, and keep them in earthen pots, which they carry on their heads in a long procession. After the ritual, the snakes are set free in the temple courtyard, sprinkled with flowers and offered milk and honey. Then the snakes are put back in the pots and carried on carts through the hamlets. One or two are let loose in front of each house; girls regard cobras as good luck in marriage. (*Baltis Shirale, Maharashtra; West Bengal; Assam; Orissa*)

INDIA: Teej Festival. This is a royal festival dedicated to the goddess Parvati. The procession includes decorated elephants, horses, camels, dancers, and an image of Parvati on an elephant. Women worship the goddess and distribute sweets. Specially decorated swings are hung from the trees and women swing from them. Parvati is asked to bless her devotees with conjugal harmony and bliss. (*Jaipur, Rajasthan*)

ITALY: Festa Della Donne. This tiny town still celebrates the local women's defense of its castle in 1522 when Picozzo Brancaleoni laid siege. (*Scheggino*)

JAPAN: Amaterasü-o-mi-kami Festival. The great festival of the sun goddess who, according to Shinto legend, is the ancestress of all Japanese emperors. When Amaterasü's brother got drunk and invaded her rice fields and temples once too often, the goddess sought sanctuary in a mountain cave; the world plunged into darkness. Uzume, the goddess of merriment, put a mirror in front of the cave and Amaterasü, never having seen her own beauty, was lured outside.

JAPAN: Shirongo Matsuri. More than 200 women divers compete in this event,

gathering abalone off the eastern shore of the island. The first two abalone are offered to the deity of the Shirahige Shrine. (*Shugajima-town, Suga Island, Toba City, Mie prefecture*)

MEXICO: Guelaguetza. This folk-dancing festival has its roots in pre-Columbian times when villagers honored the ancient Zapotec goddess, Centeotl, with song and dance to win her blessing for a bountiful corn harvest. Today, dancing in the amphitheater includes the women's Pineapple Dance. Performers often throw gifts to the audience. (*Fortin Hill, Oaxaca*)

NEW GUINEA: Yam Harvest Festival. A wife's clan has responsibility for filling the yam house of the chief, then the brothers-in-laws', then sons-in-laws'. Status within the village depends on the size and quality of a family's yams. Men carry the yams, and women form the front and rear guard in processions to display a family's yam farming prowess. Although marriages are monogamous here, mutually agreed-on flings are permitted once a year during the Yam Harvest Festival. (*Trobriand Islands*)

PORTUGAL: Festa dos Tabuleiros (Festival of the Trays). This festival grew from Ceres' fourteenth-century fertility festival. Adolescent girls parade, carrying on their heads bread loaves laced with flowers and vines. Headdresses are as tall as the girls and always heavy enough to prove that the maidens are strong enough for childbirth. Held every fourth year, most recently, 2003. (*Tomar*)

SPAIN: Saint Mary Magdalena Feast. Young men in swirling skirts dance on wooden stilts during the street procession's Danza de los Zancos. The music: bagpipes, drums, and castanets. (*Anguiano*)

*SPAIN: Romeria de Santa Marta de Ribarteme. Santa Marta is believed to heal the sick. People who have had near death experiences in the past year ride in open coffins carried by their friends and family, to give her thanks for their very lives. (*Santa Marta de Ribarteme, Galicia*)

SPAIN: Virgin del Carmen. The island's main festival celebrates the Patroness of the Fishermen. A flotilla of fishing boats comes to honor her. (*Formentera*)

UNITED STATES: Green Corn Festival. Starting about noon on the main day of the festival, Creek Indian women participate in the three-hour Ribbon Dance. Four women, appointed for life by the elders, lead the dance, which is performed single file in four circles. The women wear dangling turtle shells that are filled with pebbles, which act as percussion instruments. The men sing and play drums as accompaniment. (*Oklahoma*)

UNITED STATES: Tekakwitha Conference. When Kateri Tekakwitha, a Native American Catholic woman, died in 1676, her smallpox scars vanished instantly; she was beatified in 1980. This conference strives to unify Native American Catholics and is sometimes attended by women from 120 different tribes who convene for rituals and workshops. (*locations vary, see www.tekconf.org*)

FESTIVALS THAT CELEBRATE WOMEN

AUGUST

*BOLIVIA: Festividad de la Virgen de Urkupiña. Mother Earth and the Virgin join forces to grant people's requests for material goods. Hundreds of thousands come to ask for television sets, trucks, and Tudor houses. And to witness two days of folk dancing by hundreds of Quechua tribal celebrants. (Quillacollo)

*BRAZIL: Festa da Nossa Senhora da Boa Morte. Women who lead local Candomblé houses celebrate the Assumption of the Virgin Mary. Their sisterhood was founded by freed slave women who bought freedom for other Afro-Brazilian slaves. (Cachoeira, Bahia)

CHINA: The Cowherd and the Weaving Maiden. Since the Weaving Maiden is considered the patron spirit of women's work, this is primarily a women's festival. It celebrates the annual reunion of the Weaving Maiden, a fairy who lives on the moon, and her human husband. Single women offer paper combs, mirrors, flowers, cosmetics, fruit, and sewing kits, all in sets of seven—one each for the Weaving Maiden and her six sisters. (also Malaysia and Japan)

*FRENCH WEST INDIES: Fête de Cuisinères. Creole cooks dressed in bright, traditional attire, parade their best dishes through the streets and serve a feast to hundreds of guests. (Point-à-Pitre, Guadeloupe, French West Indies)

GREECE: Panagia (Virgin Mary). Thousands of pilgrims crawl on their knees up the steps to the church that holds the holy icon. Feasts, services, and dancing take place in the monasteries. (Tinos; Agiassos)

INDIA: Ganesh Chaturthi. Goddess Parvati immaculately created Lord Ganesh with bath oil. She sent him outside to guard the house while she was bathing. When his father, Lord Shiva came home, Ganesh wouldn't let him enter. Shiva got mad and cut off Ganesh's head. Parvati, furious, told Shiva to replace it with the head of the first sleeping animal he saw. Hence, the elephant head. Giant Ganesh images are dragged into the sea as the crowd goes wild. The festival was first celebrated in 1892. (Chowpatty Beach, Mumbai, Maharastra)

INDIA: Haritalika. The goddess Gauri is the green and golden goddess of the harvests. Women fast, then wear green bangles, green clothes, and golden bindis (dots between their eyebrows). They give painted coconuts to their female friends and relatives, and offer green vegetables to the goddess in thanksgiving. (northern India)

INDIA: Nanda Devi Raj Jat. This festival occurs only every 12 years and is based on a ninth-century royal pilgrimage for the mother goddess, Devi. The celebration resembles the Hindu postnuptial rite of seeing a daughter off as she moves to her husband's family's home. (Chamoli district, Garh, Rajasthan)

INDIA: Raksha Bandhan. Women tie a string bracelet (rakhi) around the wrist of their brothers and in return, brothers give their sisters a small gift (usually money) and protection. Some women tie rakhis around the prime minister's or soldiers' wrists. In the north and west, women tie the strings around the wrists of boys and men who have no sisters.

INDIA: Tarnetar Mela Festival. Three-day festival during which participants arrive on camels to celebrate the ancient marriage of Arjuna and Draupadi. There is music, folk dancing, and bride shopping. (Tarnetar)

IRELAND: Rose of Tralee Festival. This six-day festival exists to search for a girl as lovely as a rose. Irish girls from all over the world convene to compete for the title. Not an average beauty pageant, this festival includes pipe bands, parades, street dancing, fireworks, carnivals—plus donkey and greyhound races. (Tralee)

JAPAN: Star Festival. This festival grows from an ancient legend of forbidden love between a princess and a peasant boy. Throughout the country, people write love poems on banners. The town decorates with streamers; there are parades, fireworks. Young people are permitted to spend the evening together unchaperoned and the adults are encouraged, this one night, to speak their hearts' feelings. (Tanabata Matsuri, Sendai)

MEXICO: Feast of the Assumption of the Blessed Virgin Mary. Images of Mary are borne skyward on homemade rockets. Streets are carpeted with designs made out of flower petals or colored sawdust and the image of the Virgin is carried over these on a float. The next morning, bulls rush through the streets. (Huamantla, Tlaxcala state)

NEPAL: Teej. Hindu women pray for marital bliss, the well-being of their husbands and children, and the purification of their own bodies and souls. Day 1: women wear their best clothes for feasting, dancing, and singing devotional songs, then fast for 24 hours. Day 2: Puja to the goddess Parvati and her husband, Lord Shiva. Day 3: women bathe with leaves and red mud from the roots of the sacred Datiwan bush, to absolve themselves of sin. (Pashupatinat Temple, Kathmandu)

NIGERIA: Oshun Festival. The nine-day festival of Oshun, the Yoruba river goddess of fertility, includes ancestor worship, feasts, music, acrobats, contortionists, dancing. On the final day, 20,000 people don their best cult clothes and jewelry to accompany chiefs riding horses under silk umbrellas, to Oshun's river shrine. The chief priestess scatters food for the fish (special messengers of Oshun) and prays for fertility. Newly nursing mothers thank the goddess. After a pact of mutual protection between the goddess and her people is sealed, everyone rushes into the river to bathe and collect holy water in pots. (Oshogbo)

POLAND: Our Lady of the Herbs. Village housewives gather herbs and flowers from the garden, fields, and forests. The priest blesses these bouquets, which heightens their power as medicines and seasonings.

SCOTLAND: Festival of the Horse. Little girls between the ages of three and 15 dress in horse costumes sewn by their grannies, aunties, and mothers. Their colorful, sparkly outfits are inspired by Clydesdale horse decorations. Tails are sewn onto jackets; pom-poms and fringes onto cuffs. (South Ronaldsay, Orkney Island)

SPAIN: Festa do Polbo/Fiesta de Pulpo. Visitors have a picnic in the town where all the "octopus ladies" live, cook, and serve the famous regional specialty: octopus boiled, cut into pieces, seasoned with oil, salt, and paprika. (Parque Municipal, Carballiño, Ourense Province, Galicia)

*SWAZILAND: Umhlanga (Reed Dance). All the virgins in the country converge at the Queen Mother's compound, from which they leave to trek to the river. There, they cut reeds to build a windbreak around the royal palace, trek back to the Queen Mother's, and dance for two days. (Lobamba)

TAIWAN: Chung Yuan Ghost Month Festival. According to legend, after Mu Lan's evil, selfish mother died, a monk advised him that her salvation could be achieved only if all monks and nuns prayed for her and if Mu Lan offered food and drink to all lost souls. During Ghost Month, Buddhist temples overflow with meat, fish, and vegetables. There are processions with floats, bands, and lanterns that are set ablaze and sent to sea. (Chu Pu Tan Temple, Keelung)

UNITED STATES: Belly Dancing Festival. Hundred of participants belly dance on two stages while others take three-hour workshops to learn ancient Grecian veil rituals and Zeffah wedding ceremonies. Vendors sell exotic scarves, jangling jewelry, and music. (Snowbird, Utah)

UNITED STATES: Michigan Womyn's Music Festival. During the week, forty women's musical groups perform day and night for 5,000 women participants who camp in the woods not far from Lake Michigan. Three hundred workshops teach everything from drumming to bike mechanics. Activities include a women's film festival and craft exhibition. (two hours from Grand Rapids, Michigan)

UNITED STATES: Our Lady of Miracles Celebration. Portuguese-Americans celebrate for three days, blessing the cows, singing and dancing, praying, watching bloodless bullfights, and feasting. The highlight is the queen's procession: girls wearing velvet, satin, embroidered, bejeweled capes stitched by elderly women from the Azores. (Gustine; Hanford, California)

UNITED STATES: WiminFest. A three-day festival of women's visual and performance art, plus lesbian culture. Exhibitions of the work of women from all cultural, ethnic, socioeconomic, and artistic backgrounds. (Albuquerque, New Mexico)

VANUATU: Nekowiar (Toka Dance). Men, wearing tasseled skirts and painted hair, leap in a frenzy and try to trap women in their dance circles. Catching one, they toss her up and down, fondle, and pinch her. This continues all night. In the morning: pigs are slaughtered; everyone feasts. (Tanna Island)

SEPTEMBER

CHINA: Zhong Qiu Jie (Moon Cake or Mid-Autumn Festival). One legend says the Moon Fairy lives in a crystal palace and dances at night on the moon's surface. Another says that an empress swallowed an immortality pill and became the moon. This festival celebrates the moon with lanterns shaped like dragons, butterflies, rabbits, and fish and everyone enjoys moon cakes (pastries with sweet or savory centers). (Chinese communities worldwide)

ETHIOPIA: Maskal Festival. This festival has been celebrated for 1,600 years to honor Empress Helena who discovered the cross on which Christ was crucified. One hundred thousand spectators watch floats carrying illuminated crosses. Pilgrims in traditional dress dance around bonfires until dawn. (Addis Ababa)

*MOROCCO: Moussem of Imilchil. Widows and divorcées look for husbands during this Ait Hadiddou tribal festival where 30,000 people camp in tents for three days. If the women have good luck, they (and their engaged, single sisters) go with their grooms to register their marriages; music and dancing follow. (Agoudal, Atlas Mountains)

SINGAPORE: Lantern Festival. Legend says that during the Han Dynasty a little Chinese girl tricked the emperor into having a wonderful festival that would give her a reason to visit her family. Today, for ten days, illuminated lanterns shaped like tigers, flamingos, swans, and all kinds of creatures, are illuminated in pagodas, malls, markets, and schools. (Chinese Garden, Singapore)

SOUTH KOREA: Ch'usok. Legend says that Korean princesses led two groups, each comprised of half the women in the kingdom, in a cloth-weaving competition. The group that produced less prepared a feast for the winners. Today, this festival remembers ancestors and celebrates the harvest. The highlight is kang-gang-suwollae, a circle dance women perform wearing in their prettiest dresses.

*UNITED STATES: Miss America Competition. Fifty-one state finalists compete to become Miss America for one year, on the basis of their agendas for social change, talent, poise, fitness, and awareness of current events. (Atlantic City, New Jersey)

UNITED STATES: Na Wahine O Ke Kai Canoe Race. Na Wahine O Ke Kai (Women of the Sea) race Hawaiian-style canoes through the treacherous Kaiwi Channel. (Hale O Lono Harbor, Oahu)

UNITED STATES: Ripe Corn Festival. Cherokees celebrate Selu (First Woman) who created corn by rubbing around her stomach and beans by rubbing around her breasts.

OCTOBER

CHINA: Moon Festival. In Chinese cosmology, the moon represents the female principle, yin, and has been venerated for more than 2,000 years. The moon goddess is Chang E. Only women participate in this festival, which occurs on the night of the full moon. (Chinese communities worldwide)

INDIA: Batukamma Panduga (Festival of Flowers). Seven-day festival celebrated by women who make a bell-shaped floral representation of the goddess Uma (an

incarnation of Gauri), then sing, dance, and pray for the health and prosperity of their homes. Thousands of women dressed in silk finery converge at Bhadrakali Lake carrying floral "mountains" in every imaginable color, then immerse them in the water. (*Warangal, Telangana region, Andhra Pradesh*)

INDIA: Chhattha Festival. Women make vows to the sun god, Surya, saying that they will fast if he improves their families' conditions. They carry sugarcane shrines to a river and stand in the water as sun rises, making offerings. (*Bihar*)

*INDIA: Ka Pomblang Nongkrem. The high priestess oversees the proceedings as the matrilineal Khasi people celebrate the harvest with the sacrifice of goats and cocks, the music of flutes and drums, and dancing by the virgins and men of the tribe. (*Smit, near Shillong, Meghalaya*)

INDIA: Karva Choth. At dawn, Hindu married women eat selected grains and fruit, then fast until the moon rises. When it does, they go outside to pray for their husbands' prosperity, well-being and longevity, and offer water and flowers to Shiva and Parvati.

*INDIA: Navaratri. This nine-day festival, which overlaps with Diwali (Dipawali) and Durga Puja, is dedicated to the mother goddess, Shakti, in her forms as Durga (the warrior goddess), Lakshmi (goddess of wealth and abundance) and Saraswati (goddess of learning, music, and the arts). In Udaipur, 20,000 devotees crawl through a low temple arch. In Calcutta, clay Durga images are worshipped at marquees and at home, then immersed in the river on the final day. In Delhi and Mumbai, there are performances of the epic, Ram Lila; in Mysore, pageantry reminiscent of medieval times. Diwali is celebrated with lamps, candles, fireworks, and sweets made from milk, rock sugar, and cardamom; businesses open books for the new fiscal year. In Orissa, women paint designs on their houses. In Gujarat, women dance the Garba, a line dance performed with percussion sticks; in Rajasthan, they braid rope as they dance the Goph Guntan. In Tamil Nadu, women decorate their doorsteps with elaborate designs and start Diwali day with an oil bath.

JAPAN: Memorial Service for Dolls. Priests in temples recite sutra, burn old dolls and dedicate the ashes to a doll mound in the temple courtyard. (*Hongakuji Temple, Kamakura; Kaneiji Temple, Tokyo*)

NEPAL: Ghatasthapana-Purmina. Two-week festival honoring the goddess Durga. Every household sets up a Durga shrine and on the ninth day, devotees visit important Durga temples. On the tenth day, sword-wielding men parade with bands playing traditional music. There are many blood sacrifices of buffalos, goats, chickens, ducks. (*Thamel, Kathmandu; Mangal Bazaar, Patan*)

THAILAND: Loy Kratong Festival. Pays homage to Phra Mae Khongkha, goddess of rivers and waterways. This festival began in the thirteenth century when Nang Noppamas sent a small boat with a candle and incense downstream past a pavilion where her husband, the king, was entertaining friends. Today, Thai women fill floral

floats with candles and incense so the goddess will erase their sins and bless their love affairs. (*Chiang Mai; Arruthaya; Sukhothai, Thailand; Penang, Malaysia*)

UNITED STATES: Emma Crawford Coffin Festival. In the 1800s, spiritualist Emma Crawford was buried at the top of the 7,200 foot Red Mountain. In the 1900s, heavy summer rains washed her coffin into the canyon below. Reburied in a cemetery, she's remembered with a race of coffins on wheels. Each five-member team builds its own; one rides while four push. (*Manitou Springs, Colorado*)

UNITED STATES: Eö e Emalani i Alaka'i Festival. In 1871, Hawaii's Queen Emma, wife of King Kamehameha IV, braved the Alaka'i Swamp to see some of the world's most unusual plants. Today, celebrants pack picnics, take nature walks, and watch the festival's royal procession as well as musicians, hula, and crafts demonstrations. (*Kok'e State Park, Kauai, Hawaii*)

VIETNAM: Ka Te Festival. The Cham ethnic group celebrates yin/yang, sky/earth, mother/father. A woman psychic presents offerings. Young women compete at weaving (the winner has produced the most beautiful, longest piece of fabric in an hour). There are costumed processions, religious rituals, sacred dancing, and feasting. (*Ninh Thuan; other provinces in central region*)

NOVEMBER

BOLIVIA: Swings of San Andrés. Marriageable young women take turns on decorated swings, some of which are 35 feet high. On the beams are baskets with gifts; women believe if they touch the baskets, they will be lucky in love. "Flaming flower! Flaming flower!" they shout as they fly across the sky. Tradition says the swings help propel ancestral spirits, who have been visiting, back to the heavens. (*Tortora*)

BURMA: Tazaungdiang Festival. An all-night speed-weaving competition is held at the temple, as single women weavers make robes for the monks, which they present the next morning. (*Shwedagon Pagoda, Rangoon; Taunggyi*)

ECUADOR: Mama Negra Festival. In 1742 after the volcano Cotopaxi erupted, the Virgen de las Mercedes was declared Patroness of the Volcano. On her Saint's Day, the Ritual of the Mama Negra is performed: a sacred tragedy that dramatizes the liberation of the black slaves. Mestizo men play all the roles including Mama Negra. (*Latacunga*)

*INDIA: Kali Puja. This festival celebrates Kali, the terrifying warrior goddess for whom Calcutta was named. Black male goats are sacrificed. Kali images are worshipped, then immersed on the final day. (*West Bengal; Assam; Orissa; Bihar*)

NEPAL: Festival of Chait. Women line the area's 108 ponds with offerings to Chait, the sun god. At the holy pond of Dhanush Sagar, they immerse themselves waist-deep and hold the offerings to the setting sun. At dawn they return and perform the same ceremony to the rising sun—they used to stay in the ponds all night as penance. (*Janakpur*)

TIBET: Belha Rabzhol (Auspicious Heavenly Maid Festival). Lamas from the Moru Monastery offer sacrifices to the Auspicious Heavenly Maid, who protects the Buddhist Doctrine at the Jokhang Monastery. Her portrait is carried in procession and Tibetan women wear their best clothing to honor the portrait, bringing the Maid scarves as gifts. This is a favorite festival for Tibetan women, who nickname it the Fairy Festival. (*Lhasa*)

DECEMBER

BENIN: Egungun Festival. The Yoruba cult, Gélédé, honors women's power. The festival occurs when the priestess decides: usually at the beginning of an agricultural cycle. It pays tribute to the female ancestors, elders, and deities who are known as "our mothers," whose powers are both constructive (fertility) and destructive (witchcraft). The festival is celebrated in the marketplace (women control trade and are economically independent, so the marketplace symbolizes female power). The dancers are men who are costumed in women's head scarves, baby wrappers, and skirts, which they borrow from all the women in the village. (*also celebrated in Nigeria, where the date is set by divination between March and May*)

MEXICO: Fiesta de Inmaculada Concepcion. Parades, bullfights, and dances honor the Virgin Mary, the patron of this island which, when Spanish explorers discovered it in the fifteenth century, was inhabited only by Mayan statues of women. (*Isla Mujeres; Cancun*)

MEXICO: Our Lady of Guadalupe. In 1531, the Virgin appeared outside of Mexico City and asked a poor Indian to have the bishop build a church on that site. A long list of miracles, cures, and interventions are attributed to her. Each year, ten million visit her basilica, the most-visited Catholic Church in the world after the Vatican. (*Mexico City*)

PAKISTAN: Chaumos Festival. The Kalasha tribe's winter solstice festival. Day 3: teenage girls compete in a war of words. Days 4 and 5: music and dancing in the temple of Jeshtak (goddess of marriage, pregnancy, and birth). Day 8: Women's ceremony of sacrificial bread. Girls eat offerings and throw the remainder in the river for the dead. Women chant and perform erotic dances. Day 14: Cross-dressing and masks represent the primordial unity of the sexes, a perfect condition said to exist in another age. In order to attend the festival, visitors must demonstrate respect for local customs by sacrificing a goat. (*Mummuret Valley; Rukmur Valleys*)

SRI LANKA: Nanumuramangallaya. Emperor Asoka's daughter, Bhikkhuni Arahath Sangamitla, accompanied her brother who introduced Buddhism to Sri Lanka. She took her father's gift: a sapling from the sacred Bodhi tree under which Buddha obtained enlightenment. The sapling, now 2,283 years old and believed to be the oldest tree in the world, is treated like a living Buddha. During this ceremony, it is decorated with ornaments. (*Mahamewuna Garden*)

*SWEDEN: Sankta Lucia Day. Clad in long white gowns, girls wear crowns of candles, sing, and serve their parents saffron rolls and coffee in bed. In Stockholm, Lucia and

her attendants parade through the streets in decorated carriages.

SWITZERLAND: Achetringele Festival. Maidens are beaten with inflated pigs' bladders in a rambunctious New Year procession. (*Laupen*)

TURKEY: St. Nicholas Festival. St. Nicholas, a fourth-century bishop, anonymously dropped bags of coins down the chimneys of the homes of village girls who had no dowry, thus allowing them to marry. (*Antalya; Demre*)

SELECTED BIBLIOGRAPHY

DURGA AND KALI PUJAS, INDIA

Bahadur, Om Lata. *The Book of Hindu Festivals and Ceremonies.* New Delhi: UBS Publishers' Distributors Ltd., 158-185, 2000.

Camphausen, Rufus C. *The Yoni: Sacred Symbol of Female Creative Power.* Rochester: Inner Traditions, 1996.

Chidananda, Sri Swami. *God as Mother.* www.sivanandadlshq.org, 1999.

Daniélou, Alain. *The Myths and Gods of India: the Classic Work on Hindu Polytheism.* Rochester: Inner Traditions International, 1991.

Feuerstein, Georg. *Tantra, The Path of Ecstasy.* Boston, London: Shambhala Publications, 1998.

Harding, Elizabeth U. *Kali, The Black Goddess of Dakshineswar.* Delhi: Motilal Banarsidass, 1998.

Huyler, Stephen. *Meeting God: Elements of Hindu Devotion.* New Haven: Yale University Press, 1999.

Kinsley, David. *Hindu Goddesses: Visions of the Divine Feminine in Hindu Religious Tradition.* Delhi: Motilal Banarsidass, 1986.

Kinsley, David. *Tantric Visions of the Divine Feminine: Ten Mahavidyas.* Berkely, Los Angeles, London: University of California Press, 1997.

LaPierre, Dominique. *City of Joy.* New York City: Doubleday, 212-220, 1985.

Mookerjee, Ajit. *Kali. The Feminine Force.* Rochester, London: Thames and Hudson Ltd., 1988.

Mukherjee, Sree Narendra Lal. *The Holy Shrine of Kamakhya.* Guwahti: Sree Kamal Sharma, 1999.

Pande, Mrinal. *Devi: Tales of the Goddess in Our Time.* New Delhi: Penguin Books India, 1996.

Pintcheman, Tracy. *The Rise of the Goddess in the Hindu Tradition.* Albany: State University of New York Press, 1994.

Saraswati, Swami Satyananda. *Kali Puja.* New Delhi: Devi Mandir Publications and Motilal Banarsidass Publishers Private Limited, 1996.

Wilkins, W.J. *Hindu Mythology: Vedic and Puranic.* New Delhi: Rupa & Co., 2001.

Zimmer, Heinrich. *Myths and Symbols in Indian Art and Civilization.* Princeton: Princeton University Press, 1992.

FESTA DA NOSSA SENHORA DA BOA MORTE, BRAZIL

Amado, Jorge. *The War of the Saints.* New York: Bantam Books, 1993.

Clifford, Paul F. *Origins of Samba: Candomblé and the Music.* www.geocities.com/sd_au/samba/sambanotes2.html

Cobb, Charles E. "Bahia Where Brazil Was Born." *National Geographic* (August 2002): 62-81.

Costa, Sebastião Heber Vieira. *A Festa da Irmandade da Boa Morte e o ícone ortodoxo da Dormição de Maria.* Presented at the Instituto Geográfico e Historico da Bahia, 2002.

Deren, Maya. *Divine Horsemen: The Living Gods of Haiti.* Kingston: McPherson & Company, 1991.

Falcon, Gustavo. *Boa Morte: The Sisterhood that Exalts Life!.* Bohini Center for African Oriental Studies, Federal University of Bahia, www.geocities.com/wellesley/4328/history.htm

Fatunmbi, Awo Fá'lókun et. al. *Ìbà'se Òrìsà, Ifá Proverbs, Folktales, Sacred History, and Prayer.* Bronx: Original Publications, 1994.

Holweck, Frederick G. *The Feast of the Assumption.* Catholic Encyclopedia, www.newadvent.org/cathen/02006b.htm, 2003.

Klein, Cecelia F. et al. *Mother, Worker, Ruler, Witch: Cross-Cultural Images of Women.* Los Angeles: UCLA Museum of Cultural History Pamphlet Series, Volume I, Number 9, 1980.

Lee, Gary. "The Beat of Bahia." *Washington Post* (July 2, 2000).

Lima, Vivaldo da Costa et al. *Encontro de Nacoes de Candomblé: Anais do Encontro Realizado em Salvador.* Co-edited by Ianamá and the Universidade Federal da Bahia Centro de Estaudos Afro-Orientais and Centro Editorial E. Didático, 1981.

Lody, Raul. *A Roupa de Biana.* Salvador: Memorial das Baianas, 2003.

Nascimento, Abdias and Elisa Larkin Nascimento. *Africans in Brazil: A Pan-African Perspective.* Trenton: Africa World Press, 1992.

Page, Joseph A. *The Brazilians.* Reading: Perseus Books, 1995.

Polk, Patrick Arthur. *Haitian Vodou Flags.* Jackson: University Press of Mississippi, 1997.

Ribeiro, Antonio Moraes and J.H. Kennedy. *The Good Cause.* www.brazzil.com/p33aug02.htm, 2002.

Selveira, Renato da. *Sur Le Mouvement de Fondation du Candomble de la Barroquinha a Salvador de Bahia—1764-1851.* Revision of *Jeje-nagô, iorubá-tapá, aon-Efan, ijexá: processo de constituição do candomblé da Barroquinha—1764-1851.* Cultura Vozes, n.6, vol. 94 (Petropólis, 2000).

Tierney, J.C. *Historical Background: Belief in Mary's Assumption.* Dayton: The Marian Library, International Marian Research Institute. www.udayton.edu/mary/meditations/assmp01.html, 2002.

Voeks, Robert A. *Sacred Leaves of Candomblé: African Magic, Medicine, and Religion in Brazil.* Austin: University of Texas Press, 1997.

FESTIVALS

Boyer, Marie-France. *The Cult of the Virgin: Offerings, Ornaments and Festivals.* London: Thames and Hudson, 2000.

Clynes, Tom. *Wild Planet! 1,001 Extraordinary Events for the Inspired Traveler.* Detroit: Visible Ink Press, 1995.

Dresser, Norine. *Multicultural Celebrations, Today's Rules of Etiquette for Life's Special Occasions.* New York: Three Rivers Press, 1999.

Gulevich, Tanya. *World Holiday, Festival, and Calendar Books.* Detroit: Omnigraphics, Inc., 1998.

Ingpen, Robert and Philip Wilkinson. *A Celebration of Customs and Rituals of the World.* New York: Facts on File, 1996.

Menard, Valerie. *The Latino Holiday Book.* New York: The Marlowe Company, 2000.

Ozawa, Hiroyuki. *The Great Festivals of Japan: Spectacle and Spirit.* Kodansha International, 1999.

Pennick, Nigel. *The Pagan Book of Days: A Guide to the Festivals, Traditions, and Sacred Days of the Year.* Rochester: Destiny Books, 1992.

Rufus, Anneli. *The World Holiday Book: Celebrations for Every Day of the Year.* San Francisco: HarperSanFrancisco, 1994.

Stephanchuk, Carol. *Red Eggs & Dragon Boats: Celebrating Chinese Festivals.* Berkeley: Pacific View Press, 1994.

Warrier, Shrikala and John G. Walshe. *Dates and Meanings of Religious and other Multi-Ethnic Festivals, 2002-2005.* Berkshire: Foulsham Educational, 2001.

FESTIVIDAD DE LA VIRGEN DE CANDELARIA, PERU; AND LA VIRGEN DE URKUPIÑA, BOLIVIA

McFarren, Peter and Sixto Choque. *Masks of the Bolivian Andes.* La Paz: Editorial Quipus/Banco Mercantil S.A., 1993.

Prudencio, Javier Palza. *The Fantastic Parade.* La Paz: Bisa Grupo Financiero, 2000.

Terán, Néstor Taboada. *Urqupiña por Siempre.* Cochabamba: Editora HP, 1999.

Weatherford, Jack. *Savages and Civilization.* New York: Fawcett Columbine Books, 1994.

FÊTE DES CUISINÈRES, FRENCH WEST INDIES

Condé, Maryse. *Crossing the Mangrove.* New York: Doubleday, 1995.

Ebroin, Ary. *L'Histoire de la Cuisine Créole*, Point-à-Pitre, unpublished, 2001.

Glaude, Renée. *Un Époque d l'histoire de la Guadeloupe a traverse le costume, 1860-1920.* Point-à-Pitre: Musée St. John Perse, 1990.

LaPorte, Joelle, et. al. *West Indian Recipes.* Grand Sud Editions, 1993.

Le Costume Creole. Conservatoire du Patrimoine Culturel de la Guadeloupe, 1996.

Schneider, Sally. "Guadeloupe Cooks," *Saveur* magazine, Issue #18 (April 1997).

Schwarz-Bart, Simone and Andre. *Hommage a la Femme Noire.* Belgium: Ludion SA, 1989.

Thiry, J.F. *Le Costume Creole: Parure de Reine.* Pointe-à-Pitre: Conservatoire du Patrimoine Culturel de la Guadeloupe, 1996.

KA POMBLANG NONGKREM, INDIA

Berry, Radhon Singh. *Ka Jingsneng Tymmen*. Part I, translated by Bijoya Sawian, Shillong, 1995.

Ghosh, G.K and Shukla. *Fables and Folktales of Meghalaya*. Calcutta: Firma KLM Private Limited, 1998.

Gurdon, Major P.R.T. *The Khasis*. Delhi: Low Price Publications, 1990.

Roy, U Hipshon. Khasi Heritage: *A Collection of Essays on Khasi Religion and Culture*. Shillong: Ra Khasi Press, 1996.

Roy, U Hipshon. *Where Lies the Soul of Our Race*. Shillong: Ri Khasi Press, 1982.

Sawian, Bijoya. *Khasi Folktales*. Shillong: Ri Khasi Press, 1999.

Stirn, Aglaja and Peter Van Ham. *Seven Sisters of India: The Tribal Worlds between Tibet and Burma*. Munich: Prestel, 2000.

MAZU FESTIVAL, CHINA

Sinorama magazine (March 1993): 101-103.

Stephanchuk, Carol and Charles Wang. *Mooncakes and Hungry Ghosts: Festivals in China*. San Francisco: China Books and Periodicals, 1992.

MISS AMERICA COMPETITION, UNITED STATES

Goldman, William. *Hype and Glory*. New York: Villard Books, 1990.

Harmon, Katie with the 2001 Miss America Contestants. *Under the Crown*. Seattle: Milestone Books-Hara Publishing, 2002.

MOUSSEM OF IMILCHIL, MOROCCO

Aherdan, Meriem. *The Power of Celebrations*. Rabat: Editions Marsam, 2000.

Beckwith, Carol and Angela Fisher. *African Ceremonies*. New York: Harry N. Abrams, 1999.

Courtney-Clark, Margaret and Geraldine Brooks. *Imazighen: The Vanishing Traditions of Berber Women*. New York: Clarkson Potter, 1996.

Covington, Richard. "Dreams in the Desert," *Smithsonian* magazine (August 2002): 84-85.

Khayat, Rita El. *Women's Sumptuous Morocco*. Rabat: Editions Marsam, 2002.

Laoust, Émile. *Noces Berbères: Les cérémonies du mariage au Maroc*. Paris: Édisud/Las Boite a Documents, 1993.

Morin-Barde, Mireille. *Coiffures Féminines du Maroc au Sud du Haut Atlas*. Aix-en-Provence: Édisud, 1990.

Rauzier, Marie-Pascale. *Moussems et Fêtes Traditionnelles au Maroc*. Paris: ACR Edition Internationale, 1997.

Valentin, Jean-Pierre and Paul Lorsignol. *Haut-Atlas-Sahara: Horizons Berbères*. Fontenay-Sous-Bois, Anako Editions, 2000.

Watson, Albert. *Maroc*. New York: Rizzoli, 1998.

NOC ŚWIĘTOJAŃSKA, POLAND

Knab, Sophie Hodorowicz. *Polish Customs, Traditions and Folklore*. New York: Hippocrene Books, 1996.

Knab, Sophie Hodorowicz. *Polish Herbs, Flowers and Folk Medicine*. New York: Hippocrene Books, 2002.

Testament Ks. Krzysztofa Kluka Botanika w Ciechanowcu. Muzeum Rolnictwa im. ks. Krzysztofa Kluka w Ciechanowcu, 1999.

ROMERIA DE SANTA MARTA DE RIBARTEME, SPAIN

Grandmaison, Jean Marie. *Eglise Sante Marthe a Tarascon de Provence*. Tarascon: Presses de la Tarasque, 1984.

Pope, Hugh. *Saint Martha*. Catholic Encyclopedia, www.newadvent.org/cathen/09721b.htm, 1999.

Renard, Louis. *La Tarasque: Le Temps Retrouve*. Brooklyn: Equinox Press, 1991.

RUDOLFINA REDOUTE, AUSTRIA

Parenzan, Peter. *Hofburg-Vienna*. Barcelona: Editorial Escudo de Ora. S.A., 1999.

Taylor, AJP. *The Hapsburg Monarchy, 1809-1918*. London: Penguin, 1990.

Walterskirchen, Gudula, et. al. *Der Wiener Fasching: Die Zeit der Bälle un Walzer*. Vienna: Holzhausen Verlag, 2001.

SANKTA LUCIA DAY, SWEDEN

Ekstrand, Florence. *Lucia, Child of Light: The History and Tradition of Sweden's Lucia Celebration*. Mount Vernon: Welcome Press, 1989.

Swahn, Jan-Öjvind. *Maypoles, Crayfish and Lucia: Swedish Holidays and Traditions*. Stockholm: The Swedish Institute, 1994.

UMHLANGA, SWAZILAND

Beckwith, Carol and Angela Fisher. *African Ceremonies*. New York: Harry N. Abrams, 1999.

Dube, Oswald Basize. *The Arrow of King Sobhuza II: A Book of Poems and Tributes to the Crown Prince Makhosetive and King Sobhuza II*. Mbabane: Websters Print, 1986.

Dube, Oswald Basize and Joice Jabulile Dlamini. *The Spear of the Swazi Nation*, Mbabane. Websters Print: 1986.

Hall, James. *Speak Manzini: An Autobiography of an African City*. Manzini: Landmark Publications, 2000.

Hall, James. *Umlungu in Paradise: The Anthology*. Mbabane: Websters Pty Ltd., 1998.

Kasenene, Peter. *Swazi Traditional Religion and Society*. Mbabane: Websters, 1993.

Kuper, Hilda. The Swazi: *A South African Kingdom*. New York: Holt, Rinehart and Winston, 1986.

Matsebula, JSM. *A History of Swaziland*. Capetown: Maskew, Miller, Longman, 1995.

"Sex in Swaziland: Setting a Royal Example," *The Economist* (November 17, 2001): 45.

Westcott, Michael and Carolyn Hamilton. *A Historical Tour of the Ngwane and Ndwandwe Kingdoms: In the Tracks of the Swazi Past*. Manzini: Macmillan Boleswa Publications, 1992.

WOMEN

Harvey, Andrew and Anne Baring. *The Divine Feminine: Exploring the Feminine Face of God Throughout the World*. Berkeley: Conari Press, 1996.

Monaghan, Patricia. *The New Book of Goddesses & Heroines*. St. Paul: Llewellyn Publications, 1997.

Walker, Barbara G. *The Women's Encyclopedia of Myths and Secrets*. San Francisco: HarperSanfrancisco, 1983.

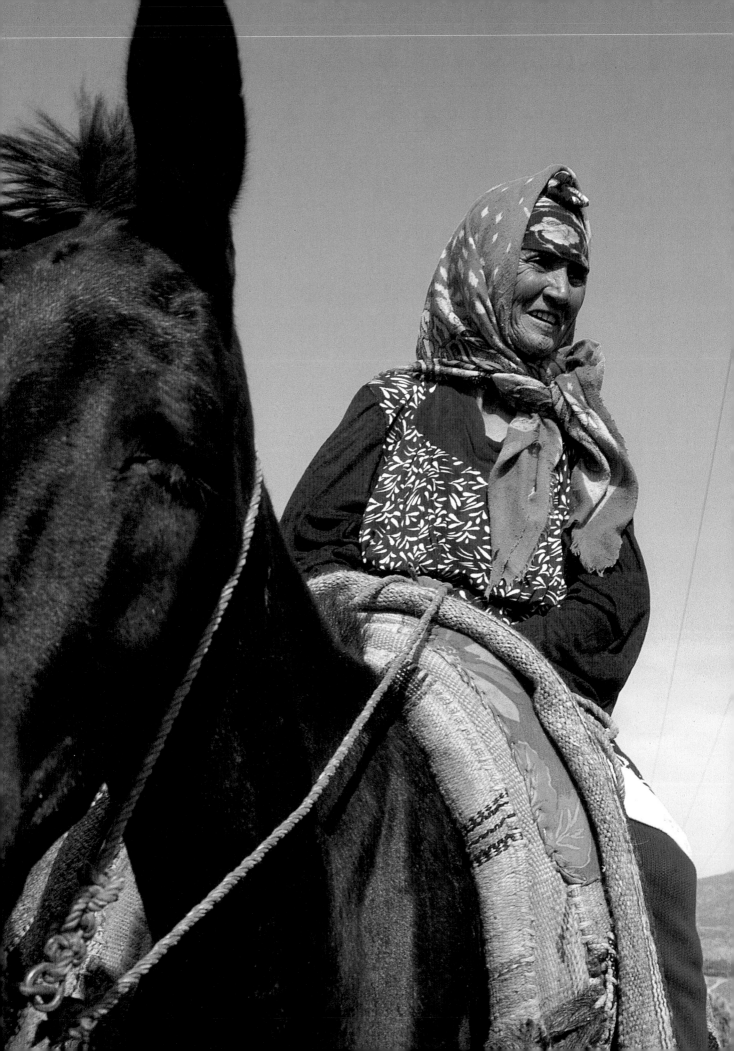

ACKNOWLEDGEMENTS

Without Liz Spander, Casto Travel/San Francisco, this book would still be just an idea. She not only created flawless arrangements in destinations far off the beaten path, she tailored an international network of travel professionals. My local, English-speaking interpreters/guides were experts in local history and culture, assertive enough to get me appointments with mayors, governors, and royalty and person-able enough to stop people on the street for spontaneous interviews. Months later, every one read the chapter s/he helped create, to double-check facts and spelling. Austria: Gertie Schmidt. Bolivia: Tim Johnson. Brazil: Carlos Scorpäio. China: Jack Hisa Bin Chiang. French West Indies: Hedwige Kelly. Finland: Tuula Estola. India: Anoop Adhikari, Tapoti Barooah, Babu Mohapatra, Rekha Ramamurthi. Morocco: Sarhan Hajjaj. Peru: Roger Valencia. Poland: Paweł Celejowski. Spain: Sean O'Rourke. Swaziland: Ndileka Mabusa. Sweden: Kerstin Englund. Thailand: Krit Teowanichkul.

Visionary Elizabeth Colton and the Board of the International Museum of Women in San Francisco provided invaluable support. Festival artifacts acquired with their grant will become part of the museum's permanent collections. The first exhibition to be originated by IMOW will be "Celebrating Women," opening in October 2004. For more information, visit www.imow.org/celebratingwomen/index.html

As my work unfolded, photographers Sam Abell, David Alan Harvey, and Alex Webb taught me. Alev Lytle-Croutier and members of the writing group she leads offered invaluable suggestions. Judith Jaslow, Rebecca Moudry, and Anne Sunderland translated French and Spanish documents, and my husband, David Hill, not only deciphered German texts but contributed frequent flier miles when mine ran out and was generous with editorial ideas as well as enthusiastic support. My friends Beverly Allen, Joan Chatfield-Taylor, Tessa and Harris Gordon, Stephen Huyler, and Toby Tuttle kept me company at six festivals, contributing expertise and fun.

People in fifteen countries allowed interviews and photographs, offered infor-mation, ideas and introductions. Without these amazing people and the rest of my international team, there would be no book: Hafsat Abiola, Carlos Aguiar, Jeanne Alberi, Isabel Allende, Joselita Sampaio Alves, Antti Amyttanen, Alston Anderson, Frank Anderson, José Aramayo, Eva Auchincloss, Märit Antonsson, Agneta Baczewska, Katarzyna Baliszewska, Anne Balsamo, Lin Jin Bang, Cynthia Barreiro, Florigna Bello, Linda Beeman, Leah Ben-David Val, Teresa Benitez, Santimoy Bhattacharya, Sumit Bhattacharyya, Michel Bitritto, Michelle Boc, Agnetha Borgh, Britt-Marie Borgström, Carrol Boyes, Karolina Bozek, Peter Block, Laetitia Broulhet, Ketty Bregmestre, Tanisha Brito, Daniel Buckley, Lucjan Budlewski, Hector Cartegena Chacon, Fernando and Yomar Cespedes, Nikhilesh Choudhuri, Pongpring Chandjaya, Pracha Chitsuthipol, Marika Chojnowska, Kehaulani Christian, Craig Cohen, Viktoria Colonna, Samuel Coppage, Sharon Cresse, Olga Czerepow, Maria da Anunciação Nascimento, Maria Cesaria da Conceição, Renildes Rodriques da Conceição, Maria das Dores da Conceição, Marge D'Wylde, Casimir Dadak, Bonnie Dahan, Nilza Matias da Paixão, Anália da Paz Santos Leite, Anand Dasgupta, Maria Lameu da Silva Santos, Laura Dearborn, Nilza Prado de Carvalho, Tomasz Deptula, Adeildes Ferreira de Lemos, Lindaura Paz dos Santos, Antonia Dias Brito, Harriet Dlamini, Ntokolo and Simile Dlamini, Tsandzile Dlamini, Naobile Dludlu, Almerinda Pereira dos Santos, Valmir Pereira dos Santos, Floriceia dos Santos Balbino, Carmen Duran, Paras Nath Dwivedi, Ary Ebroin, Susanne Elser, Thomas Schaëfer-Elmayer, Ashok Elwin, Marcello Esprella, Ruth Eriksson, Dotty Ewing, Maxe Favieres-Custos, Birgit Feichtinger, Estelle Freedman, Sheila Freemantle, Nicole Freese, Gaiacú Luiza, Ks. Bogdan Geiylc, Guy Claude Germain, Mukul Ghosh, Kesolin Giri, Jennifer Glover, Cassemira Moreira Gomes, Wande Goncalves, Adenor Gondim, Rosemary Gong, Mme. Henry Golte, Fatma Gout, Monika Grabowska, Susan Griffin, Luis Alberto Butrón Guardia, Joseph Gulietti, Geeta Gupta, David Hannoah, Erika Harold, Nora Harris, Roza and Liana Hassan, Karla Henrick, Peter Hofer, Colleen Hummer, Niilo Huttusen, Sharon Hyche, Mohammed Imtiaz, Barbara Jackson, Judy Jaeger, Regina and Stefan Jaszcroft, Hannele and Johanna Jauhiainen, M.L. Rajadarasri Jayankura, Phoebe Johnson, Judith Joseph, Jone Juntunen, Leena Juntumen, Stina Kachadourian, Prapason Kaewtrairat, Suep Pong Kairerk, Quinn Kharumnuid, Honsa Khatwar, Jacky Keith, Aneta, Ewa and Milena Koc, Jukka Kauppinen, Markku Kamppainan, Leena Korhonen, Susan Krieger, Magdalena Kula, Suvit Kumdee, David Laitphlang, Marissa Lamagna, Dorota Łapiak, Docey Lewis, Gnag Jin Lin, Yin Jin Lin, Mavis Litchfield, Agnieszka Łochnicka, Manuel Janeiro Lopez, Jose Aranjo Lorenzo, Susan Lundy, Bridget Maasland, Viviane Madacombe, Victorine Madacombe, Elizabeth Maldonado, Prasan Mangprayoon, Tizzie Maphalala, Lorna Marbaniang, Andrew Masina, Valéria Mattos, Hlengiwe and Welile Mdluli, Jim Metzner, Mphica Mtetwa, Elli Moilanen, Sharon Moran, Antoni Mosieqicz, Amy Mulkey, Shaju Müller, Maria Murawska, Luiz Cláudio Nascimento, Arlene Neher, Saalomn Sipho Nkatbule, Tracy Nongsieh, Karen Offen, Małgorzata Oleszkiewicz, Bonnie Oliver, Agda Oliveira, Angela O'Rourke, Wolfgang Ortner, Kamil Osiński, Hadda Oushba, Shoha Kirti Parekh, Keith Pariat, Kim Parker, Gaspar Broullon Pastoriza, Ann Peden, Rolando Perez, Prayut Piangbunta, Valdina Olivera Pinto, Jennifer Pitts, Liisa Pirila, Eero Pitkänen, Daniel Power, Barbara Prag, Tiyaphan Praphanvitaya, Marigita Pudell, Suchata Pulalert, Lin Qin Qu, Rajyashree Ramamurthi, Sana Rantala, Tuija and Arja Rantalainen, Darron Raw, Carmen Regina, Luci Revollo, Carol Rimm, Victoria Rivers, Soonthorn Riwleung, Bill Roberson, Raúl Emilio Castro Rodriguez, Sara Rosen, Simone Rueff, Monika Rutkowska, Jolanta Rybak, Queenie Rynjah, Eveliina Saarinen, Rauno Sabolinen, Luis Sainz, Michelle and Scott Sangster, Celina Maria Sala, Lucienne and Robert Salcede, Estallita Souza Santana, Sandy and Stanley Sapire, Pablo, Veronica and Ruthkavina Saravia, Sitimon Sawian, Parteii and Prabhat Sawyan, Isabela Senatore, Diana Serbe, Maswazi Shongwe, Busisiwe Shongwe, Vanessa Short Bull, Evelyn Norah Shullei, Nokuthula Simelane, Mme. Joseph Sioul, Magnus Skarstedt, Molly Smith, Christina Solimando, Anna Sorensson, Anestina Santos Souza, Molly Sterling, Sriprachan Surakan, Roman Svabek, Silverine Swer, Eliza Tenza, Néstor Taboada Terán, Kless Thongni, Marilyn Timbrook, Michael Tohey, Norbert Tomaszewski, Jackie Mayer Townsend, Alicja and Joanna Tymińska, Riitta Sinikka Väisänen, Ladavan Vannaburana, Padre Ivań Vargas, Victoria Villca, Pairath Vittayaanumas, Jose Blanco Vrive, Monique Vulgaire, Charles Wankel, Maria-Luise Walek, Harald Willenig, Nancy Williams, Peggy Willman, Jeany Wolf, Zhou Jin Yan, (Kent) Kuang Xiao Yee, Wa Yee, Wu Zhen Yu, Ashraf Zahedi, Adriana Zehbrauskas, Oscar Escalante Zelada, Jelena Zjeliabovskaia.

Opposite: A Berber woman riding in the Atlas Mountains, Morocco

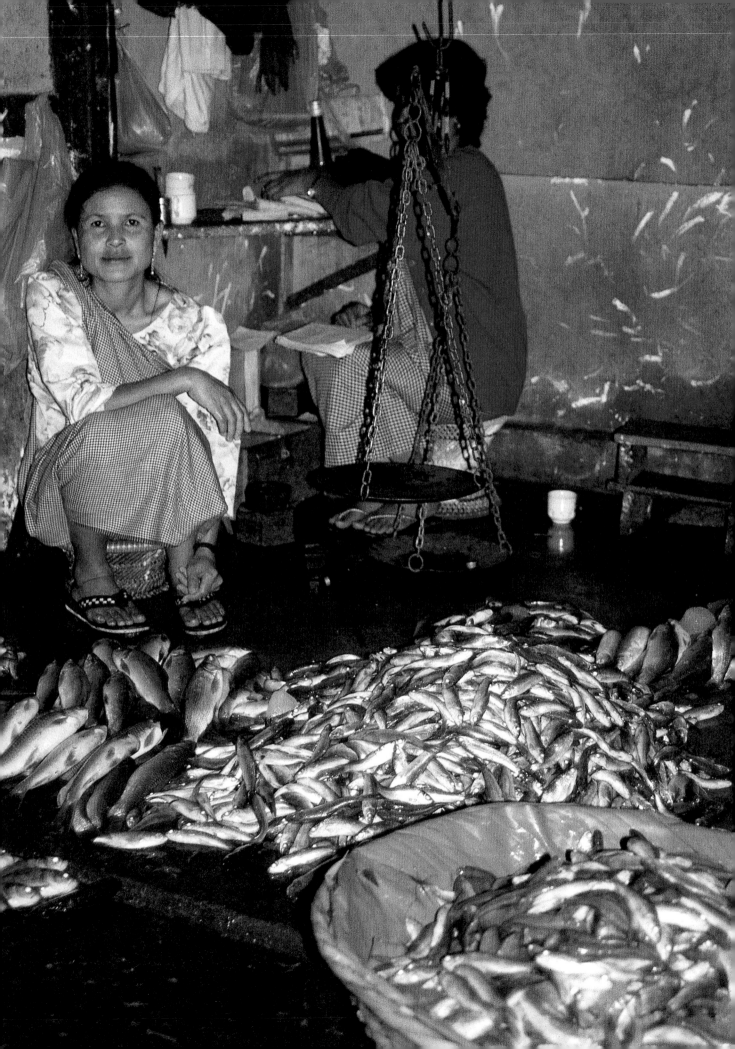

INDEX

Opposite: Khasi fishmongers in the Bara Bazaar, Shillong, India, will probably be commercially active all their lives.

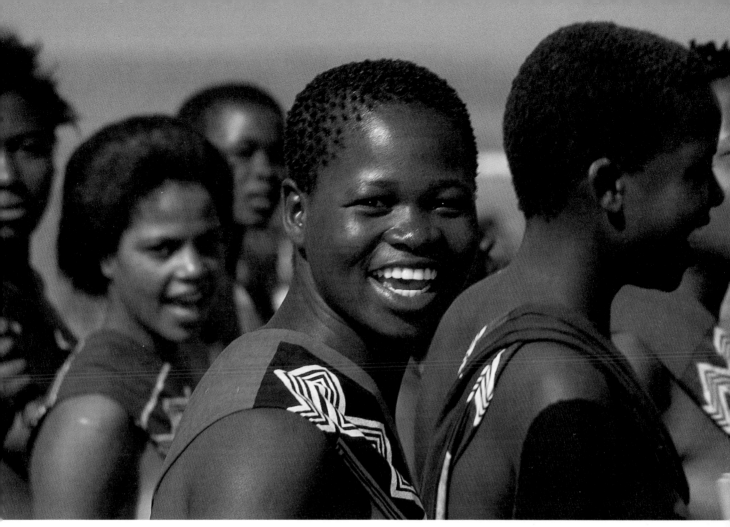

Above: To start the Umhlanga Festival, 25,000 Swazi maidens burst from the Queen Mother's compound in Lobamba, Swaziland.

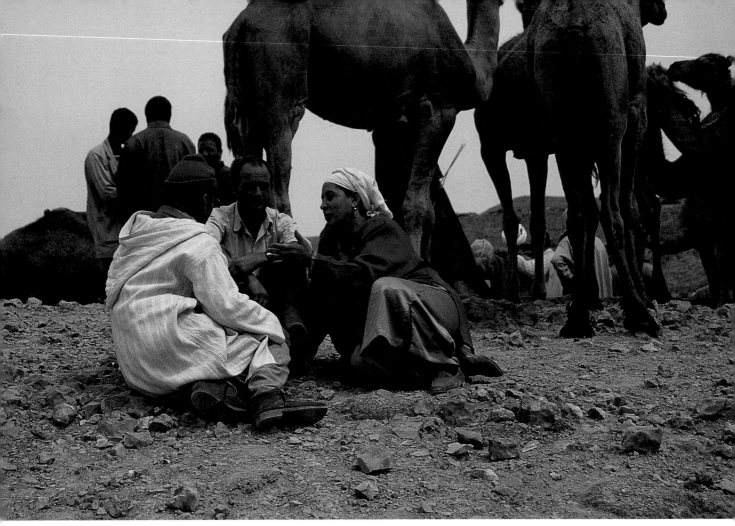

Above: Berber shepherd women sell animals at the livestock market during the Moussem of Imilchil, in Agoudal, Morocco.

Celebrating Women
© 2004 powerHouse Cultural Entertainment, Inc.
Photographs © 2004 Paola Gianturco
Text © 2004 Paola Gianturco

Published in the United States
by powerHouse Books, a division of
powerHouse Cultural Entertainment, Inc.
68 Charlton Street,
New York, NY 10014-4601
telephone: 212 604 9074
fax: 212 366 5247
e-mail:
celebratingwomen@powerHouseBooks.com
website: www.powerHouseBooks.com

First edition, 2004

Library of Congress Cataloging-in-Publication Data:

Gianturco, Paola.
Celebrating women / photographs and
text by Paola Gianturco.-- 1st ed.
p. cm.
Includes bibliographical references and index.
ISBN 1-57687-229-7 (hardcover)
1. Photography of women.
2. Festivals--Pictorial works.
3. Gianturco, Paola. I. Title.

TR681.W6G53 2004
779'.24'092--dc22
2004007834

Hardcover ISBN 1-57687-229-7

Separations, printing, and binding by D'Auria S.p.A., Ascoli Piceno

Book design by Karla Henrick

A complete catalog of powerHouse Books and
Limited Editions is available upon request;
please call, write, or celebrate women on our website.

10 9 8 7 6 5 4 3 2

Printed and bound in